Rodin and His Contemporaries

RODIN
and His Contemporaries

The Iris & B. Gerald Cantor Collection

Photographs by
David Finn

Text by
Marie Busco

CROSS RIVER PRESS
A Division of Abbeville Press
NEW YORK LONDON PARIS

Designed and produced by Ruder Finn
Designer: Laura Seuschek
Art director: Michael Schubert
Additional photographs: Lynton Gardiner

Front cover: Rodin, *Eve*, 1887
Back cover: Rodin, *Hand of God*, 1897

Library of Congress Cataloging-in-Publication Data
Busco, Marie.
 Rodin and his contemporaries: the Iris & B. Gerald Cantor
Collection/photographs by David Finn: text by Marie Busco.
 p. cm.
 Includes bibliographical references.
 ISBN 1-55859-364-0
 1. Rodin, Auguste, 1840–1917—Catalogs. 2. Rodin, Auguste.
1840–1917—Contemporaries—Catalogs. 3. Art, European—Catalogs.
4. Art, Modern—19th century—Europe—Catalogs. 6. Cantor, B. Gerald, 1916–
—Art collections—Catalogs. 7. Cantor, Iris—Art collections—Catalogs.
8. Art—Private collections—United States—Catalogs.
I. Finn, David, 1921– . II. Title.
NB553.R7A4 1992
730 .92—dc20 91-35810
 CIP

For Vera

Contents

Preface, by Philippe de Montebello 11

Curatorial Note, by Vera Green 13

B. Gerald Cantor: A Three-Dimensional Collector, by Albert E. Elsen 15

The Sculpture Collection 17

Rodin as Spokesman of the Unspeakable, by Albert E. Elsen 19

Rodin *Hand of God* 22

The Thinker 28

The Creator 35

Adam 36

Eve 42

The Three Shades 48

She Who Was Once the Helmet-Maker's Beautiful Wife 52

Women Damned 56

Cupid and Psyche 58

The Kiss 60

Eternal Idol 64

Meditation 68

Toilette of Venus 74

The Walking Man 78

The Monumental Torso of the Falling Man 82

Iris, Messenger of the Gods 84

Dance Movements 88

Nijinsky 90

La France 93

Head of Hanako 94

Monumental Head of St. John the Baptist 97

Monumental Bust of Victor Hugo 98

The Burghers of Calais 100

Monument to Balzac 110

Hand of Rodin with a Torso 116

Bourdelle	*Herakles the Archer*	*118*
Claudel	*The Waltz*	*122*
Dalou	*Torso of Abundance*	*128*
Kolbe	*Lament*	*130*
	Seated Girl (1907)	*132*
	Seated Girl (1926)	*134*
	Falling Woman	*136*
	Large Seated Woman	*138*
	Assumption	*140*
	Large Kneeling Woman	*144*
Lachaise	*Classic Torso*	*146*
Lehmbruck	*Seated Girl*	*148*
Manzù	*Seated Cardinal*	*150*
The Painting Collection		*153*
Paintings in the Cantor Collection, by Philip Conisbee		*155*
Sisley	*The Chestnut Tree at Saint-Mammès*	*161*
La Fresnaye	*Eve*	*163*
Vlaminck	*The Poet Fritz Vanderpyl*	*165*
	Hôtel du Laboureur, Rueil-la-Gadelière	*166*
	Snowy Landscape	*167*
Delaunay	*Portrait of Jean Metzinger*	*169*
Nolde	*Sunflower Garden*	*171*
	Three Figures	*172*
	Landscape with Red House	*173*
Beckmann	*Femina Bar*	*174*
Van Dongen	*Portrait of Jules Berry*	*176*
	Masked Ball at the Opéra	*177*
Caillebotte	*Nude Reclining on a Divan*	*179*
Guillaumin	*Dr. Martinez in the Painter's Studio*	*180*
Forain	*Woman Dressing*	*183*

Carrière	*Leaving the Theater*	184
	The New Wrist-Watch	185
Steinlen	*The Lovers*	187
Valtat	*The Steamboat*	188
	La Toilette	189
Corinth	*Portrait of Elly*	190
Boldini	*Portrait of Mrs. Edward Parker Deacon*	192
Hayet	*Boulevard in the Evening, Paris*	194
	At the Café	195
	The Concert	196
	At the Theater	197
Knight	*A Village Wedding*	199
Miller	*Sewing by Lamplight*	201
	Afternoon Tea	202
	L'Aperitif	203
Stewart	*Five O'Clock Tea*	205
Simon	*Studio Party*	206
Slevogt	*Supper on the Terrace*	209
Helleu	*Portrait of a Pensive Woman*	211
	Woman Viewing a Bust	212
	Portrait of a Young Woman	213
Larionov	*The Soldier's Cabaret*	215
Kokoschka	*Italian Peasant Woman*	217
Signac	*Garden at Saint-Tropez*	219
Additional Works in the Cantor Collection		221
Catalog of Works		229
Highlights of B. Gerald Cantor Donations		241
Notes		247
Sources Consulted		253

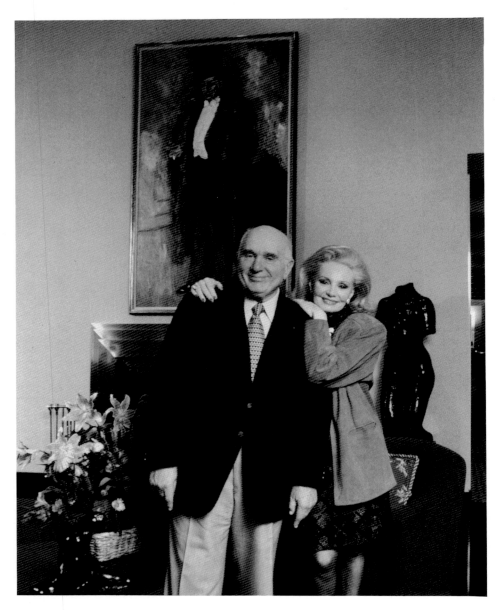

Iris and B. Gerald Cantor

Preface

In one of those rare and precious encounters with a work of art that affects the course of one's life, B. Gerald Cantor first became aware of Rodin's sculpture on a visit to the Metropolitan Museum in 1945. He was overwhelmed by the beauty of the *Hand of God;* eighteen months later he purchased one of Rodin's versions of this same sculpture. Thus began a unique career of patronage, which combined the building of a great collection with a veritable flood of generous gifts to institutions around the country.

It is incredible to realize that over the next forty-five years, B. Gerald Cantor's passion for Rodin's work has led to the acquisition of approximately seven hundred of his large- and small-scale sculptures, as well as prints, drawings, photographs, and memorabilia. And what is perhaps even more astonishing is that more than half of this largest and most comprehensive collection of Rodin works in the world has been given to seventy museums—along with many paintings and sculptures by other leading artists of the nineteenth and twentieth centuries. In addition, the Cantors have underwritten exhibitions, publications, and fellowships, as well as endowed galleries and sculpture gardens, including the Metropolitan Museum's own Iris and B. Gerald Cantor Exhibition Hall and Roof Garden.

It has been one of the overriding aims of the Cantor philosophy to stimulate scholarship and appreciation of great works of art. It is consistent with such a goal that selections from their collection that are still in their possession are now being published in this volume. Readers will be able to appreciate not only the excellence of the individual works themselves, but also have a sense of the cohesiveness of the collection, which is in itself testimony to the integrity of the collectors' aesthetic sensitivity.

The cultural life of our era has been immeasurably enriched by the Cantor vision, and all of us who have been the grateful beneficiaries applaud the genius that made it possible.

Philippe de Montebello
Director, The Metropolitan Museum of Art

Curatorial Note

The publication of this book provides a special opportunity to express my thanks and appreciation for a long and rewarding association with Iris and B. Gerald Cantor.

When I began my association with Mr. Cantor in 1969 he had already developed a profound knowledge of the work of Rodin and acquired what I considered at the time to be an impressive collection of his sculpture. Compared to what evolved over the next twenty years it was, of course, quite modest, but I had no way of anticipating what was in store for the future. I was aware that despite my art historical background and professional interest in art of the late nineteenth and early twentieth centuries, Mr. Cantor's depth of understanding of Rodin and the scope of his knowledge of the artist's life far exceeded mine. In the years that followed I was often the student and he the teacher in what proved to be a most exciting and rewarding experience. It was amazing to me that a businessman who obviously was an outstanding success in the world of finance could have developed such a passionate devotion to an artist's work.

I had the pleasure of serving a genuine partnership in taste and judgment as both Mr. and Mrs. Cantor made collective decisions in their selection of works of art they wanted to live with. My role was to find works for them to consider, to help them evaluate the ones that came to their attention through dealers and auctions, to represent their interest with major museums—in special projects such as the casting of *The Gates of Hell* and in arranging exhibitions of selections from their collections—and to participate in the many decisions of gifts to different institutions.

We didn't always agree, but the Cantors were always respectful of my opinion and I of theirs. From a curatorial as well as a personal perspective it has been an ideal relationship, and a "dream job." My hope is that the excellence of the collection as revealed in this publication reflects the fine spirit with which we have worked together for these many years, and represents the fruits of a combined effort by a husband and wife whose consuming desire was to be surrounded in their daily lives by great works of art.

Vera Green
Curator, The Cantor Collection

B. Gerald Cantor: A Three-Dimensional Collector

Historically, no collector has acquired in number or importance more works by Auguste Rodin than B. Gerald Cantor. What is even more startling is that Mr. Cantor has given away more than half of his collection to various museums around this country, in Europe, and in Israel. Just the donations of Rodin's most famous works—*The Gates of Hell, The Thinker, The Burghers of Calais,* and the *Monument to Balzac*—to public and university museums are enough to establish Mr. Cantor among the great American collectors and museum benefactors.

The history of Mr. Cantor's collecting roughly follows the way the artist's reputation has changed with the public and the critics. As a collector, he was at first strongly attracted to the romantic themes of amorous couplings, to full figures, and to portraits of famous men; then to the monuments, the études, and finally the more challenging "pieces of nature," as Rodin called his figural fragments. But he followed no model for collecting. From the beginning he gave his allegiance to Rodin's bronzes. Beginning with his first purchase— *The Hand of God*—Mr. Cantor began to teach himself about this great sculptor. And he learned about the depth and range of Rodin's art not simply from available literature but from museum curators such as Cecile Goldscheider and Monique Laurent, and scholars such as John Tancock and myself. Over a thirty-year period he has made sure that the works of Rodin are well represented in his collections and donations: early to late works, études to monuments, paired and isolated figures, full and partial figures, heads and hands.

No other collector has been more committed than Mr. Cantor to educating the public about Rodin's art. He has lent countless sculptures to innumerable museum exhibitions. He deliberately purchased poor casts for willing museums to use for educational purposes. Knowing the public's curiosity about the production of bronzes, he commissioned the Musée Rodin to have the Fondation Coubertin foundry perform all the steps of lost-wax casting a Rodin piece. To prevent unauthorized casting from plasters on the market, he purchased several and donated them to museums such as that at Stanford. All these activities confirm Mr. Cantor as a three-dimensional collector: for personal pleasure, to benefit museums, and to educate the public.

Albert E. Elsen
Walter A. Haas Professor of Art History, Stanford University

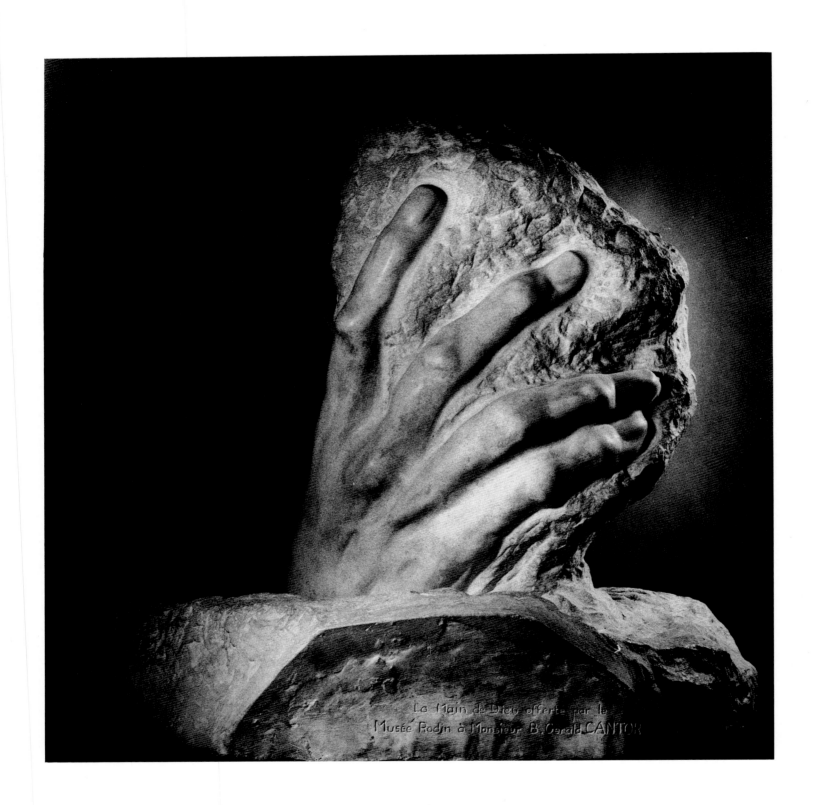

La Main de Dieu offerte par le
Musée Rodin à Monsieur B. Gerald CANTOR

The Sculpture Collection

Rodin as Spokesman of the Unspeakable

There are at least three areas that distinguished Rodin from his sculptor contemporaries and that established his importance and his distinctiveness as an artist. These areas are well represented in the Cantor Collection. The first is Rodin's audacity in treating the unspeakable in terms of the socially forbidden. This translated into a violation of decorum: the art world and the public expected exhibitions of the proper figural types for a certain subject, and in turn these types were to display appropriate, socially acceptable conduct called for by tradition.

Consider *The Thinker*. When enlarged and exhibited and then installed in front of the Paris Pantheon in 1906, the figure was condemned as a base or brutish physical type, unsuitable for such an elevated subject as the expression of thought. Conceived as the thematic and visual fulcrum of *The Gates of Hell*, Rodin's *Thinker* represents the artist, in the broadest sense, in the act of thinking about art and life in order to create his artistic vision. To dramatize the effort of creation, Rodin made *The Thinker* deaf, dumb, and blind, thus shutting out the distractions of the external world. The powerful, tensed physique embodies Rodin's view that the artist, as a worker, must strain with every muscle to concentrate and then have the strength and stamina to create sculpture.

When first exhibited, *The Kiss* shocked with its nakedness, its absence of the anticipated decorous period costume. It is the woman who seduces the reluctant man, appropriating him sexually by pulling his head toward hers and slinging her right leg over his left thigh. Both then and now, women have appreciated such works by Rodin for showing the female fully aware of her sexuality, without shame; assertive, not passive.

Rodin's sexual candor was matched by his challenge to conventional notions of beauty. *The Helmet Maker's Wife* seemed a shocking invasion of an old woman's privacy, and to many its revelation of time's toll on the body was repulsive. But for Rodin, no subject in life was ugly or without character. Early on he established this principle in his 1864 portrait *Man with the Broken Nose*. With its later version Rodin moved from objective description to allowing feelings to intervene, and he became more inventive and compassionate in shaping the old man's corroding features.

Degas brought the high art of modern ballet to his paintings and pastels. Rodin brought the low art of improvised dancing such as the cancan to his sculpture. Fortified against the criticism of obscenity by his sincerity and convictions about the truth of observation, he was able—in *Iris, Messenger of the Gods*—to show the genitals of a Montmartre dancer as the natural fulcrum of an inspired movement.

The Unspeakable as Wordless Expression

Rodin was certainly inspired by great French writers such as Hugo and Baudelaire as they taught him to look at that dark side of human nature unexpressed by his painter contemporaries, especially the Impressionists. Monet, Renoir, Degas, and the others celebrated humanity's hope for the good life, whereas Rodin gave form to humanity's fears of the opposite. When it came to creating *The Gates of Hell*, Rodin decided not simply to be an illustrator of Dante or anyone else, but to rely on his own experience, ideas, and intuitions about modern life. Working from living, nonprofessional models left to their natural movements in the studio, Rodin greatly enlarged the repertory of gestures and postures in sculpture to embody his view of the hell of the passions. What he learned in the process was that his sculpture could take up where words left off. He once declared that it would take him a year to talk about one of his *Burghers of Calais*. He gives us the unspeakable with his gift for creating sculptures that convey wordless experience, as with *Fallen Caryatids, The Three Shades*, and *Meditation*. Sculptures such as *The Burghers of Calais* invite verbalization, but in the end words are exhausted before all that these tragic figures convey to our senses.

The portraits and symbolic heads brilliantly exemplify Rodin's defiance of verbal description and analysis. Except for the *Head of St. John the Baptist*, he did not impose an expression but allowed the character of the subject's face to speak for itself. How Rodin gave new credibility to the portrait and humanized the monument can be seen in his *Naked Balzac with Folded Arms*, a work that totalizes its subject more penetratingly than could the great writer himself in his *Human Comedy*.

Then there are the hands, so eloquent that we feel no incentive to imagine the arms or faces of their original owners. They are life encapsulated. But what is considered deformity

in life, such as a "claw hand," is translated into a marvelous interlocking of modeled planes that results in powerfully expressive sculpture. That so often these bronze hands evoke associations with other life forms is telling of Rodin's belief in the unity of all living things.

The Technically Taboo

By the brilliance of their execution, and by daring to exhibit them in public, Rodin gave his études parity with his finished sculpture. His partial figures like *The Walking Man* and *Cybele* were intended as complete works of art, stripped to the sculpturally essential. For his *Dance Movements* series, Rodin invented a way of making sculpture that enabled him to keep his eyes on the dancer and promptly fix her movements by joining, pinching, and flexing rolls of clay prepared beforehand. From at least the 1890s, as in the *Meditation* figures, he retained the traces of casting seams, thereby defeating total illusion. To further his cause in his war against the critics' and public's expectations of finish, in late figures like *Prayer* he deliberately roughened the surface to create greater interaction between the sculpture and the light and atmosphere. With *The Three Shades* he did the unheard of by triplicating the same figure. Rodin's audacities were not always imitable but they did set a crucial example for younger sculptors to redefine the purposes and nature of sculpture for themselves, and to be daring.

Camille Claudel received that lesson and encouragement in her ten-year association with Rodin; it is evident in *The Waltz*, where the totally self-absorbed figures challenge gravity. Wilhelm Lehmbruck derived his license for elongating proportions from the older artist, who had taken proportional liberties for expressive effect and to permit the gestures of his life-size figures to carry from a distance. Georg Kolbe followed Rodin in seeking new movements for the figure generated from internal states of being, but without Rodin's dramatic tensions and vigorous facture. Gaston Lachaise's sexual candor expressed in the torsos inspired by his wife would have been unthinkable without Rodin's speaking the unspeakable in theme and form.

Albert E. Elsen
Walter A. Haas Professor of Art History, Stanford University

Rodin: Hand of God

"When God created the world," Rodin once remarked, "it is of modeling He must have thought first of all."[1] This idea, first documented in an article in the May 1898 issue of the *Gazette des beaux-arts*,[2] was given tangible form in *Hand of God*, also known

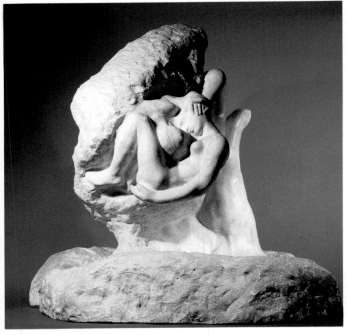

Hand of God, 1897
Plaster, 28 3/4 x 26 3/4 x 38 in.
(73 x 68 x 96.5 cm)

as *Creation*. Here, Rodin likens the sculptor's talent to God's life-giving touch. The large hand holds a rugged, amorphous mass from which the smooth forms of a man and woman materialize. Rodin's use of the Michelangesque *non finito*, so prevalent in his marble sculptures, achieves its most meaningful embodiment here. The roughly hewn stone symbolizes the sculptor's medium as well as primal matter.[3] The textural contrast is particularly effective in the marble versions in the Musée Rodin, Paris; the Rhode Island School of Design, Providence; and the Metropolitan Museum of Art, New York.

The marble in the Metropolitan Museum made a deep and lasting impression on Mr. Cantor when he saw it in 1945. Within two years he purchased a six-inch-high bronze version, which formed the nucleus of his Rodin collection. In 1974 the Musée Rodin presented him with a large plaster cast of the work in recognition of his efforts to encourage wider appreciation of Rodin's work.

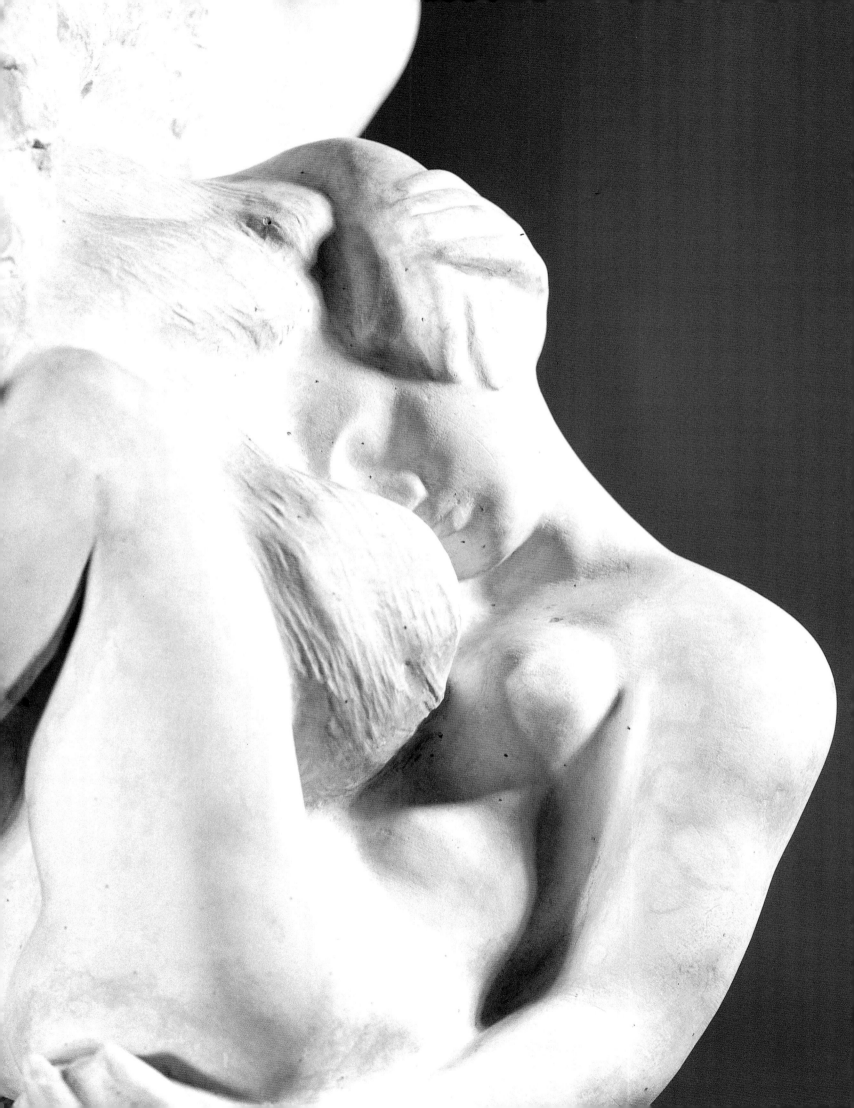

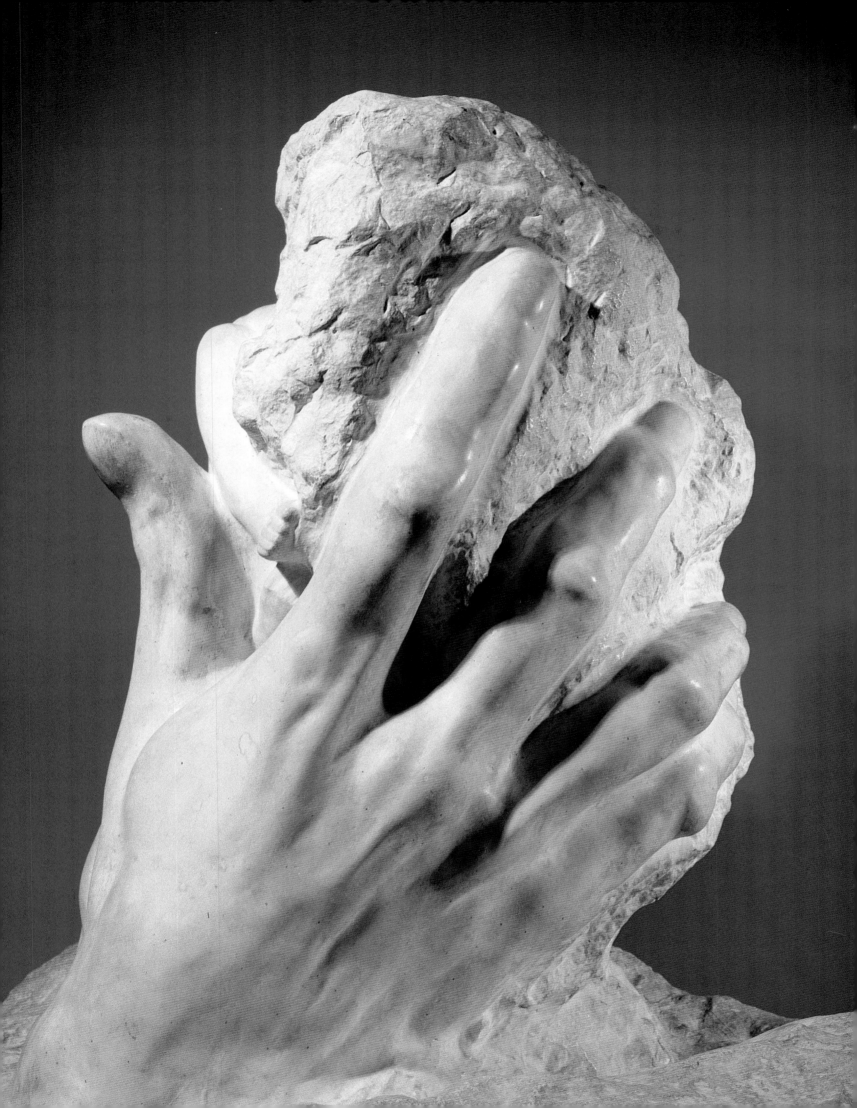

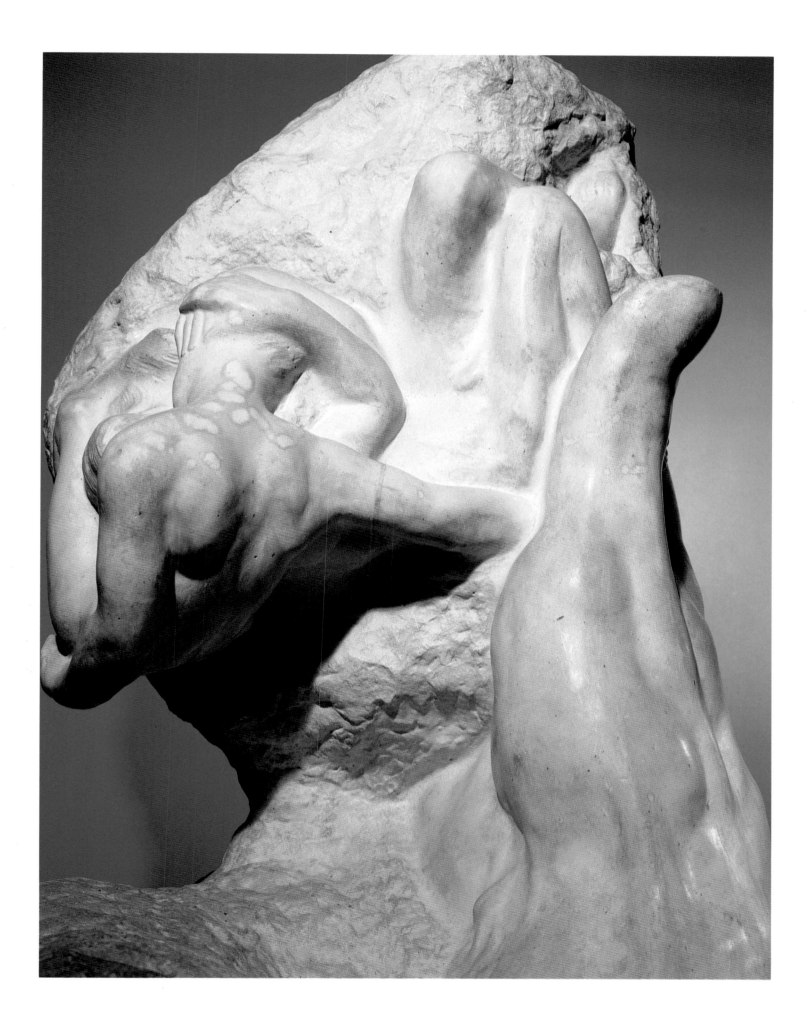

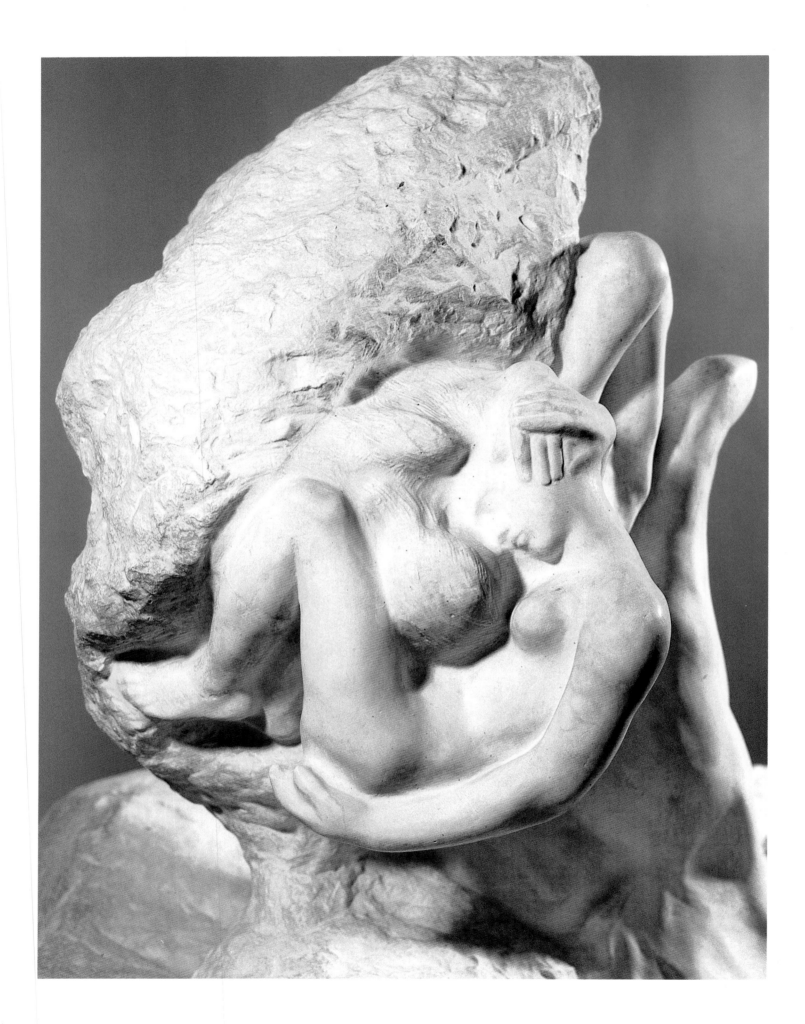

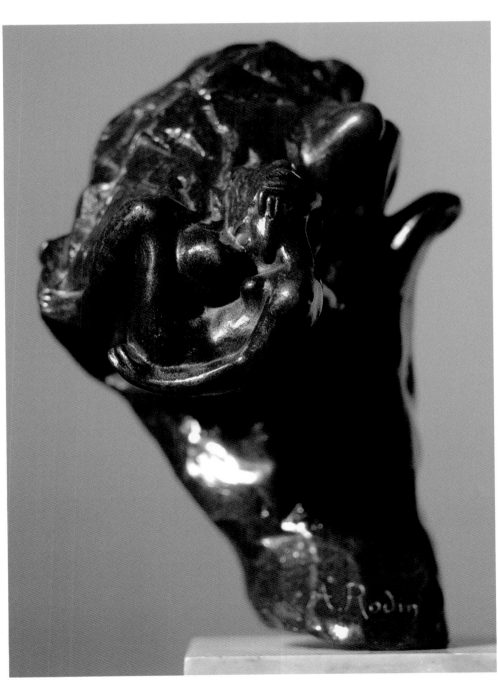

Hand of God, 1897
Bronze, 6 x 3 1/2 x 3 in.
(15.2 x 9 x 7.7 cm)

Rodin: The Thinker

The Thinker, 1880
Bronze, 28 x 20 1/4 x 23 in.
(71 x 51.5 x 58.5 cm)

The Thinker, Rodin's best-known work, is one of the most famous sculptures in the world today. Though depicted in sober meditation, the figure is anything but static; the apparent restraint of the pose belies the figure's powerful internal struggle. Rodin described the intended effect shortly before his death: "What makes my Thinker think is that he thinks not only with his brain, his distended nostrils, and compressed lips, but with every muscle of his arms, back and legs, with his clenched fist and gripping toes."[4]

Like so many of his masterpieces, this too originated with *The Gates of Hell*; Elsen considers the figure to be the earliest sculpture made for the portal.[5] Rodin sketched a seated man in his preliminary drawings for *The Gates of Hell*, and the figure also appears on the tympanum in the final terra-cotta maquette of the composition (1880, Musée Rodin, Paris). A photograph dating from 1880-81 shows the clay model of *The Thinker* in its definitive form.[6]

At the very beginning of his work on *The Gates*, Rodin associated this prominent figure with Dante. There is evidence that he also thought of the figure in broader, more universal terms; in letters of September 1882 and December 1884 he described it as *le penseur*.[7] *The Thinker* was exhibited separately from *The Gates of Hell* for the first time in Copenhagen in 1888, where it was entitled *The Poet*. Rodin called it *The Thinker; The Poet; Fragment of a Door* when it was shown at the Galerie Georges Petit, Paris, in June 1889.

The Thinker in the Cantor Collection reproduces the sculpture's original 28-inch-high scale. Casts of this size appear to have been produced by the 1890s.[8] The Cantor bronze was cast sometime before 1952. A cast of the 78-inch enlargement, first made in 1903, adorns Rodin's grave at Meudon. Mr. Cantor presented a cast of this large version to Stanford University in 1988. The Cantor Collection also features a 14 ¾-inch reduction of *The Thinker* that was originally made as a gift from the Musée Rodin to Paul Doumer, a former president of the French Republic.

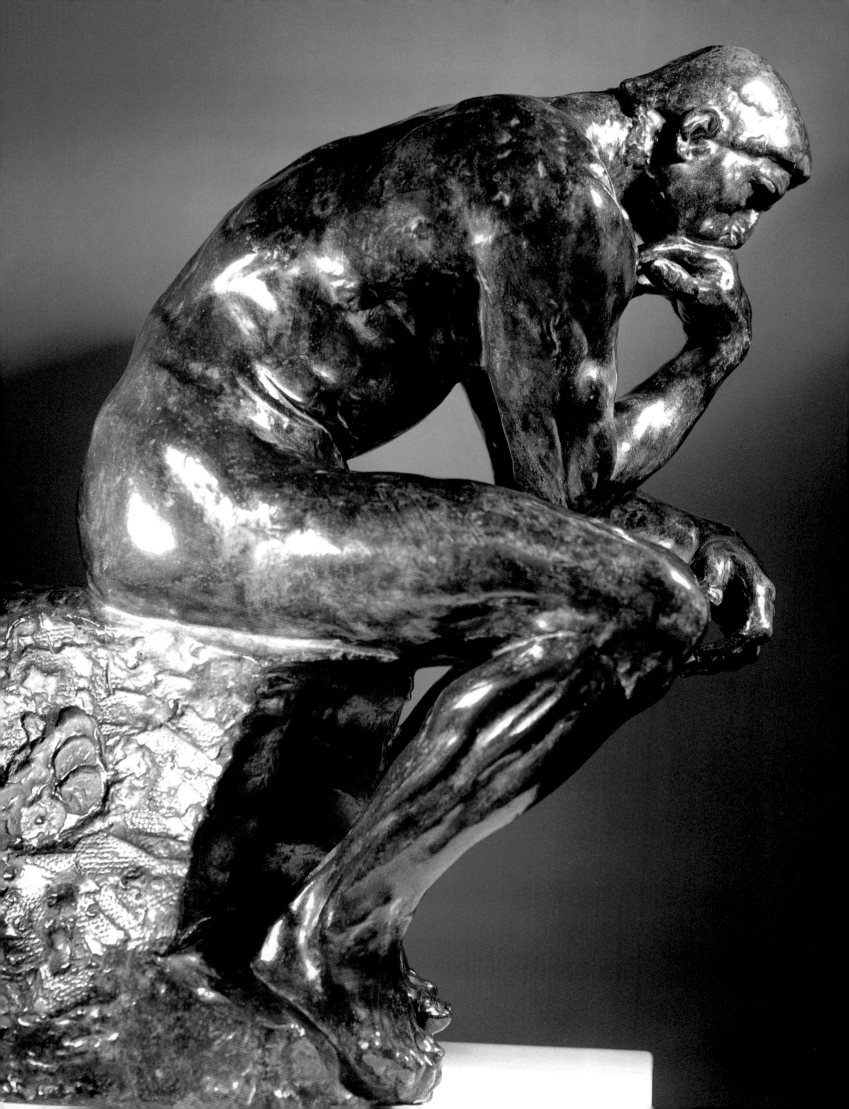

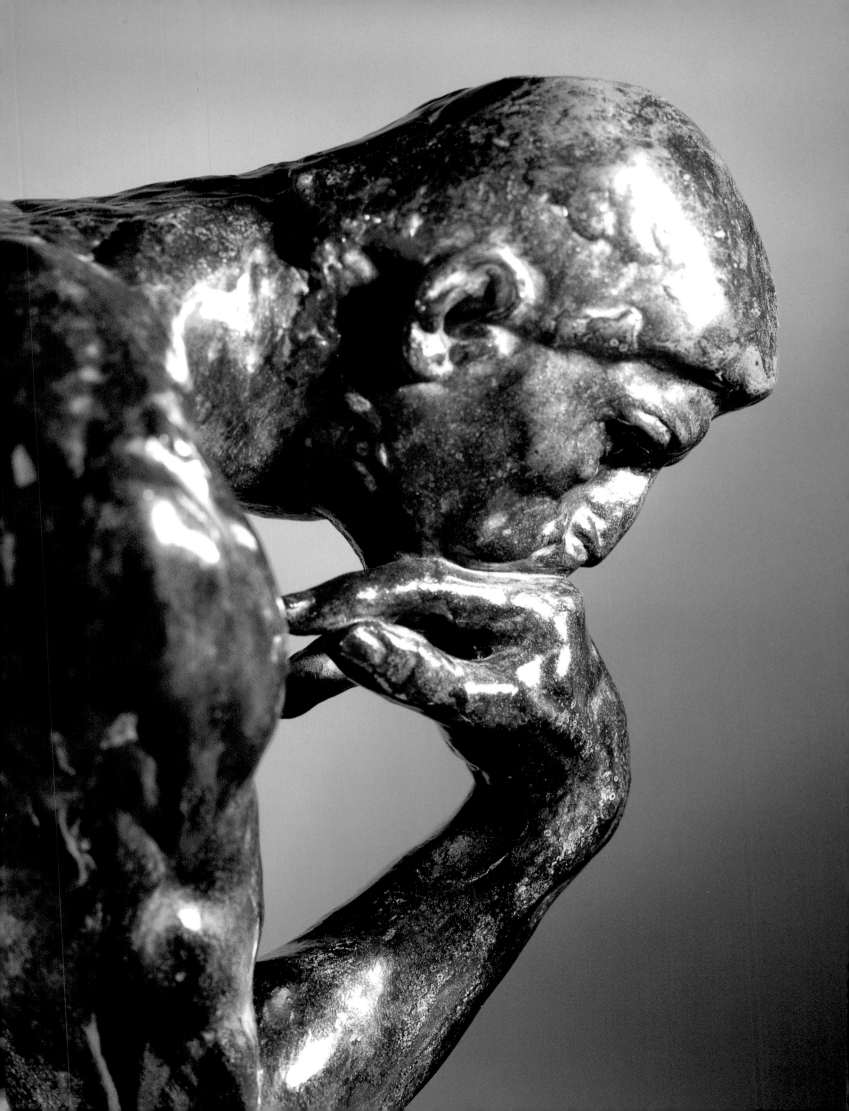

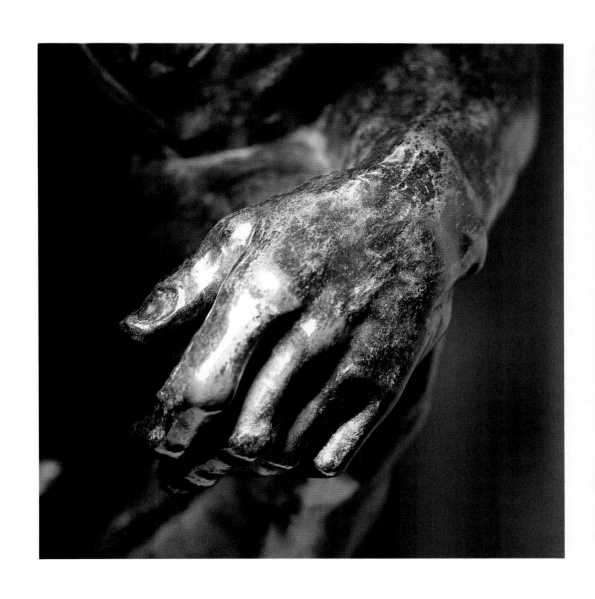

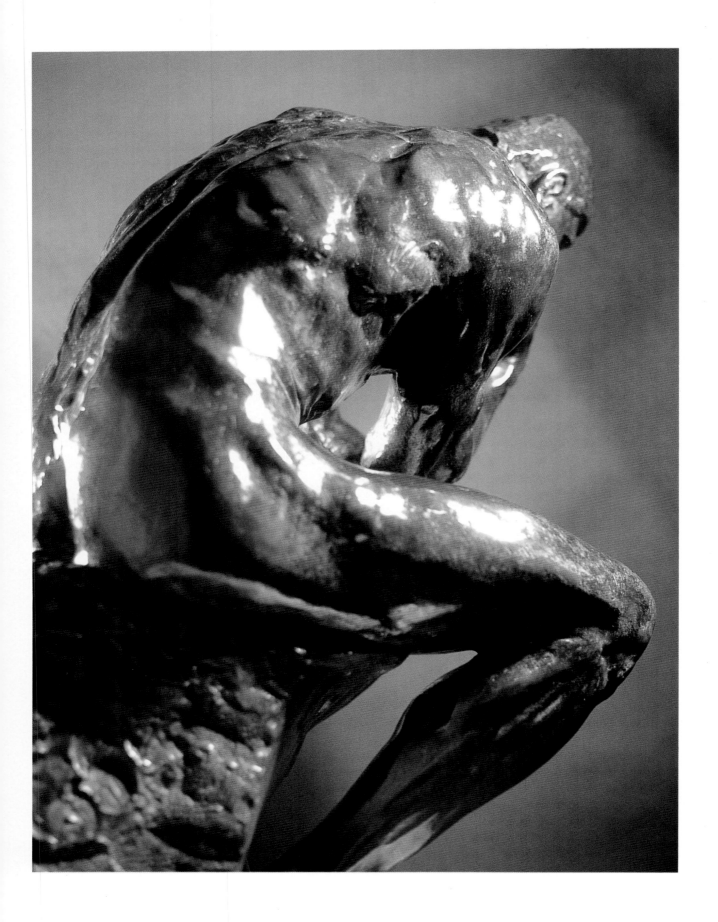

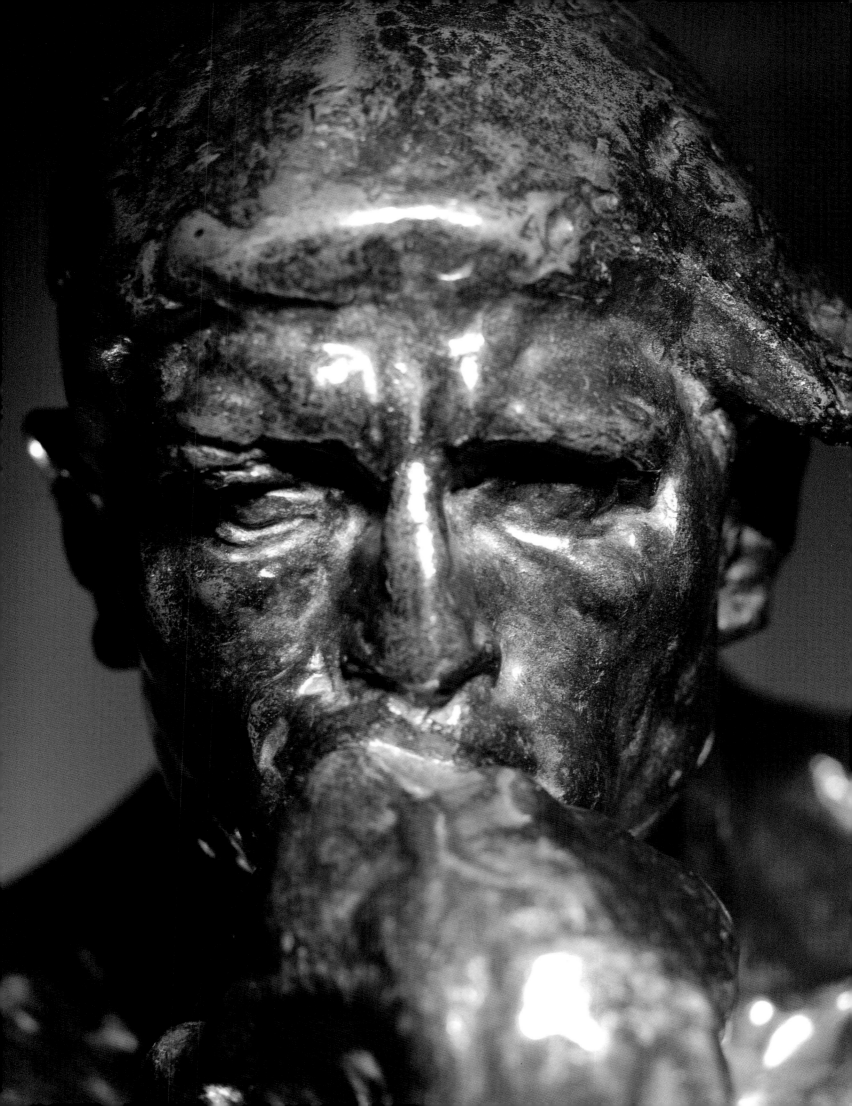

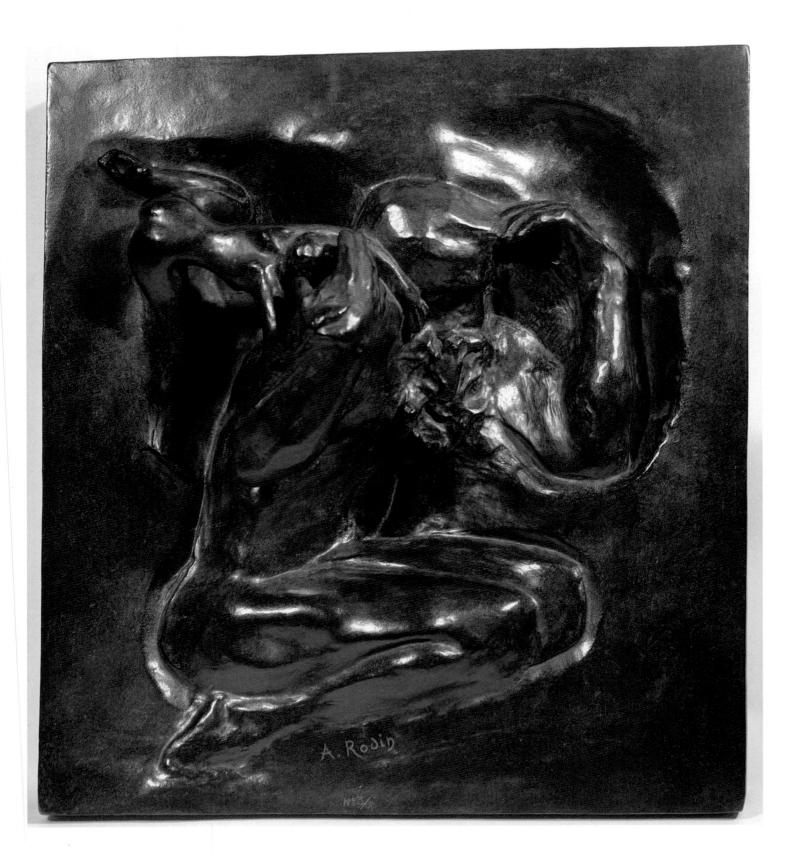

Rodin: The Creator

The Creator, c. 1900
Bronze, 16 x 14 1/4 x 2 1/2 in.
(40.6 x 36.2 x 6.4 cm)

The theme of artistic inspiration obsessed Rodin. He portrayed the subject in drawings as well as in his public and private sculpture. As Elsen observed, the presence of *The Creator* on *The Gates of Hell* parallels that of the more familiar *Thinker*, which alludes to the poet or to creators in general.[9] The woman who emerges from *The Creator's* meditation apparently represents his muse.

In 1966 Albert Alhadeff proposed that this kneeling bearded man lost in thought is a self-portrait of Rodin.[10] The profile of the head, the furrowed brow, and the long, wavy beard do bear a convincing resemblance to the sculptor's features. Elsen originally interpreted the figure of *The Creator* as God.[11] Given the new identity as a "godlike" self-portrait, the relief could well serve as Rodin's signature.[12]

Rodin: Adam

Adam, 1880
Bronze, 75 1/2 x 29 1/2 x 29 1/2 in.
(191.8 x 75 x 75 cm)

Late-nineteenth-century sculptors frequently sought inspiration in Michelangelo's works. Such influence, however, often resulted in a superficial adaptation of poses or attitudes. Only after Rodin examined Michelangelo's sculptures during a trip to Italy in 1875 did he come to understand the principles underlying his works. Decades later, in discussions with Camille Mauclair and Paul Gsell, he described what he learned from his study. Rodin noted that Michelangelo "understood that the human body can create an architecture, and that in order to obtain a harmonious volume, one must inscribe a figure or group in a cube, a pyramid, a cone."[13] He also commented on how Michelangelo's compositions communicate mankind's tragedy: "We notice that his sculpture expresses the painful withdrawal of the being into himself, restless energy, the will to act without hope of success, and finally the martyrdom of the creature who is tormented by his unrealistic aspirations."[14]

According to Judith Cladel, Rodin began work on a figure of *Adam* soon after his return from Italy in 1876 but, displeased with the results, he abandoned it.[15] He revived the idea in 1880, when a fairground strongman named Caillou modeled for him. Rodin arranged the figure of *Adam* into what he called the "console" composition of Michelangelo's figures.[16] Rodin envisioned Adam flanking *The Gates of Hell* along with a figure of *Eve*, but he was unsuccessful in gaining permission to include them in the commission.

Rodin exhibited a plaster model of *Adam*, of the same height as the present bronze, at the Salon of 1881 under the title *The Creation of Man*. The figure's right arm and pointing gesture are derived from Michelangelo's *Creation of Adam* in the Sistine Chapel, while the left arm hangs in emulation of the Italian sculptor's Florence *Pietà*. As Elsen observed: "This single figure enacts gestures of life and death, while his agonized body dramatizes the suffering of earthly existence between its beginning and end."[17]

36

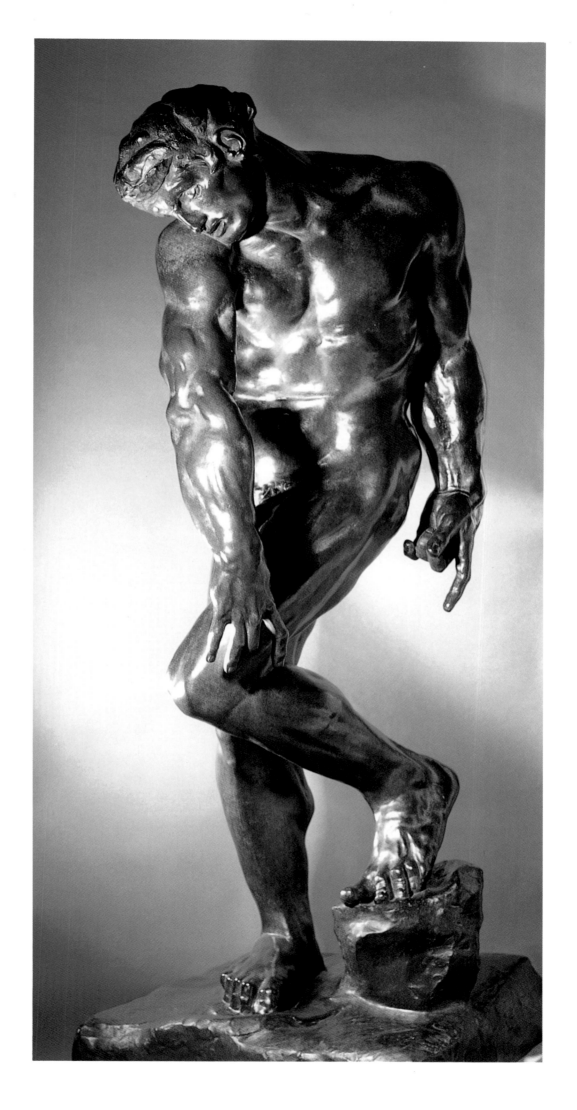

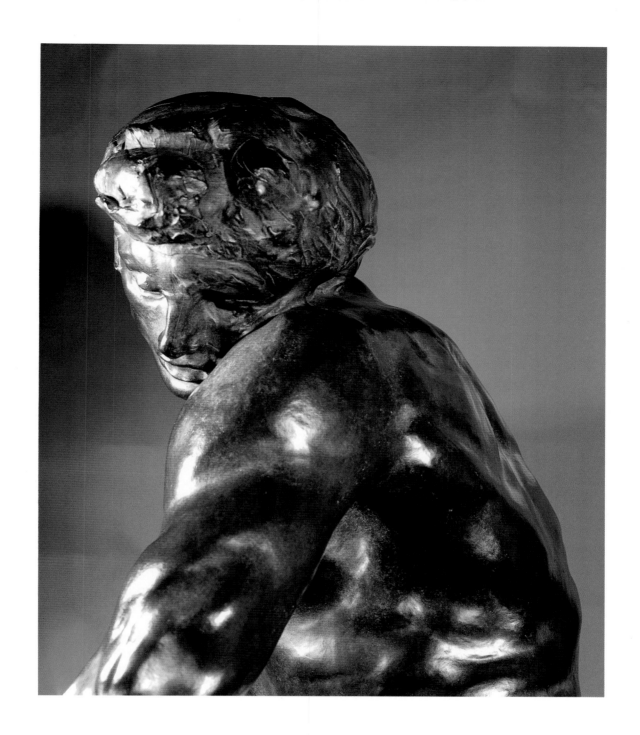

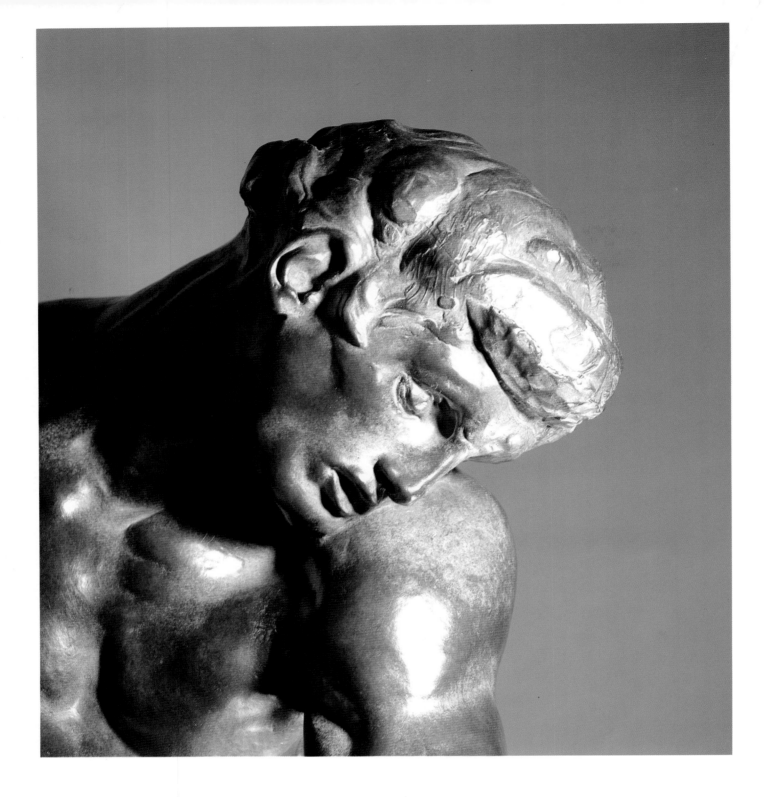

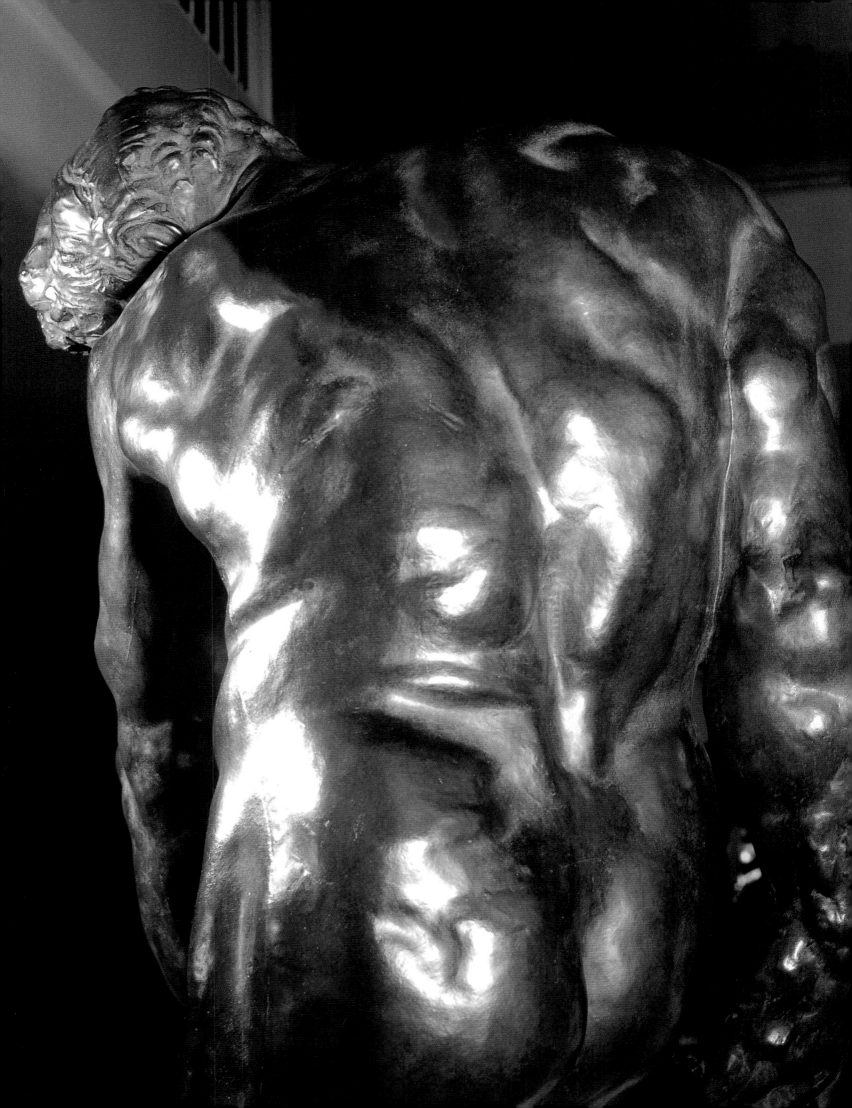

Rodin: Eve

Eve, c. 1887
Marble, 30 1/4 x 11 1/2 x 13 in.
(76.8 x 29.2 x 33 cm)

Eve is depicted directly after her fall from grace, repentant and cowering in shame. As with *Adam*, her gesture was inspired by Michelangelo, adapted from the figure of *Adam* in the *Expulsion* from the Sistine Chapel.[18] Rodin appears to have begun the sculpture in late 1880 or early 1881. He produced two different versions, both represented in the Cantor Collection. The life-size figure (formerly in the collection of Norton Simon) is distinguished by rougher passages. At the Salon of 1899 Rodin buried the sculpture's base in sand so the figure appeared to stand on the ground—a gesture then considered revolutionary.

The physical differences between the two works suggest reworking and a change of models. It is a matter of speculation which version originated first, although evidence points to the smaller figure, which is characterized by smoother modeling, and is more rounded and muscular.

A half-life-size bronze was exhibited at the Dudley Gallery, London, in 1883, and the first marble version, acquired by Auguste Vacquerie in 1886 (now in the Art Institute of Chicago), was also small.[19] Eleven other marble examples are known, including the superb figure in this collection, which was purchased from Rodin's studio around 1910 by Madame Bourlon de Rouvre, Paris.[20] The marble figures are supported behind the legs by a rock formation. Georges Grappe entitled this composition *Eve on the Rock* to distinguish it from the bronze sculptures.[21]

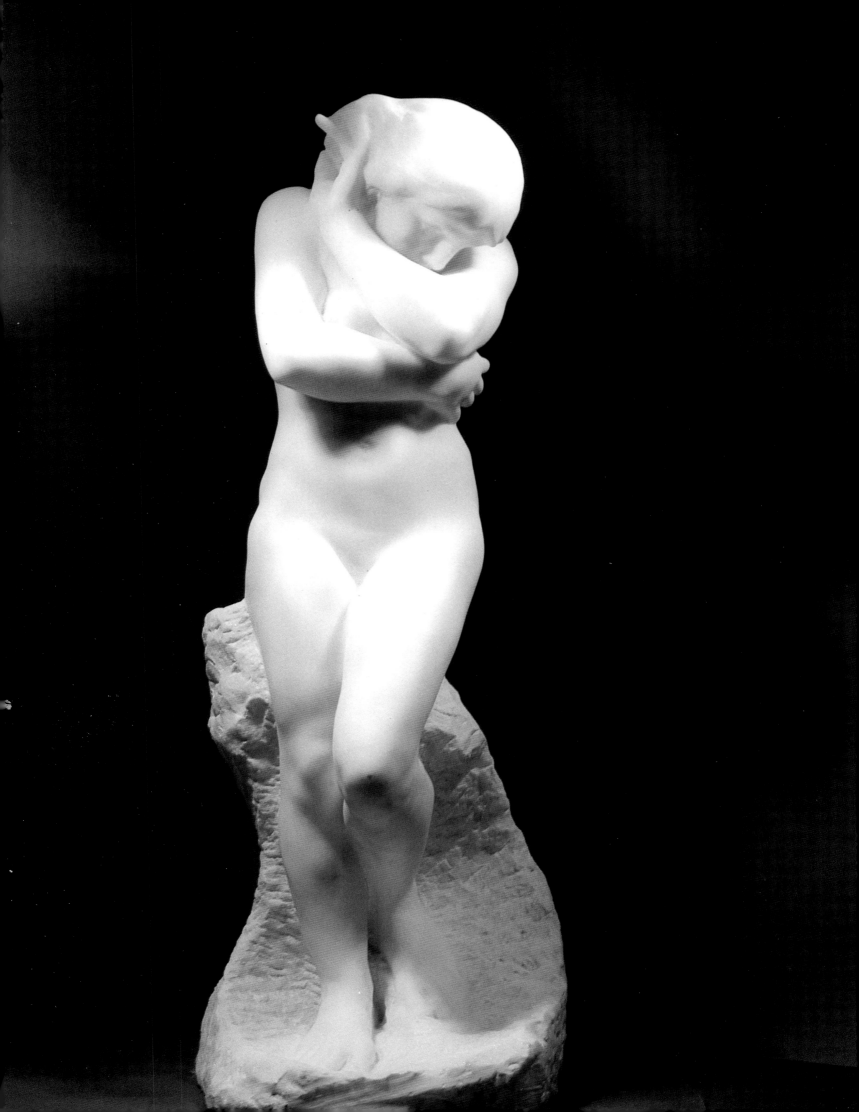

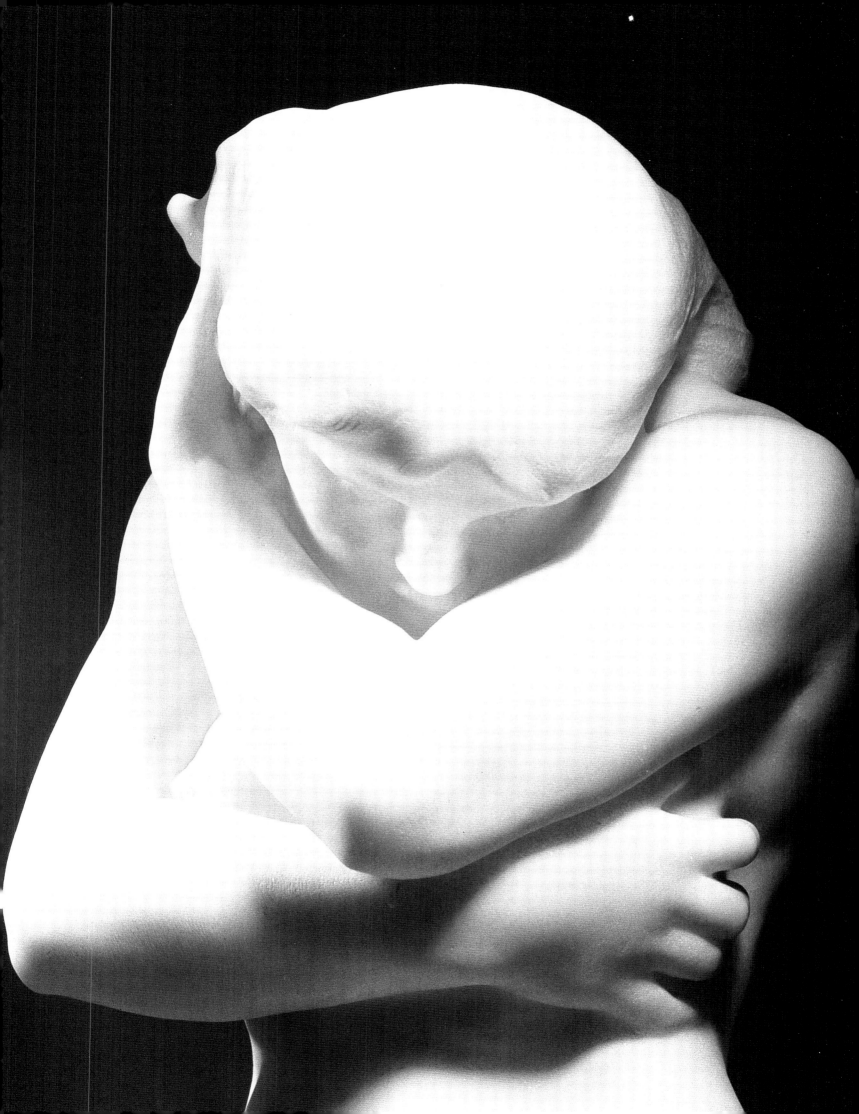

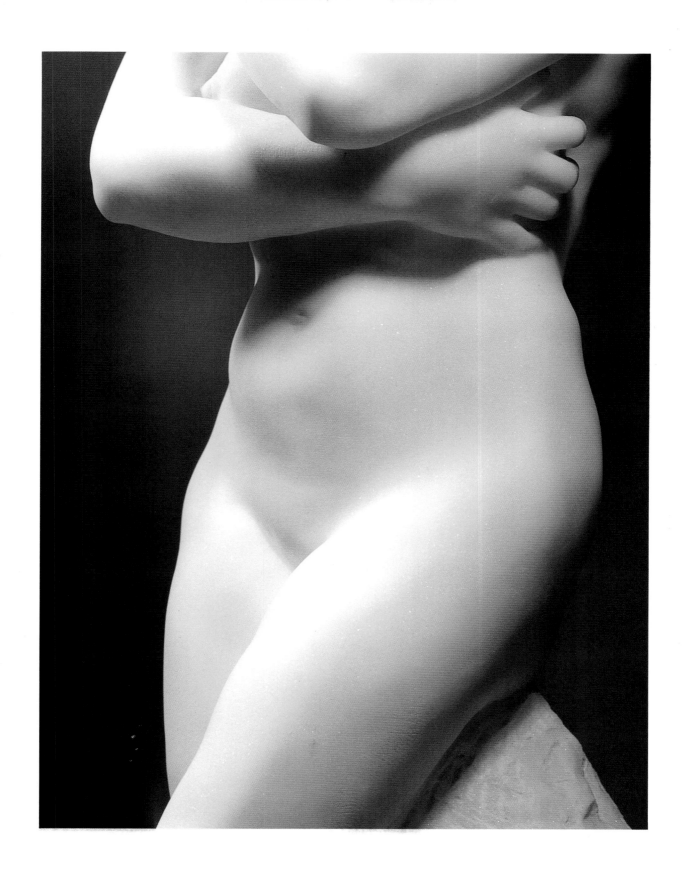

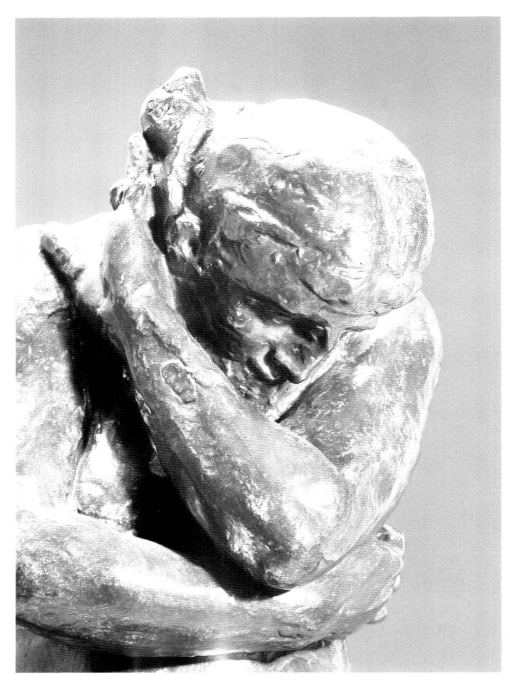

Eve, 1881
Bronze, 68 x 23 3/4 x 30 in.
(172.7 x 60.4 x 76.2 cm)

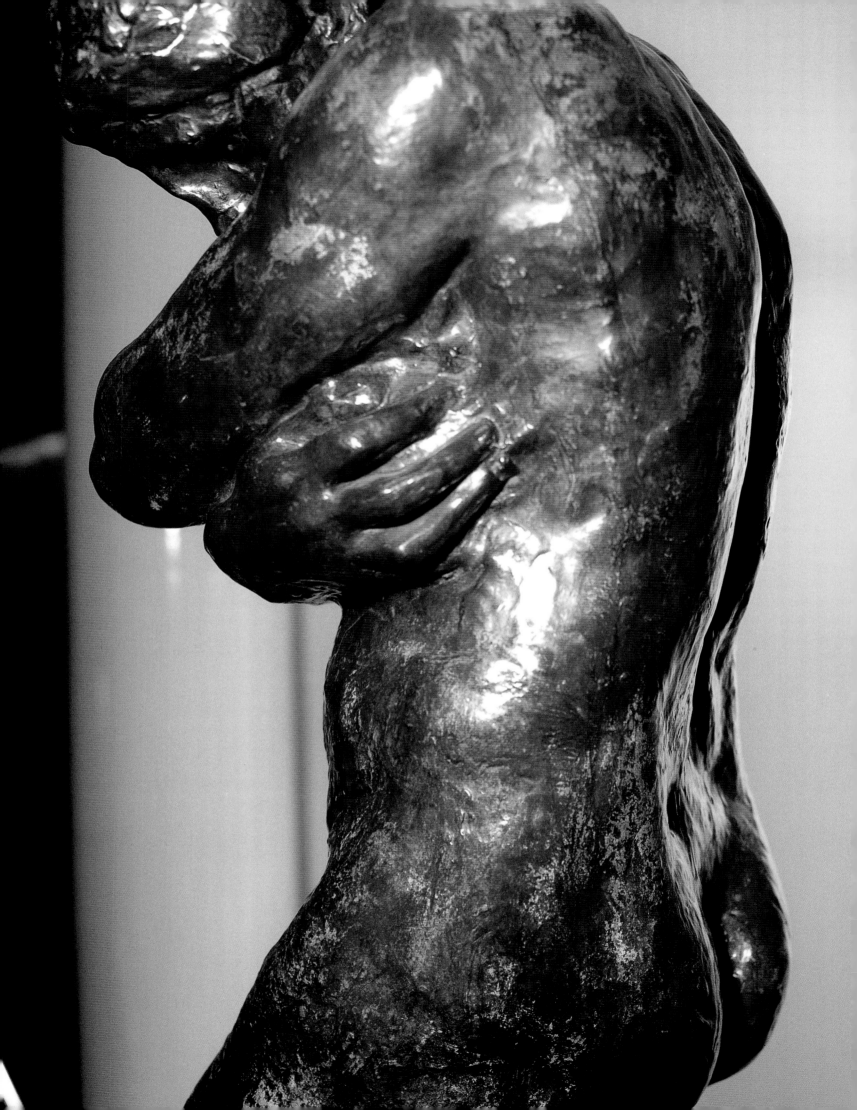

Rodin: The Three Shades

The Three Shades, 1880
(enlarged c. 1898)
Bronze, 75 1/2 x 75 1/2 x 42 in.
(191.8 x 191.8 x 106.7 cm)

The Three Shades comprises three casts of a figure adapted from Rodin's *Adam*. Like *Adam*, the group was born of his desire to rival Michelangelo. In the course of transformation, the sculptor extended the left arm forward and bent the neck further down so that it aligned with the shoulder. The repetition of the tormented figure presents three different views, and more importantly, intensifies the somber mood.[22]

The Cantor Collection features a fine cast of the monumental enlargement created sometime around 1898. In 1886 Félicien Champsaur proposed that the group incarnated Dante's warning—inscribed on the pediment of *The Gates* but later removed—"Lasciate ogni speranza voi ch'entrate" ("All hope abandon ye who enter in." *Inferno*, III:9).[23] Their gesture directs the beholder's gaze down to the portal's unfolding drama.

Rodin: She Who Was Once the Helmet-Maker's Beautiful Wife

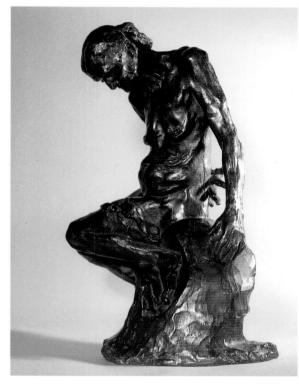

Rodin was amused to hear that the public recoiled from the sight of this hagggard crone when the sculpture was on view at the Musée du Luxembourg. He observed: "That which is considered ugly in nature often presents more character than that which is termed beautiful, because in the contractions of a sickly countenance... in all deformity, in all decay, the inner truth shines forth more clearly than in features that are regular and healthy."[24]

This belief had guided the sculptor from the beginning of his career, when he modeled *The Man with the Broken Nose.*

In this sculpture, made about twenty years later, Rodin delineated his sitter's shriveled, dry skin, sagging breasts, and bloated stomach to create an uncompromising yet poignant portrayal of old age. The title is taken from a line in the fifteenth-century poem "Les Regrets de la Belle Heaulmière," by François Villon, in which an old woman laments her lost beauty. Although there are parallels between the two works, Rodin created a much more pyschologically complex memento mori; he did not make the sculpture to illustrate the poem but, typically, named it only later.

The bronze in the Cantor Collection was produced by Léon Perzinka, who cast seventy-three of Rodin's works between 1896 and 1901.[25]

She Who Was Once the
Helmet-Maker's Beautiful
Wife, c. 1880-83
Bronze, 20 x 12 x 10 in.
(50.8 x 30.5 x 25.4 cm.)

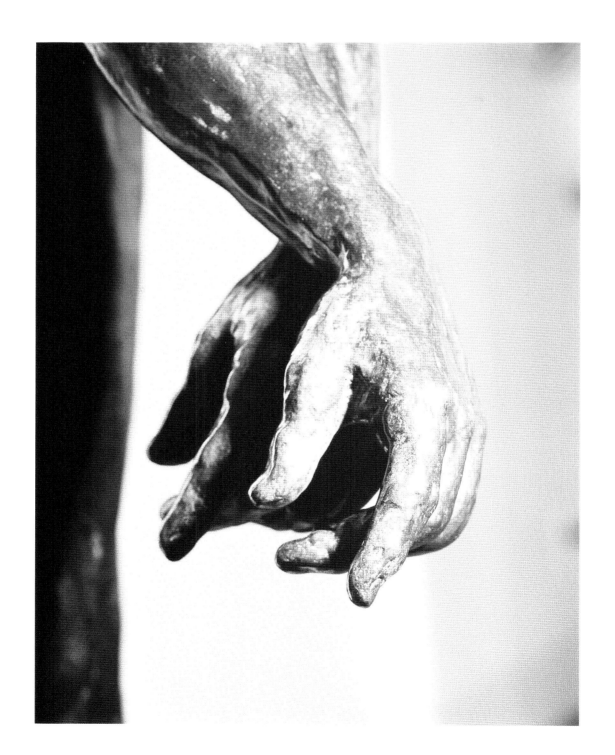

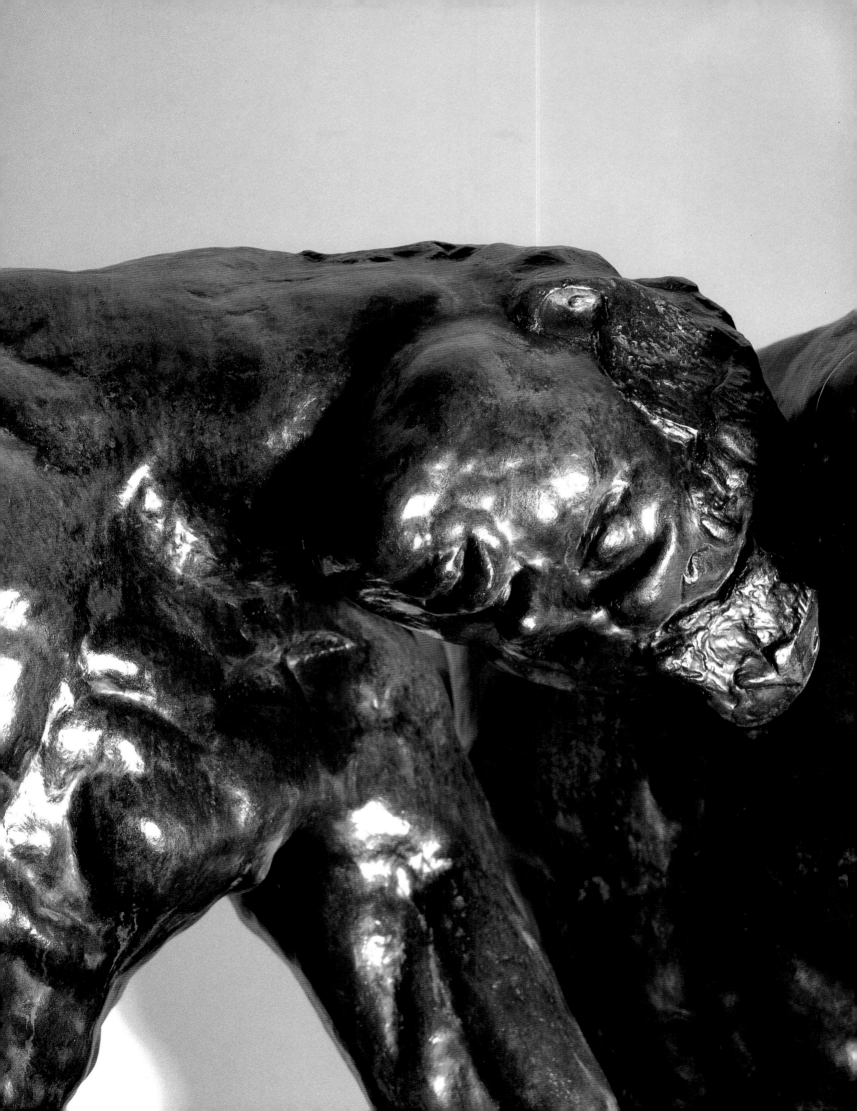

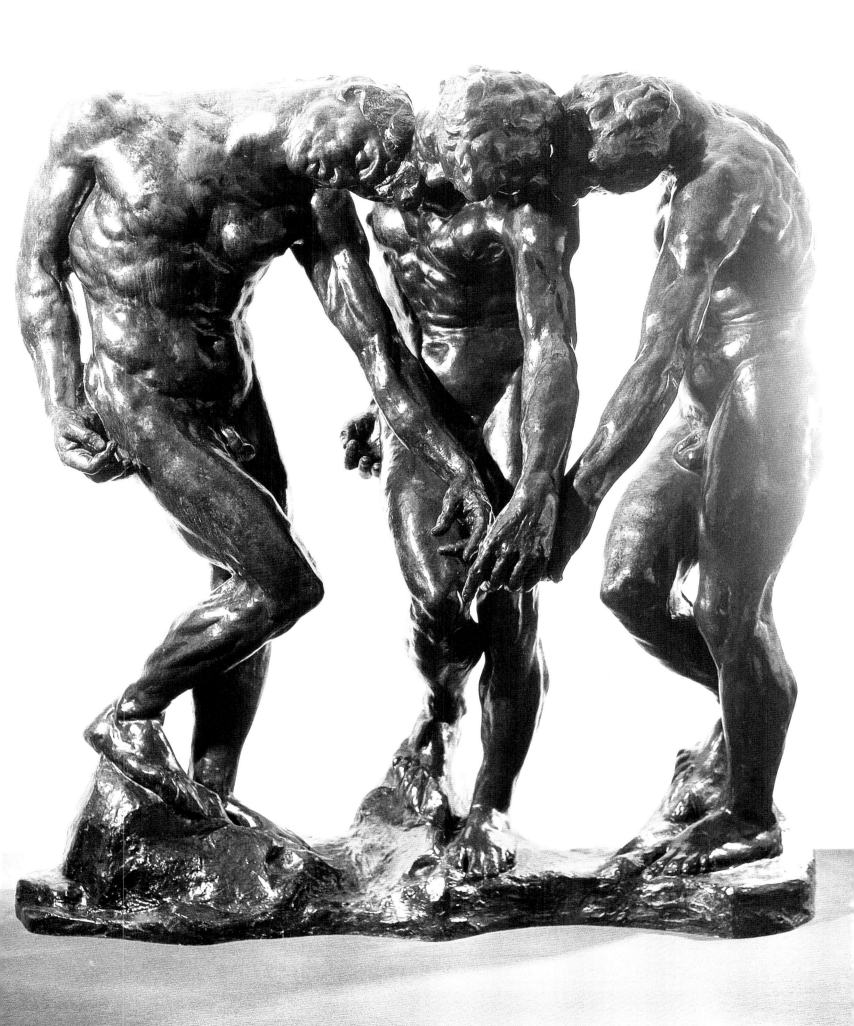

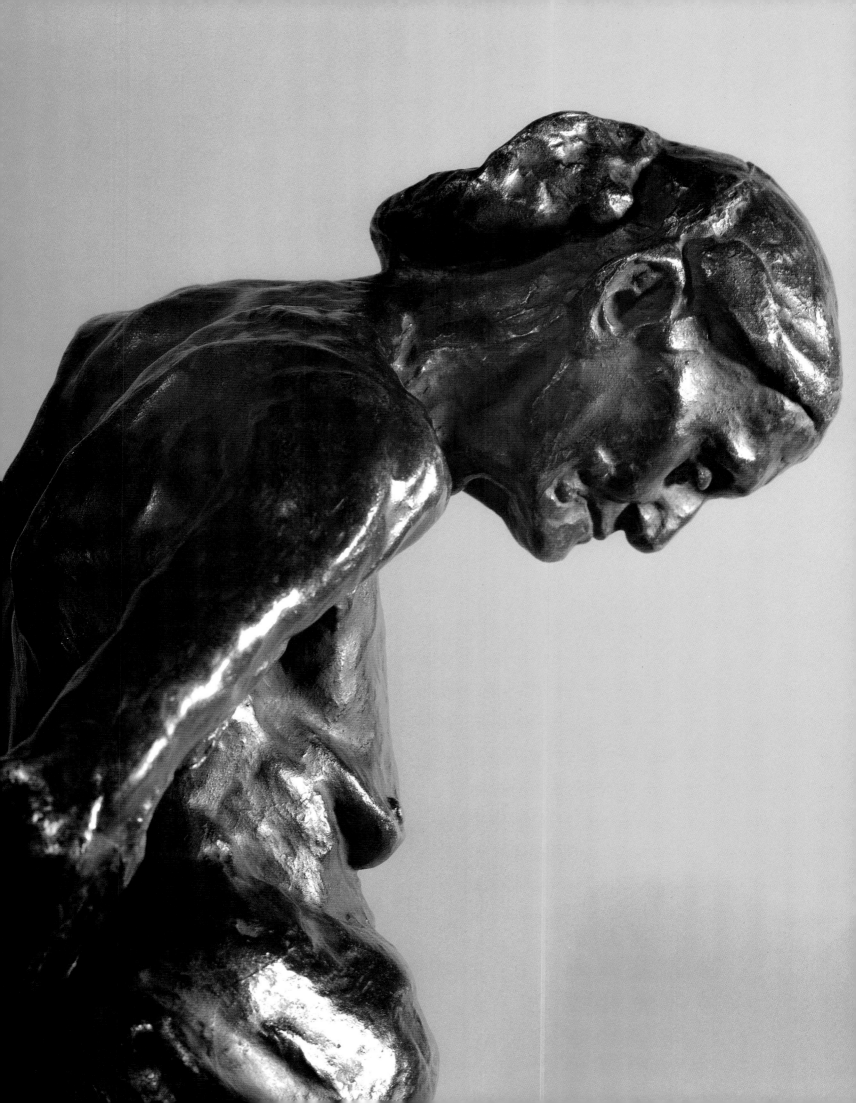

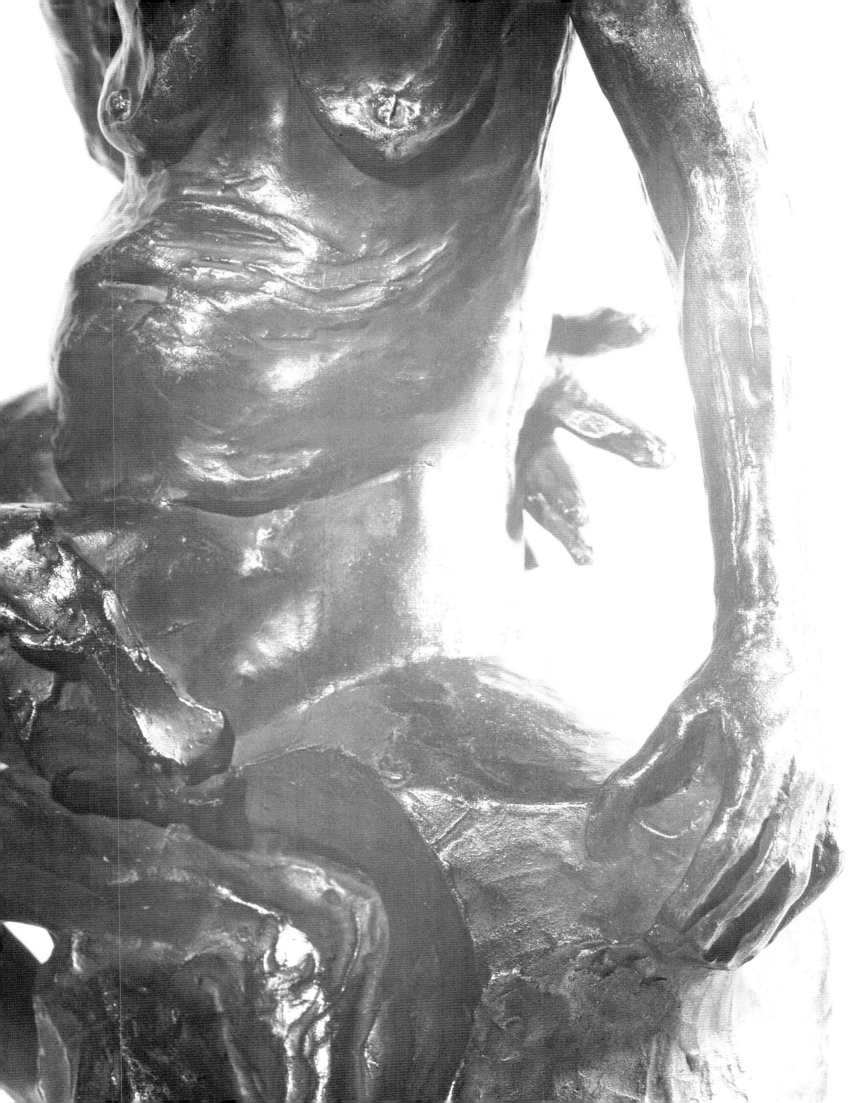

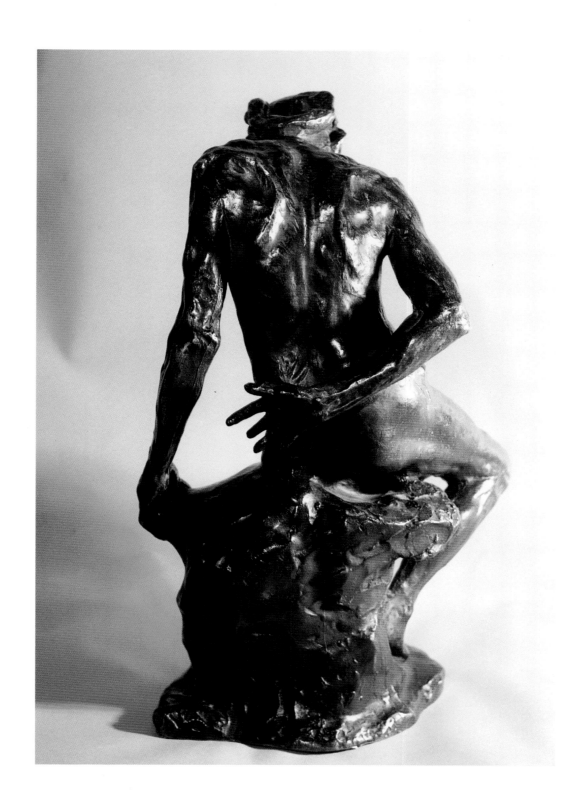

Rodin: Women Damned

Although this particular group does not appear on *The Gates of Hell*, Rodin included another pair of women, known by the same title, in the upper right corner of the portal. The subject was directly inspired by Baudelaire's poem "Femmes Damnées," which Rodin illustrated in his designs for *Les Fleurs du Mal* (1888). In 1889, Hugues le Roux commented on Baudelaire's influence on Rodin: "I knew a time when the walls, the studio floor...the furniture was covered by these small bodies of naked women, twisted in poses of passion and despair. Rodin was then under the influence of Baudelaire's book. He seemed intoxicated with it."[26]

The models for this group, lesbian dancers from the Paris Opéra, had been recommended by Degas, who was among the artists of the era interested in the subject of female love.[27] Grappe dated *Women Damned* to 1885 because the women were known to have posed for Rodin at that time.[28] Characteristic of his working method, he appears to have conceived the figures separately and later combined them to form the passionately entwined couple. This bronze was a gift to Mr. Cantor from the Musée Rodin in Paris.

Women Damned,
c. 1885-86
Bronze, 8 x 10 3/4 x 5 in.
(20.3 x 27.3 x 12.7 cm)

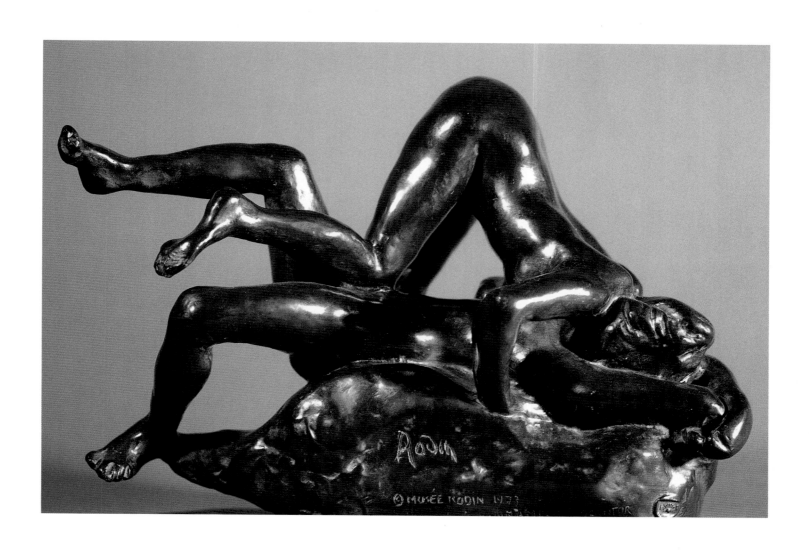

Rodin: Cupid and Psyche

Cupid and Psyche is one of several groups of amorous couples inspired by the poses of lesbian dancers who modeled for Rodin in 1885. A few of these sculptures have been entitled *Women Damned* or *Lovers Damned,* in reference to Baudelaire's "Femmes Damnées" from *Les Fleurs du Mal.* Others were given classical titles such as *Daphnis and Chloe, Daphnis and Lycenion,* and *The Metamorphoses of Ovid,* possibly to provide an edifying pretext for these highly erotic groups.[29]

The plaster model of this sculpture is in the Musée Rodin, Paris. Marble versions are located in the Musée du Petit Palais, Paris, and the Metropolitan Museum of Art, New York. The signed bronze in the Cantor Collection was shown at the fourth Venice Biennale exhibition in 1901 in a room reserved exclusively for Rodin's works.[30] At that time it was acquired by Mrs. Rosa Piazza.

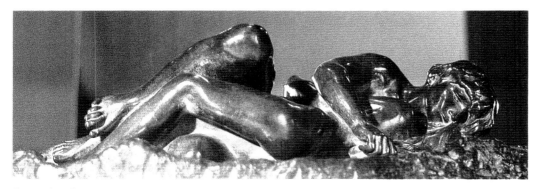

Cupid and Psyche, 1886
Bronze, 9 x 28 1/4 x 18 1/2 in.
(22.8 x 71.8 x 47 cm)

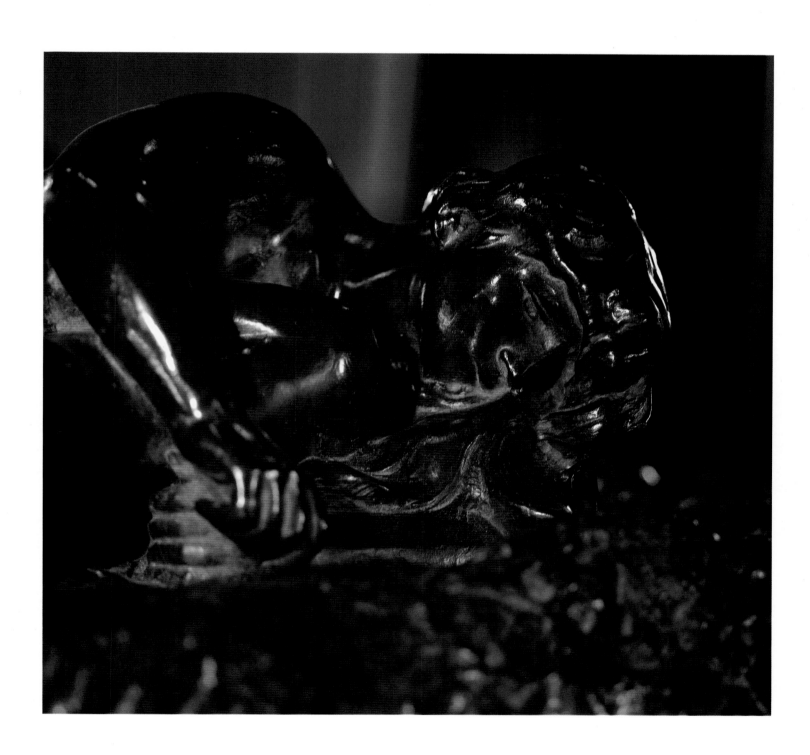

Rodin: The Kiss

The Kiss was one of the first works Rodin created for *The Gates of Hell*. The group appears on the lower left side of his third terra-cotta maquette for the portal made sometime around 1880-81.[31] It is one of the few groups originally designed for *The Gates* that actually illustrate an episode from Dante's *Inferno*. In canto five, lines 127-38, Dante and Virgil encounter Paolo Malatesta and Francesca da Rimini, who recount their illicit passion for each another. While reading the tale of Lancelot and Guinevere together, the couple exchanged glances and realized their feelings. As they embraced, they were discovered and killed by Giovanni Malatesta, Francesca's husband and Paolo's brother. The historical incident, immortalized by Dante and by many later writers and artists, is thought to have occurred around 1289.

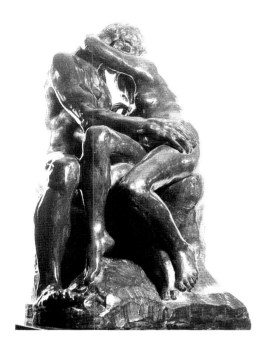

The Kiss, c. 1880-84
Bronze, 34 x 17 x 22 in.
(86.4 x 43.2 x 55.9 cm)

Rodin has portrayed the unhappy lovers at the moment before their kiss. Paolo's left hand holds the open book, his right hand barely presses Francesca's thigh. Their lips do not yet touch. The harmoniously interlocked figures, organized in a pyramidal arrangement, is one of sculpture's most traditional compositions. Rodin recognized its academic character when the marble version was located near his revolutionary Balzac at the Salon of 1898, and later commented: "It is a theme treated according to the tradition of the School; a subject complete in itself and artificially isolated from the world which surrounds it."[32] This insular quality, along with the group's relatively large scale (about half-life-size), ultimately prompted him to remove the model from *The Gates of Hell*, where it had been placed at least until January 1886.[33] At an undetermined time, he replaced *The Kiss* with another group on the lower left door, which depicts the couple tormented in hell.

In 1887 Rodin exhibited *The Kiss* in its original size at the Galerie Georges Petit in Paris, and at the Exposition Général des Beaux-Arts in Brussels.[34] Around that time the French government commissioned the first over-life-size marble version (75 inches [190 cm] high), which was displayed at the Salon in 1898 (Musée Rodin, Paris). The Cantor bronze, cast in an edition by the Georges Rudier Foundry, is based on the marble version.

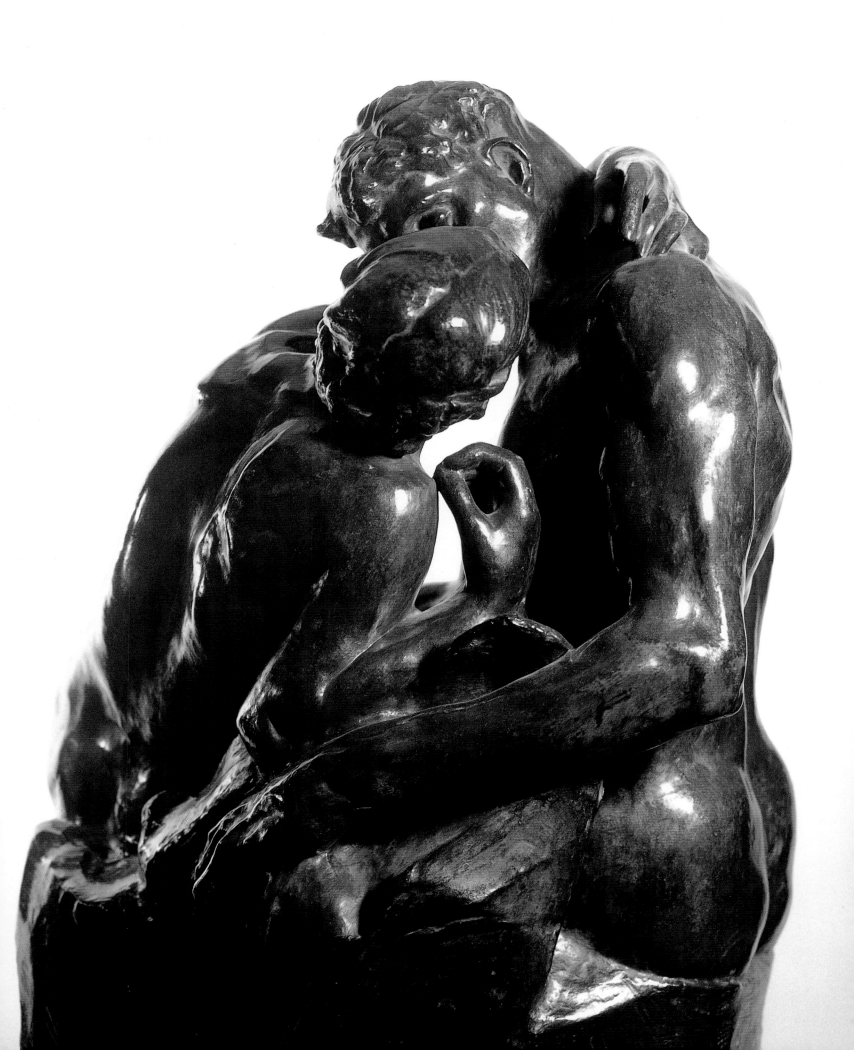

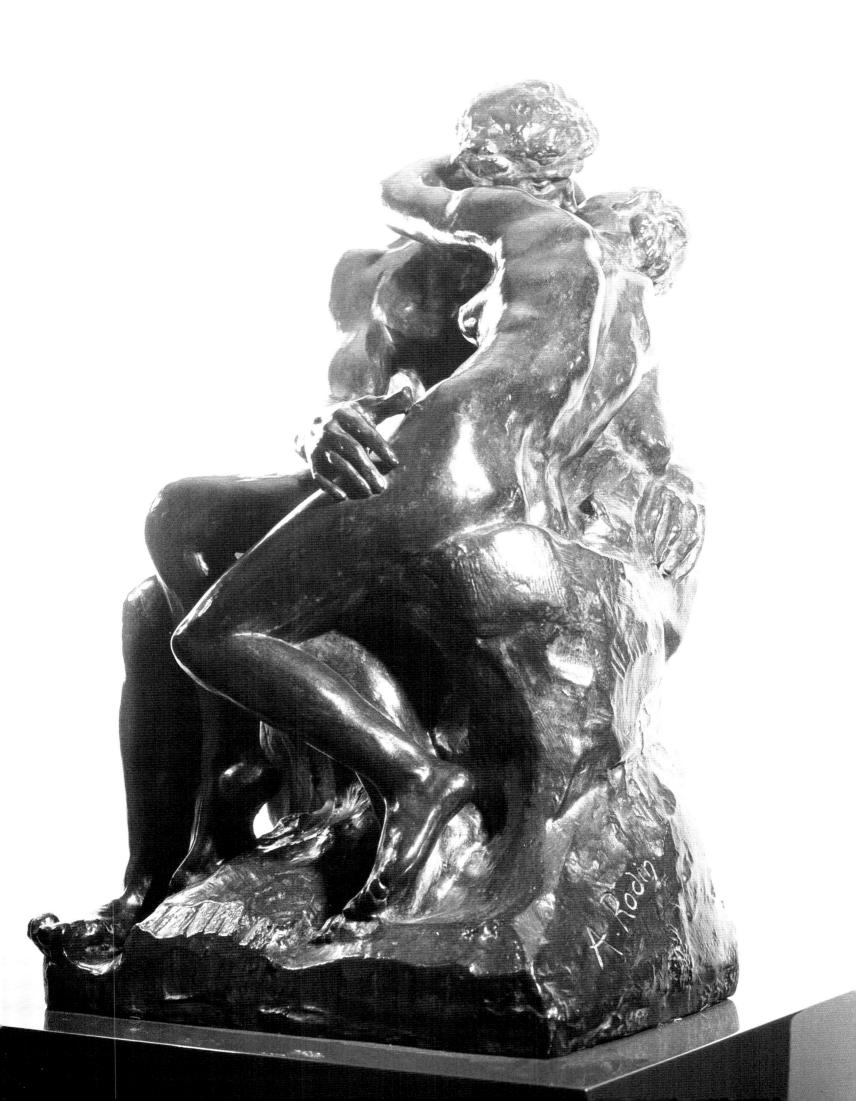

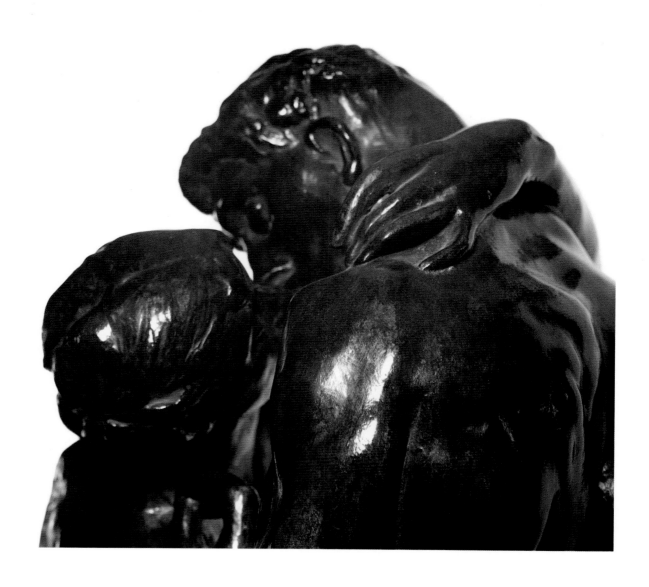

Rodin: Eternal Idol

"A mysterious greatness emanates from this group," wrote Rilke. "As so often with Rodin, one doesn't dare assign a meaning to it. It has thousands."[35] In *Eternal Idol* the sculptor presented another aspect of love, a theme he explored in many works relating to *The Gates of Hell*, including *The Kiss* and *Eternal Spring*. Distinct from the the latter two groups, the couple's amorous activity appears reverential, if not ritualistic. The woman leans backward on her knees. The man kneels forward, with his hands behind his back, and kisses her abdomen. Grappe reported that the sculpture was first entitled *The Host*, which suggested Rodin's tendency to merge the sacred with the carnal.[36]

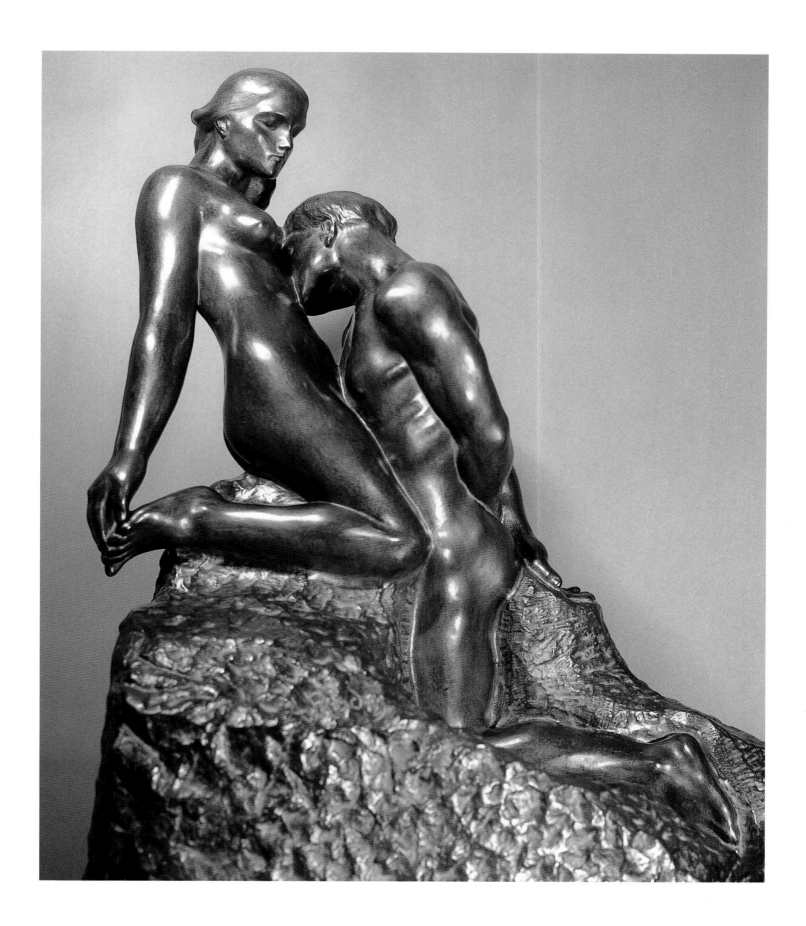

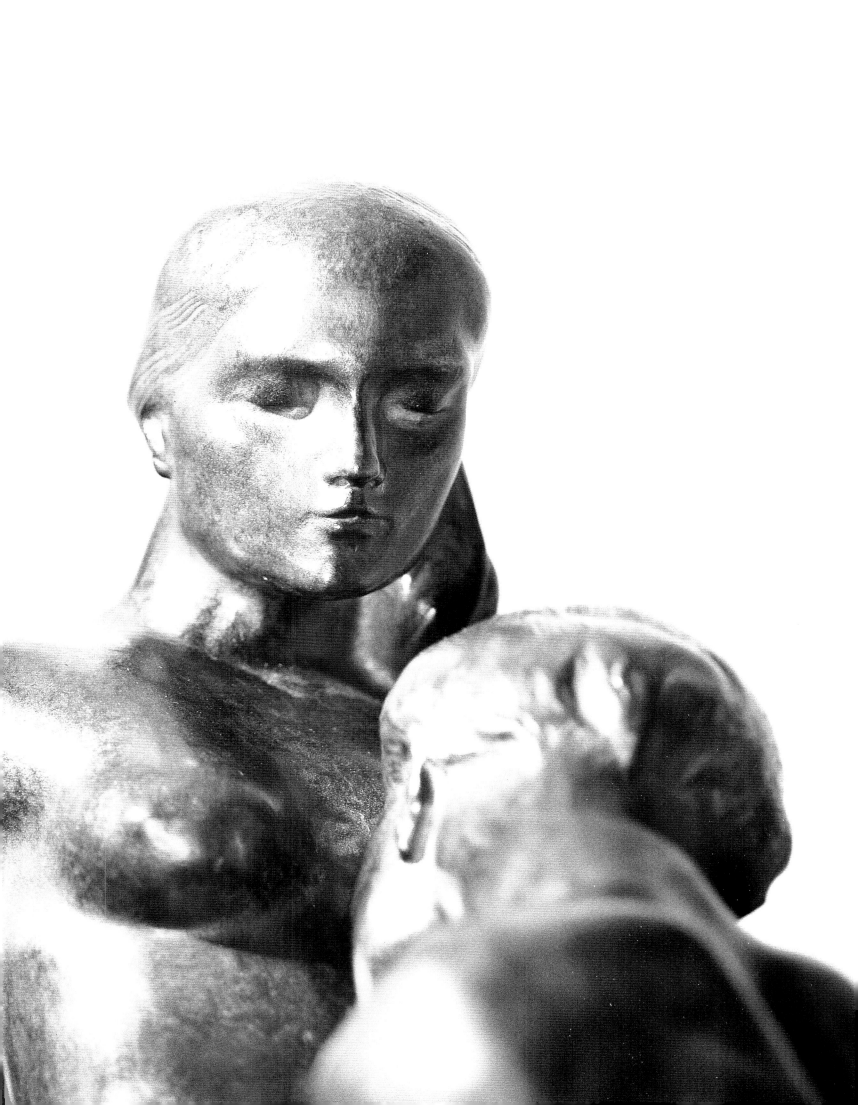

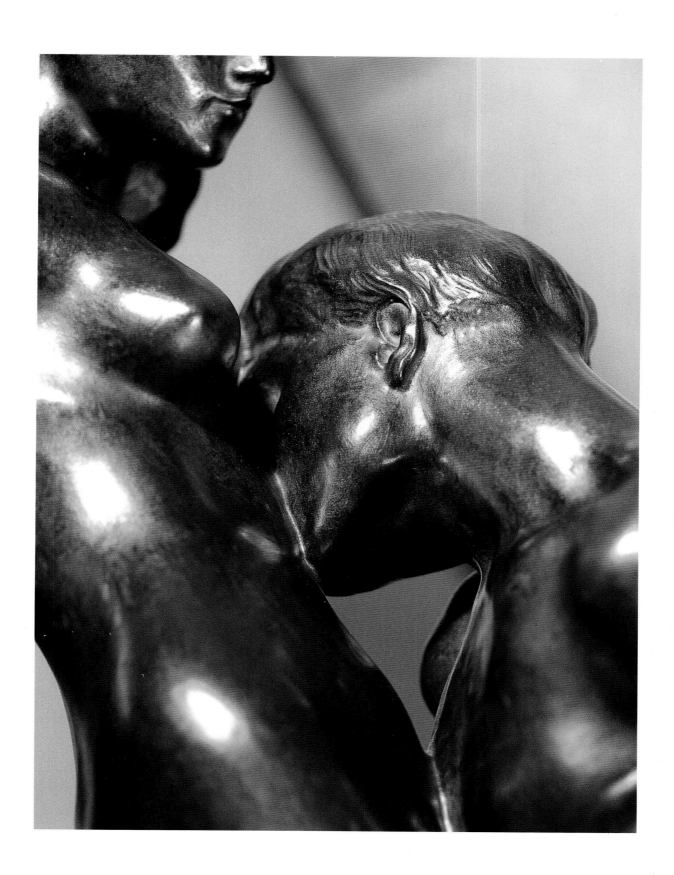

Rodin: *Meditation* and *Meditation without Arms*

Meditation without Arms may represent Rodin's most eloquent evocation of the thought process. The sculptor discussed the fragmented version with Paul Gsell in 1910: "My figure represents Meditation. That's why it has neither arms to act nor legs to walk. Haven't you noticed that reflection, when persisted in, suggests so many plausible arguments for opposite decisions that it ends in inertia?"[37]

Rodin initially created the prototype for *Meditation* in *The Gates of Hell*, where it appears on the far right side of the tympanum. This early treatment presents a figure whose violently twisted torso is attached to a pair of legs that are derived from his studies for *Eve*.

Around 1885 Rodin reworked the figure as an independent piece. In one version the figure supports a large stone between her forehead and left arm; her strained neck and bowed head suggest mental suffering.[38] Later, Rodin removed the stone, adjusting the head so that it rested on the right shoulder, and moving the left hand so that it touched the breast.

Rodin probably created the radically edited *Meditation without Arms* around 1897. Not only did he remove the sculpture's arms, but parts of its knees and upper legs as well, focusing instead on the dynamic, exaggerated contrapposto that animates this thoughtful figure.

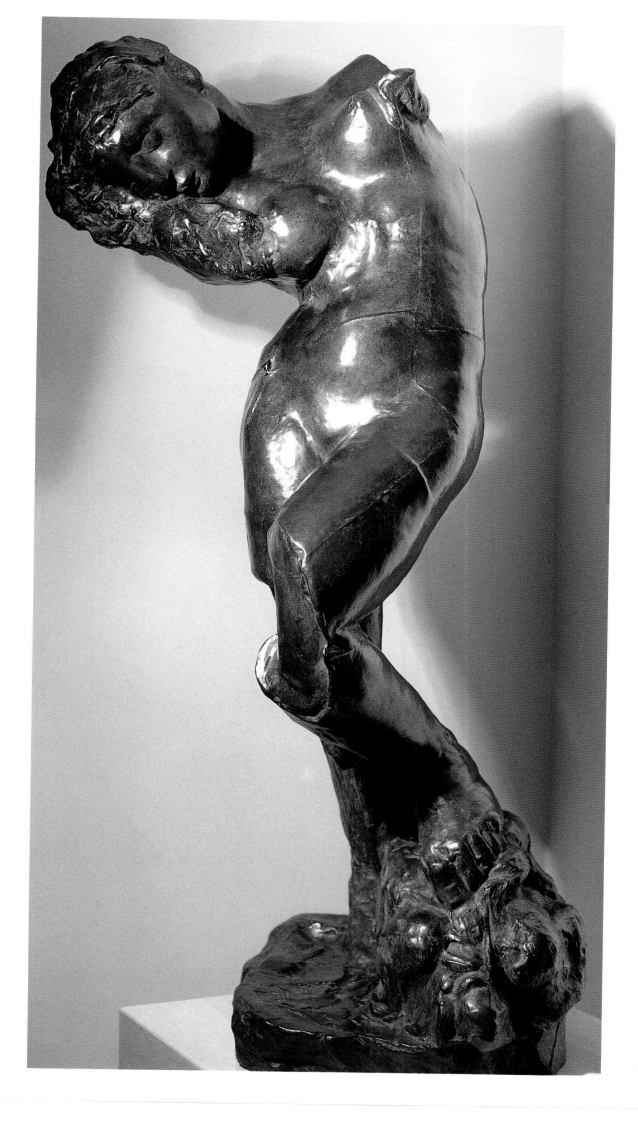

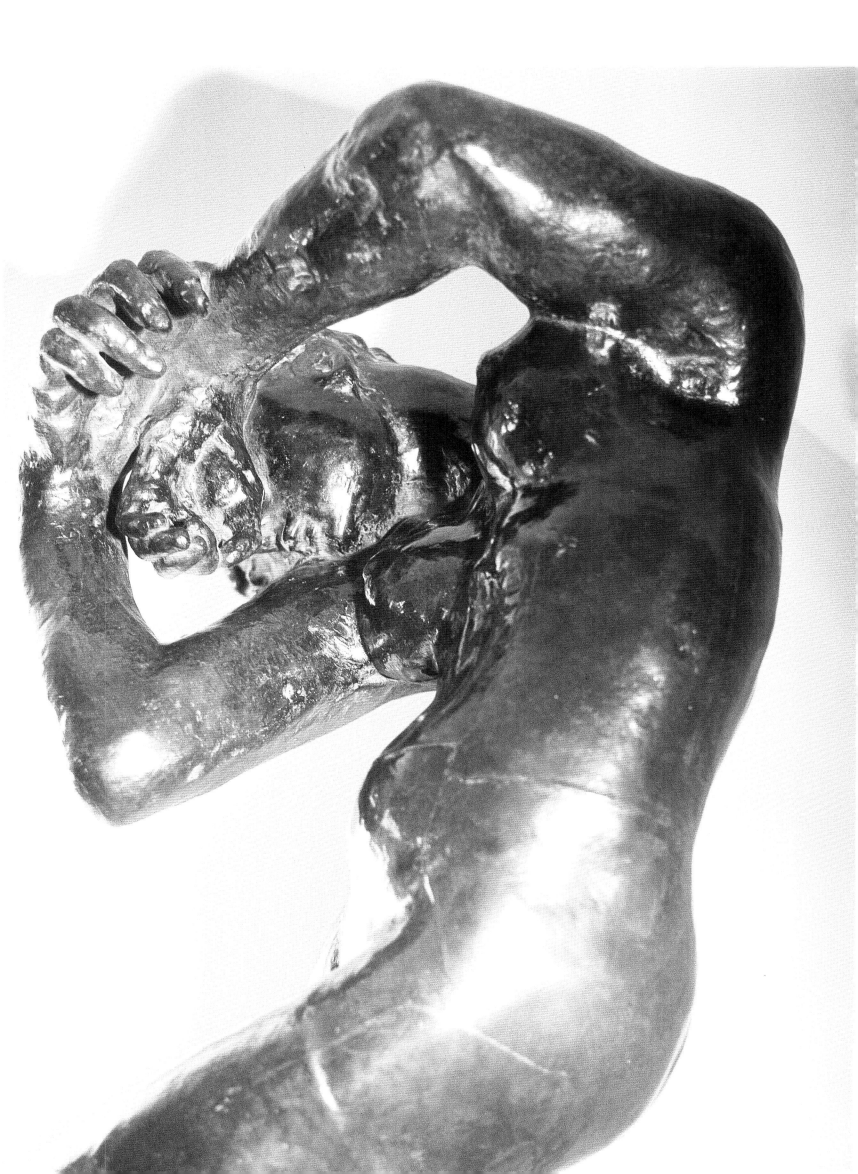

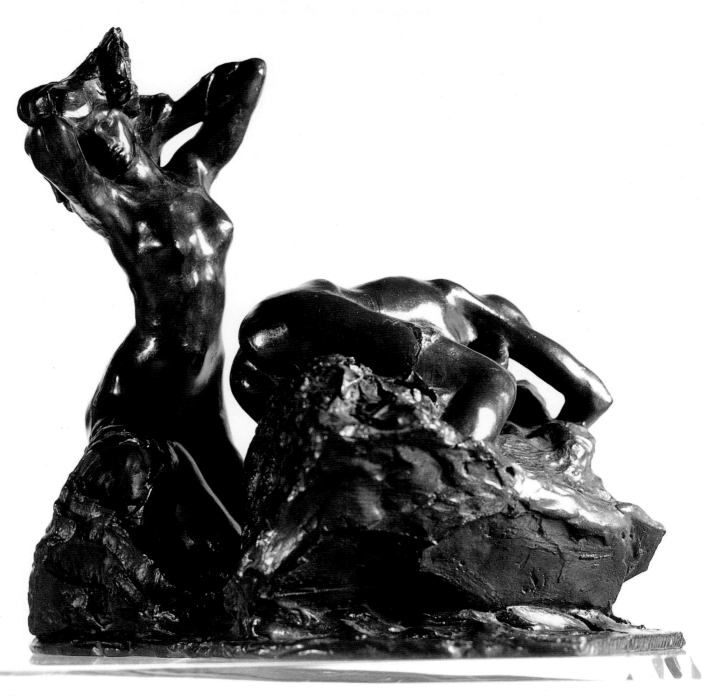

Toilette of Venus and
Andromeda, cast 1987
Bronze, 20 x 14 1/2 x 23 1/2 in.
(50.8 x 36.8 x 59.7 cm)

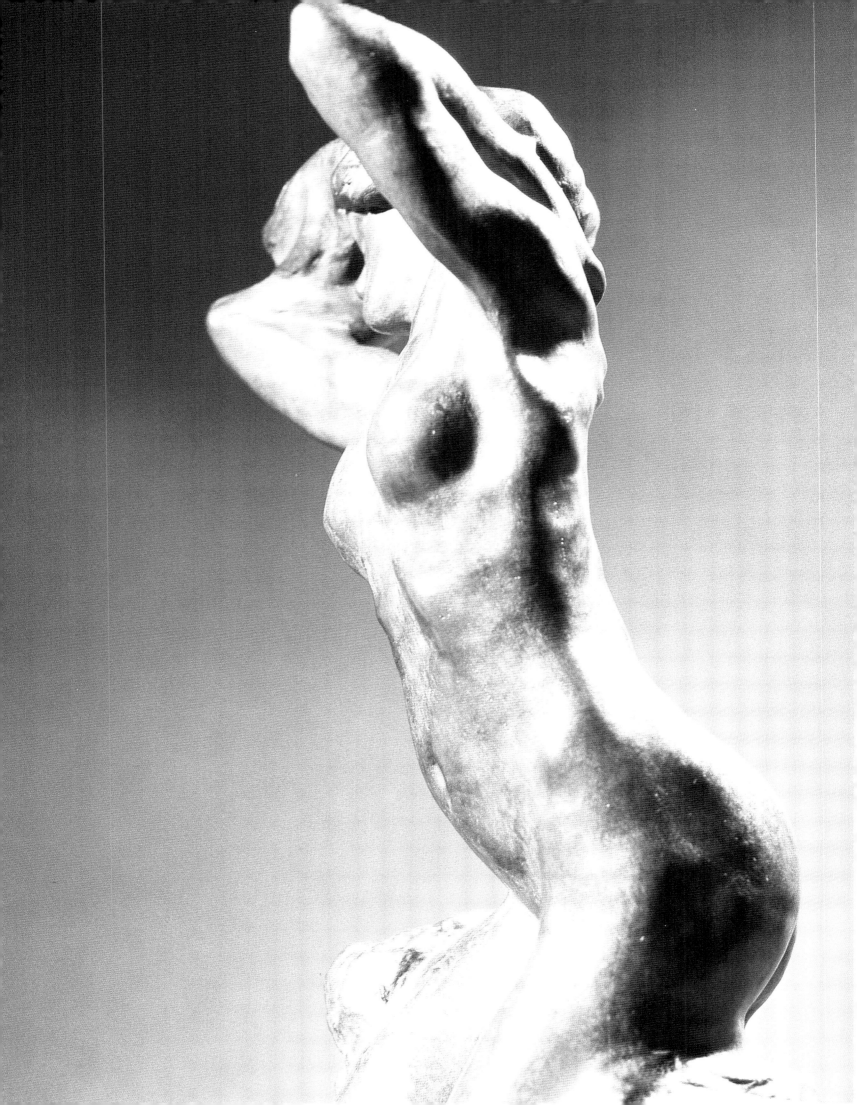

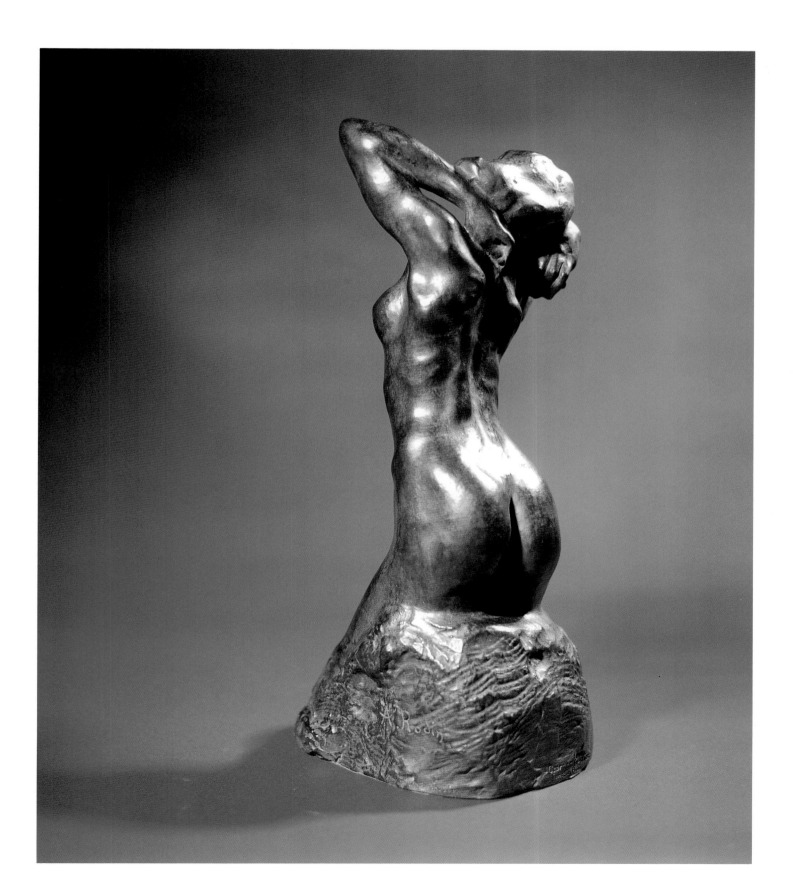

Rodin: *The Walking Man* and *Torso of the Walking Man*

Once considered a preliminary study for *St. John the Baptist Preaching* (1878), *The Walking Man* is now thought to have been created in 1900.[42] Rodin exhibited the plaster model of the work for the first time at his Paris retrospective during that year. The cast shown here (formerly in the collection of Anne-Marie Guillaume, Paris) is the same size as the plaster model.

The Walking Man is one of Rodin's most innovative works and forms a keystone in the development of modern sculpture. The sculptor joined the legs of the *St. John* with an

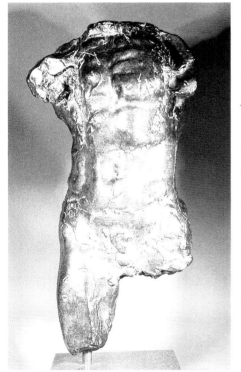

Torso of the Walking Man, 1877
Bronze, 20 1/2 x 10 3/4 x 8 in.
(52 x 27.3 x 20.3 cm)

adaptation of a torso he had made while working on the figure in 1877. This so-called *Torso of the Walking Man* is one of the sculptor's earliest fragmented figures. Although it may have begun as a study after his model Pignatelli, the work is emphatically unnaturalistic. In contrast to the more lifelike torso of *St. John*, the surface is punctuated by gouges and gashes. Rodin probably intended the ruggedly modeled and truncated torso to evoke a battered ruin from classical antiquity.[43] The bronze also preserves fissures accidently produced during the casting, which contribute to the scarred effect.

Rodin did not smooth over the joining of the naturalistic legs with the mutilated torso when he created *The Walking Man*. By leaving the juncture only roughly patched, he daringly emphasized the sculptural process. He extended the left leg to lengthen the stride, and set the torso facing in a different direction from the legs. Headless and armless, the figure has been divested of all narrative connotations. Rodin has focused on the suggested sense of movement rather than actually depicting the figure walking. The sculptor has synthesized the beginning and end of the figure's motion by planting both of its feet firmly on the ground. As Leo Steinberg has observed, the resulting work is "profoundly unclassical, especially in the digging-in conveyed by the pigeon-toed stride and the rotation of the upper torso."[44]

The Walking Man, 1900
Bronze, 33 x 20 1/4 x 20 in.
(84 x 51.5 x 50.8 cm)

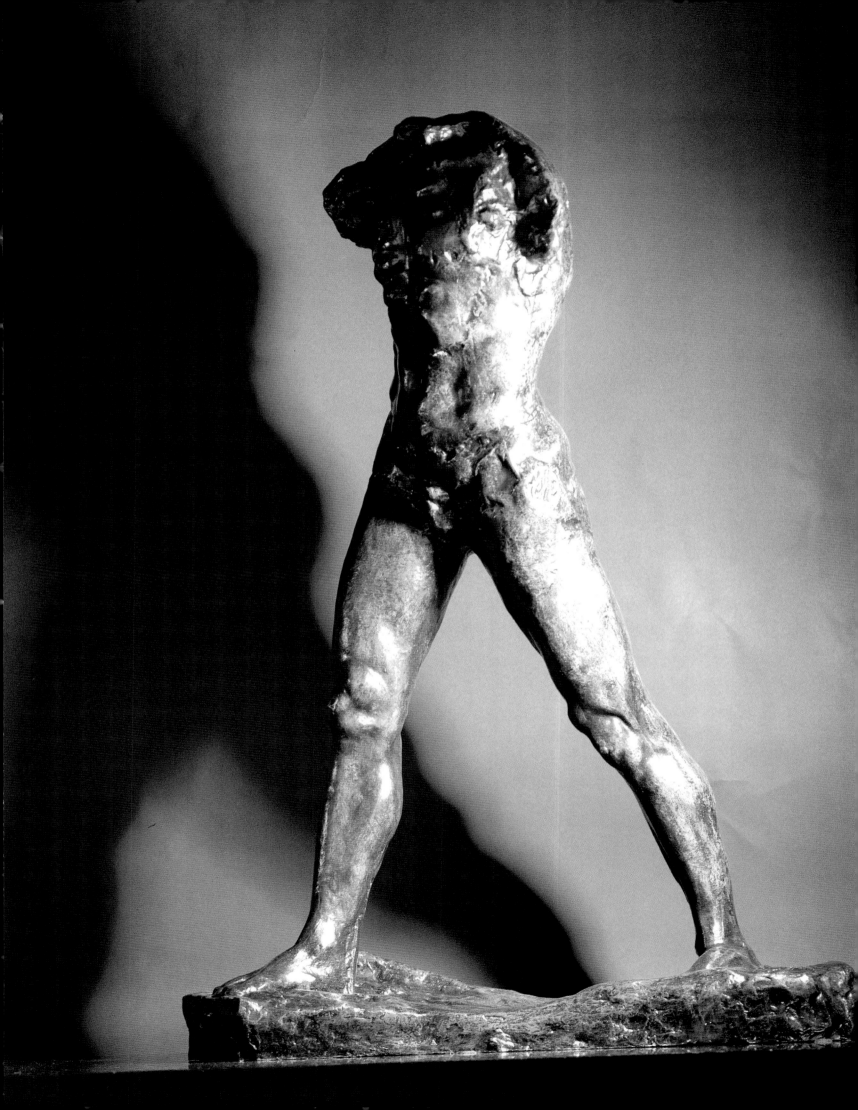

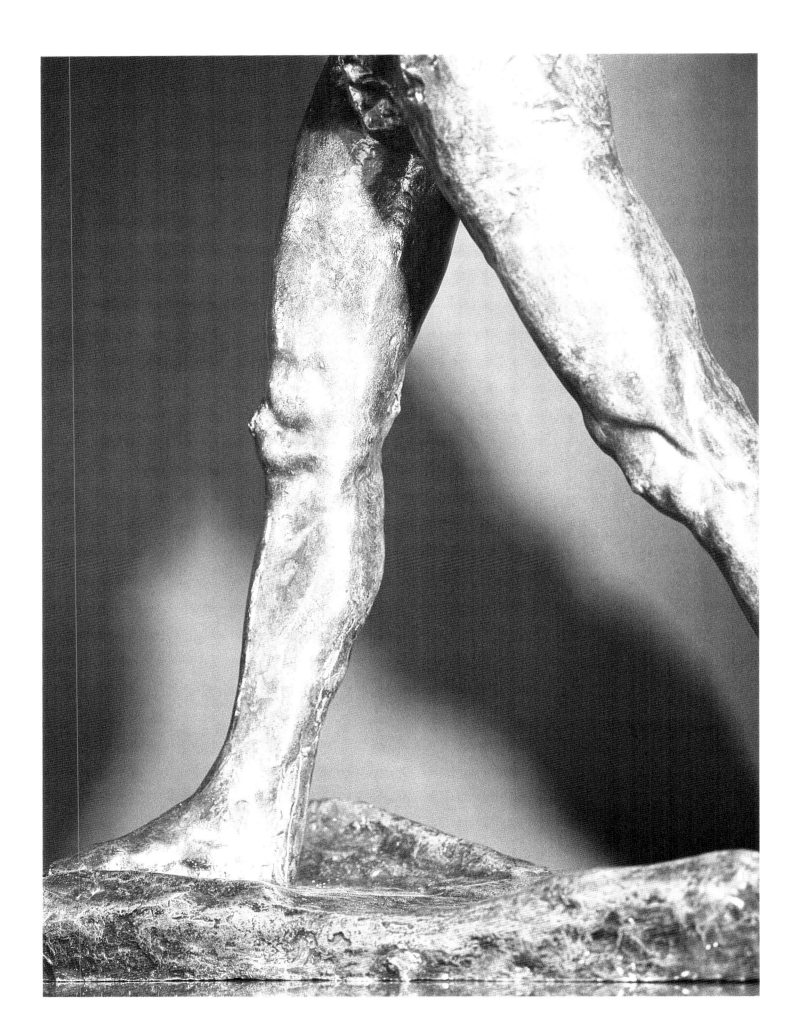

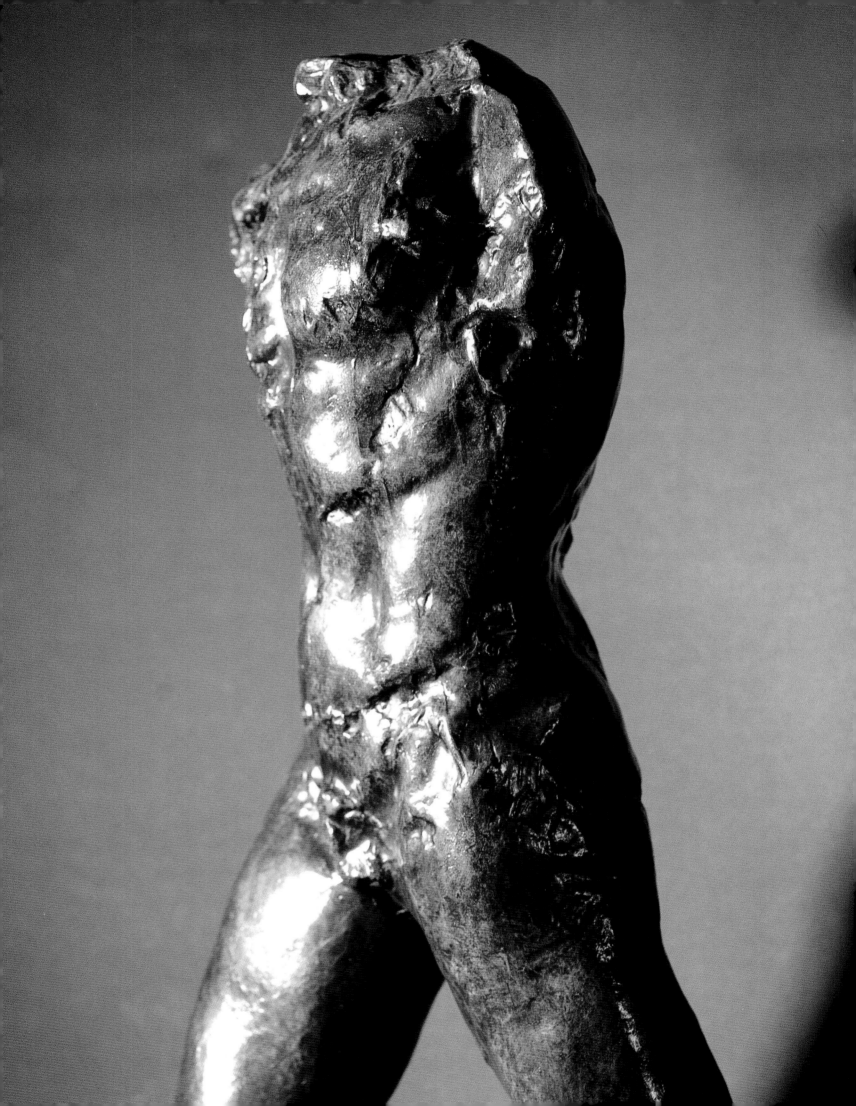

Rodin: The Monumental Torso of the Falling Man

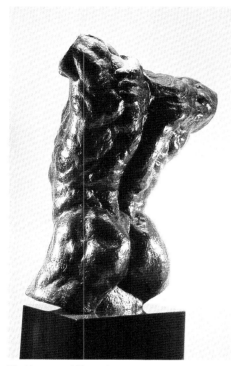

The Monumental Torso of
the Falling Man, 1882,
Bronze, 40 1/2 x 27 1/2 x 18 1/2 in.
(103 x 69.9 x 47 cm.)

Pignatelli, the model for *St. John the Baptist Preaching*, is said to have posed for the figure of *The Monumental Torso of the Falling Man*.[45] His spine arches back in agony. The posture suggests spiritual suffering as well as physical strain. The figure, turned to its back, appears underneath the lintel on the left side of *The Gates of Hell*. The historian Jules Michelet christened it *Atlas* in 1886.[46]

Rodin considered the muscular form of the man's back so compelling that he cast it independently in its original size and in an enlarged version, as seen in the Cantor bronze. The chest shows vestiges of the spike that held it to *The Gates of Hell*.

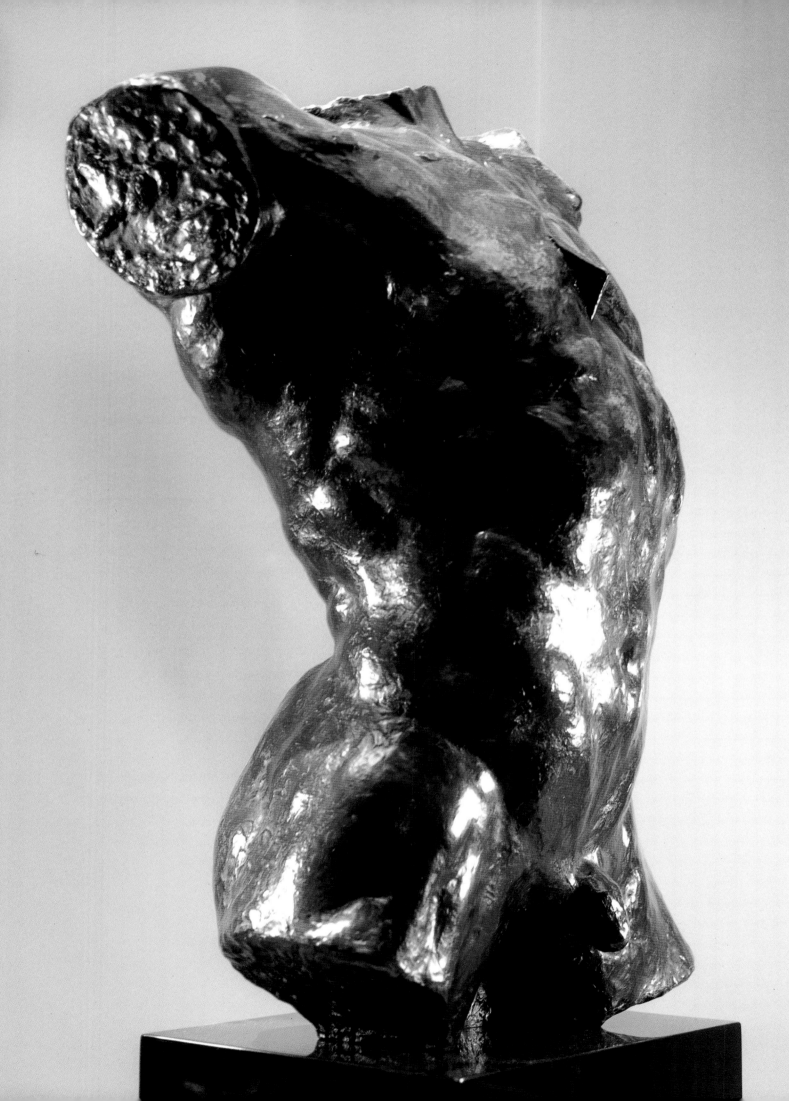

Rodin: Iris, Messenger of the Gods

The sculptor Aristide Maillol thought Iris "quivered with life," and was perhaps "the most beautiful thing" Rodin ever made.[47] This dynamic, provocative partial figure is remarkable both for its undefined relationship to gravity and for its sexual candor, which earned it the alternative title *The Eternal Tunnel*.[48]

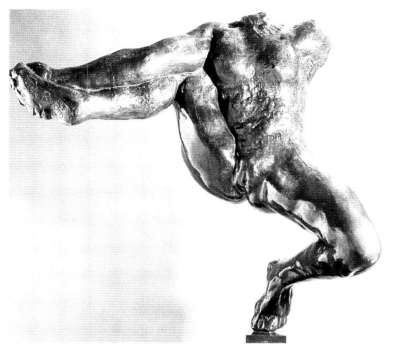

Iris, Messenger of the Gods,
c. 1890-91, cast 1969
Bronze, 38 x 32 1/2 x 15 1/2 in.
(96.5 x 82.5 x 39.4 cm)

The figure's uninhibited splayed pose prevented Rodin from exhibiting it for many years. Public prudery persisted even into the mid-twentieth century. The sculpture was labeled "unexhibitable" at the Museum of Fine Arts, Boston, and was traded to the dealer Curt Valentin in 1953 in exchange for six small maquettes.[49]

Rodin suspended the figure vertically on a rod in the 1890s, as it is shown today.[50] This arrangement makes it appear to be flying or dancing. *Iris's* energetic leap, reminiscent of a cancan, suggests Rodin's practice of sketching and modeling from dancers and acrobats.

Iris was preceded by numerous preliminary studies. Rodin first conceived the figure as a personification of glory for his Victor Hugo monument. It was intended to portray a winged muse that would descend upon the great writer. The bronze in the Cantor Collection represents the final form of the sculpture, enlarged by Lebossé from an 18-inch-high version. It has not been determined when Rodin gave the figure the mythological title by which it has always been known.

Mr. Cantor presented a cast of this piece, the same size as the present example, to the Los Angeles County Museum of Art in 1974. In the same year, he gave a cast of *Iris, Messenger of the Gods with Head* (18 in. high) to Stanford University.

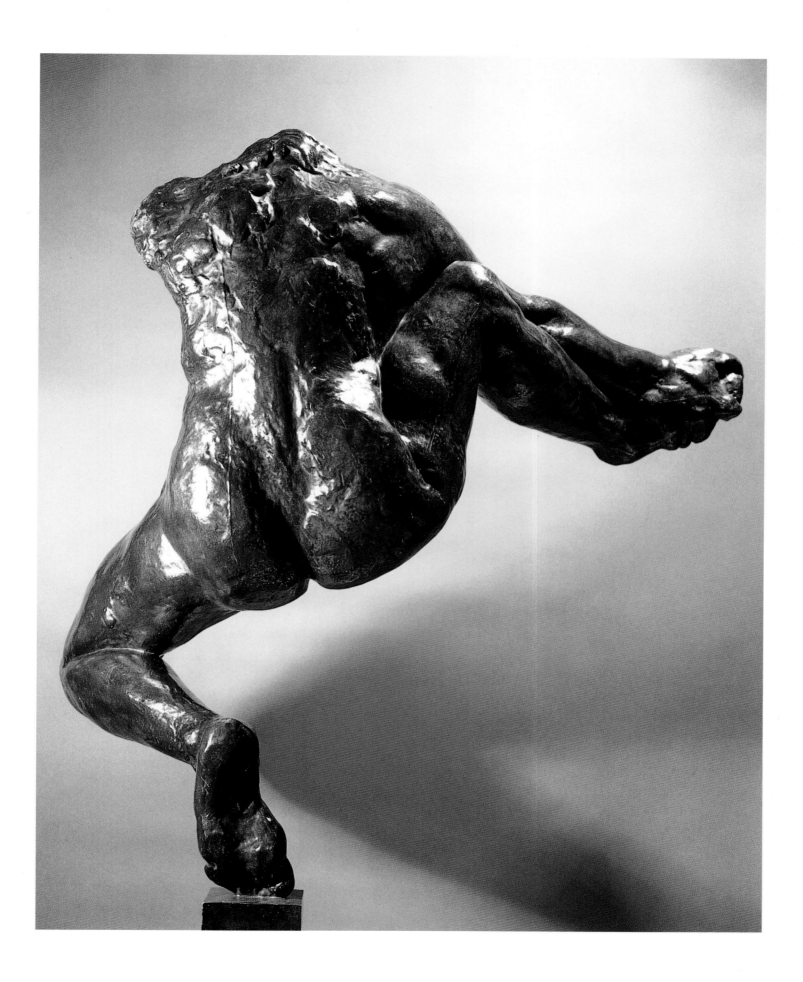

Rodin: Dance Movements

Rodin did not become interested in dance until late in his life. Classical ballet never appealed to him; he once recalled: "In my youth when I saw our Opéra ballets, I was unable to understand how the Greeks could have exalted the dance to a supreme position in the arts."[51] But modern dance was congenial to his love of spontaneous, natural movement, and his association with dancers presented him with new possibilities in the depiction of gesture and movement. By the 1890s he became enthusiastic about the cancan, and often had dancers from the Moulin Rouge and the Moulin de la Galette pose for him. These uninhibited models would strike casual, unusual postures that inspired numerous quick studies in pencil and clay.

Around 1910 he made a series of dancer figures, most of which were not cast until after his death. The generalized modeling of the figures increases the impression of fleeting movement, while their sausagelike forms suggest their origins in small rolls of clay. Their actions appear to be impulsive and flexible in contrast to the controlled, disciplined poses of Degas's dancers, with which they are often compared.[52]

Dance Movement F, 1911
Bronze, 11 x 10 1/2 x 5 1/2 in.
(28 x 26.7 x 14 cm)

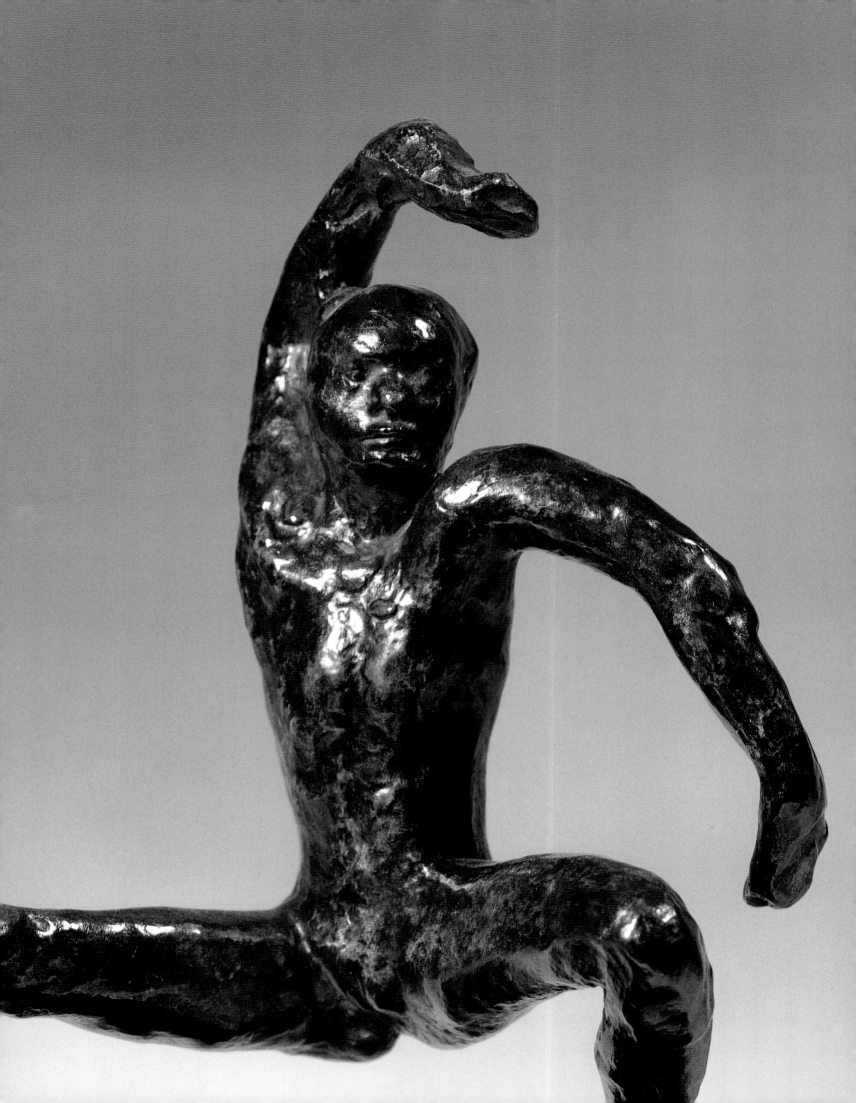

Pas-de-Deux B, c. 1910-11
Bronze, 13 x 7 1/8 x 5 in.
(33 x 18.5 x 12.7 cm)

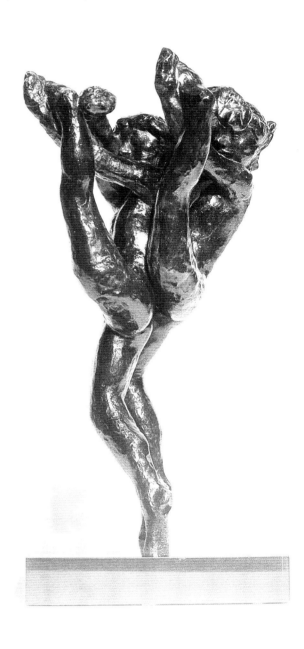

Dance Movement H, c. 1910
Bronze, 11 x 5 1/4 x 5 1/2 in.
(28 x 13.3 x 14 cm)

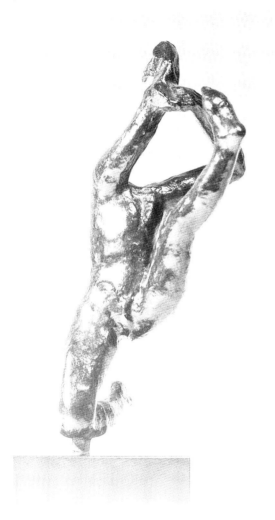

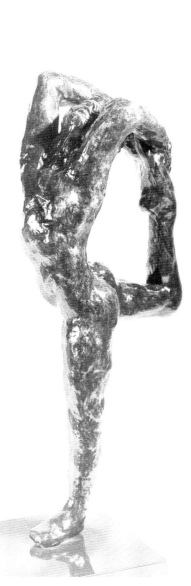

Dance Movement A, c. 1910-11
Bronze, 25 3/4 x 10 7/8 x 5 1/4 in.
(65.5 x 27.5 x 13.3 cm)

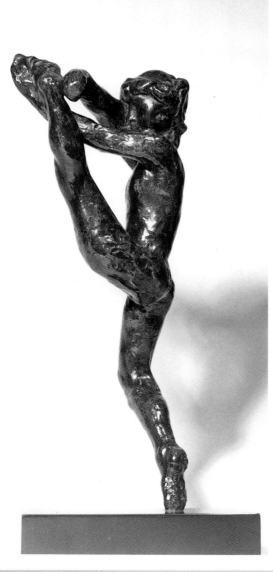

Dance Movement B, c. 1910-11
Bronze, 12 1/2 x 5 1/8 x 4 1/2 in.
(31.8 x 13 x 11.5 cm)

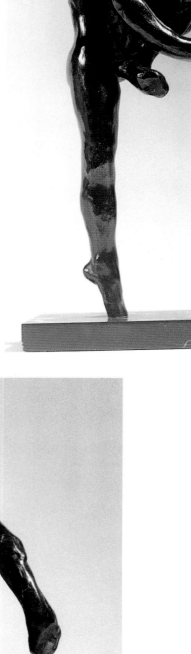

Dance Movement D, c. 1910-11
Bronze, 12 3/4 x 41/4 x 3 5/8 in.
(32.5 x 10.8 x 9.2 cm)

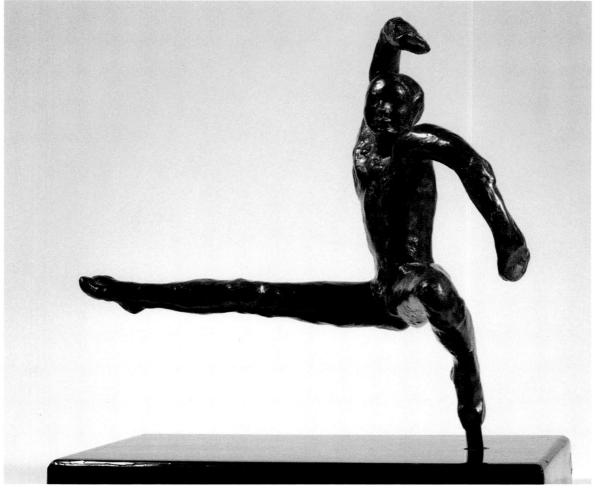

Dance Movement F, 1911
Bronze, 11 x 10 1/2 x 5 1/2 in.
(28 x 26.7 x 14 cm)

Rodin: Nijinsky

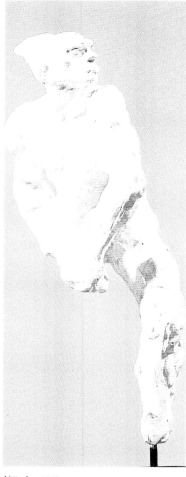

Nijinsky, 1912
Plaster, 7 1/2 x 3 3/4 x 3 1/2 in.
(19 x 9.5 x 9 cm.)

Rodin was dazzled by Vaslav Nijinsky's debut in *Prelude to the Afternoon of a Faun* at the Châtelet Theatre on May 29, 1912. The next day he told Malvina Hoffman: "It was youth in all its glory, like the days of ancient Greece when they knew the power and beauty of a human body and revered it. Such grace, such *souplesse!*"[53] The dancer posed nude for Rodin a few times at Meudon in June. The resulting figure and head are among Rodin's final great works. The sketchily modeled figure not only captures the immediacy of his impressions, but also evokes Nijinsky's swift movements. As in several of Rodin's major sculptures, the energetic pose defies gravity.[54] Viewed in the round, the sculpture presents a dynamic silhouette from every angle. The head of the small figure shows the high cheekbones and craggy Slavic features of Nijinsky's face.[55]

Rodin may have intended to create a life-size sculpture of Nijinsky, but the work never progressed beyond this sketch. Nijinsky's wife recorded that on one hot summer afternoon Rodin and the dancer fell asleep after drinking wine at lunch.[56] Diaghilev arrived unexpectedly to find Rodin asleep at Nijinsky's feet. His suspicions and jealousy are thought to have curtailed the sittings.

The plaster figure shown here was a gift to Mrs. Cantor from the Musée Rodin in Paris.

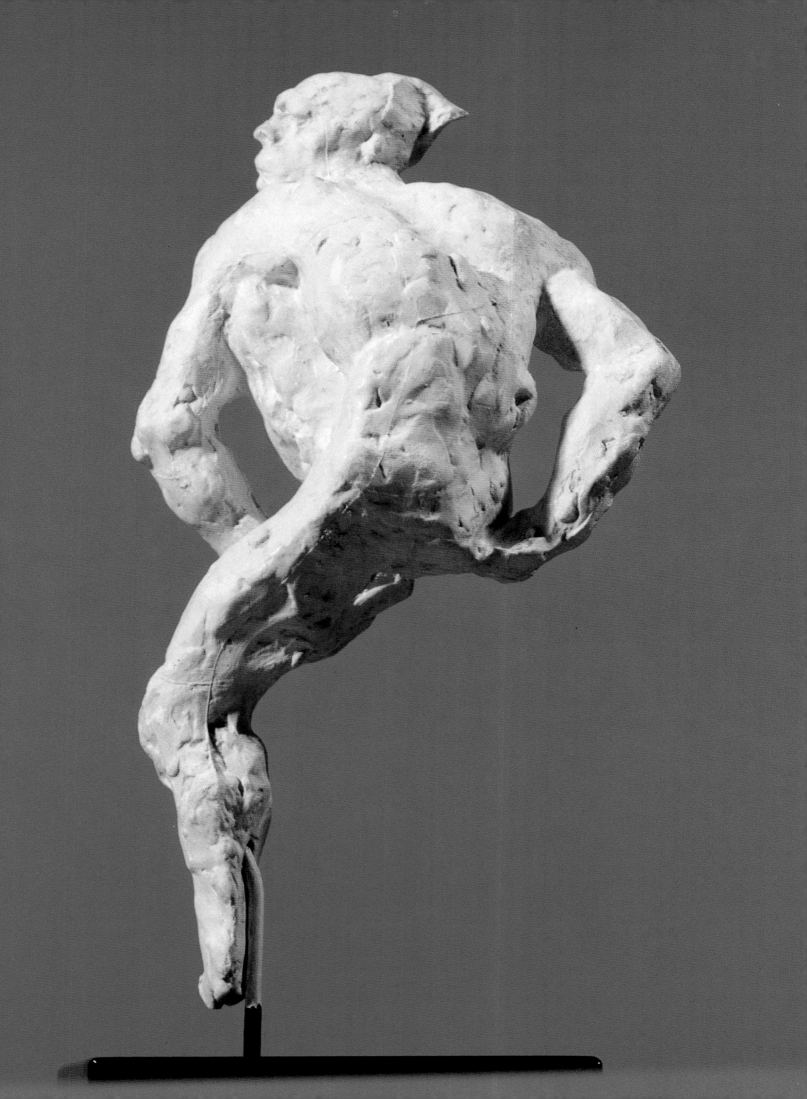

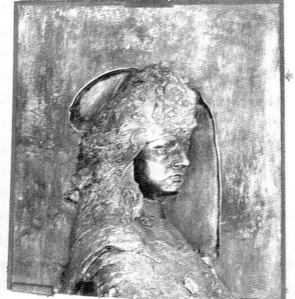

Rodin: La France

La France, 1904-6
Bronze, 23 3/4 x 21 1/2 x 12 in.
(60.5 x 54.5 x 30.5 cm)

In *La France*, the nation is personified by Camille Claudel (1856-1945), Rodin's student and mistress. By 1905 they had been separated for nearly a decade, so this likeness was inspired by his memory and other portraits of her, notably *Thought* (1886; Musée Rodin, Paris). An earlier variant of the sculpture, without the niche, entitled *St. George* (Musée Rodin, Paris), was shown in the 1889 Monet-Rodin exhibition at the Galerie Georges Petit.[57] *La France* was also known as *The Byzantine Princess, Bust of a Young Warrior*, and *The Empress of the Low Countries*.[58]

René Chéruy, Rodin's secretary from 1902 to 1908, observed the assemblage of this relief, the composite of a bust and a plaque: "I must confess that Rodin did not exert himself in doing this composition. He took a face of Camille Claudel, added the shoulders and the sketchy helmet in the round. Then placed it as a high relief in front of a plaster plaque with the indication of a vault—profile turned to the right he called it *La France*. Immediately after, perhaps the next day, he took a second cast and repeating the same process he turned the profile to the left and called it *St. George*."[59]

Chéruy dates this episode to late 1907 or early 1908, but Grappe assigned the work, and a study for it, to 1904, because a sculpture entitled *La France* was exhibited at the Salon d'Automne in 1905, and at Versailles two years later.[60]

Rodin: Head of Hanako

Head of Hanako, 1908-11
Bronze, 12 x 9 1/2 x 9 1/2 in.
(30.5 x 24.2 x 24.2 cm)

Rodin portrayed the Japanese actress Ohta Hisa (or Hisako Hohta, 1868-1945), known as Hanako, more often than any other sitter. Fifty-three different heads and masks of her, modeled between 1907 and 1911, are preserved in the Musée Rodin, Paris. Rodin met Hanako in1906 through his friend the famous American dancer Loïe Fuller (1862-1928).[61] Born in 1868 near Nagoya, Hanako became a geisha at the age of six. In 1901, she joined a group of dancers and acrobats traveling to Europe. A few years later Fuller hired Hanako as a mime, and wrote melodramas designed specifically to exploit her wide emotional range. Her talents inspired one admirer to call her "the Japanese Duse."[62]

Rodin was astounded by Hanako's skill in holding poses for a long time. He sketched her in the nude, but ultimately the mobility of her facial features fascinated him the most. He found her Kabuki-style expressions of torment and fury particularly compelling. Rodin also portrayed her in quieter moments, as revealed in this impressive head.[63] Rodin has captured her delicacy without sentiment. The bronze is one of the few portraits to depict her traditional hairstyle.

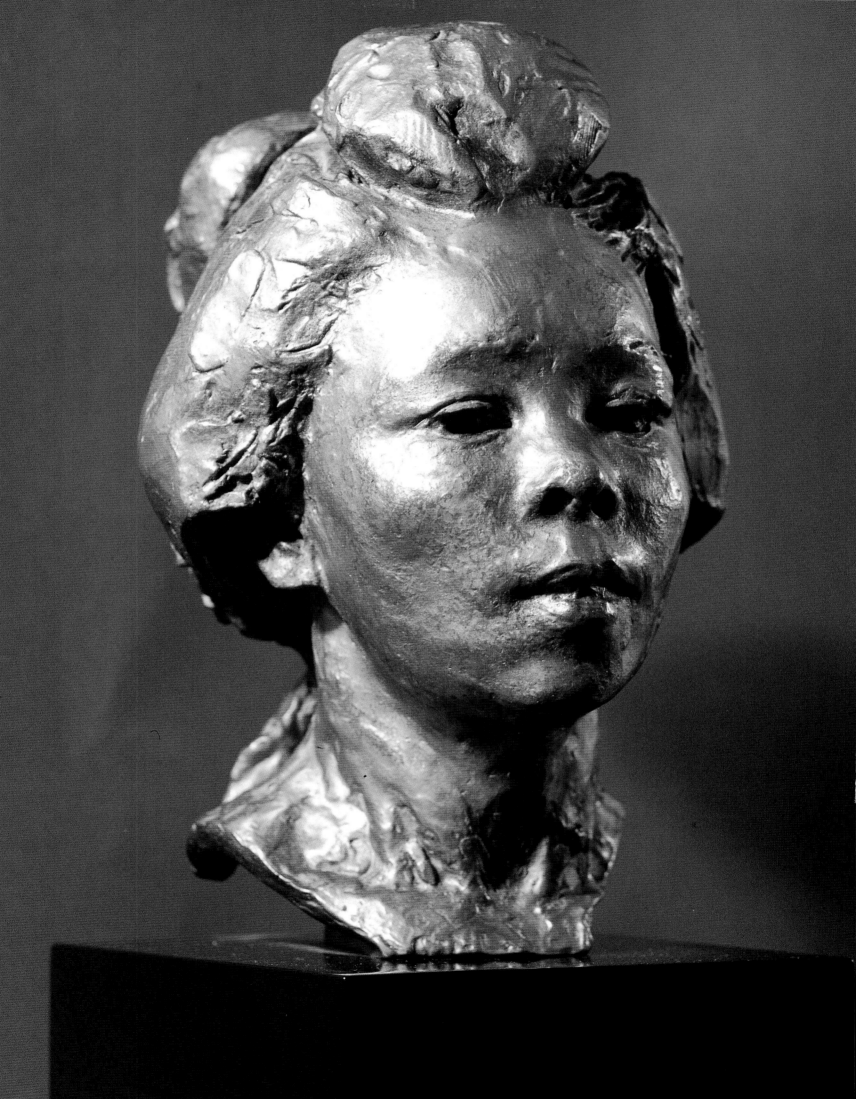

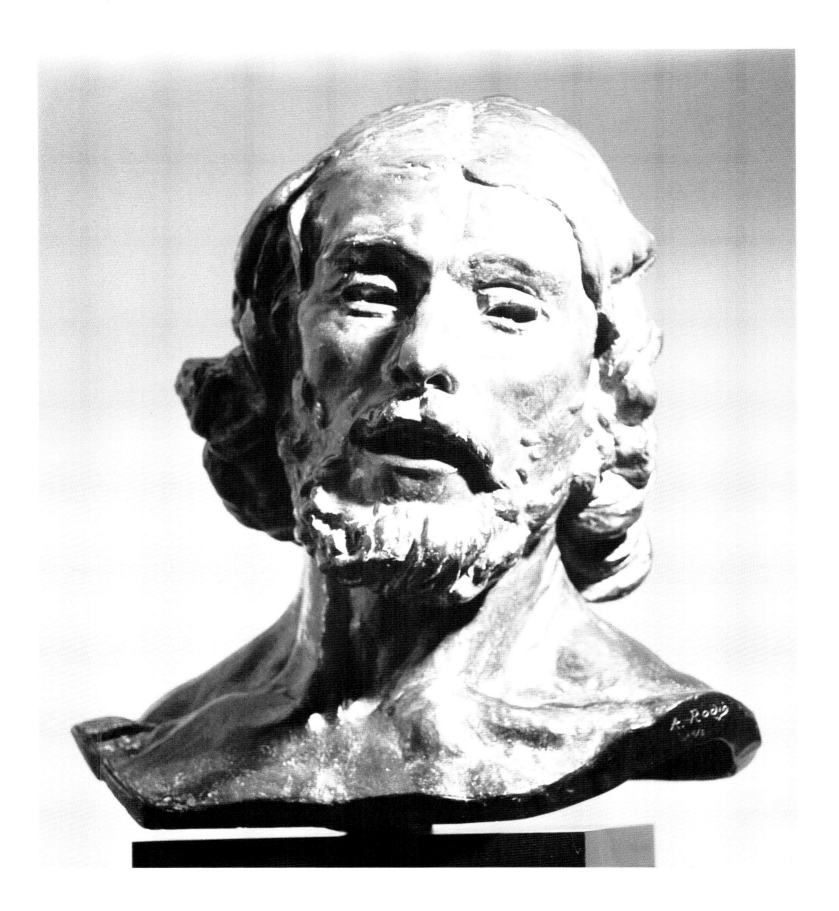

Rodin: Monumental Head of St. John the Baptist

Monumental Head of St.
John the Baptist, c. 1879
Bronze, 21 1/2 x 20 3/4 x 15 1/4 in.
(54.5 x 52.7 x 38.7 cm)

St. John the Baptist Preaching marked one of Rodin's earliest official successes. A bronze cast of the figure was acquired by the French government in 1881 soon after it was shown at the Paris Salon. Two years earlier the plaster bust from this figure won him an honorable mention there. The critic Eugène Véron praised the head's poignant expression: "His eyes are filled with faith and he dominates those who follow him, and with his open mouth he eloquently proclaims the coming of the Messiah."[64]

Rodin's model for *St. John* was a forty-two-year-old Italian peasant from the Abruzzi named Pignatelli. Rodin admired Pignatelli's strong, rough features and observed in him a certain mystical quality appropriate to the subject.[65] A bronze bust of *St. John* was exhibited in 1882 at the Royal Academy in London, and it was illustrated in the *Magazine of Art*.[66] In 1893 another bronze version became the first of Rodin's sculptures to enter the collection of the Metropolitan Museum of Art in New York.[67]

Rodin: Monumental Bust of Victor Hugo

Monumental Bust of Victor
Hugo, 1897 Bronze,
29 1/4 x 23 1/2 x 21 1/4 in.
(74.3 x 59.7 x 54 cm)

In the late nineteenth century, Victor Hugo (1802-1885) was widely regarded as the greatest creative genius of his era. Rodin, among others, idolized him. When the sculptor was introduced to Hugo in 1883 he compared him to a "French Jupiter,"[68] but as they became acquainted, he was reminded of another mythological figure: "Hugo had the air of a Hercules; belonged to a great race. Something of a tiger, or of an old lion. He had an immense animal nature. His eyes were especially beautiful, and the most striking thing about him."[69]

This heroic bust of Hugo was derived from a maquette Rodin made in preparation for an unrealized monument in the Pantheon.[70] Rodin hoped Hugo would sit for him, but Hugo, who had recently posed thirty times for an indifferent sculptor called Vilain, was not interested. He did, however, allow Rodin to create a bust, even though he refused to pose for it. The sculptor set up his modeling stand on Hugo's balcony, where he would race from the dining room to record what he had just observed. He also made eighty quick sketches of his subjects's head from every angle.[71] The arrangement proved to be less than satisfactory. As he later related to Paul Gsell: "Often on the way, my impression had weakened, so that when I arrived before my stand I dared not touch the clay, and I had to resolve to return to my model again."[72]

Undoubtedly hampered by this awkward method, Rodin produced a relatively straightforward likeness that lacked the brooding, dramatic intensity of this poetic, posthumous portrait. Here, Hugo's downcast gaze and furrowed brow evoke the torment of inspiration, expressing the underlying theme of the monument.

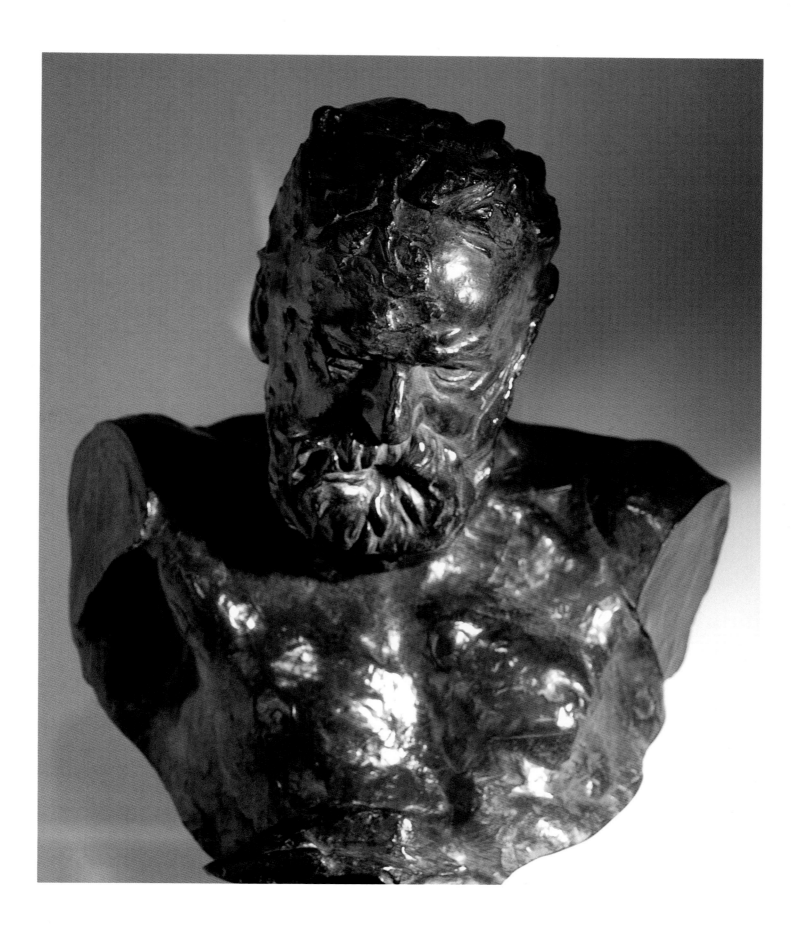

Rodin: The Burghers of Calais

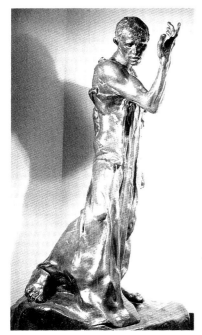

Pierre de Wiessant
(grand model), 1885-86
Bronze, 81 x 40 x 48 in.
(206 x 101.6 x 122 cm)

In *The Burghers of Calais* Rodin radically transformed the form and meaning of the public monument as it was known in his time. By focusing on human suffering rather than triumphant glory, he presented a new, personal interpretation of heroism. He rejected the academic pyramidal composition that then prevailed, and arranged his protagonists alongside each other close to the ground.

In September 1884 the Municipal Council of Calais voted to initiate a subscription for a memorial to Eustache de Saint-Pierre, a local hero during the Hundred Years War.[73] According to the fourteenth-century *Chronicles of Jean Froissart*, in 1347 Saint-Pierre and five other leading citizens of Calais offered themselves in sacrifice so that Edward III would end his eleven-month siege of the city. They were freed only through the intercession of Edward's wife, Queen Philippa.

Rodin received the commission for a monument honoring all of the burghers in January 1885. For the next year he worked diligently on the project. Rodin first conceived the figures in the nude, and then clothed them in robes intended to represent sackcloth.[74] In April 1886 Edmond de Goncourt recorded that he had seen the six life-size clay models for the monument.[75] Rodin displayed the full-scale plaster models for the first time at the Monet-Rodin exhibition at the Galerie Georges Petit in June 1889. The monument, cast by Leblanc Barbedienne, was completed in March 1895. It was unveiled with great fanfare in Calais on June 2 and 3 of that year.

Rodin executed several hundred studies in preparation for the monument. Over 250 of these have been cast into bronze.[76] The Cantor Collection features several of these works, including bronzes of the final full-scale figures of Eustache de Saint-Pierre, Jean de Fiennes, and Pierre de Wiessant. The latter is one of most impassioned figures Rodin ever created. Anguish reverberates throughout his twisting body into his fingertips, and culminates in his tragic face, which Elsen has compared to Gothic representations of Christ as the Man of Sorrows.[77] The adolescent Jean de Fiennes addresses the beholder with outstretched arms that suggest hopelessness over his fate. The monumental heads of Pierre de Wiessant and Jean d'Aire amplify the emotional impact of their suffering.

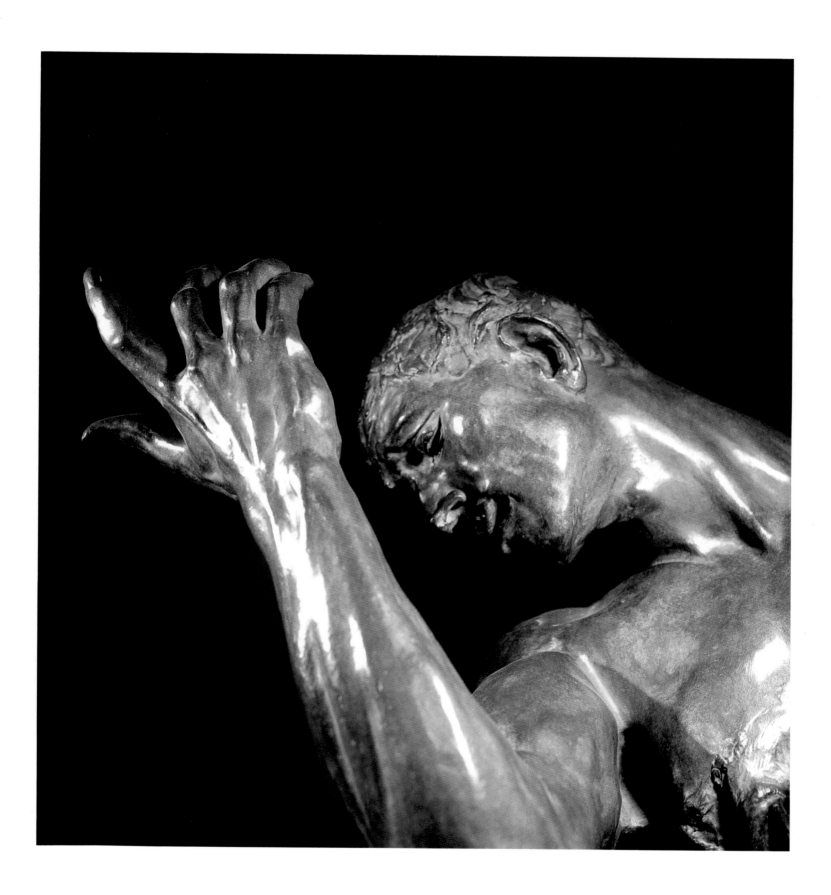

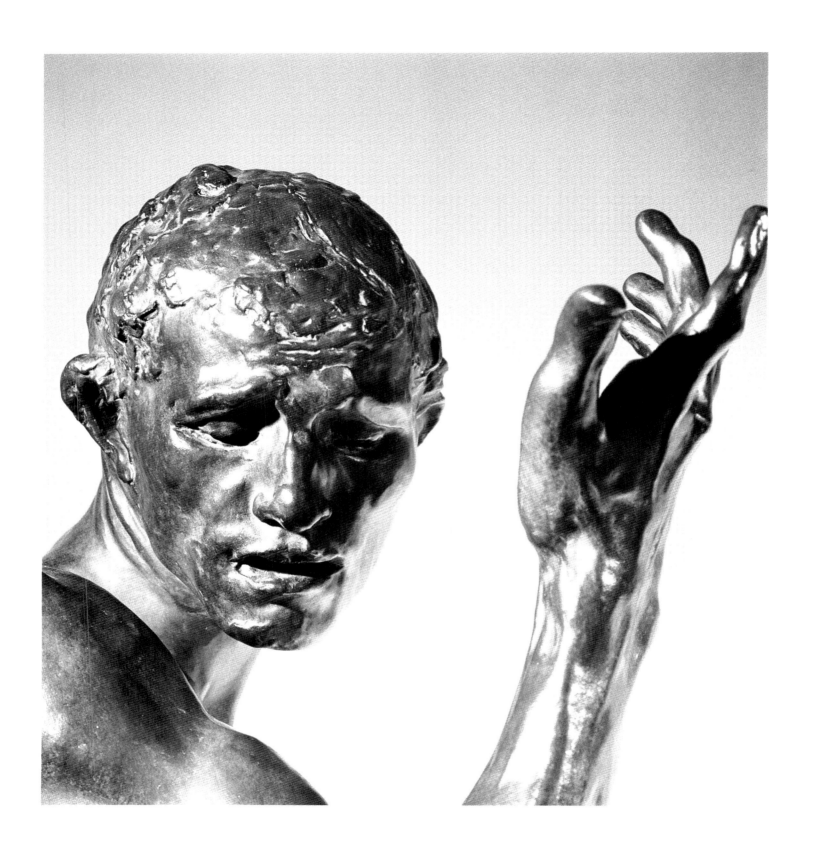

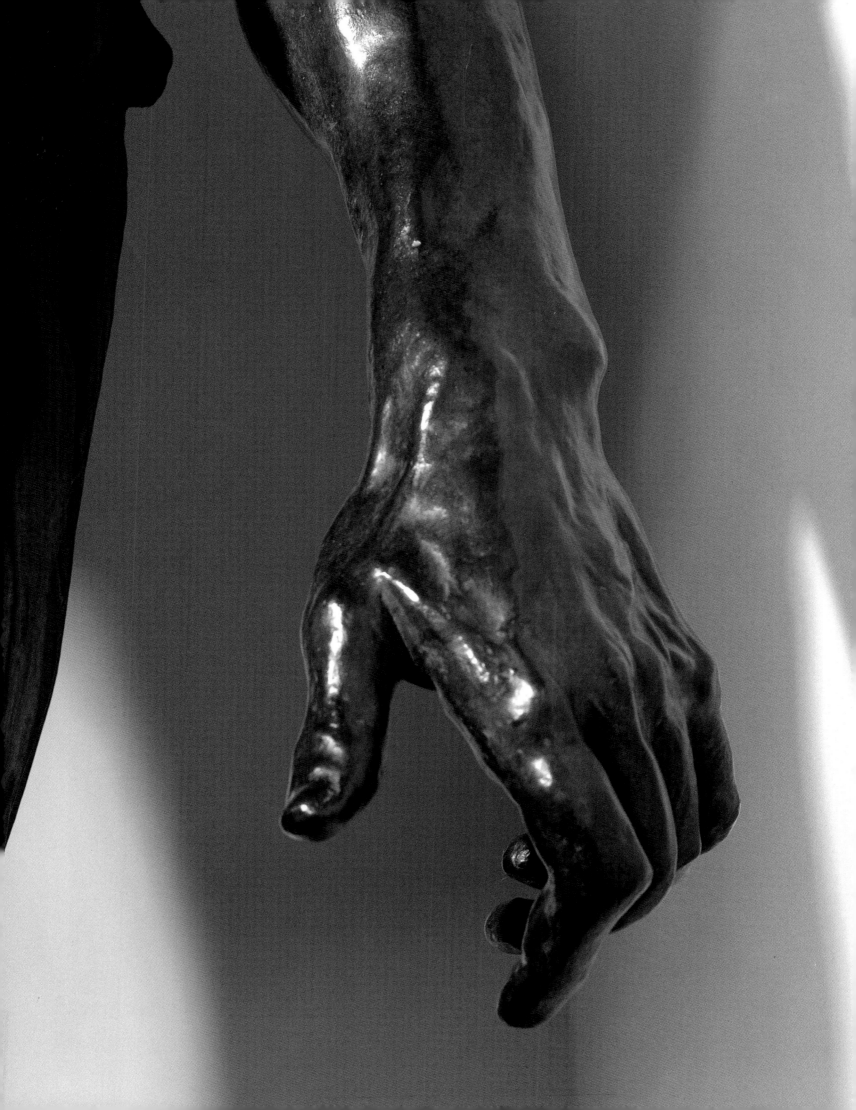

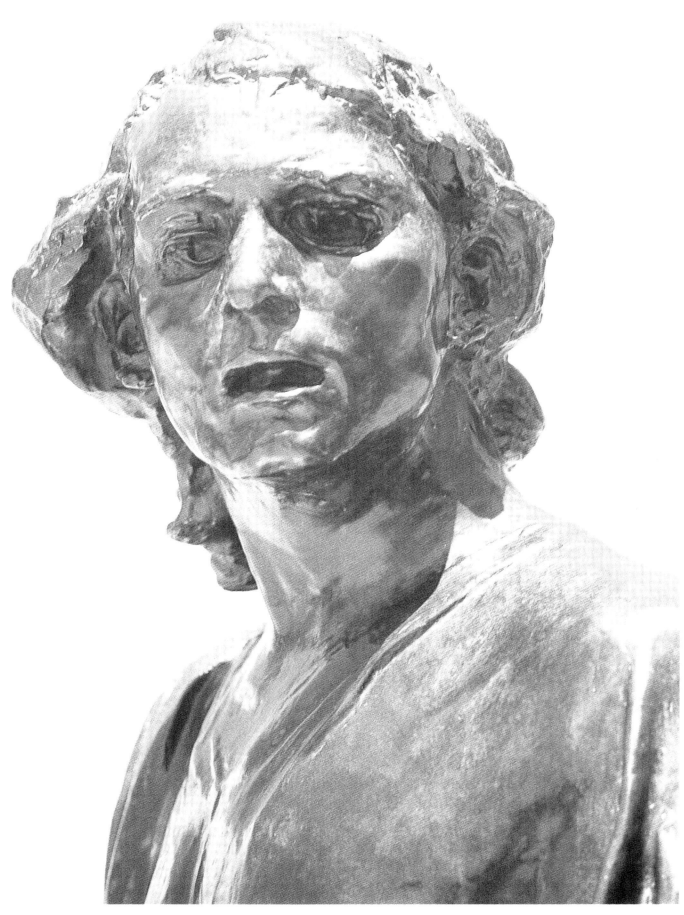

Jean de Fiennes
(grand model), 1885-86
Bronze, 82 x 48 x 38 in.
(208.6 x 122 x 96.5 cm)

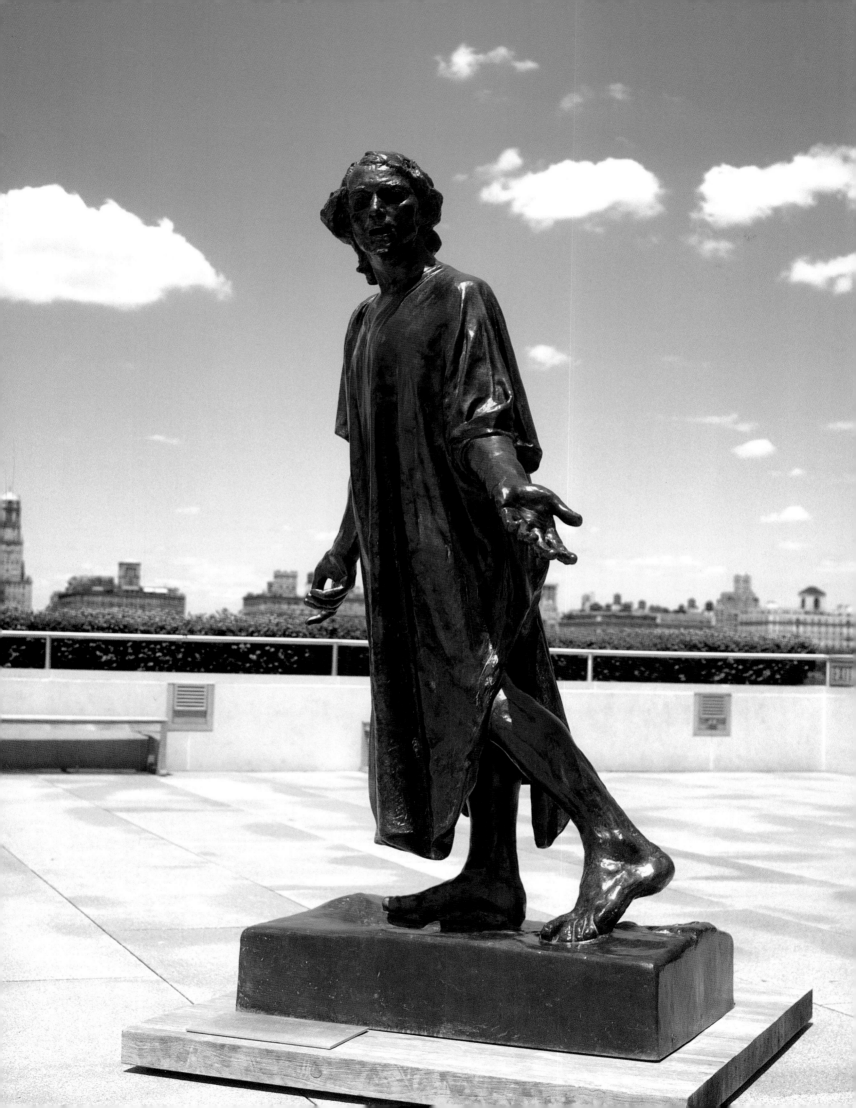

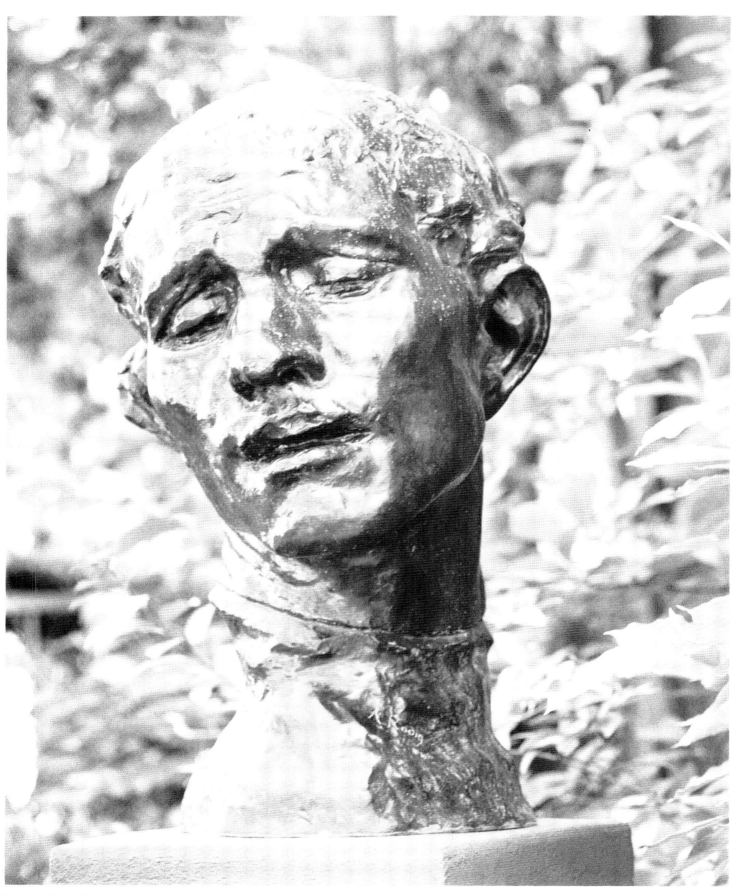

Monumental Head of
Pierre de Wiessant, c. 1900
Bronze, 28 1/2 x 19 3/4 x 21 in.
(72.5 x 50.2 x 53.4 cm)

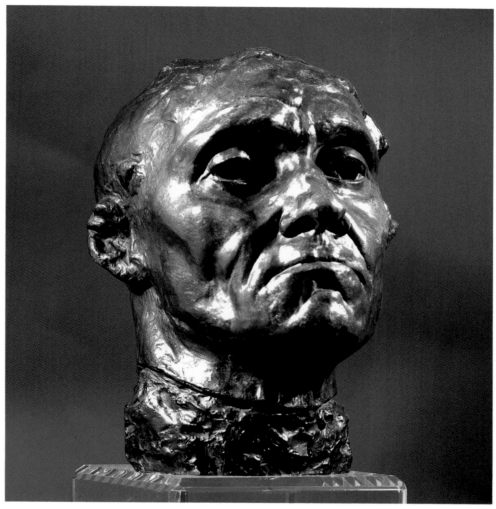

Monumental Head of
Jean d'Aire, c. 1900
Bronze, 26 3/4 x 19 7/8 x 22 1/2 in.
(68 x 50.5 x 57.2 cm)

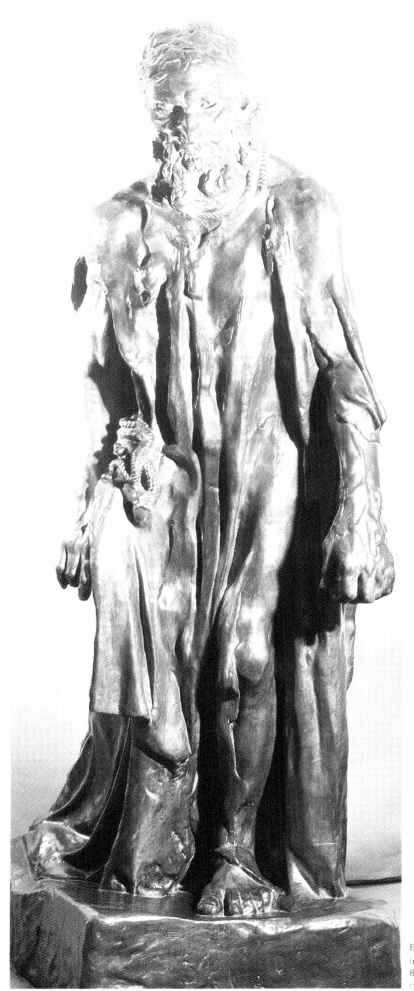

Eustache de Saint-Pierre
(grand model), 1885
Bronze, 85 x 30 x 48 in.
(216 x 76.2 x 122 cm)

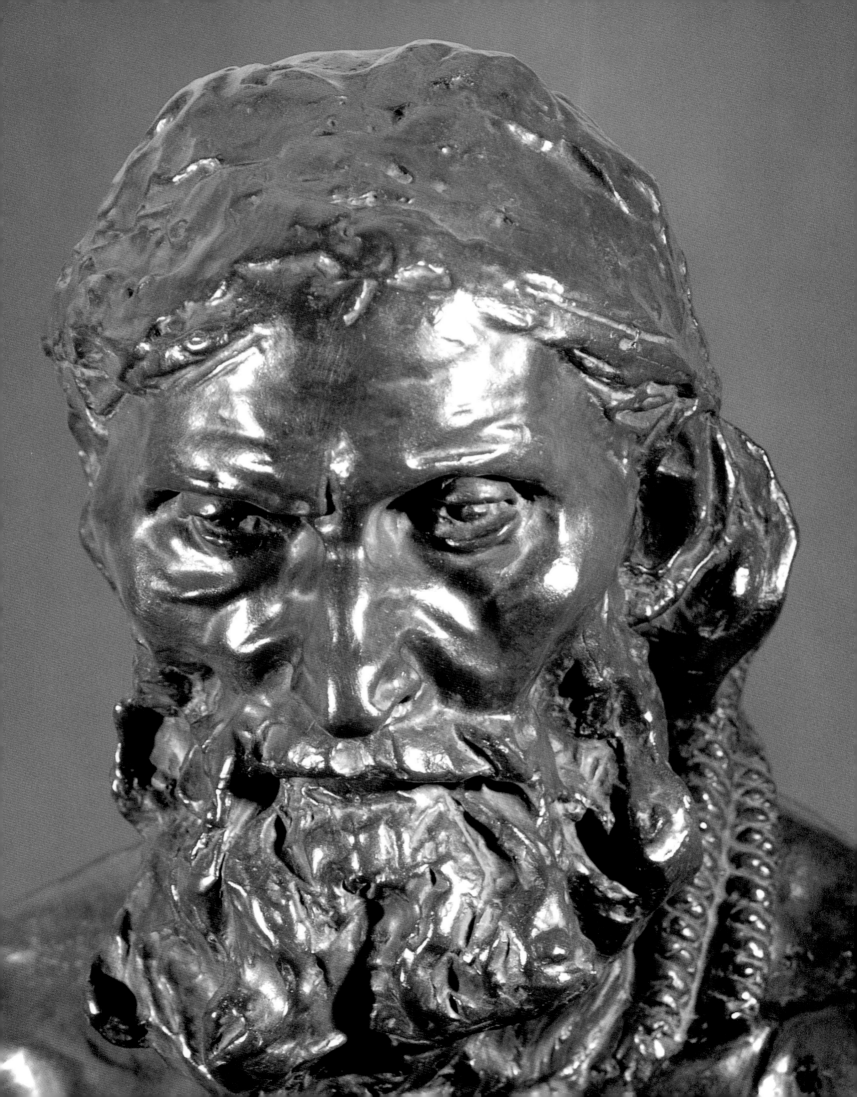

Rodin: Balzac

The *Monument to Balzac* is arguably Rodin's greatest work, but in his lifetime it was regarded as his worst public failure.[78] He considered the *Balzac* "the logical outcome of my whole life, the very pivot of my aesthetics."[79] Never before had he identified so completely with a subject. He received the commission to create the monument for the Société des Gens de Lettres in Paris in July 1891. He devoted much of the next six years to the project, ultimately making about fifty studies of the head and figure.[80]

The history of the monument falls into two phases. From 1891 to 1895 he pursued a scrupulous analysis of Balzac's life, works, and physical appearance. He read all of his books and collected portraits of him. He visited Balzac's native Touraine, where he ordered a suit made by his tailor, and sketched local citizens whom he thought resembled the novelist. This resulted in a series of busts and figural studies in which Rodin portrayed him in different moods and ages. He depicted him nude, in a frock coat, and in the monk's robe Balzac liked to wear when he wrote. During the final stage of production, from 1896 to 1898, Rodin departed from this naturalistic approach and sought instead to make a symbolic portrait of Balzac as a creative genius. He explained his unusual conception to Paul Gsell in 1907: "I had to show a Balzac in his study, breathless, hair in disorder, eyes lost in a dream, a genius who in his little room reconstructs piece by piece all of society in order to bring it into tumultuous life before his contemporaries and generations to come; Balzac truly heroic who does not stop to rest for a moment, who makes night into day."[81]

In April 1897 the maquette was completed and ready for enlargement. Rodin exhibited the full-scale plaster at the Salon in May 1898, where it stood, a "towering phantom," seventeen feet above the crowds.[82] Not surprisingly, Rodin's esoteric, innovative interpretation was largely misunderstood. In 1898 the Société des Gens de Lettres claimed the sculpture to be unsuitable and rejected it. Rodin removed the model of his *Balzac* to Meudon. It was not cast into bronze until 1930.

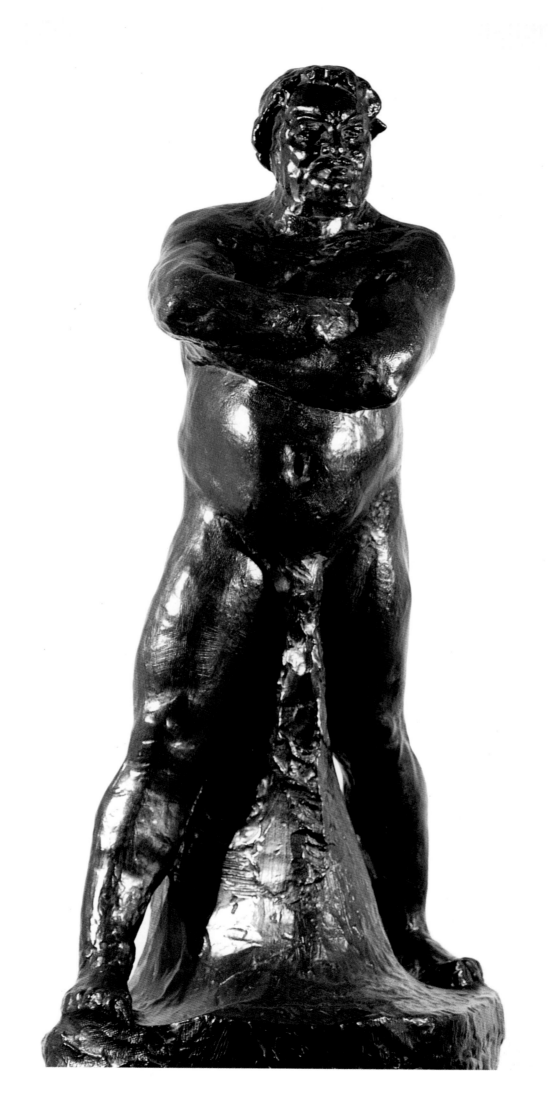

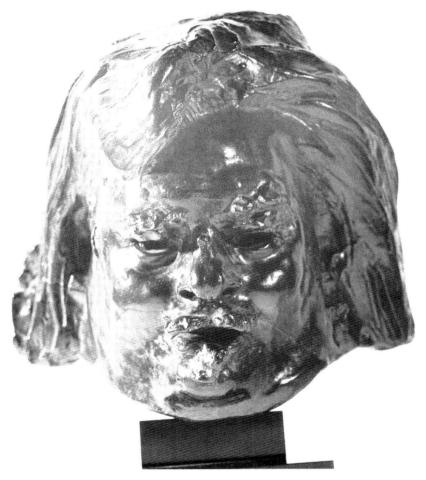

Head of Balzac, 1892-93
Bronze, 10 x 10 1/4 x 9 7/8 in.
(25.4 x 26 x 25.1 cm)

Balzac in a Robe, 1987
Bronze, 44 x 19 x 17 in.
(112 x 48.3 x 43.2 cm)

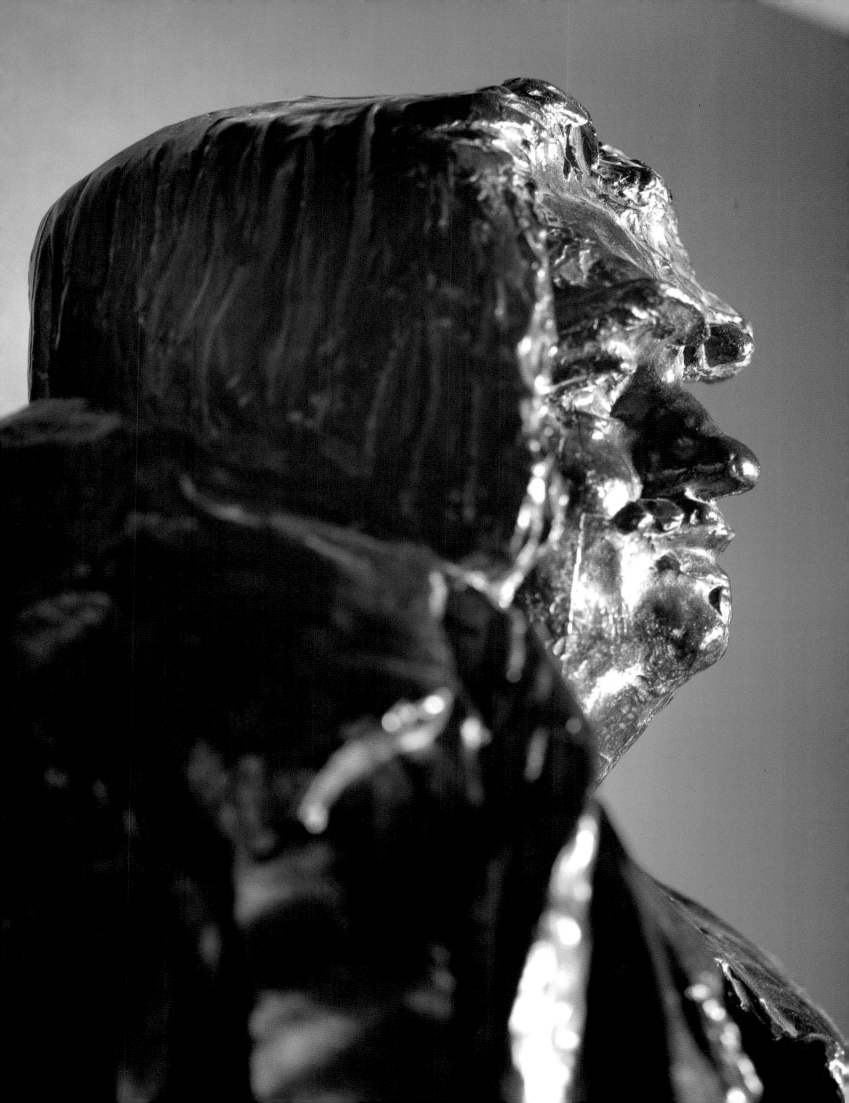

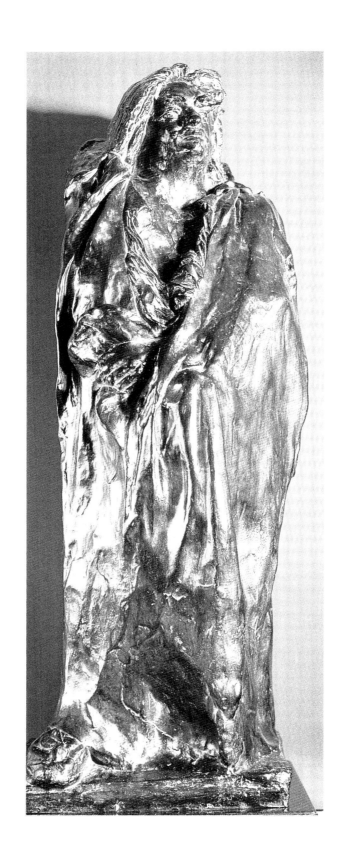

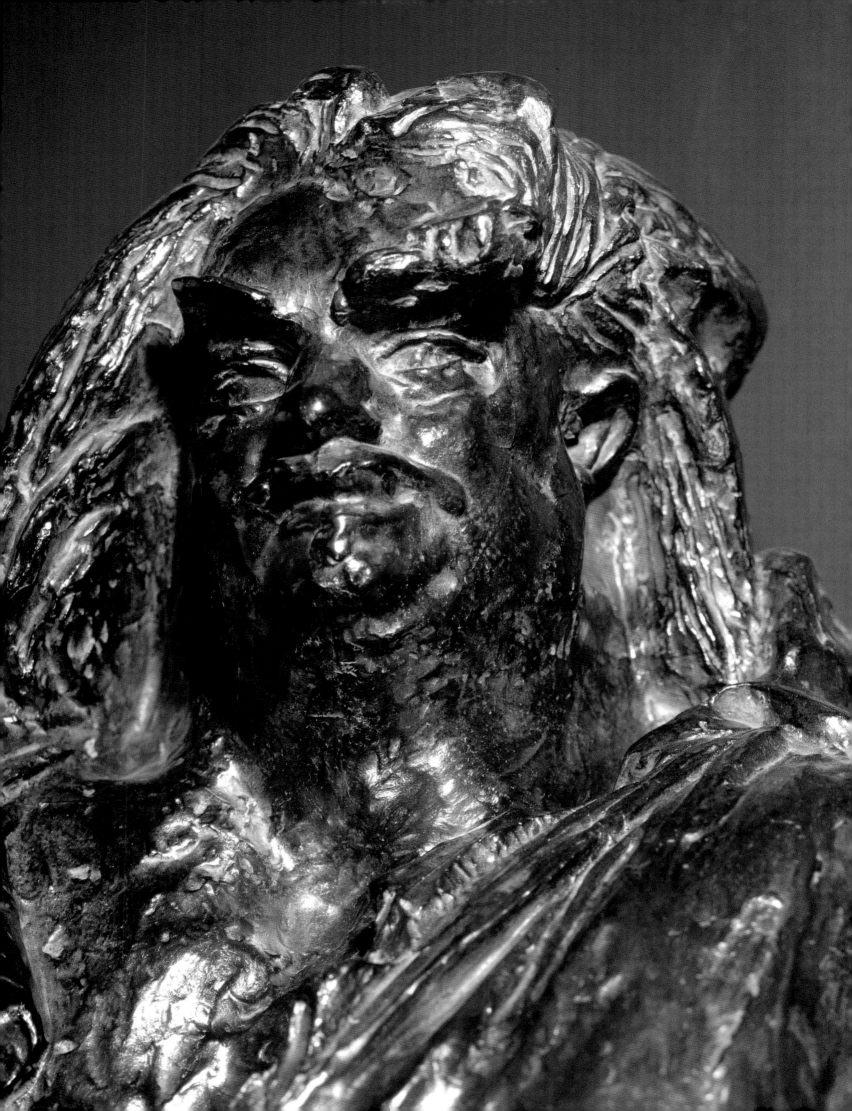

Rodin: Hand of Rodin with a Torso, 1917

Hand of Rodin with a Torso, 1917
Bronze, 6 1/8 x 8 3/4 x 4 1/8 in.
(15.5 x 22.2 x 10.5 cm)

In November 1917, three weeks before Rodin died, Paul Cruet, one of his assistants, made a life cast of his right hand.[83] It is not known if Rodin or someone else decided to place in it a small female torso, which may derive from *The Gates of Hell.* The assemblage relates to the *Hand of the Devil Holding Woman* (1903), and to the far more evocative *Hand of God* (1897). Like the latter sculpture, this work provides a statement of the sculptor's art, although in a more straightforward manner. Elsen considered the assemblage to be "an offering to artists that followed...about the importance of the partial figure as a carrier of the beauty of metier."[84]

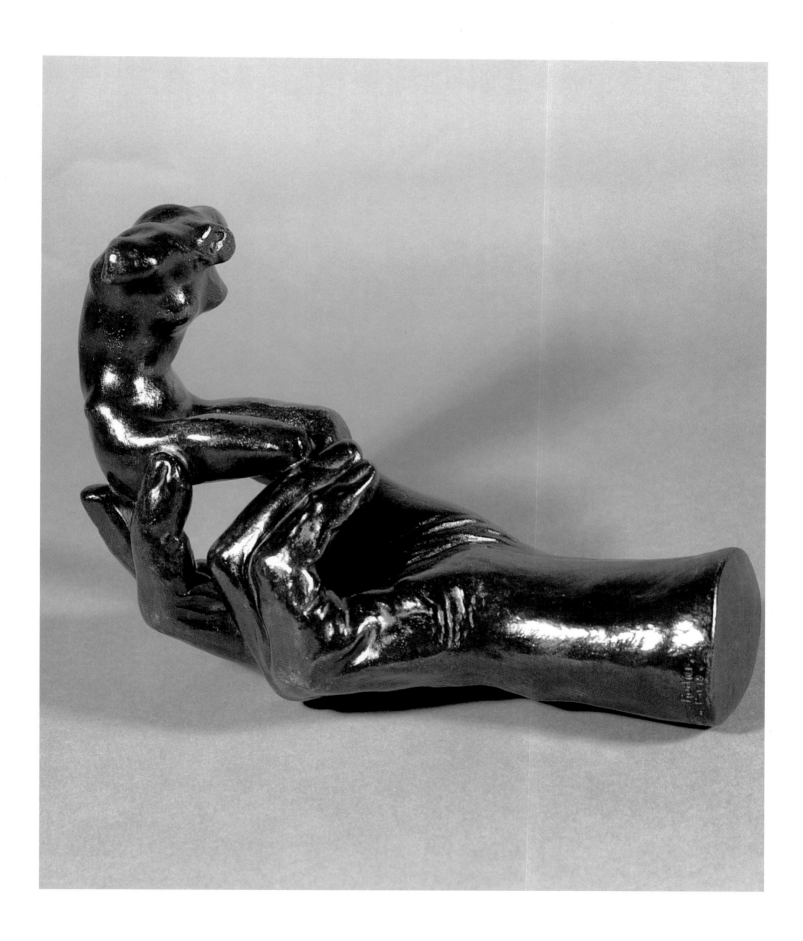

Emile-Antoine Bourdelle (French, 1861-1929)

Bourdelle is the best-known sculptor to have emerged from Rodin's studio, where he worked as a *practicien* from 1893 to 1906. Although he was influenced by Rodin, many of his sculptures after 1900 became more classicizing in spirit. In general, Bourdelle sought to achieve a highly disciplined aesthetic, less grounded in naturalistic observation. His most famous work, *Herakles the Archer,* epitomizes his mature style and represents his homage to archaic Greek sculpture. A few critics noted more than a passing resemblance to the *Herakles Archer* fragment from the east pediment of the Temple at Aegina, preserved in the Glyptothek, Munich, which Bourdelle could have known through plaster casts.[85]

The sculpture portrays the sixth of Herakles's labors, the shooting of the cannibal birds of Lake Stymphalis. The athletic male figure balances his weight against a large rock to draw his bow. Bourdelle's model was Doyen Parigot, an art-loving commander of the Cuirassiers who volunteered to pose for him.[86] The dynamic stance displays the officer's taut, developed muscles. Bourdelle decided to gild the completed eight-foot-high figure when it was exhibited in a dark corner at the Salon of 1910. Despite its poor location, the sculpture caused a sensation and established Bourdelle's reputation.

Herakles the Archer, 1909
Bronze, 21 1/2 x 23 1/2 x 11 in.
(54.5 x 59.7 x 28 cm)

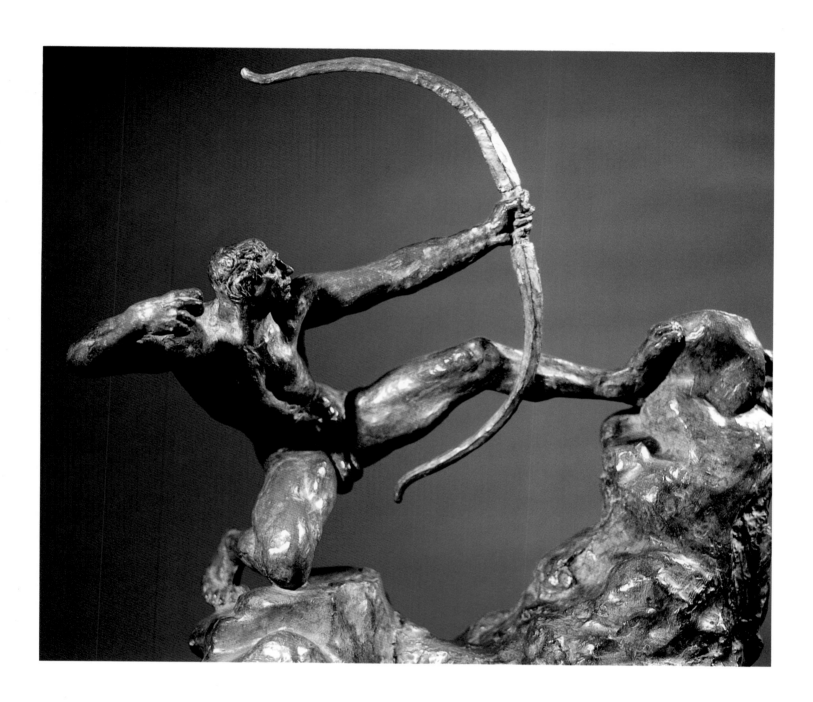

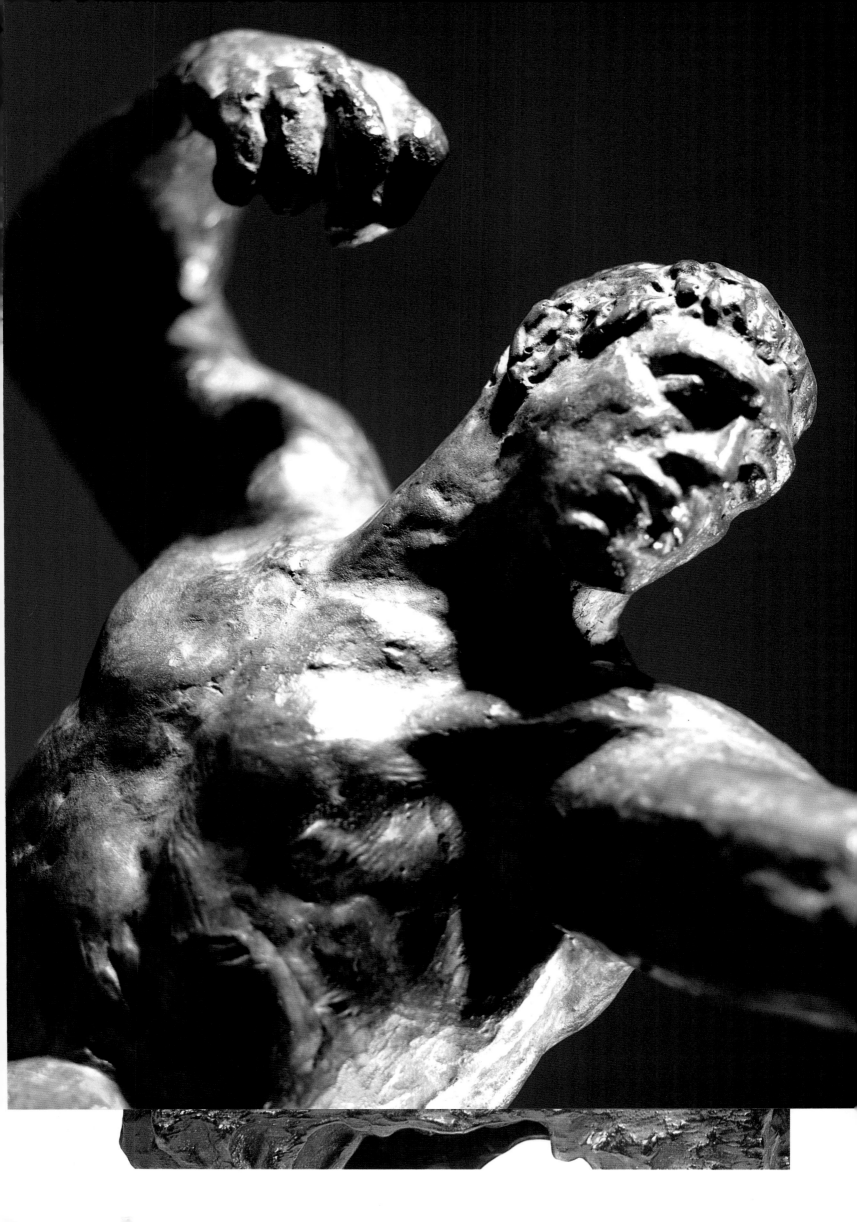

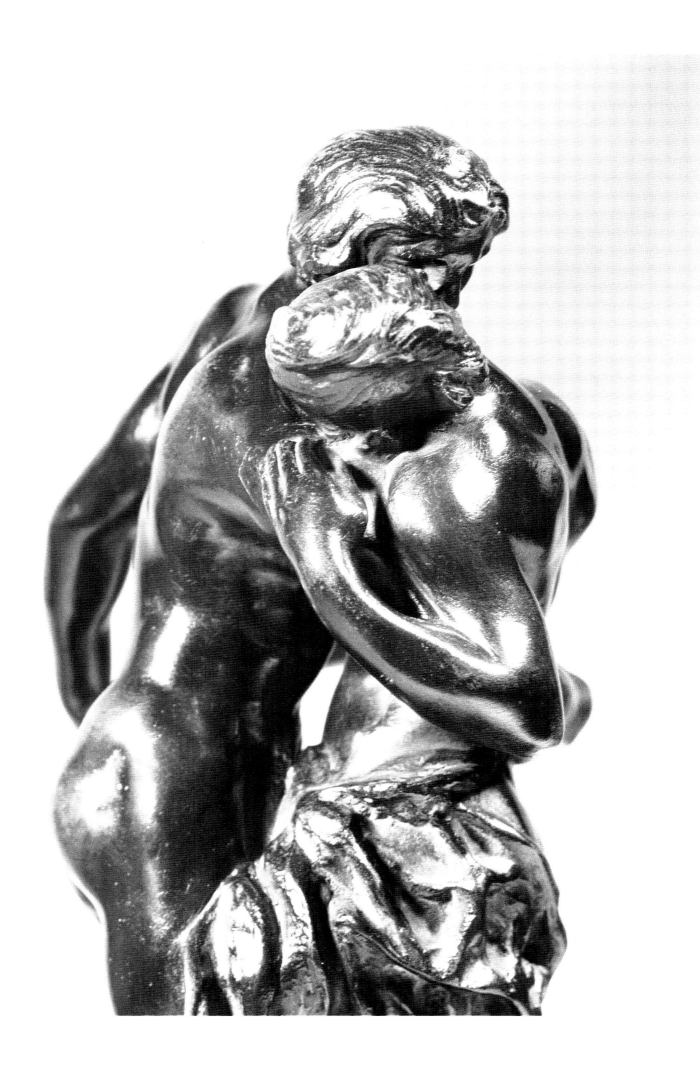

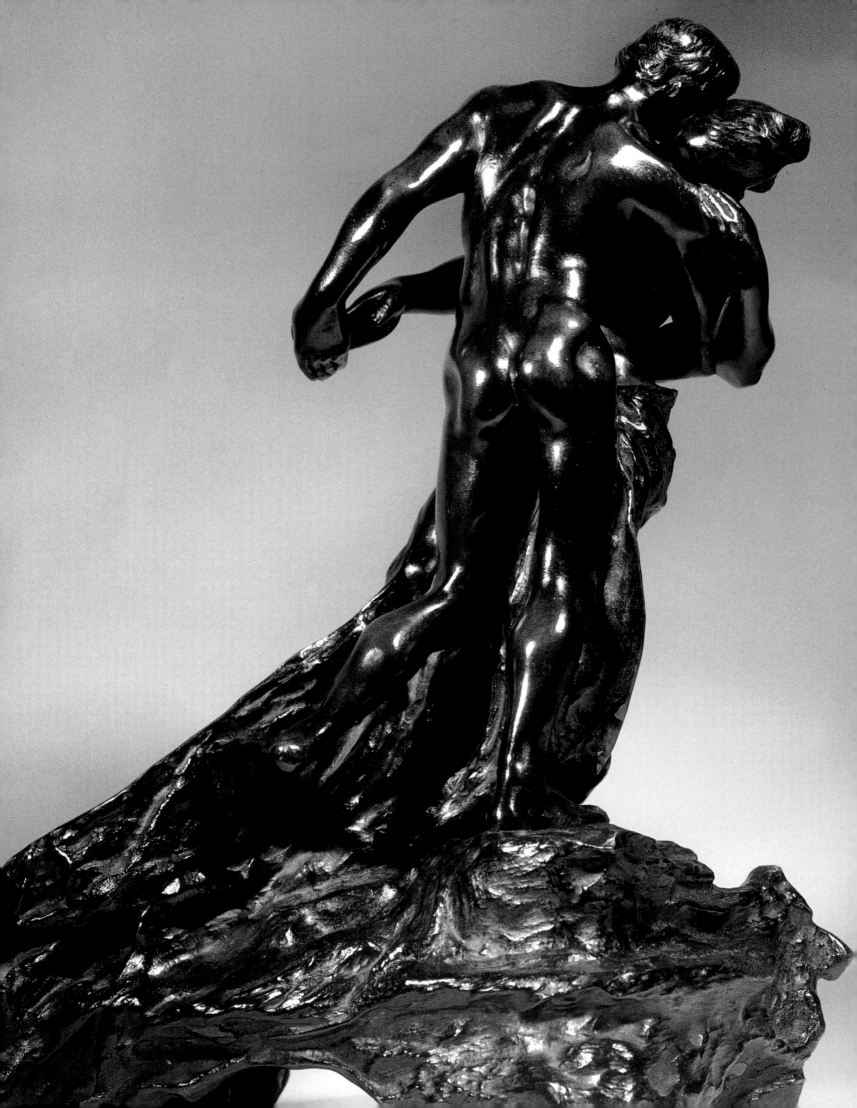

Jules Dalou (French, 1838-1902)

A contemporary of Rodin, Jules Dalou achieved great fame for the public monuments he created during the late nineteenth century. Several of these works reflect his republican, utopian beliefs. Nowhere are his political and artistic ideals better expressed than in his masterpiece *The Triumph of the Republic*. In 1879 he entered a competition for a monument to the Republic in the place de Château d'Eau (now place de la République) sponsored by the city of Paris.[73] Léopold Morice won the commission, but Dalou's design for a colossal, neobaroque allegorical group was so impressive that he was awarded a commission for the place de la Nation. The project

would occupy him for the next twenty years. Unveiled in 1899, the eleven-meter-high bronze monument depicts a female personification of the Republic riding in a lion-drawn chariot, surrounded by figures of Liberty, Labor, Justice, and Abundance.

The robust vitality of Dalou's female personifications particularly appealed to critics and connoisseurs. They reminded Gustave Geffroy of Veronese, and since then, others have compared the ensemble to Rubens.[74] The silver-patinated bronze torso in the Cantor Collection represents a study for the figure of Abundance, which, in the monument, is shown throwing flowers toward the populace. This torso and the nude study for the monument were edited independently in bronze reductions. Dalou's biographer Maurice Dreyfous mentioned that posthumous casts of the *Torso of Abundance* rivaled reproductions of antique fragments in popularity.[75]

Jules Dalou (1838-1902)
Torso of Abundance
Bronze, 21 x 9 x 7 3/4 in.
(53.4 x 22.9 x 19.7 cm)

The Cantor bronze was produced through the lost wax method by the Susse Frères Foundry. A plaster cast of the torso, approximately the same size as this bronze, is preserved in the Musée d'Orsay in Paris.[76] Mr. Cantor has presented another cast of this torso as a gift to the Los Angeles County Museum of Art.

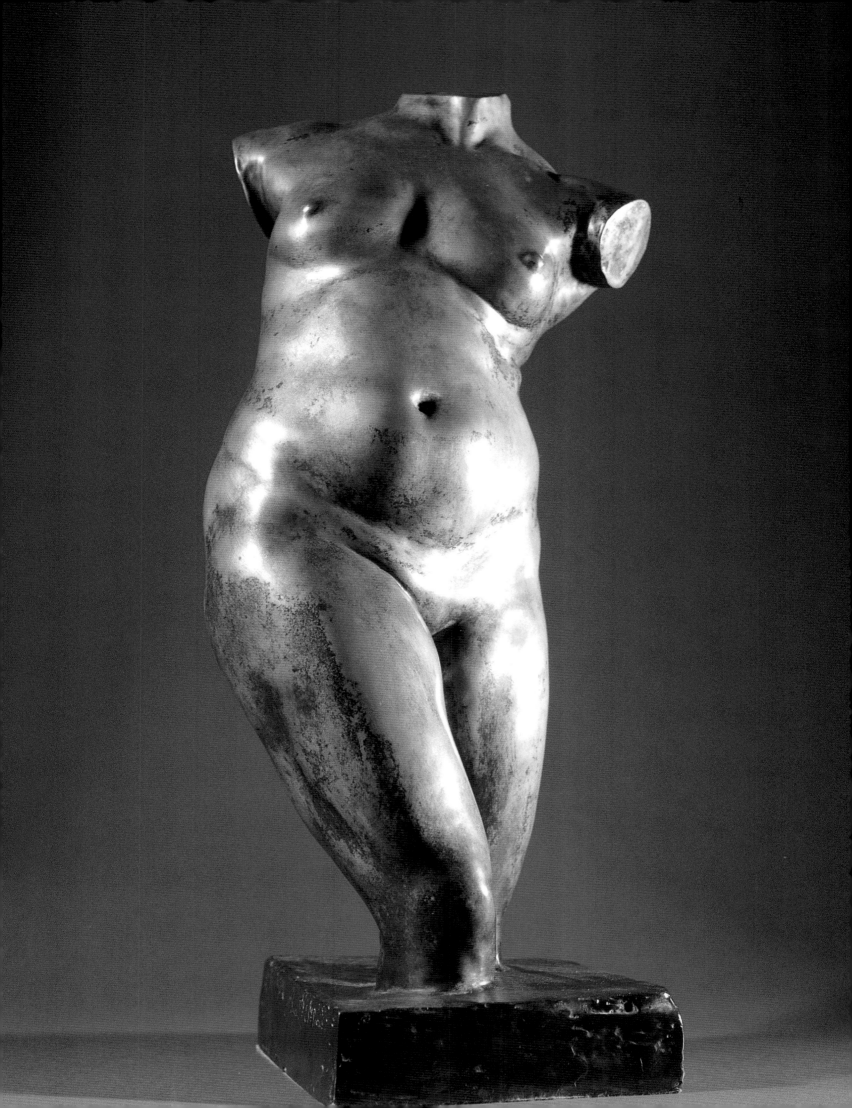

Georg Kolbe (German, 1877-1947)

At the age of fifty Georg Kolbe was widely regarded as the greatest living German sculptor. By 1930 he had produced fifteen public monuments. He was represented in thirty-five museums, and in private collections from Hollywood to Moscow.[97] One of his early works, the *Seated Girl,* modeled in 1907, already displays the quiet, contemplative quality that would distinguish his mature sculpture.

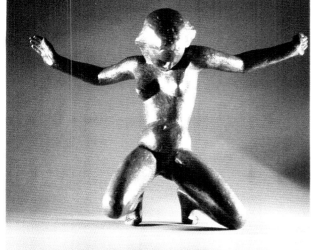

A decade later the soft, undulating forms of his early figures become severe and angular. These expressionistic tendencies are apparent in his famous *Assumption* and *Lament,* both dated 1921.

The figures he made later in the 1920s tend to be more self-contained and serene, such as *Large Kneeling Woman* (1924), *Seated Girl* (1926), and *Large Seated Woman* (1929). The bronze surfaces are more heavily modeled and sensuous in contrast to the smooth planes of his earlier sculptures. This tendency is accentuated in his late works such as *Falling Woman.*

Lament, 1921
Bronze, 15 1/2 x 21 1/2 x 10 in.
(39.4 x 54.6 x 25.4 cm)

Mr. Cantor discovered Kolbe's sculptures at the Nationalgalerie in East Berlin about thirty years ago. Impressed by the sculptor's balance between the real and ideal, he acquired casts of every major work, with the assistance of Kolbe's granddaughter Maria von Tiesenhausen, then the director of the Kolbe Museum in Berlin. His collection of Kolbe sculpture was organized into a traveling exhibition which opened at Cornell University in 1972.

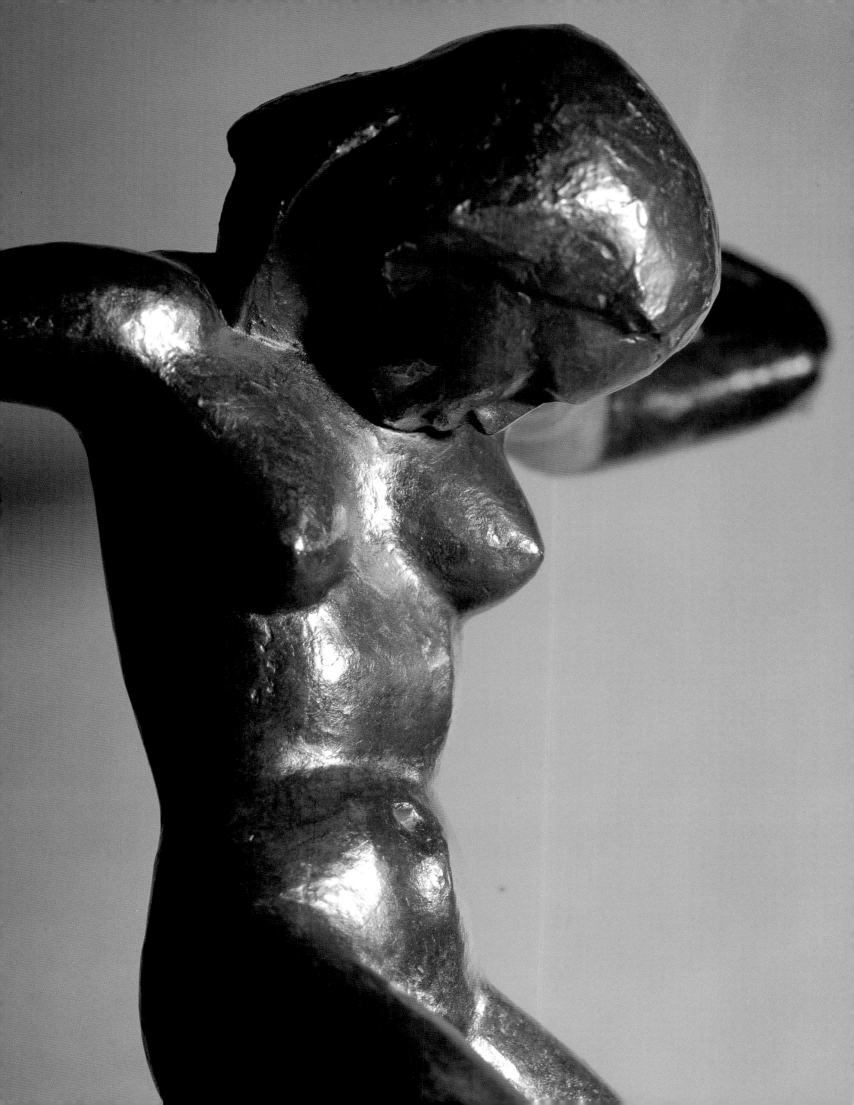

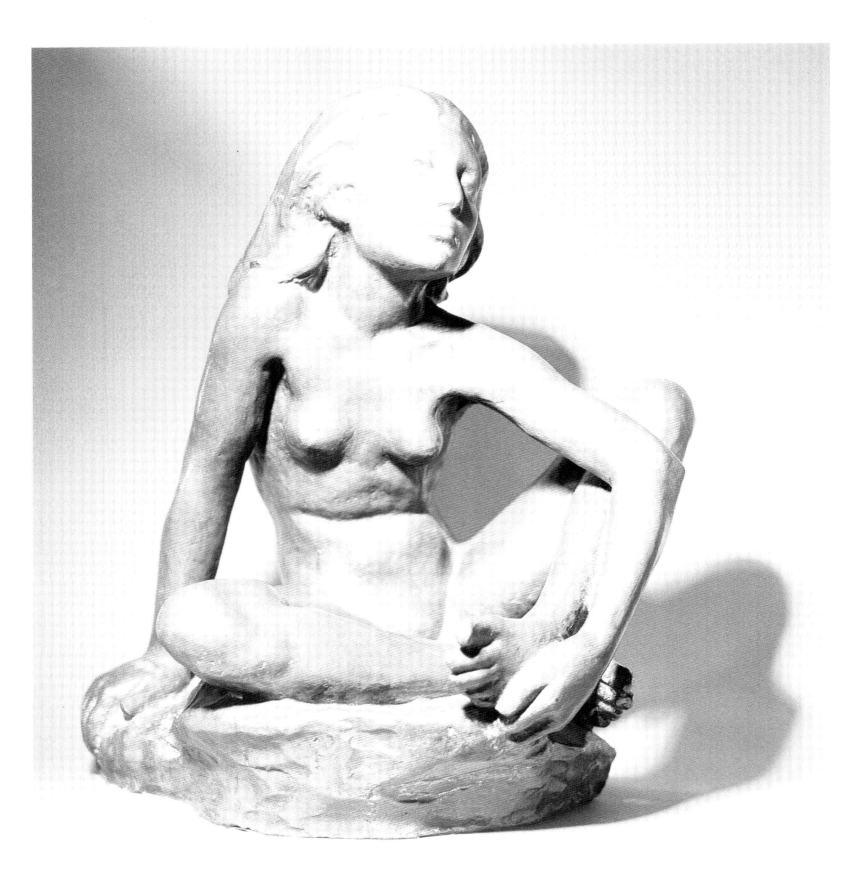

Seated Girl, 1907
Bronze, 17 1/4 x 12 x 11 in.
(45 x 30.5 x 28 cm)

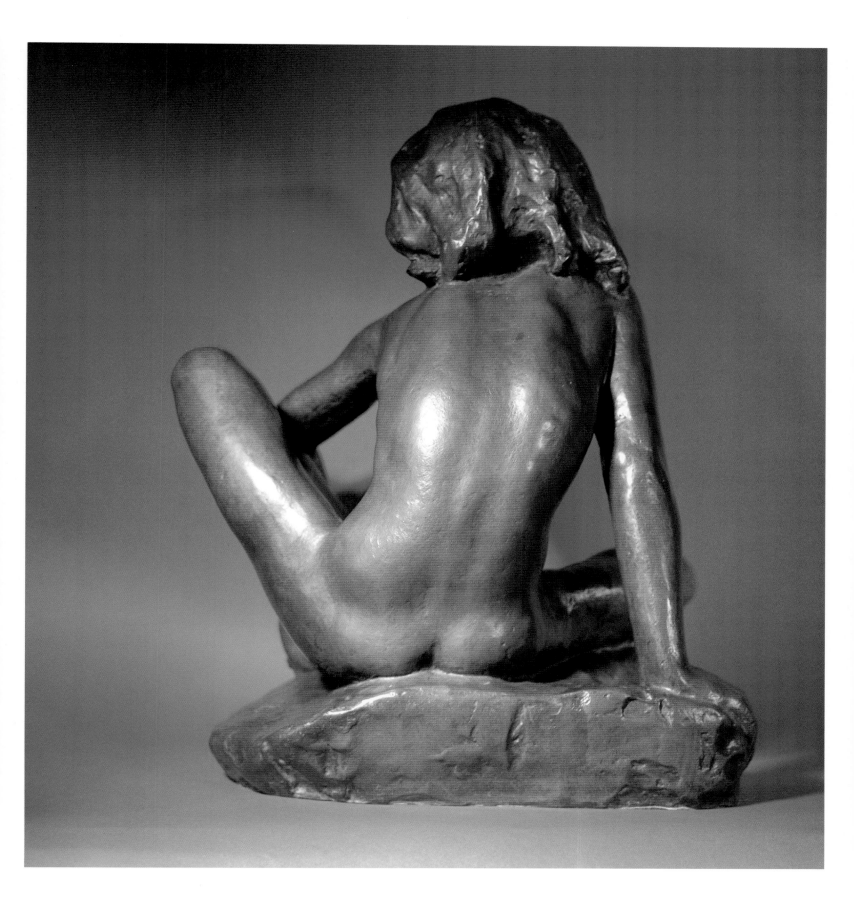

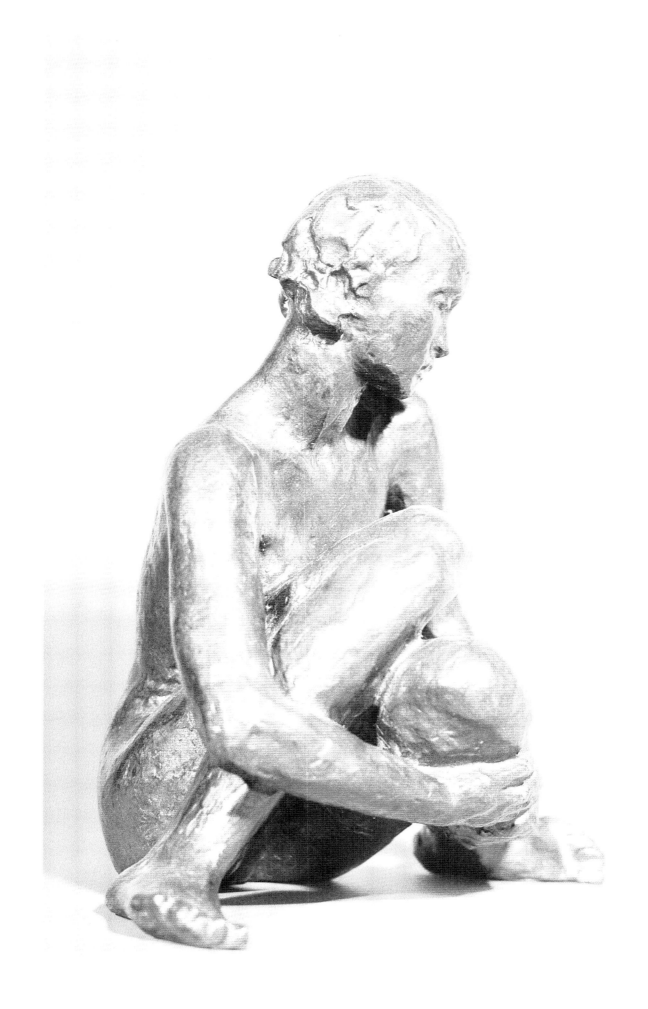

Seated Girl, 1926
Bronze.
11 1/4 x 10 1/4 x 7 1/4 in.
(28.5 x 26 x 18.4 cm)

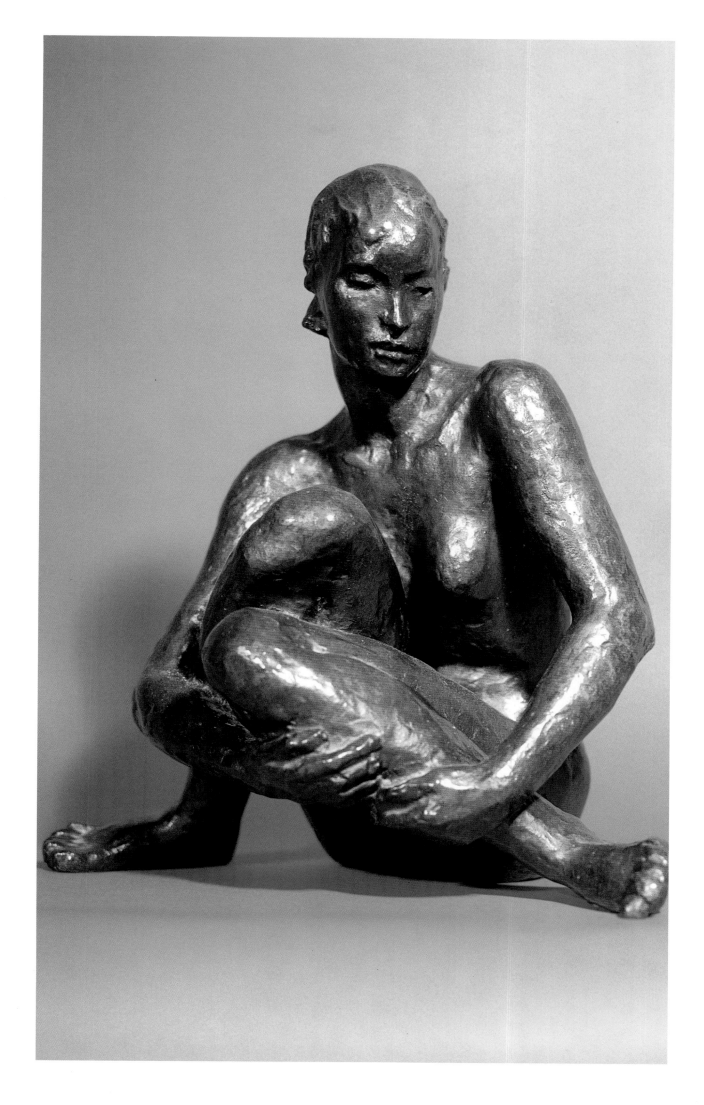

Falling Woman, 1938
Bronze, 15 1/4 x 18 x 11 7/8 in.
(38.8 x 45.7 x 29.8 cm)

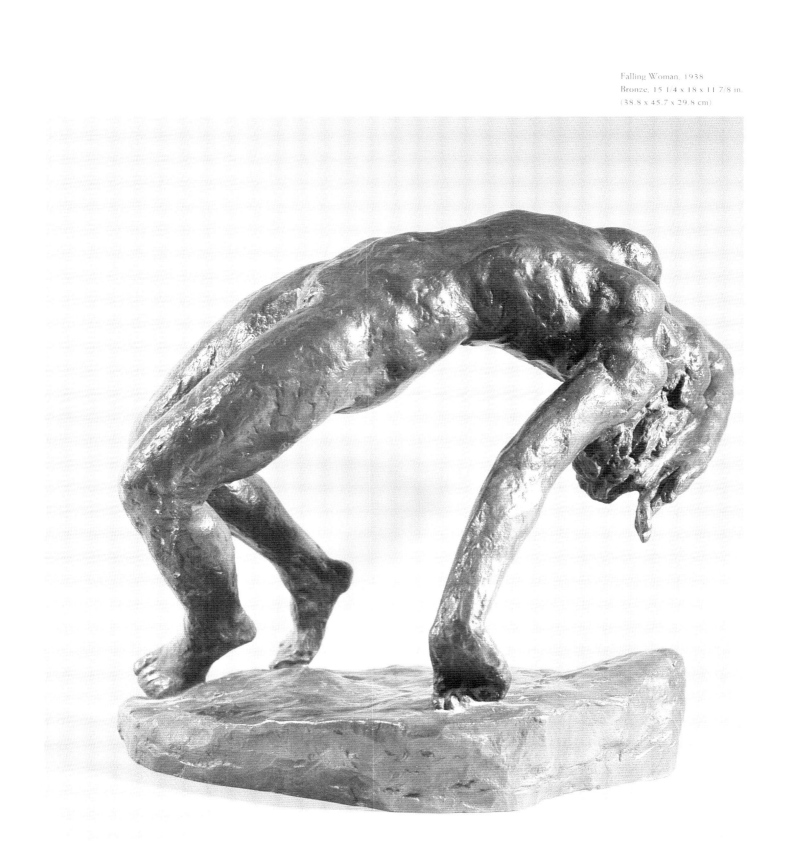

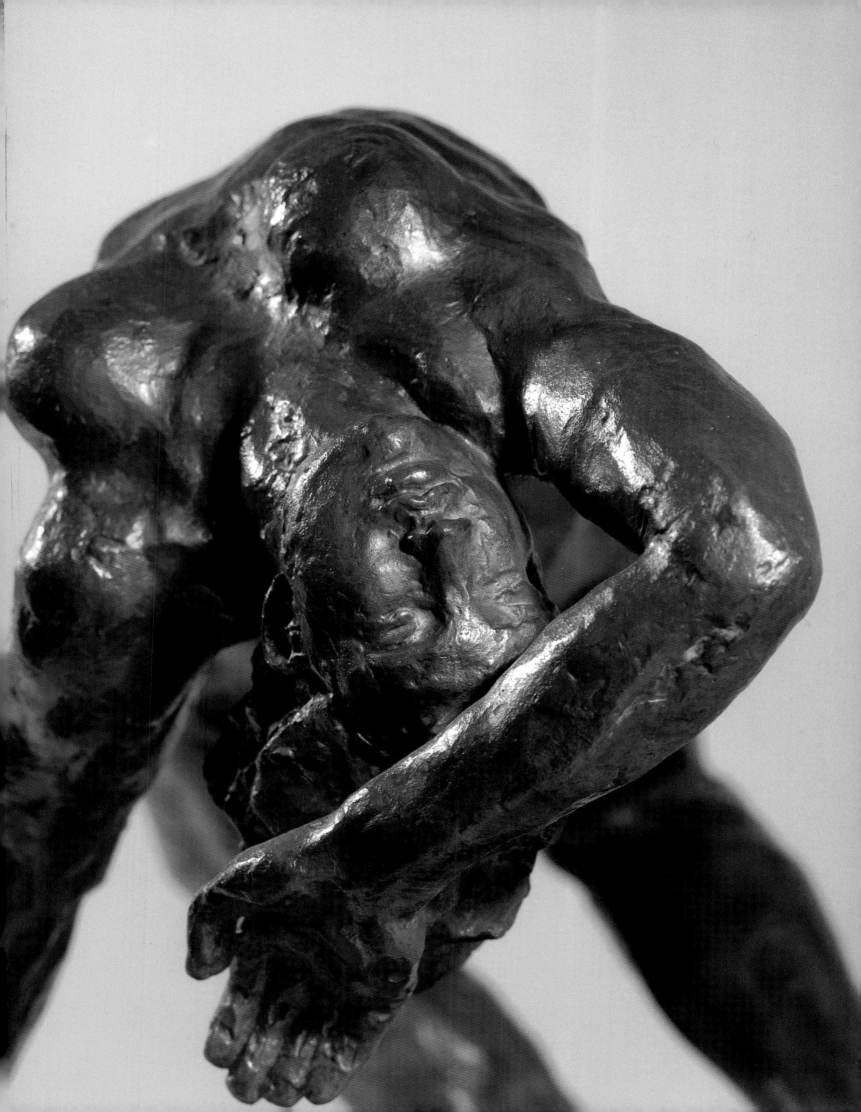

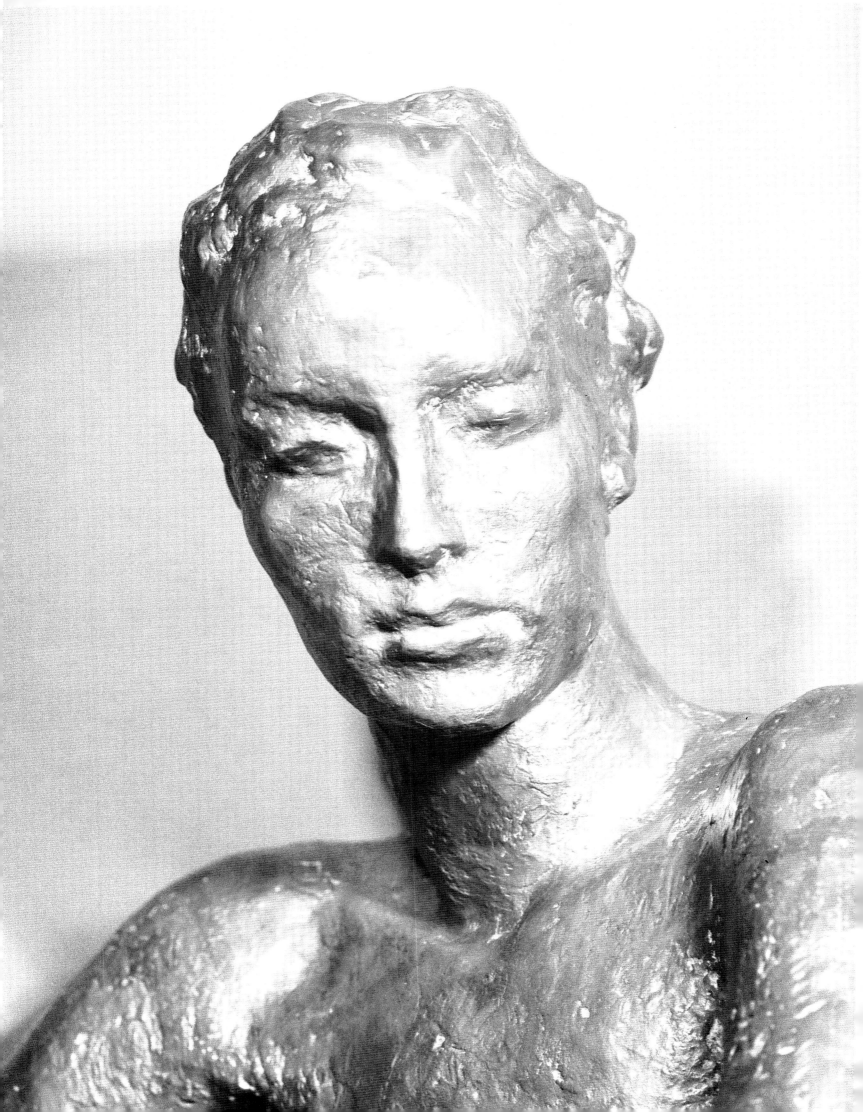

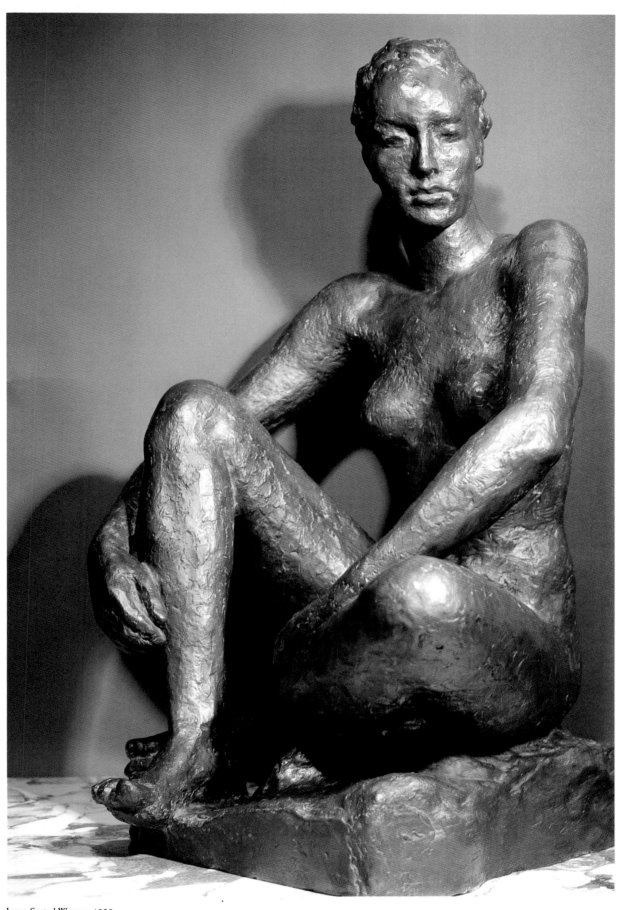

Large Seated Woman, 1929
Bronze, 38 3/4 x 24 1/2 x 24 in.
(98.5 x 62.3 x 61 cm)

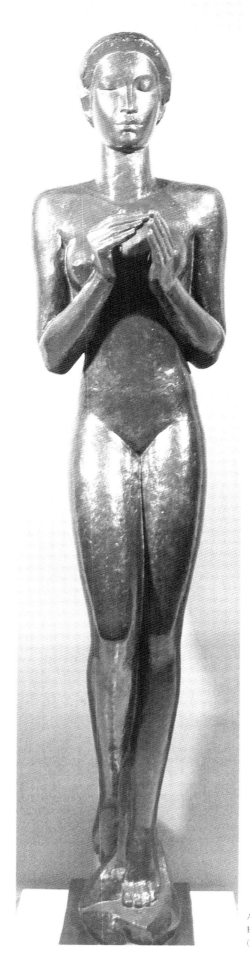

Assumption, 1921
Bronze, 77 x 15 1/2 x 19 1/2
(195.5 x 40.3 x 49.5 cm)

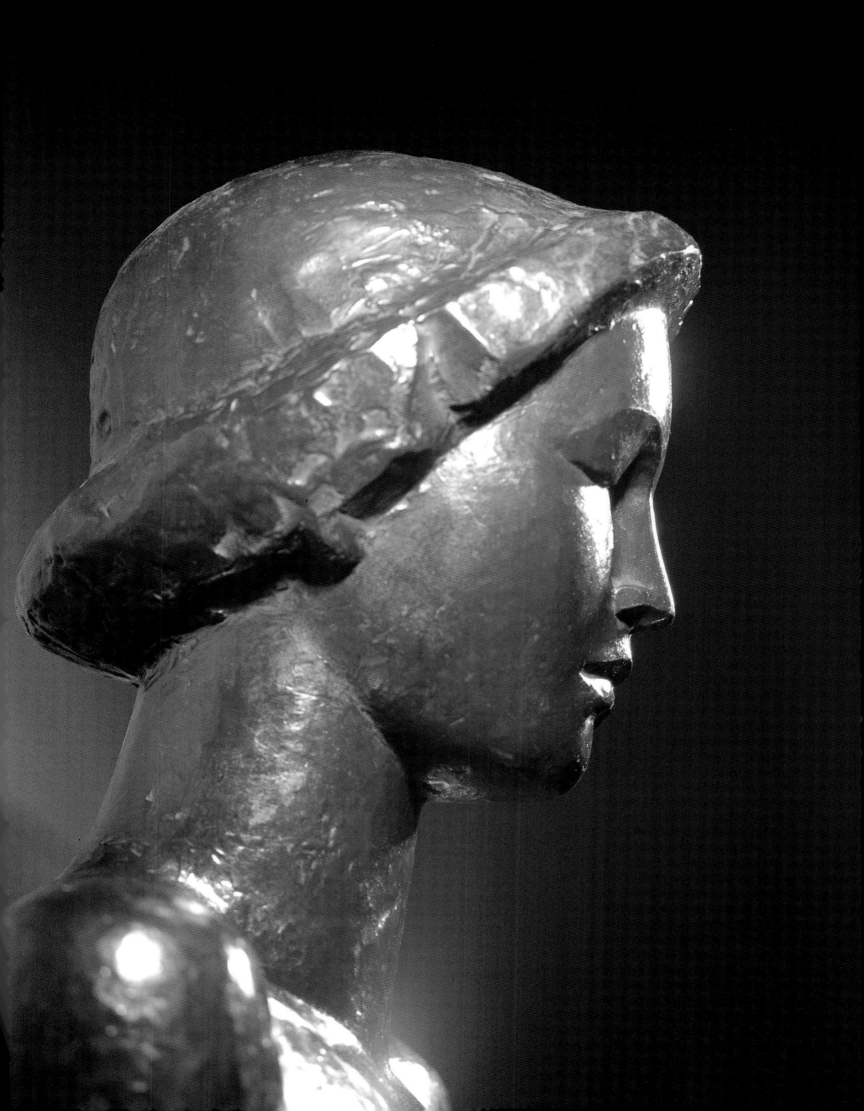

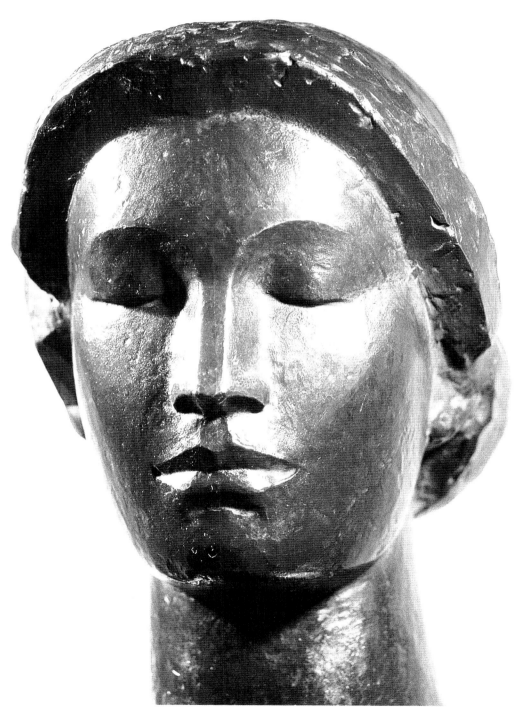

Assumption, 1921
Bronze, 77 x 15 1/2 x 19 1/2″
(195.5 x 40.3 x 49.5 cm)

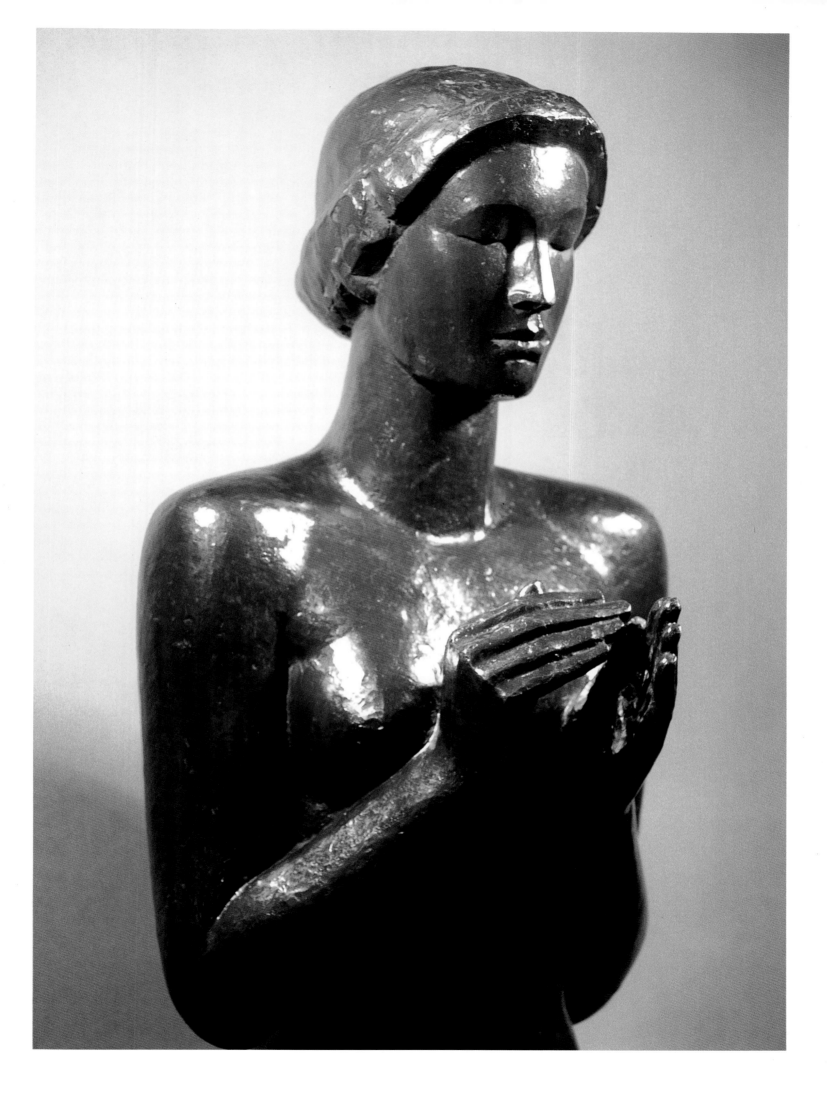

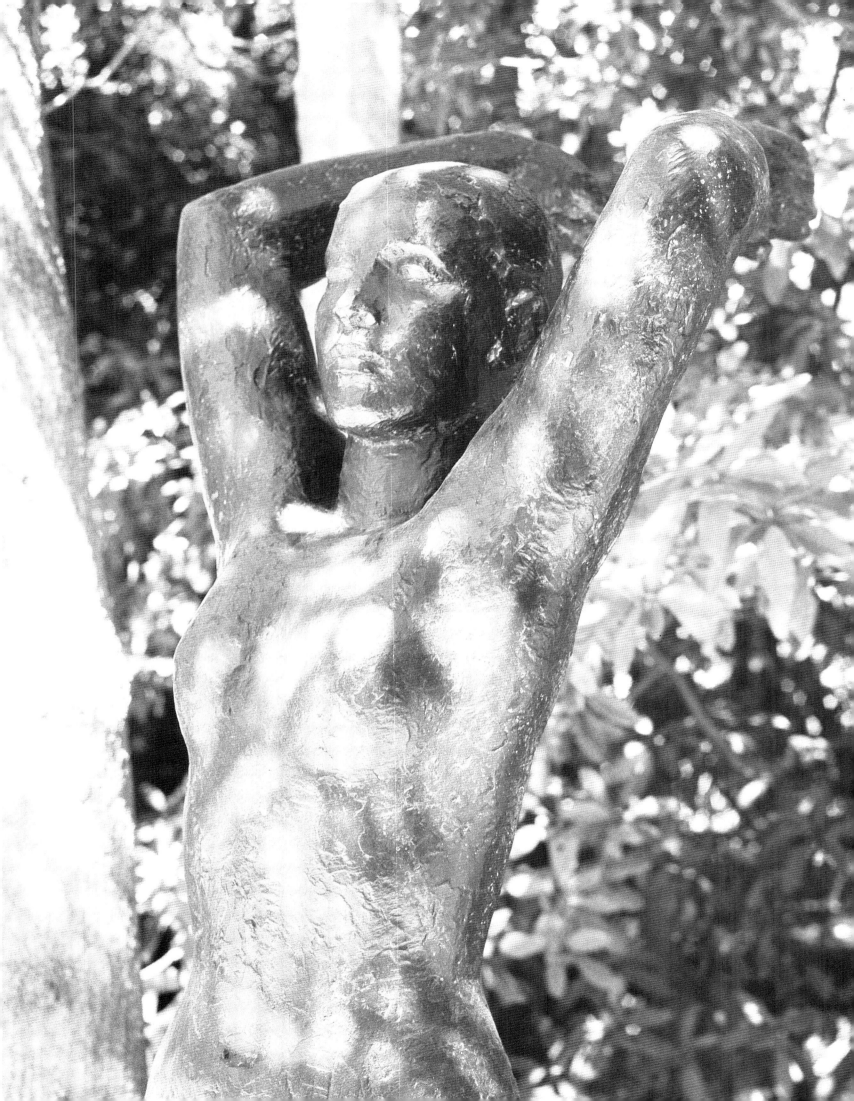

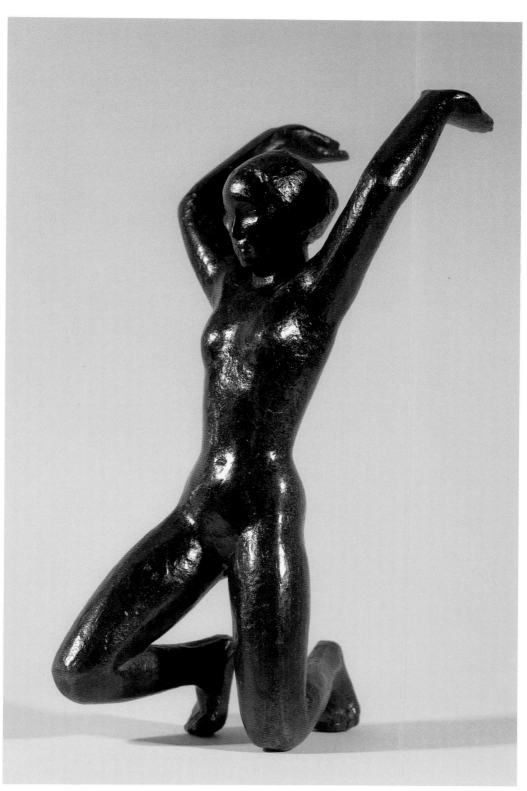

Large Kneeling Woman, 1924.
Bronze, 44 1/2 x 16 3/4 x 23 3/4 in.
(113 x 42.5 x 60.3 cm)

Gaston Lachaise (American, 1882-1935)

Classic Torso, 1928
Polished bronze, 11 x 7 x 3 in.
(28 x 17.8 x 7.6 cm.)

In 1906 Gaston Lachaise gave up a promising career in Paris to lead a new life in the United States with Isabel Dutaud Nagle, a Boston matron, who became his wife and muse. Her abundant proportions inspired his famous monumental, provocative figures that shocked the public during his lifetime. In Boston he supported himself as an assistant to the sculptor Henry Hudson Kitson, and in 1912 he began to work for Paul Manship in New York. Striking out on his own in 1921, Lachaise was relatively successful in obtaining commissions; however, he always had difficulties in supporting his wife's expensive tastes.

It was not until 1912 that he made his first life-size idealized portrait of Isabel, *The Standing Woman* (1912-27; Whitney Museum of American Art, New York). In this and in subsequent works, such as *Classic Torso*, Lachaise celebrated her as a primal life force akin to the prehistoric earth goddess.[98]

Following the example of Rodin and Brancusi, Lachaise experimented with the partial figure during the 1920s and 1930s.[99] *Classic Torso* is one of his first independent fragments. Lachaise animated the fragment by focusing on the implied movement of the missing limbs—the rising of the right arm, which emphasizes a stretch on the right side, and a compression on the left.[100] It remains one of the sculptor's most popular works.

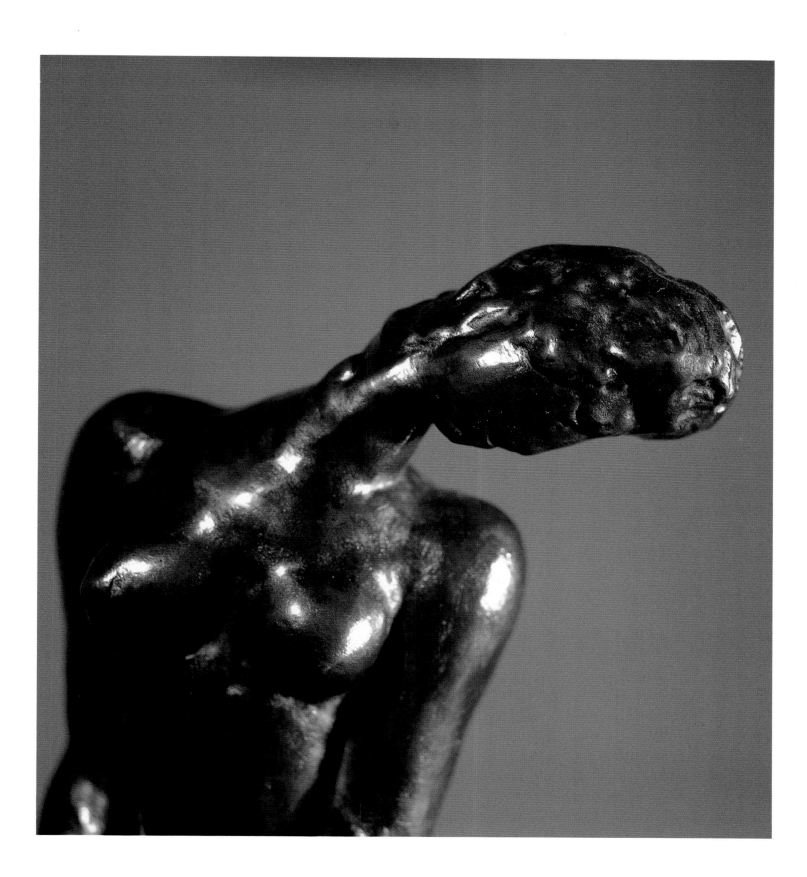

Giacomo Manzù

Born into a humble and pious family, Manzù made his artistic debut as a child with a voluptuous female clay figure, which earned him a spanking.[104] His artistic repertoire would embrace both sacred and profane subjects, although he is best known for his religious sculpture. It is remarkable that he was an atheist from the age of thirty-seven.

During a brief trip to Rome in January 1934, Manzù was overwhelmed by the sight of Pope Pius XI enthroned between two seated cardinals. The sculptor recalled: "The first time I saw the cardinals...I was impressed by their massiveness, rigid and immobile, yet vibrant with spirituality.... The impulse to create in sculpture my version of that inexpressible reality was irresistible."[105] Soon after that he made a drawing of a seated cardinal. In 1936 he produced his first sculpture of the subject, which he later destroyed. The earliest extant version dates from 1937-38 (Galleria Nazionale d'Arte Moderna, Rome). This bronze is modeled in more detail than later versions and expresses a contemplative if not sorrowful mood. Manzù soon eliminated the emotional dimension, and the theme would preoccupy him for decades primarily as an exploration of abstract, pyramidal form.

Seated Cardinal, 1972
Bronze, golden patination,
20 x 11 x 9 inches,
including self base
(50.8 x 28 x 23 cm)

The Cardinal series won him the grand prize at the Venice Biennale in 1948. By 1960 he had executed forty-nine different bronze *Cardinals* in various sizes. Although some observers believed that the sculptures glorified Catholicism, Manzù maintained that they represented "not the majesty of the church, but the majesty of form."[106] Through the years, the draped figures became increasingly simplified, hieratic, and monumental. The bronze *Cardinal* in the Cantor collection represents a later, highly refined variation of the theme. Manzù conceived the figure's head, miter, and cloak in strictly geometrical terms. The golden patination enhances the *Cardinal's* iconic presence. The sculptor continued to revise his images of these imposing, impassive prelates. An eight-foot-high *Cardinal*, executed in 1988, shows more detail in the modeling of the head, and depicts hands emerging from under the armorlike cloak.[107]

 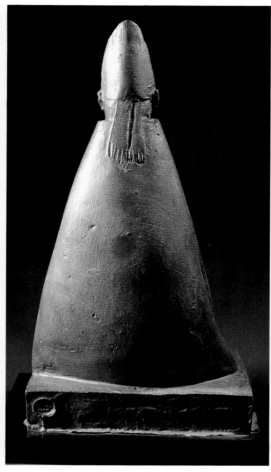 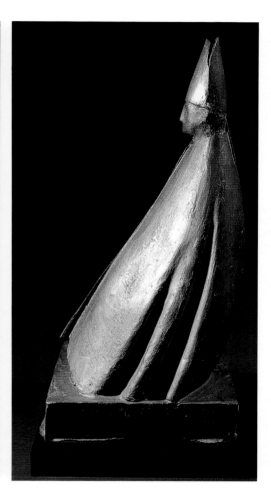

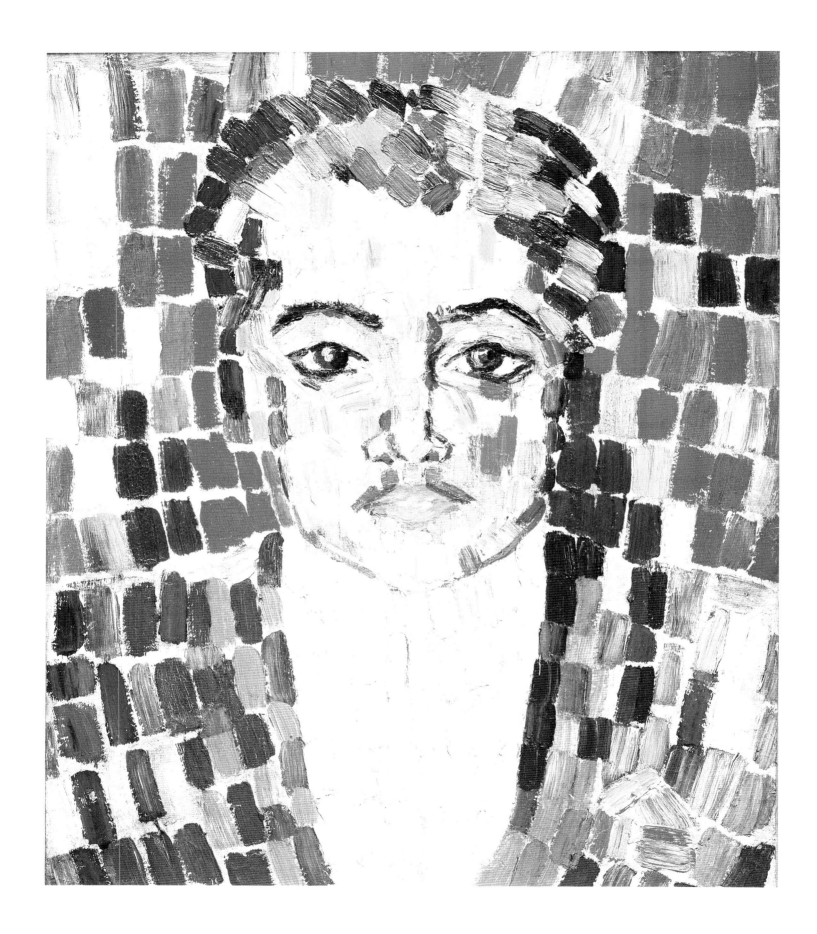

The Painting Collection

Paintings in the Cantor Collection

One of the defining characteristics of a "collection"—as opposed to a more or less random assemblage of works of art—is the sense we have of a controlling intelligence imposing connections upon them, a common denominator. There are several unifying themes in the Cantor Collection. It is only fair to begin by saying that the Cantors have only collected paintings that they like, rather than seeking to document some phase of the history of art or trying to give a complete or representative image of a school or a particular painter. Theirs are paintings that above all please the eye. More often than not they show the pleasant, even pleasurable, sides of life, reflecting its moments of serenity and happiness.

Given the well-known passion for Rodin, it is not surprising that the collection, since its beginnings in the 1950s, has been dominated by paintings from late-nineteenth- and early-twentieth-century Paris and its celebrated Belle Époque. If much of this painting—by artists of several nationalities who worked in Paris—represents the glamour of city life with elegant portraits and scenes of fashionable outings and entertainments, we are also reminded from time to time of the other side, of its anguish and sadness. Indeed, the harsh imagery of the Expressionists was frequently a reaction to turn-of-the-century gloss both in life and in art. In addition to contemporaneity, the main linking factor of the collection—in both painting and sculpture—is the employment of the human figure as a vehicle of expression, from the individual portrait to the interactive group. Landscape and still life, two of the most popular themes of nineteenth- and twentieth-century painting, are only marginally represented here.

The picture surface and the surface of things, the energy of the brush, freedom, and expressive painterliness—the paintings in the Cantor Collection always assert themselves as *painting*, a medium with qualities quite distinct from the monumental sculptural forms of the great Auguste Rodin, the artist with whom the Cantor name is most readily associated. Indeed, no painter was less sculptural and more painterly than one of Rodin's own favorite contemporaries, Eugène Carrière. This fascinating fin de siècle artist is well represented in the collection with two works: *The New Wrist-Watch*, a typically evocative work showing a dreamy young woman admiring her latest bauble, and *The Departure from the Theater*, whose wispy, ethereal image seems but breathed onto the canvas, giving the scene an almost spectral air.

The majority of the paintings in the Cantor Collection belong to the modern tradition of art initiated by the Impressionists. Each artist represented here speaks clearly of his or her own sensations, drawing inspiration from experience of the contemporary world. Nearly all these artists spent at least a part, if not all, of their careers in Paris, the supreme artistic center of Europe in the late nineteenth and early twentieth centuries. It was the Impressionists who laid the cornerstone of the modern movement in the 1870s by asserting personal rather than conventional artistic values. Their intention was to remain true to their individual responses to nature and to modern life around them, free from the constraints of the old academic system with its hierarchy of subject matter and highly finished manner of painting. Their loose, sketchy brushwork allowed maximum range and variety of effect to express their unique impressions of the world. The effects of this important liberation of artistic vision and technique soon spread throughout the western world, into neighboring Britain, Germany, Italy, and the Low Countries, and further afield to the United States and Russia, and the implications are still felt today.

Although Impressionist works by no means dominate the collection, that pioneering movement in its pure form is represented here in a typical work by Alfred Sisley, *The Chestnut Tree at Saint-Mammès*. Fresh, freely handled, full of bright sunlight and luminous shadows, it was painted at one of the artist's favorite locations. Another Impressionist was Armand Guillaumin, whose *Portrait of Dr. Martinez* (an early collector of Impressionist paintings) is set in the artist's studio; the walls are covered with some of the artist's own landscapes, typically executed in the open air.

Working outdoors was one of the tenets of Impressionist painting, but they also celebrated life in the city both indoors and out. The collection boasts a luscious, frankly erotic reclining *Nude on a Divan* by Gustave Caillebotte, another Impressionist painter who was also a wealthy collector and supported his colleagues in hard times by purchasing their works. The bulk of his impressive collection was bequeathed to the French nation in 1894, though not without controversy, since this was the first significant group of avant-garde pictures to enter the public domain.

Some of the consequences of the Impressionist liberation of brushwork can be seen in five charming works by Louis Hayet, who came under the influence of Geoges Seurat's Pointillism during the 1880s. They should be considered alongside Paul Signac's more assertive *Garden at Saint Tropez*, which captures the brilliant light of the south, in contrast to Hayet's dimmer interiors and misty Parisian light. All these works are typical of Pointillism: the brushmarks have been applied very visibly in a quasi-scientific manner that boldly asserts their presence as brushmarks while simultaneously creating an optical mix that at a distance suggests representational forms. Robert Delaunay's stunning portrait of fellow painter Jean Metzinger is somewhere between the Pointillism of Signac and the broader areas of color employed by the Fauve painters around 1905-6. Maurice de Vlaminck did not long remain a Fauve painter, but his later heavily impastoed snow scenes *Snow* and *Hôtel du Laboureur, Rueil-la-Gadelière* are still in a related painterly tradition, dramatized by strong contrasts and steep perspectives. The bold portrait of his friend *The Poet Fritz Vanderpyl*, however, with its strong use of unmodulated color, recalls Vlaminck's earlier Fauve period.

In his famous essay "The Painter of Modern Life," the poet and critic Charles Baudelaire defined the essential subject matter of the truly modern artist as the daily life he observed around him, especially the life of the city—its streets and parks, cafés and bars; its high life to low, from the fashionable salon to the seamstress's garret. This is another unifying theme of the Cantor Collection. What could be more Baudelairean than sometime Fauve painter Kees van Dongen's *Masked Ball at the Opéra*, where a pretty but anonymous reveler stops to adjust her garter and top-hatted dandies escort their colorful companions in the sulphurous glow of the lamplight? Equally indicative of this theme are Théophile-Alexandre Steinlen's lovers seen in dramatic, anguished perpective on a bleak park bench, recalling Henri de Toulouse-Lautrec and Edvard Munch; and Jean-Louis Forain's intimate *Women Dressing*, reminiscent of Edgar Degas's obsessional treatment of similar themes.

While the French Impressionists—unlike many of their fin de siècle followers in Paris—rarely painted a tragic or even a sad picture, the German Expressionists often did so. The links between the two movements are tenuous; to some extent the Teutonic artists were

reacting with their rather self-conscious northern angst to the sunny optimism of their French predecessors. But Expressionism, like many twentieth-century movements, probably could not have developed as it did without the earlier painters' liberating attitudes to subject matter and technique. Baudelaire, as the poet of urban life, would certainly have appreciated Emil Nolde's luridly lit watercolor *Three Figures* (surely observed in some melancholy bar), or Max Beckmann's unquiet revelers in the powerful *Femina Bar*, both images the very epitome of '30s Berlin. Beckmann's dramatic and almost brutal execution conveys the sadness and dissipation of his subjects' lives. The brighter side of German Expressionism is represented in Nolde's magnificent *Sunflower Garden*, where the gorgeous blooms jostling for space on the crowded canvas inevitably put us in mind of Vincent van Gogh's intense and celebrated paintings.

But it is images of leisure and entertainment that dominate this collection of paintings and drawings. A down-to-earth popular entertainment is captured by Mikhail Larionov in *The Soldiers' Cabaret*, where the working-class ambiance is captured with bold, expressive color and simplified forms that have a deliberately childlike effect. Larionov's admiration for the art of children and other forms of "primitive" art enabled him to resist the somewhat slick reputation that Impressionist-inspired painting had accumulated by the first decade of this century. At the higher end of the social scale, a world we encounter more often in the Cantor Collection, we can admire the brilliant, graphic sketchiness of Max Slevogt's *Supper on the Terrace*. It is easy to imagine one of the elegant ladies from a portrait pastel by society painter Giovanni Boldini or Paul-César-Francois Helleu—well represented in the Cantor Collection—strolling in to join the company for the liqueurs that seem to be served at Slevogt's table. Louis Corinth's *Portrait of Elly* (Eleonore von Wilke) and van Dongen's portrait of actor Jules Berry, although painted nearly forty years apart, could almost be pendants, not only because of their comparable scale and because the sitters are dressed for parties, but also because they are very much in the same rather glamorous version of the Impressionist tradition, happily adopted by these two north European painters. The two artists shared a love of color, painterly texture, and brash good-time display, an approach that can certainly be traced back to their training in Paris during the Belle Époque.

A more sedate but no less opulent scene is set for Julius Leblanc Stewart's *Five O'Clock Tea*, painted and exhibited in Paris by this American artist. A rival of John Singer Sargent and a friend of Jean Béraud and James Tissot, all of whom delighted in glamorous depictions of high society enjoying itself, Stewart represents with loving attention to detail the upper bourgeois life in all its luxury, with its flirtations and polite conversation.

The viewer may feel like a surreptitious observer at Stewart's tea party, while the feeling in Lucien Simon's impressive *Studio Party* is akin to a photographer setting off a flash a moment too soon. The mood and design of this complex work has a sophistication reminiscent of James Whistler and novelist Henry James: it is as much an aesthetic "pictorial effect" as a portrait group of the artist's family and friends. Richard Emil Miller, another American trained in Paris during the Belle Époque, depicts the typically secluded daily life of women at the turn of the century—taking *Afternoon Tea* or, in a brilliant display of brushwork, *Sewing by Lamplight*. In his *L'Aperitif*, a bar scene that ultimately derives its theme and design from Edouard Manet and the Impressionists, Miller's chief character is still isolated from the crowd as she looks wistfully or perhaps flirtatiously at the viewer.

How different is Oskar Kokoschka's vision of woman in his *Italian Peasant Woman*. Solitary at her work, the figure is executed with a loose, painterly freedom but a dignified air of self-possession and meditative mood. The weighty monumentality of the woman's form and the lively surface that plays across it and catches the light remind us of the sculpture of Rodin.

Rodin explored human experience and the human body, from the merest study of a hand, to portraits both elegant and penetrating, to the grander themes of destiny and human suffering. If the painters in this collection were less intellectually ambitious in their focus on contemporary life and avoided the grand literary, philosophical, and historical themes that constituted Rodin's grandest efforts, they were no less concerned than the great sculptor with the human clay. All these artists belong to the great tradition of figurative or representational art, avoiding abstraction and concentrating on humankind as the measure of all things.

Philip Conisbee
Curator of European Painting and Sculpture, Los Angeles County Museum of Art

Alfred Sisley (French, 1839-1899)

The Chestnut Tree at
Saint-Mammès, 1880
Oil on canvas,
19 5/8 x 25 7/8 in.
(50 x 65.8 cm)

Alfred Sisley's oeuvre has been characterized as "the most even-tempered and uneccentric" of the Impressionists.[1] Except for trips to England and Normandy, he preferred to paint in Fontainebleau and the Île-de-France. In 1880 he moved to Veneux-Nadon, near Moret-sur-Loring at the edge of the Fontainebleau Forest. He later recommended the town to Monet: "There is a market once a week, a pretty church and beautiful scenery round about. If you are thinking of moving, why not come and see?"[2] Monet did not join him, but Sisley remained in the region for the rest of his life. He painted this view of Saint-Mammès—located near Moret at the confluence of the Loring and Seine rivers—not long after he moved there. The painting was purchased by his patron, Paul Durand-Ruel, on September 15, 1880, and was bought by Robert Eisner in New York on March 5, 1942.[3]

Sisley painted over a hundred scenes of Saint-Mammès; in several of these he employed a similar composition of a receding road bordered on one side by houses and on the other by trees and a view of the river. Chestnut trees, such as the isolated one seen here, featured prominently in the town landscape, though in none of the other paintings is the tree so monumental and imposing. The large expanse of subtly rendered sky distinguishes many of Sisley's finest paintings; he was constantly preoccupied with capturing the effects of light and changing weather. The meticulous, intricate brushwork is typical of Sisley around 1880, but unlike Monet, his forms always remained distinct masses.

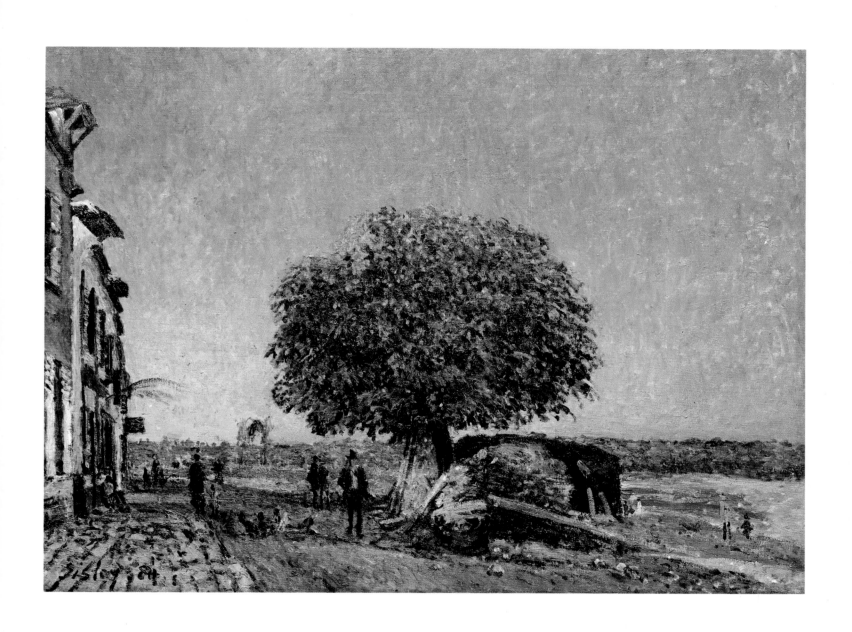

Roger de la Fresnaye (French, 1885-1925)

Roger de la Fresnaye entered the Acadèmie Julian in 1904 and was admitted to the École des Beaux-Arts a year later. In 1908 he discovered the paintings of Maurice Denis (1870-1943) and sought instruction from him at the Académie Ranson. Later that year la Fresnaye spent a few productive months with Denis's fellow *Nabi* Paul Sérusier (1864-1927), during which he created landscapes inspired by Gauguin's paintings. His first ideas for *Eve* are thought to have been related to a competition at the Académie Ranson in 1909.[3] Denis proposed an exercise in warm and cool tones, based on a sample of van Dyke brown. A preliminary sketch (location unknown), shows a nude seated in a pose similar to *Eve*.[5] Beside her La Fresnaye placed a basket, which he eliminated in the final composition.

La Fresnaye presented Eve poised and serene in Paradise before her fall. The idyllic scene descends more from representations of classical Arcadia or the mythical Golden Age than from Genesis.[6] The figure could just as easily represent Pomona, or Aphrodite in the sacred grove of the Hesperides. The idea of humanity living in peaceful harmony with nature was popular in the nineteenth century. Puvis de Chavannes, Cézanne, and Gauguin, among others, created memorable images of this theme, and Matisse (*The Joy of Life*, 1905-6; Barnes Foundation, Merion, Pennsylvania), and Derain (*The Golden Age*, 1905; Museum of Modern Art, Tehran) offered modern interpretations.[7] La Fresnaye's immediate inspiration may have been his teacher, Maurice Denis, who produced visions of an ideal, innocent world throughout his life.

La Fresnaye exhibited *Eve* at the Salon des Indepéndants in 1910. Around this time, he produced a sculpture of Eve, whose similar, simple pose and smooth anatomy recalls Maillol's contemporaneous goddesses and allegorical figures.[8] Mr. Cantor presented a bronze cast of this sculpture to the Los Angeles County Museum of Art in 1984. La Fresnaye painted another *Eve* in 1910 (Oscar Ghez Collection, Geneva), this time depicting an even more abstract standing figure.

Maurice de Vlaminck (French, 1876-1958)

Descended from Flemish and Dutch ancestors, Maurice de Vlaminck was born in Paris to musician parents. As a young artist he was overwhelmed by the van Gogh paintings exhibited at the Bernheim-Jeune Gallery in 1901. "I love him more than my father," Vlaminck declared.[9] He soon adopted the artist's characteristic agitated, broken brushwork and vibrant color. By 1915 he had established the romantic, expressive style with which he became identified.

Vlaminck painted this portrait of his good friend poet Fritz Vanderpyl in 1918. A truculent character, Vanderpyl scowls at the viewer while puffing furiously on a cigarette. The frontal pose and the cigarette recall Vlaminck's earlier self-portrait (1910; private collection, Paris).

From the 1920s until his death at the age of eighty-one, Vlaminck was celebrated for his winter landscapes and village views. In these paintings the artist sought to convey the beauty he found in "icy ponds, ashen grey, cold days, and thawing sludge."[10] The Cantor Collection features two of his finest snow scenes dating from the mid-twenties. The subject evolved from Vlaminck's growing rapport with the French countryside. In 1919, after a Norwegian art dealer purchased a group of paintings for 10,000 francs, he bought a country house at Valmondois, about forty kilometers from Paris. Six years later he settled in a farmhouse called La Tourillière, at Rueil-la-Gadelière in Normandy.

The numerous winter subjects Vlaminck portrayed from the 1920s until his death share many similarities, but no two are identical. *Snowy Landscape* may have been executed near Valmondois. *Hôtel du Laboureur* was painted at Rueil-la-Gadelière. In both paintings small structures border a receding road that cuts diagonally through the village. The snow he painted was far from pristine; as he noted: "Snow doesn't remain immaculate for long....It all forms a muddy...liquid."[11] His winter scenes are thus usually pervaded by a somber brown-beige tonality. The prevailing desolate mood suggests some of Jacob van Ruisdael's landscapes, especially his *Winter Landscape* (c. 1670; Rijksmuseum, Amsterdam), which is similarly dominated by a receding road and humble cottages. Vlaminck himself acknowledged that he rediscovered his Dutch-Flemish heritage in Northern France.[12]

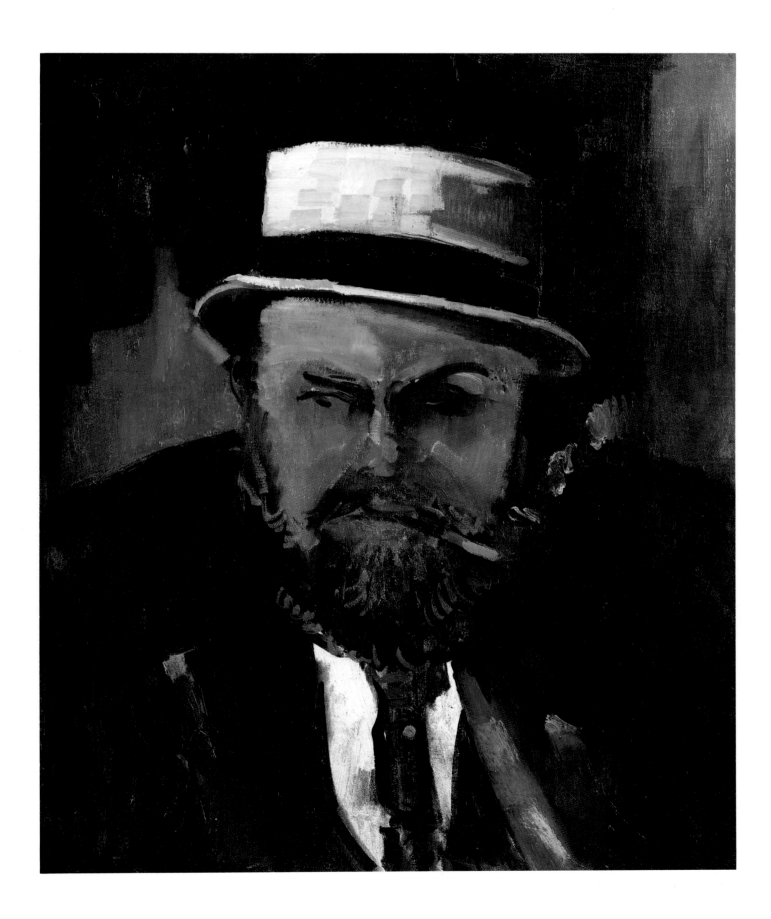

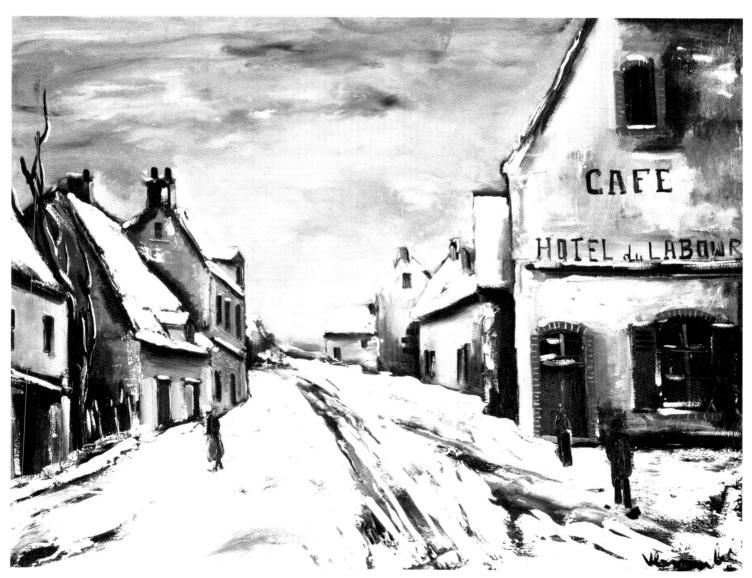

Hôtel du Laboureur,
Rueil-la-Gadelière, c. 1925
Oil on canvas,
35 1/2 x 45 3/4 in.
(90.2 x 116.3 cm)

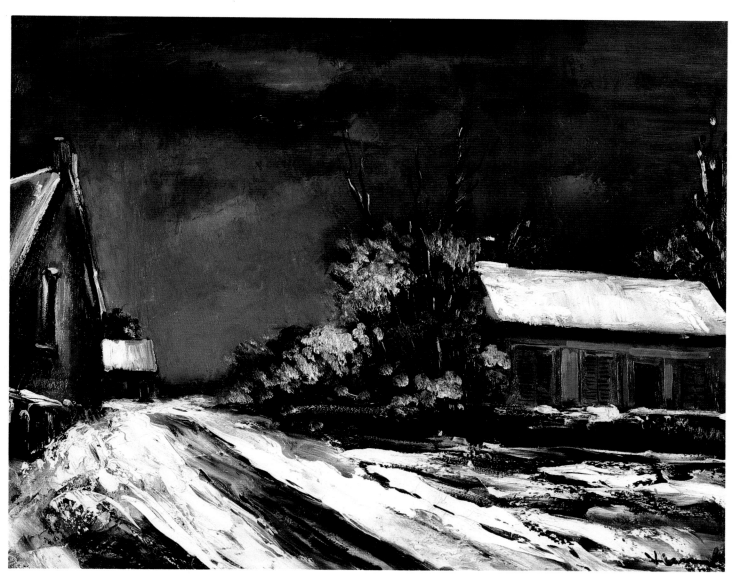

Snowy Landscape, c. 1924
Oil on canvas, 32 x 39 in.
(81.3 x 99 cm)

Robert Delaunay (French, 1885-1941)

Portrait of Jean Metzinger, 1906
Oil on paper, 20 3/8 x 17 in.
(51.8 x 43.2 cm)

Robert Delaunay distinguished himself as a gifted colorist from the time he began to paint in 1904. He met Jean Metzinger (1883-1956), a painter from Nantes, the following year. Together they experimented with the divisionist technique, then very popular in Paris; Seurat (1859-1891) was honored by a major retrospective at the Salon des Indépendants in the spring of 1905. The paintings of Henri Edmond Cross (1856-1910) were exhibited at the Galerie Druet the same years, and Cross's vivid palette appealed to Delaunay, as did his large, rectangular brushstrokes. From 1906 to 1907, Delaunay and Metzinger spent a great deal of time together painting and discussing the color theories of Ogden Rood and Michel Eugène Chevreul.[13] In January 1907 their works were exhibited at the Galerie Berthe Weil.

The artists painted each other in 1906. Delaunay created four portraits of his friend; this painting is the most severe and abstract of the series. The aligned blocks of color, adapted from Cross's late works, create a mosaiclike surface. Delaunay's brushstrokes, however, are larger and more controlled than Cross's. The composition is nearly identical to Delaunay's *Portrait of Metzinger* in the Museum of Fine Arts, Houston, though here the artist grouped blocks of identical color so that the effect is less neo-impressionistic than the portrait in the Cantor Collection.[14] In both of these paintings, the technique, the close-up frontal view, and the subject's staring gaze are all reminiscent of a Byzantine icon.[15]

Delaunay presented Metzinger in a similar fashion in a painting in the Arnold Saltzman Collection, New York, but the figure and color blocks are smaller, so the image is not nearly as bold. Behind the head, he depicted circular, flowerlike forms that anticipate the artist's later color disks. In the fourth portrait, often entitled *Man with the Tulip* (private collection, Paris), Delaunay's Neo-Impressionist technique is even less rigorously applied, with the brushwork adjusting more to the contours of the forms, and Metzinger is depicted from a high, oblique view. The derby hat, cigarette, and lapel flower depicted in the painting chararcterize the painter as a modern dandy.[16]

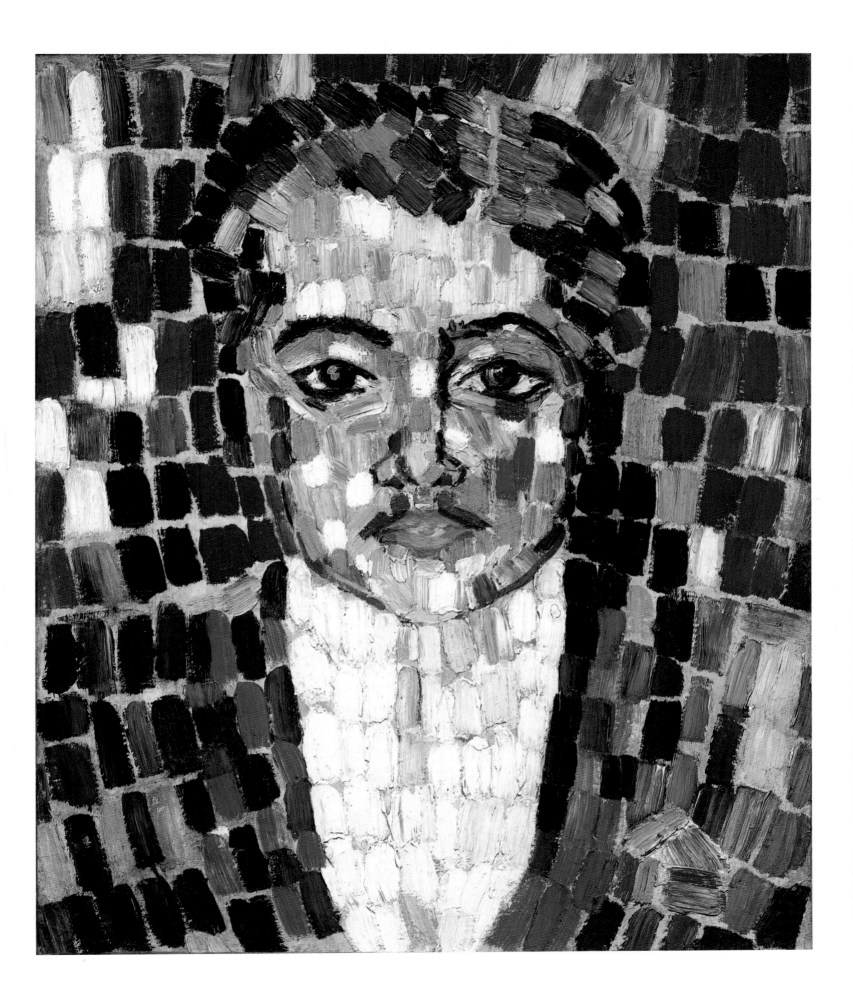

Emil Nolde (German, 1867-1956)

Sunflower Garden, 1937
Oil on canvas, 26 3/4 x 35 in.
(68 x 89 cm)

Although Emil Nolde's fame rests with his impassioned interpretations of religious themes, these subjects form only part of his rich oeuvre. Flowers also stirred his deepest emotions: "The flourish of colors in the flowers and the purity of those colors—I love them. I cherished the flowers in their fate: bursting forth, blooming, shining, glowing…[then] bending slightly, wilting…tossed in a ditch."[17]

From 1928 to 1940 Nolde created over twenty pictures of sunflowers, including the impressive painting in the Cantor Collection, which was originally in the collection of Nolde's physician, Hans Berg, in Hamburg. In his catalogue raisonné, Martin Urban has dated the painting to 1937.[18] Typical of Nolde's later floral compositions, the blossoms burst to the edges of the canvas. As Robert Rosenblum has observed, Nolde's sunflowers, like van Gogh's, bloom "before us with a kind of supernatural vigor….[They] often loom like giants against the sky, their dimensions related to heaven rather than earth."[19]

The sunflower paintings were executed at Seebüll, his home in the Schleswig-Holstein region near the Danish border. The gloomy, desolate character of Nolde's native marshland countryside appealed to his romantic sensibility, and his peasant roots bonded him spiritually to the landscape.[20] He often painted the farmhouses of the region, such as the one portrayed in the watercolor in the Cantor Collection.

Early in his career Nolde created several haunting paintings of masks. Subsequently, he painted *Three Russians* (1914; Nolde Stiftung, Seebüll) and *Three Girls* (1915; Nolde Stiftung, Seebüll), in which the portraits retain masklike qualities. The watercolor *Three Figures* (c. 1930) continues this concern with similar melancholic undertones and forecasts the artist's so-called "unpainted pictures,"—1,300 small watercolors of imaginary subjects he executed between 1938 to 1945 in a hidden room at Seebüll. Nolde survived the war to enjoy worldwide accolades. He continued to paint into his eighties.

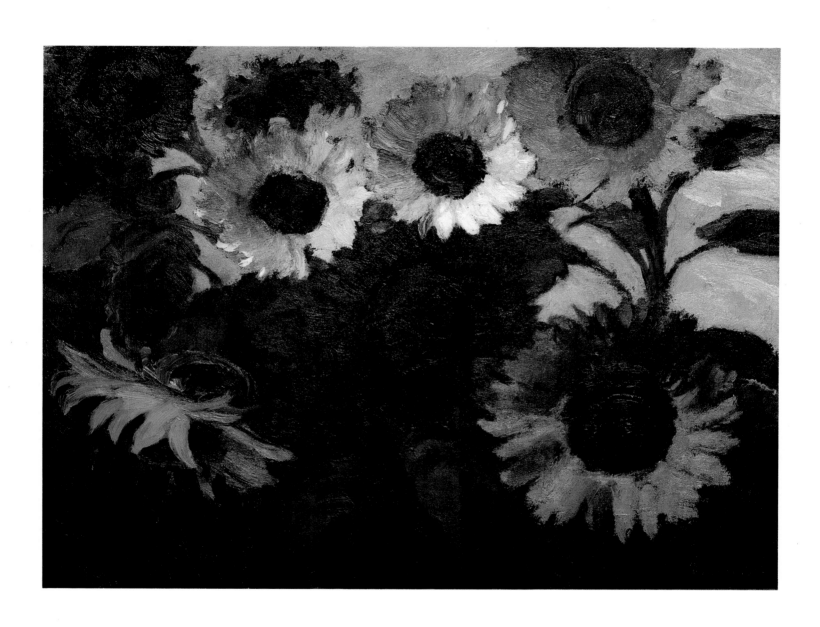

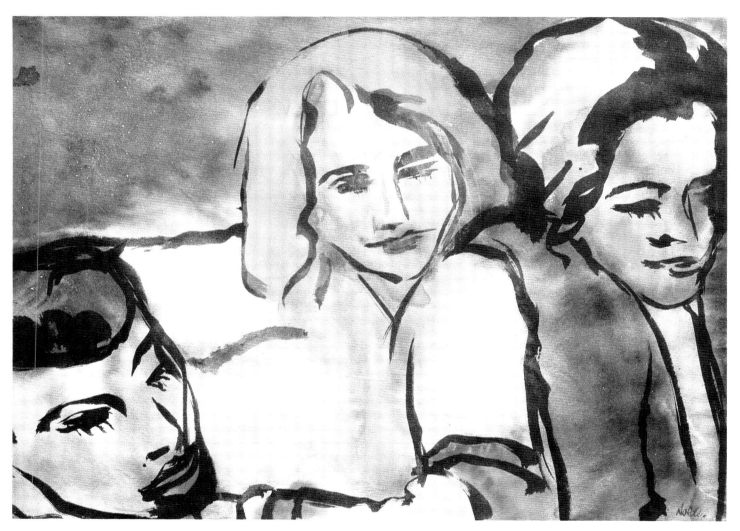

Three Figures, c. 1930
Watercolor on Japan paper,
13 x 17 1/4 in.
(33 x 43.8 cm)

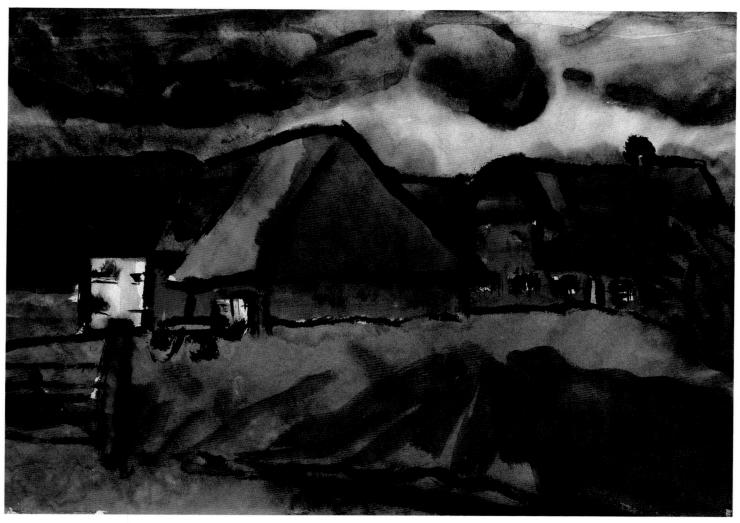

Landscape with Red House,
c. 1920
Watercolor, 13 x 18 in.
(33 x 45.7 cm)

Max Beckmann (German, 1884-1950)

Femina Bar, 1936
Oil on canvas,
23 3/4 x 54 3/4 in.
(60.3 x 139 cm)

The atrocities and carnage Max Beckmann witnessed while serving as a medical orderly during World War I led to a nervous breakdown. His tragic view of mankind was reflected in his famous paintings of cruelty and violence, such as *The Night* (1919; Kunstsammlung Nordrhein-Westfalen). During the 1920s and 1930s Beckmann's imagery became increasingly symbolic and personal, particularly in *The Departure* (1932-33; Museum of Modern Art, New York), the first of his five triptychs.

In contrast to these works, *Femina Bar*, painted in Berlin in 1936, represents a relatively straightforward scene from contemporary life. The bar was one that Beckmann frequented, but it is believed that the figures portray typical bar crawlers rather than people he knew.[21] Dominated by the truncated figures of three women and two men, the shallow, congested space—characteristic of Beckmann's work—intensifies the claustrophobic atmosphere of the crowded room. The crude, masklike features of the embracing couple on the right leave no doubt that they represent a prostitute and her client. Since the 1920s similar paintings of nightlife and urban decadence proliferated among the German realist artists associated with *Die Neue Sachlichkeit* (The New Objectivity). Although Beckmann exhibited with the group, he painted in a more abstract style than they did, and above all, he usually intended his paintings to convey a profound spiritual meaning. In his café scenes, however, he aimed primarily at social commentary.

Femina Bar was sold for 2900 Swiss francs soon after it was shown in Beckmann's exhibition at the Kunsthalle, Bern, in 1938. In 1949, it was purchased by Morton D. May, the eminent collector of German Expressionist art. On May 30 of that year Beckmann noted in his diary: "Another good day. May bought four pictures! Vampire, Hotelhalle (2 Women), Red Table, and old Femina from 1936—ha!"[22]

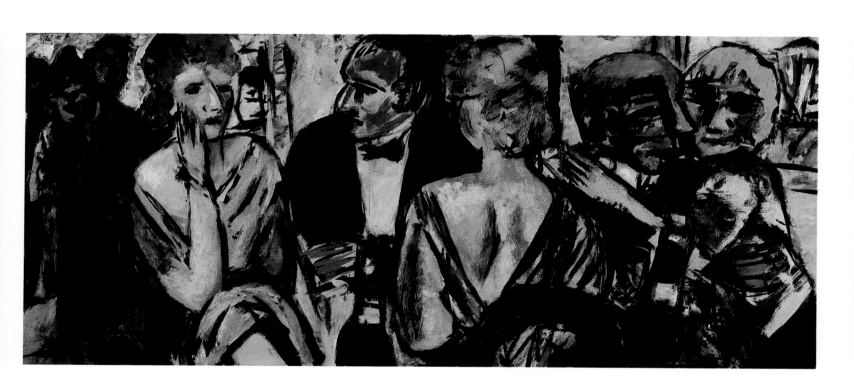

Kees van Dongen (Dutch, 1877-1968)

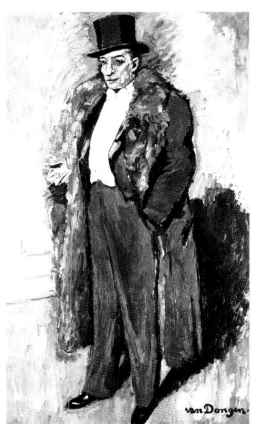

Portrait of Jules Berry, 1937
Oil on canvas,
88 5/8 x 51 5/8 in.
(227 x 131 cm)

The Dutch artist Kees van Dongen arrived in Paris in 1897, where he quickly immersed himself in the bohemian life of Monmartre. He made his debut with six paintings at the Salon des Indépendants in 1904. In November of that year Ambroise Vollard exhibited 105 of his paintings, a remarkable achievement for the twenty-seven-year-old artist.

The Indépendants exhibition included a painting entitled *Corner of a Masked Ball* (location unknown), which anticipates *Masked Ball at the Opéra,* one of his most ambitious compositions from this period. Already van Dongen had set his sights on gaudy café society, which he would immortalize in glaring color in the following decades; *Masked Ball at the Opéra* demonstrates his early adoption of Fauve color. Several of his works were exhibited alongside those by Matisse, Derain, and Vlaminck in the famous Salon d'Automne of 1905. The painting is identical in composition to a later, slightly larger work, *Restaurant de la Paix* (formerly in the collection of Margaret Thomspson Biddle).[23]

Van Dongen achieved his desire for glamour and celebrity during the 1920s and 1930s when he became the leading society portraitist in France. A bon vivant, he lived the luxurious, carefree life of his sitters, following them from Paris to Deauville and Monte-Carlo, where he acquired a villa. Although van Dongen is best known for his female portraits, he executed several fine paintings of men, notably this distinguished portrait of the actor Jules Berry (1883-1951). Berry had gained a reputation as "the most original and seductive comedian" on the Paris stage before he turned his talents to motion pictures.[24] Between 1931 and 1951 he made over ninety films, including *Le Crime de M. Lange* (directed by Jean Renoir) in 1936, the year before van Dongen painted him. Berry's striking full-length portrait, in evening dress and fur-lined overcoat, captures the actor's imposing, dignified presence.

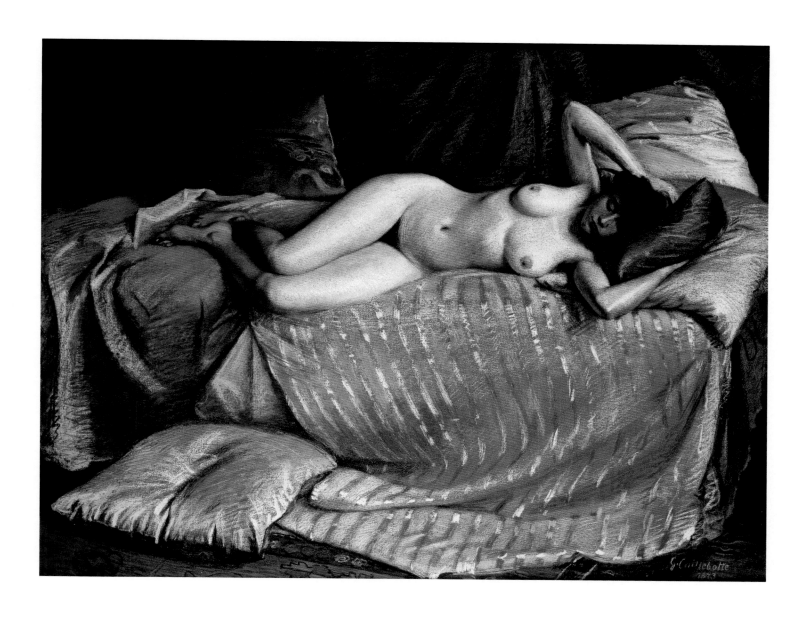

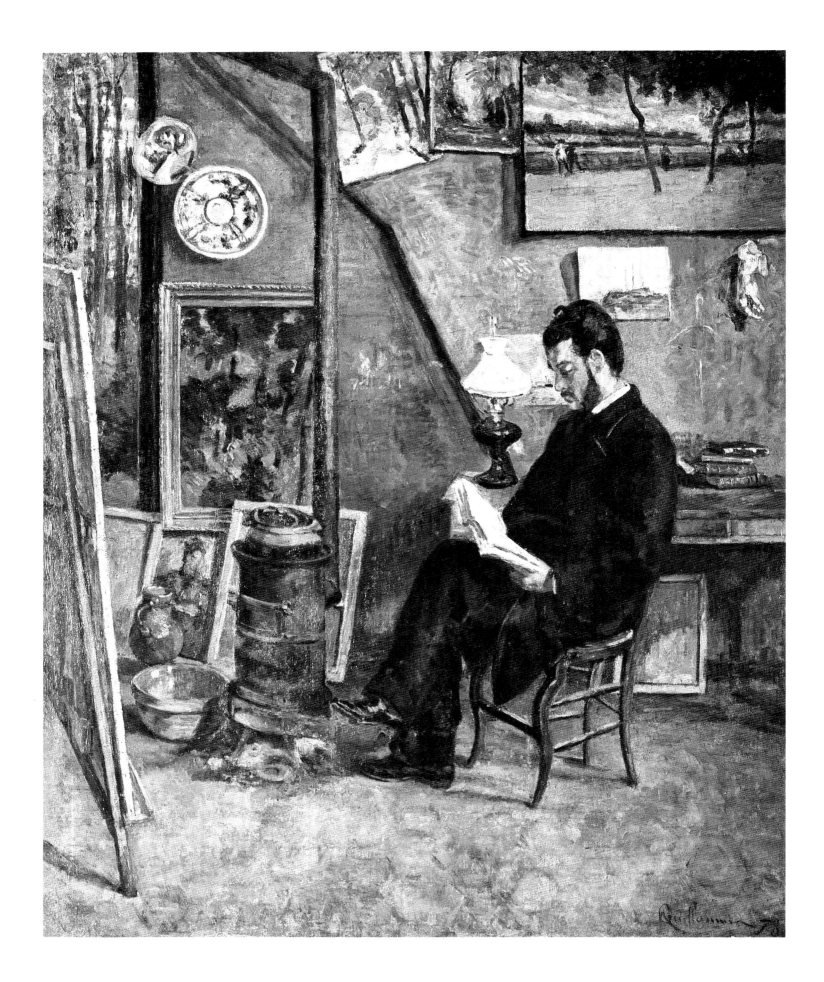

Armand Guillaumin (French, 1841-1927)

Dr. Martinez in the Painter's
Studio, 1878
Oil on canvas,
35 1/8 x 29 1/4 in.
(89 x 74.3 cm)

Guillaumin was the only original member of the Impressionists who could not support himself as a painter. In 1891, when he won 100,000 gold francs in the Paris lottery, he is said to have declared: "Excellent, I'm going to be able to paint the sea."[27] Soon after that he retired to the coastal towns of Agay and Saint-Palais-sur-Mer.

During most of his life Guillaumin struggled to find time for painting. From 1861 to 1863 he studied part-time at the Académie Suisse, where he met Cézanne and Pissarro. In 1868 he began work for the Department of Bridges and Public Roads. According to Pissarro, Guillaumin painted with him and Cézanne in Pontoise in 1872: "He works at painting during the day and in the evening he digs ditches, what courage!"[28]

Like Pissarro, Guillaumin primarily painted landscapes. This portrait of Dr. Martinez, a friend of Pissarro, is a rare interior scene. Martinez is portrayed sitting in Guillaumin's studio, surrounded by paintings and props. The subject is reminiscent of Degas's *James Tissot in an Artist's Studio* (1866-68; Metropolitan Museum of Art, New York). At least two of the paintings shown here can be identified with certainty. In the upper right corner Guillaumin depicted his own painting *La Seine à Paris (Quai de la Rapée)* (1871; John Beck Collection, Houston, Texas). Behind the blue vase in the lower left is one of Cézanne's portraits of his wife, Hortense (c. 1872; Max Muller Collection, Soleure, Switzerland), which the artist may have given to Guillaumin when they painted together in 1872-73.[29] Directly above this picture is one of Guillaumin's typical landscapes from the 1870s, such as *Paysage de Î'Ile de France* (c. 1875). Next to *La Seine à Paris* are two smaller paintings very similar to his autumnal landscapes, notably *Valleé de Chevreuse: Automne* (1876).[30] The small picture above Martinez's head may be *Quai d'Austerlitz* (c. 1877, Bauer Collection).

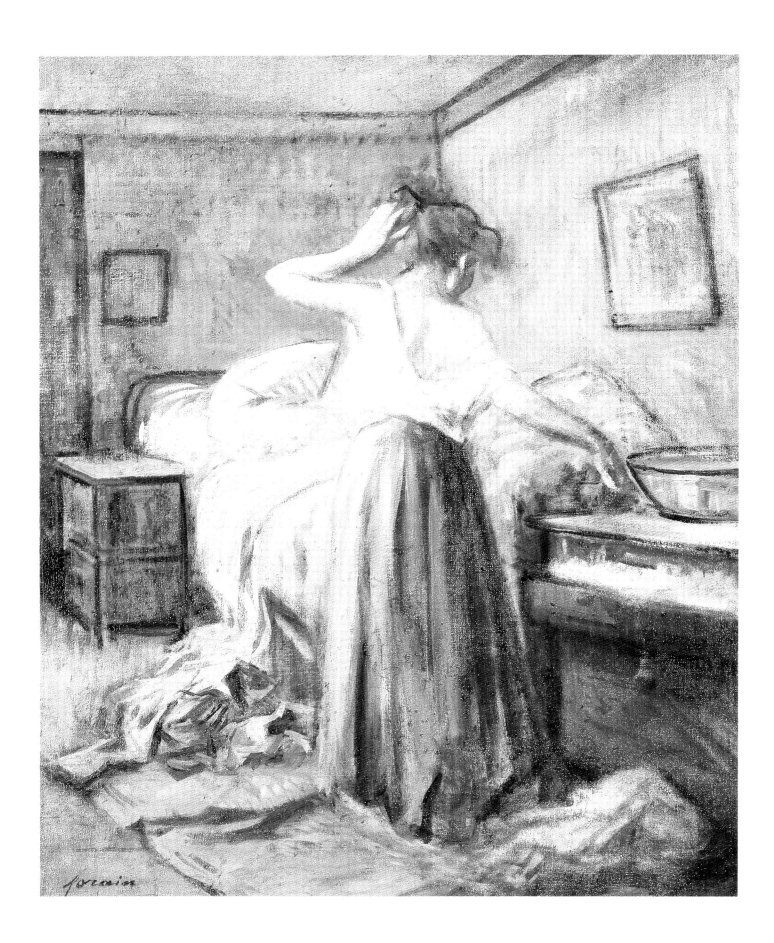

Jean-Louis Forain (French, 1852-1931)

Woman Dressing, c. 1890
Oil on canvas, 32 x 26
(81.3 x 66 cm)

Renowned for his satirical illustrations, Jean-Louis Forain was also an accomplished painter who participated in five Impressionist exhibitions. His earliest extant paintings, a portrait of his mother and *Au Café*, date from 1872.[31] The latter anticipates numerous paintings he would create into the next decade. Forain's friendship with the poets Arthur Rimbaud and Paul Verlaine brought him into the orbit of the Café de la Nouvelle-Athènes, a meeting place for intellectuals and artists including Manet and Degas, whom he met sometime around 1876. He soon became a follower of Degas, and adopted many of the older artist's familiar subjects of modern life: the ballet, the racetrack, cafés, theatres, and brothels.

The brothel afforded artists ample opportunity to study women in private moments, as they bathed or dressed. Throughout his career, Forain portrayed women at their toilette; a painting from the mid-1880s (collection of the Hon. Mrs. W. E. Wallace) shows a woman studying herself in a mirror.[32] Sometimes he depicted a prostitute dressing or undressing in front of a male companion or client.

It is not known if the woman in *Woman Dressing* was a prostitute or model. The broadly handled paint and almost monochromatic tonality are similar to paintings Forain executed in the 1890s, notably one of his wife and young son dated 1898 (Galea Collection). In the 1870s he had adopted the vivid, clear palette of the Impressionists but he would later comment: "The Impressionists discovered the way to paint light, a magnificent discovery. But the cloud is also splendid, as are all the tones of a grisaille."[33]

Eugène Carrière (French, 1849-1906)

Carrière's misty, evocative domestic scenes attracted many admirers in the late nineteenth century, including Rodin, who owned nine of his paintings.[34] Carrière, in turn, became one of Rodin's closest friends and earliest supporters. In 1904 the sculptor presided over a dinner honoring the painter. Eight years later Rodin began work on a monument to Carrière, which he would never finish.

Around 1885 Carrière became involved with Symbolist artists and writers, an affliation that intensified during the1890s. His figures, veiled in a mysterious haze, suggested the "visionary quality of reality" he and the other Symbolists sought to convey.[35]

The New Wrist-Watch, formerly in the collection of the artist's grandson, is a prime example of Carrière's mature style. Robert J. Bantens has proposed a date of about 1892 for the painting.[36]

We have come to associate Carrière with intimate themes such as this; his rare scenes of public life are not well known. Bantens has observed that *Leaving the Theater* (originally from the collection of Carrière's son-in-law) is related to a projected series

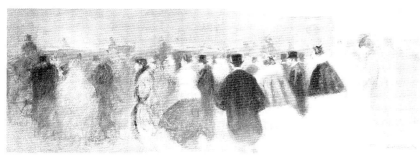

Leaving the Theater,
c. 1895-1900
Oil on canvas, 10 x 26 in.
(25.5 x 66 cm)

of scenes from contemporary life that Carrière planned to paint.[37] At this time Carrière was painting a large work, *Le Théâtre de Belleville* (1886-95; Musée Rodin, Paris), and Edmond de Goncourt's journal entry for December 20, 1890, mentions that the artist showed him a list of urban themes he intended to depict, including "the parade of the Parisian crowd" and the refreshments being offered to people leaving the *Théâtre de Belleville.*[38] *Leaving the Theater* does not conform exactly to the description in the Goncourt *Journal,* but it clearly developed from the same interest. As in *Le Théâtre de Belleville,* details are submerged beneath the misty atmosphere that unifies the diverse elements of the setting.

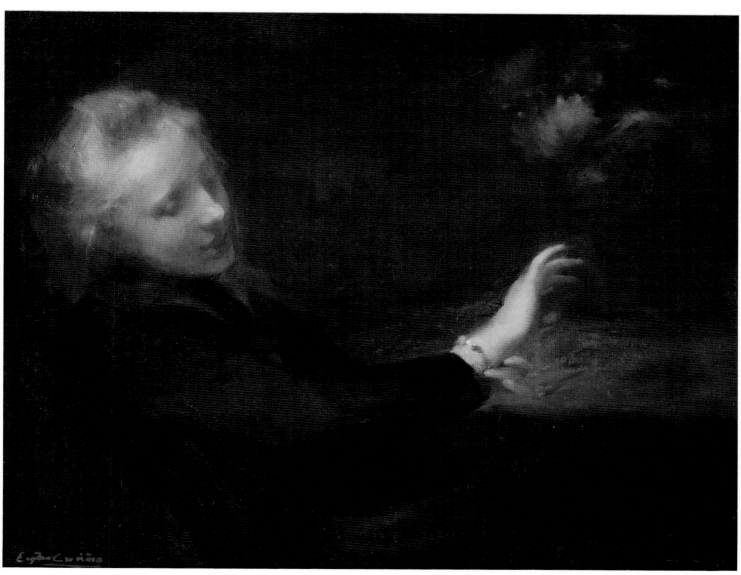

The New Wrist-Watch, c. 1892
Oil on canvas, 12 1/2 x 15 7/8 in.
(31.8 x 40.3 cm)

Théophile-Alexandre Steinlen (Swiss, 1859-1923)

At the turn of the century Steinlen had illustrations in more periodicals than any other living artist. This prolific draftsman and painter was raised in Lausanne and moved to Paris in 1881. He soon became friends with a fellow Swiss ex-patriot, Rodolphe Salis, who commissioned him to design images of cats for his new cabaret, the Chat Noir. In 1882 his drawings for Salis's periodical, *Le Chat noir*—including several striking representations of cats—established his reputation.

Beginning in 1885, Steinlen's staunch socialist convictions were embodied in the drawings he produced for *Le Miriliton,* and the seven hundred designs he made for *Gil Blas illustré* from 1891 to 1901 provided him with an opportunity to collaborate with the realist writers and poets he admired. His anticapitalist, anticlerical views gave birth to satirical drawings for the journals *Le Chambard* (1893-94) and *L'Assiette au beurre,* which also included illustrations by Felix Vallotton, Kees van Dongen, Jacques Villon, and Franz Kupka.

Steinlen's depictions of the Parisian working class parallel the naturalist novels of Emile Zola and the Goncourt brothers. In his introduction to the artist's 1901 exhibition at the Galerie Edouard Pelletan, Anatole France hailed him as "the painter of passing life, the master of the street."[39] Steinlen frequently portrayed lovers embracing in secluded corners of Paris. He treated the subject in at least two paintings, *The Kiss* (1895; Musée du Louvre, Paris) and *Idyll* (1909; Petit Palais, Genf). In *The Lovers,* also entitled *Nocturne,* the couple embraces on a bench in a park or public square.[40] An illustration representing the same composition was published in *L'Assiette au beurre* on May 16, 1901. The design is closely related to a watercolor in the Cabinet des Dessins in the Louvre.[41]

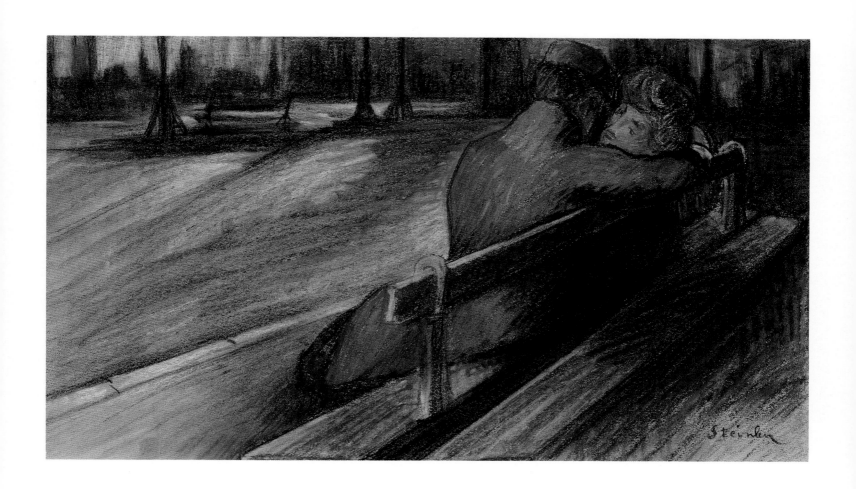

Louis Valtat (French, 1869-1952)

Raised in Paris and Versailles, Louis Valtat entered the École des Beaux-Arts in 1887. His father, an amateur painter, encouraged his talent and they later exhibited together at the Salon des Indépendants. Valtat's earliest extant works date from 1889. In 1891, after he completed his military service, he studied at the Académie Julian, where he befriended Pierre Bonnard and Maximilien Luce. By that time he had already established a studio for himself on the rue de la Glacière.

La Toilette (c. 1893) reveals Valtat's admiration for the paintings of Bonnard and Edouard Vuillard. The intimate domestic theme, rendered with a dense juxtaposition of different patterns and textures, strongly resembles their contemporaneous works. He painted a related subject, *Woman on a Divan* (location unknown), three years later.[42]

The Steamboat, c. 1895
Oil on canvas,
20 3/4 x 25 1/4 in.
(52.7 x 64.2 cm)

In 1895 Valtat began to employ pointillist stippling to achieve rich textural effects. In some of his paintings from that year he used small dots of opposing colors, although the resulting works remain closer in spirit to the Nabis than the Neo-Impressionists.[43] The same holds true for *The Steamboat,* thought to date from the same time. Here, his much bolder brushstrokes and more vibrant palette anticipate the works he would create with the Fauves a decade later. The painting depicts a group of passengers on a sight-seeing boat that still operates on the Seine. Despite the bright colors and festive theme, the mood is solemn. The passengers appear to be withdrawn into their own thoughts, in keeping with the *intimiste* sensibility. Valtat portrayed the boat again, in 1905 (Boris Fisz Collection).

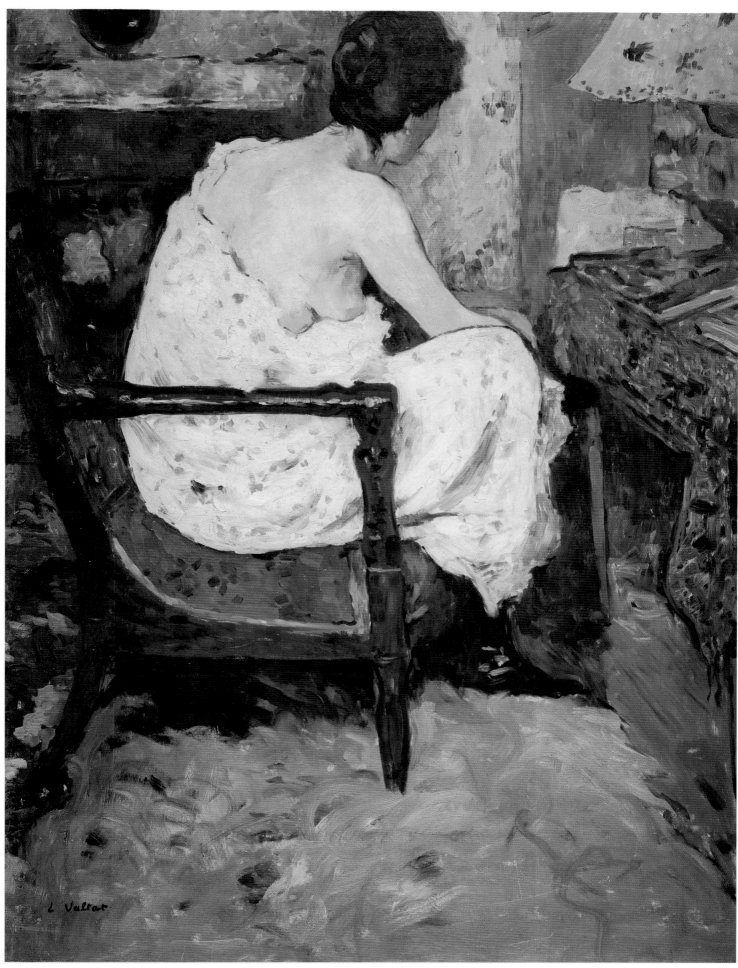

La Toilette, c. 1893

Oil on canvas, 51 x 39 1/4 in.

(129.5 x 99.8 cm)

Lovis Corinth (German, 1858-1925)

Portrait of Elly, 1898
Oil on canvas,
74 1/2 x 45 1/2 in.
(189.2 x 115.5 cm)

Lovis Corinth, along with Max Slevogt and Max Liebermann, is often classified as a German Impressionist. Although these artists employed bright colors and loose brushstrokes, they were not as interested in the optical effects of light on color as were their French counterparts. Corinth, raised in Tapiau, East Prussia, studied at the Konisberg Academy of Art (1876-80) and the Académie Julian in Paris (1884-87). He subsequently moved to Munich, where he painted the *Portrait of Elly*, one of his most impressive portraits.[14] The painting was among the 228 works by Corinth exhibited at the Berlin Secession in 1913, where it was called *Portrait of a Woman*. It appears prominently in two photographs of Corinth in his studio on Gabelsberger Strasse.[15]

Eleonore von Wilke ("Elly"), was the wife of one of his closest friends in Munich, the writer Dr. Ado von Wilke. Corinth executed a smaller, half-length portrait of Dr. von Wilke in the same year (Georg Schafer Collection, Schweinfurt). Whereas that portrait is a sober likeness, the painting of his vivacious wife shows her in fancy dress displaying a large ostrich fan. Her full-length figure stands set against an undefined grayish-salmon background, which echoes the tones of her ensemble. The entire surface of the painting pulsates with Corinth's distinctively loose, fluid brushwork. The format, the artificial pose, and the emphasis on elaborate clothing, however, anticipates Corinth's later full-length female portraits, notably that of his fiancée, Charlotte Berend (1902). The artist painted Elly von Wilke nine years later, in October 1907, in a portrait sometimes entitled *Countess Finkh* (Galerie des 20 Jahrhunderts, Berlin).

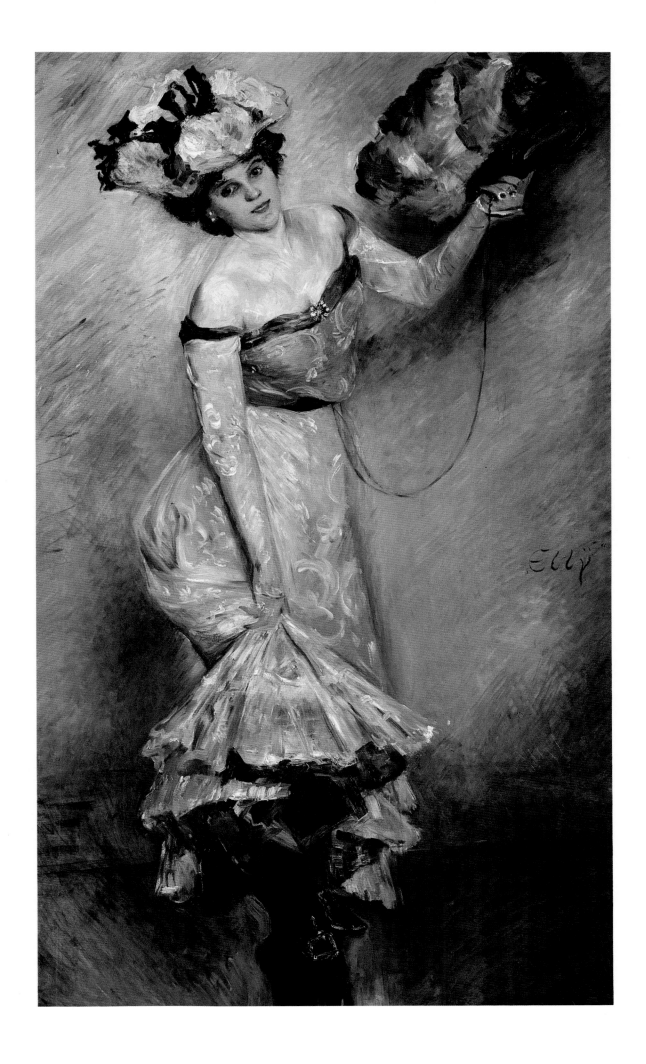

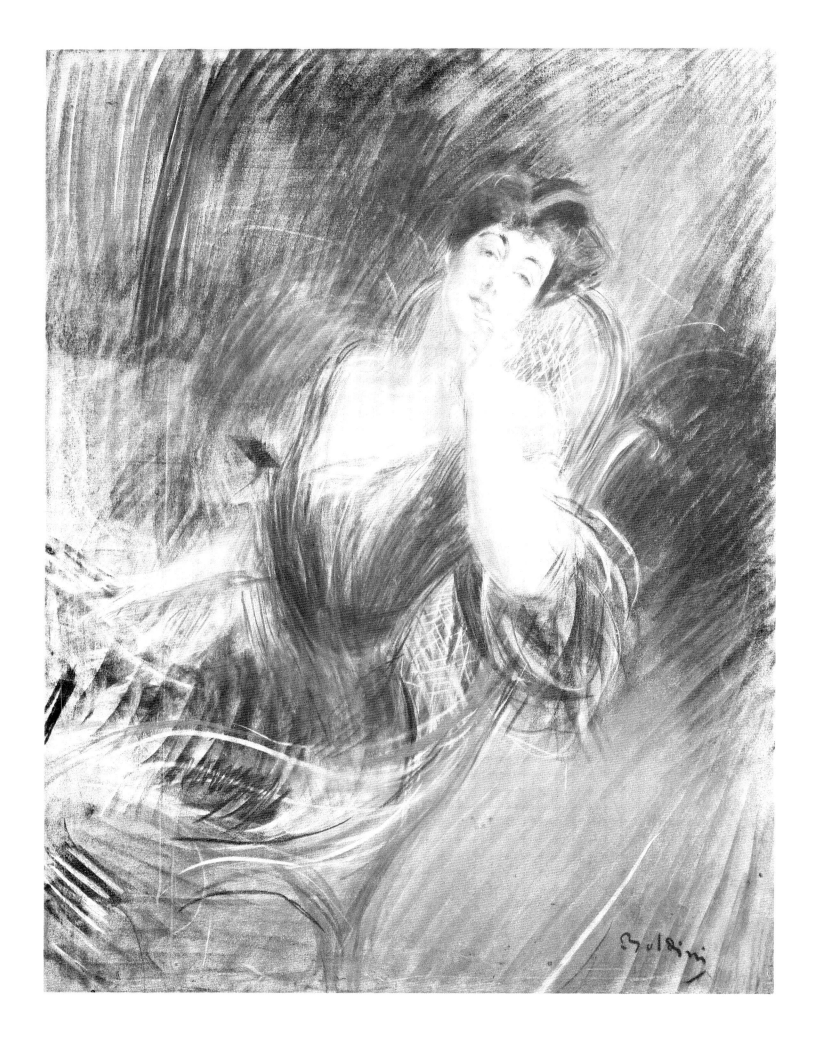

Giovanni Boldini (Italian, 1842-1931)

At the turn of the century Giovanni Boldini rivaled John Singer Sargent as the
leading high-society portraitist. As a young artist in Florence he frequented the Caffe
Michelangelo, where he befriended Giovanni Fattori (1825-1908) and other painters
known as the Macchiaioli. Under their influence Boldini began to paint in broad,
patterned strokes and to examine the effects of light on form. In Florence he
frequented the colony of English expatriates, and in May 1871 he traveled to London
at the invitation of his friend Sir William Cornwallis-West, who provided his entree
to aristocratic circles. Boldini soon obtained commissions for portraits, which would
reflect his new-found admiration for the works of Sir Joshua Reynolds and Thomas
Gainsborough. Encouraged by success in England, Boldini moved to Paris in 1871
and soon established himself. His flattering likenesses appealed to his affluent sitters,
and he became renowned for his paintings of glamorous fin de siècle beauties. He
developed a flamboyant, bravura style dominated by slashing, agitated brushwork
and a luminous palette.

Many of Boldini's finest portraits are executed in pastel, a medium rarely employed
on such a large scale. His portraits of Guiseppe Verdi (1886; Galleria d'Arte
Moderna, Rome) and Emiliana Concha de Ossa (1888; Galleria d'Arte Moderna,
Milan) are among his earliest pastels to win critical acclaim. This impressive pastel of
Mrs. Edward Parker Deacon was formerly in the collection of her daughter, Gladys
Deacon, duchess of Marlborough (1881-1977).[46] Descended from a wealthy New
England family, Florence Baldwin (1859-1918) married Edward Deacon in 1879.
They settled in Europe, where she was distinguished for her beauty and stylishness.[47]
Mrs. Deacon enjoyed the company of artists and aesthetes, including Rodin, Bernard
Berenson, and Boldini himself, who has portrayed her at age forty-seven as a still-
attractive if not majestic society matron. Characteristic of his mature works, long
curved and swirling strokes transcend descriptive purposes to enliven and unify the
pictorial surface.

Louis Hayet (French, 1864-1940)

A leading exponent and theorist of Neo-Impressionism in the 1880s, Hayet passed most of his later life in obscurity. He was forgotten at the time of his death, and only within the last twenty-five years has his remarkable oeuvre gained full appreciation.

Hayet was the fourth of twelve children born to a poor painter-decorator in Pontoise. At the age of twelve he had to leave school to help support his struggling family. He

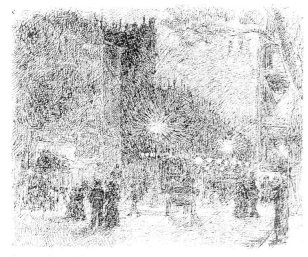

Boulevard in the Evening,
Paris, 1884
Ink drawing, 9 x 12 in.
(22.9 x 30.5 cm)

became fascinated by color at seventeen, when he discovered notes on Eugène Chevreul's theories among his father's papers. Already a precocious talent, Hayet wished to devote himself to art, but his family's precarious existence forced him continually to search for employment. In 1884 he sought decorating work in Paris, where he met Paul Signac, and two years later he fell under the influence of Georges Seurat. During his military service in Versailles in 1886, he made color disks to facilitate his analysis of color.[18]

Some artists claimed that Hayet's personal theories would result in tonal neutralization, but the paintings in the Cantor Collection, executed at the height of his career, are distinguished by patches of vivid color. Like many other painters of the period, he preferred to portray urban life and popular entertainment, as is evidenced by these views of a café, a theater, and a bustling street.

The Concert may depict some of his musician friends.[49] Hayet included this painting in an exhibition he organized at a shop on the rue Lamartine in Paris in November 1903. Because the colors have not yet been separated according to divisionist principles, Robert Herbert has dated this painting to about 1886.[50] In contrast to the dense, matte surface of The Concert, the small gouache and watercolor shown here are delicate.

In 1890 Hayet began to withdraw from the Neo-Impressionist circle. His palette grew more subdued, and by the end of the decade he developed a modified Impressionist technique that he employed for the rest of his life.

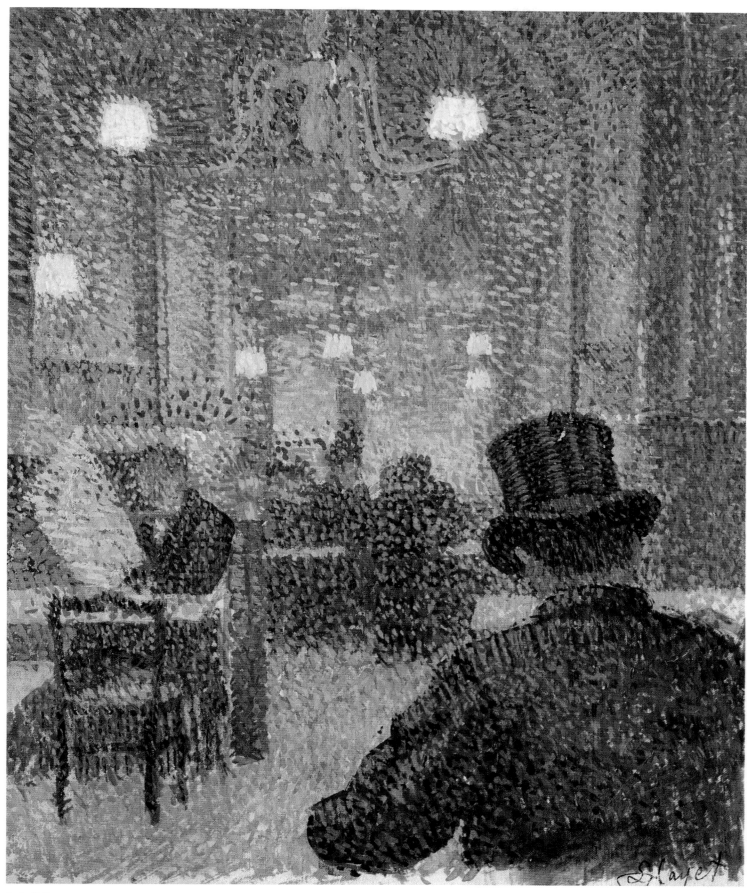

At the Café, 1888
Gouache on prepared linen,
8 1/4 x 6 3/4 in.
(21 x 17 cm)

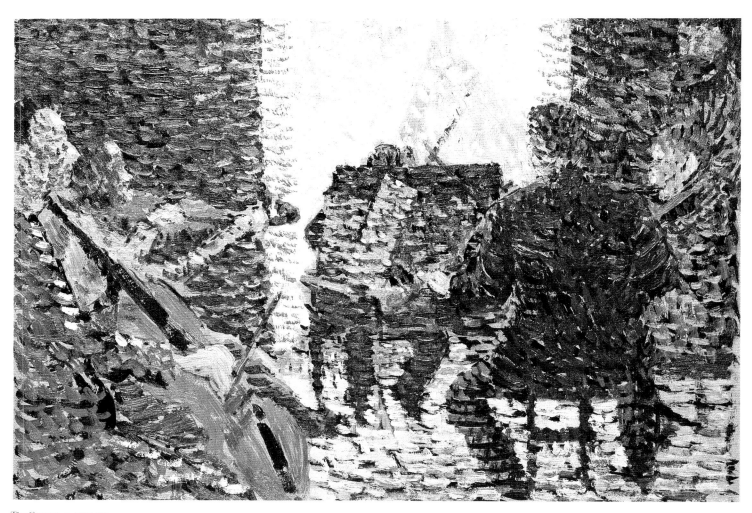

The Concert, c. 1886-89
Encaustic on paper laid
down on board, 7 x 10
(17.8 x 25.5 cm)

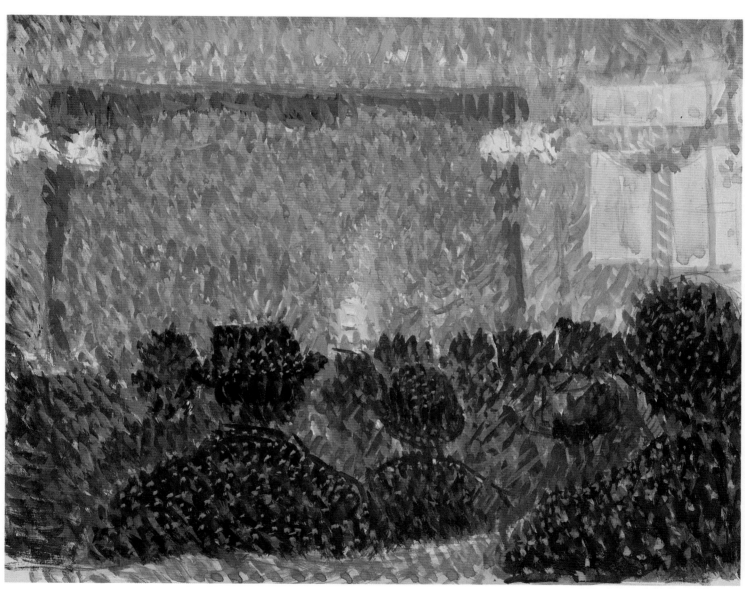

At the Theater, c. 1888
Watercolor and gouache on
paper, 6 1/2 x 9 3/4 in.
(16.5 x 24.8 cm)

Harold Knight (English, 1874-1961)

A Village Wedding, 1908
Oil on canvas,
63 1/2 x 75 1/4 in.
(161.3 x 191 cm)

In 1907 Harold Knight, a native of Nottingham, moved to Newlyn, a village on a stretch of coast sometimes called the Cornish Riviera. The temperate climate had attracted many artists to the region since the 1880s. Knight and his wife, the painter Dame Laura Johnson Knight (1877-1972), who had both hitherto painted in the sombre tones of the Hague School, gradually lightened their palettes after they settled there.[51] *A Village Wedding* (1908), Knight's first important painting in Newlyn, depicts the members of a wedding party being showered by confetti as they pass a group of well-wishers. The vividly colored bits of paper enliven the otherwise solemn scene. The sunlight streaming in from the right illuminates the modest bride and a few of the people behind her, and in the distance can be glimpsed a luminous view of the sea. Although his Newlyn pictures are sometimes linked with British Impressionism, Knight carefully delineated all of his subjects.

In 1909 Knight started to paint the tranquil interior scenes for which he would become renowned. These paintings typically represented elegantly clad, contemplative women seated in well-appointed drawing rooms. His subjects, as well as his emphasis on soft, reflected light, express an indebtness to Vermeer, which earned him the reputation of being a "quiet painter."[52] Studied and sophisticated, these works lack the freshness of Knight's earlier paintings of local village life.

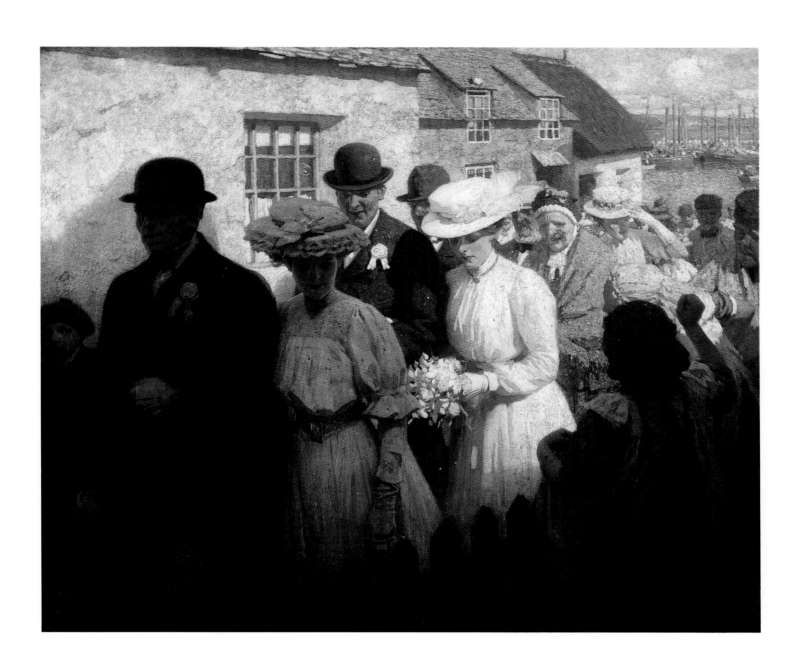

Richard Emil Miller (American, 1875-1943)

Sewing by Lamplight, 1904
Oil on canvas, 24 x 24 in.
(61 x 61 cm)

Raised in Saint Louis, Richard Emil Miller studied at the Académie Julian in Paris from 1898 to 1901. He is often affliated with Frederick Carl Frieseke (1874-1939), a friend from the Académie with whom he taught summer courses at Giverny. Both artists practiced a modified form of impressionism and specialized in paintings of young women in dreamy repose. Like most of the other so-called American Impressionists, they emphasized bright color and broken brushwork, and did not dissolve their solidly modeled forms under the effects of light. Their style perhaps derives more from Sargent and Boldini than from the French Impressionists.[53]

Miller often portrayed his models lost in reverie in the privacy of a decorative, light-filled boudoir. *The Crinoline* (location unknown), exhibited at the Salon of 1904, is thought to represent his earliest rendition of the theme, and *Afternoon Tea* is one of his finest and most characteristic works. The sitter pauses in her afternoon repast, framed by a view of a veranda and sun-dappled foliage. The ruffled white skirt, which occupies a large portion of the canvas, was one of the artist's favorite reoccurring motifs.

Two of Miller's works in the Cantor Collection demonstrate his mastery of artificial illumination. In *Sewing by Lamplight* the light focuses on the form of the model and flickers over her pink dress. The artist's flair for pattern and texture is displayed in the stack of fabrics awaiting the seamstress's attention. *L'Aperitif* provides an inviting café scene bathed in sparkling golden light.[54] In the immediate foreground, an attractive young woman beckons the viewer while her older male companion appears to be absorbed in his drink. Miller has treated the mirror reflection at the rear of the room with great finesse. The artist conceived more elaborate café scenes, notably *Café de Nuit* (Collection of Dr. and Mrs. Henry C. London III), but none of them are as accomplished as this painting.

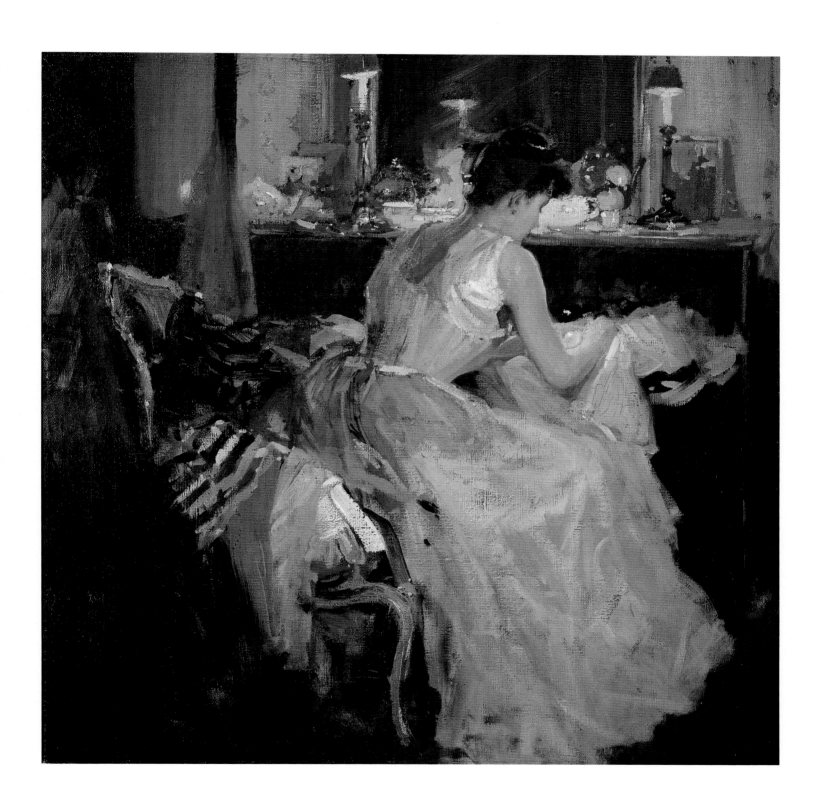

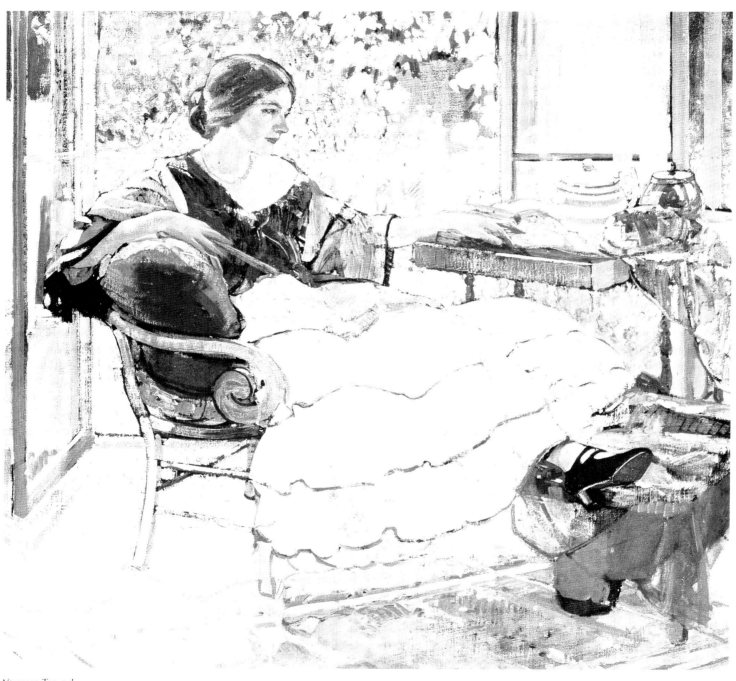

Afternoon Tea, n.d.
Oil on canvas, 34 x 36 in.
(86.4 x 91.5 cm)

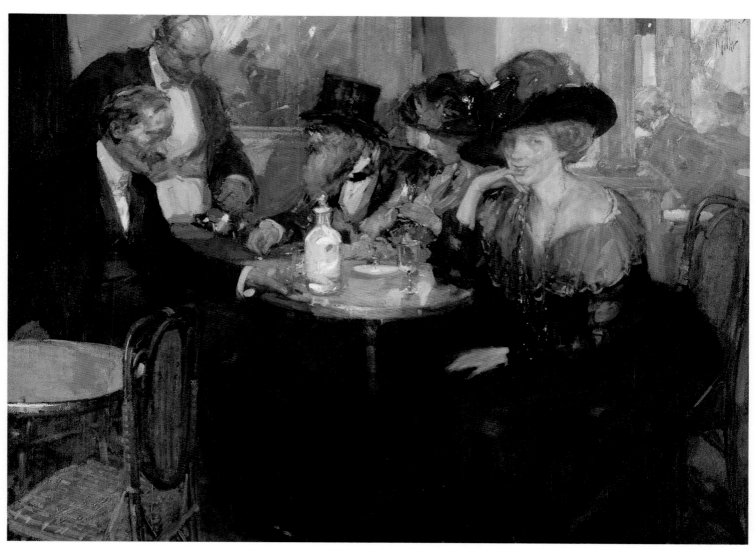

L'Aperitif, c. 1905
Oil on canvas,
38 1/4 x 50 1/4 in.
(97.2 x 127.5 cm)

Julius Leblanc Stewart (American, 1855-1919)

Five O'Clock Tea, 1883-84
Oil on canvas, 66 x 91 in.
(167.5 x 231.3 cm)

The highly successful American expatriate artist Julius Leblanc Stewart was born in Philadelphia, the son of a wealthy sugar plantation owner. In 1865 his family moved to Paris, where his father soon established himself as an important patron of the arts. At eighteen, Stewart began his studies at the École des Beaux-Arts under Jean-Léon Gérôme (1824-1904) and made his debut at the Salon of 1878.

Five O'Clock Tea, executed in 1883-84 when Stewart was twenty-eight, established his reputation. A critic in the *Art Amateur* praised the painting as "admirably colored and well-composed," and observed that it was "one of the most popular…American pictures" at the Salon of 1884.[55] The large composition depicts a group of stylish American expatriates, including the artist himself in the upper left-hand corner. They converse and enjoy their late afternoon tea in a bright, airy, opulent drawing room. The painting is replete with charming genre vignettes, notably the young girls at the table. One nibbles a piece of fruit, the other gently touches the arm of the woman serving tea. In the foreground, a dog begs for a morsel from a female guest. Stewart's animated characters and realistic style, cited by critics as typically American traits, raised his works above costume studies.[56] Details such as the lace and ruffles of the ladies' finery and the bouquet of flowers in the lower left are rendered with remarkable freshness.

Stewart's flattering portrayals of fashionable American and continental beauties, such as those depicted in this painting, brought him great fame. During his career he painted Lillie Langtry, Baronne Rothschild, and the countess of Essex, among others. At the height of his success, in the 1880s, Stewart achieved more critical attention than John Singer Sargent.[57] Following the examples of his friends Jean Béraud and James Tissot, he continued to specialize in multifigured genre paintings of high society. A year after he exhibited *Five O'Clock Tea*, he painted *The Hunt Ball* (1885; Essex Club, Newark, New Jersey), which included portraits of the duc de Morny, the vicomte de Jange, and Baron Rothschild, and surpassed the earlier picture in popularity.

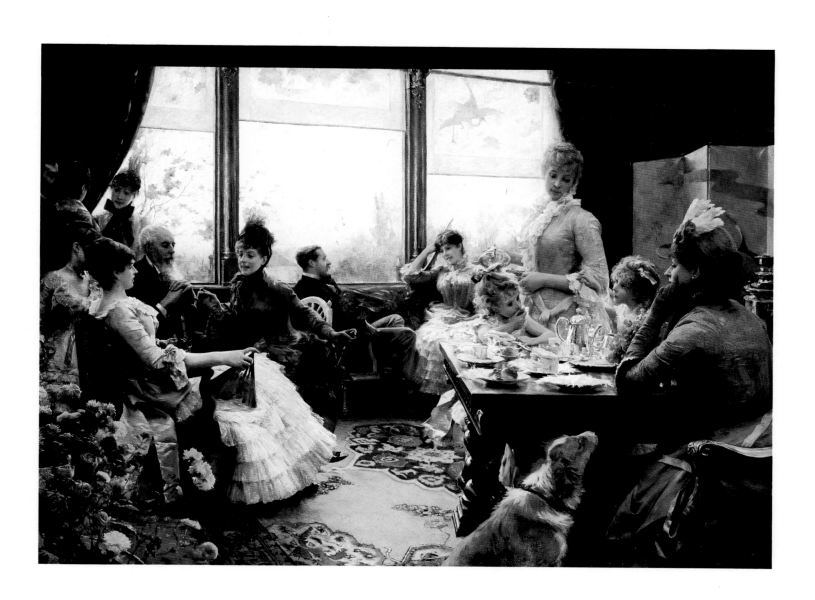

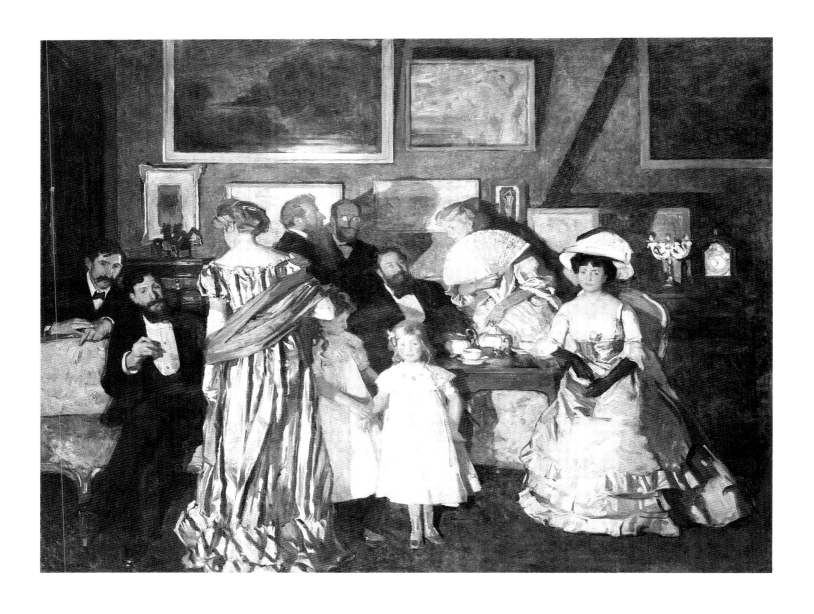

Lucien Simon (French, 1861-1945)

Lucien Simon was highly esteemed in his day for his paintings of both Breton peasants and fashionable Parisians. His admirers included Rodin, who regarded him as one of the greatest living French artists.[58] In 1883 Simon entered the Académie Julian, where he met a group of other aspiring artists who became lifelong friends. Georges Desvallières (1861-1950), René-Xavier Prinet (1861-1941), Charles Cottet (1863-1925), and Emile-René Menard (1862-1930) soon formed part of the salon held every Friday at Simon's home. During the 1890s these artists were dubbed *La Bande noire*, because, for a few years, they chose to paint in dark tonalities.[59]

Studio Party commemorates a meeting of Simon's friends in 1904 and provides us with a glimpse into his studio on the Boulevard Montparnasse. The artist later discussed the subject: "My painting represents a gathering of friends in my studio. There is no other idea to be sought. A pictorial effect is intended rather than a portrait group."[60] Nevertheless, Simon has immortalized his closest friends and family: all of the figures can be identified. At the center he placed his daughter Lucienne. Charlotte, daughter of the painter Edmond-François Aman-Jean (1860-1936), stands at her side. From left to right he portrayed Edouard Saglio, Georges Desvallières, Jeanne Simon (rear view), Charles Cottet, René-Xavier Prinet, Emile-René Menard, Madame Menard, and Jeanne Prinet.

As Simon insisted, the painting was not conceived strictly as a portrait group. The faces of the three artists at the center, though recognizable, are somewhat obscured by shadow. A cool silver tonality reverberates throughout the composition. Employing a palette limited almost entirely to neutral tones, the artist distinguished himself a master of subtle gradations.

In 1905 Simon exhibited *Studio Party* at the Paris Salon and the Carnegie Institute Exhibition in Pittsburgh, where it won a first-class medal and was acquired by the museum. The painting was praised and illustrated in the leading art journals of the day, including *Les Arts* and the *Gazette des beaux arts*.[61]

Convivial by nature, Simon enjoyed sociable gatherings such as this one throughout his life. As one writer observed in 1913: "There is no more delightful a coterie in Paris than that which gathers in his beautiful home."[62]

Max Slevogt (German, 1868-1932)

Supper on the Terrace, 1912
Oil on canvas,
27 1/2 x 23 1/2 in.
(69.8 x 57.2 cm)

Born on an estate in Landshut, Lower Bavaria, Max Slevogt spent his childhood in Würzburg. At nineteen, he was admitted to the Munich Academy, and about four years later, in 1889, he attended the Académie Julian in Paris. It was not until 1900 that he began to assimilate aspects of *plein air* painting and Impressionism into his work, first fully revealed in the sketchy, luminous paintings he executed at the Frankfurt Zoo in 1901.

In 1911 Slevogt met the art historian Johannes Guthmann (1876-1956) through a mutual friend, Dr. Johannes Siever, a print specialist from Berlin.[63] An enduring friendship blossomed between them during a ten-day visit that summer at Guthmann's palatial estate, Neu-Cladow, on the Havel River, near Berlin, and Slevogt painted playful Pompeiian-style allegorical figures on the walls of the garden pavilion.

During his sojourn at Neu-Cladow in June and July of 1912, Slevogt created nine paintings, of which *Supper on the Terrace,* dated July 17, is the most personal. Guthmann related how one evening the artist astonished his guests by placing his easel in front of the dinner table, and in an hour and ten minutes produced the painting.[64] The scene commemorates one of many stimulating dinner parties Slevogt would have enjoyed there, as his host was noted for attracting cultivated, congenial guests. Present on this occasion, in addition to Guthmann and the painter, were pianist and composer Conrad Ansorge (1862-1930), actress Lucie Hoflich, her husband, art historian Dr. Anton Mayer, and Guthmann's companion, Dr. Joachim Zimmerman. On evenings such as this, lively conversation would reportedly extend into the wee hours, interrupted only when Ansorge, celebrated for his stirring renditions of Romantic music, would play the piano.

Slevogt conveyed the casual atmosphere by portraying the group seated around the table in relaxed attitudes. The glassware and remnants of the dinner, including a magnum of Heidsieck champagne, are summarily-indicated. The red floral centerpiece provides a colorful counterpoint to the prevailing muted tonalities.

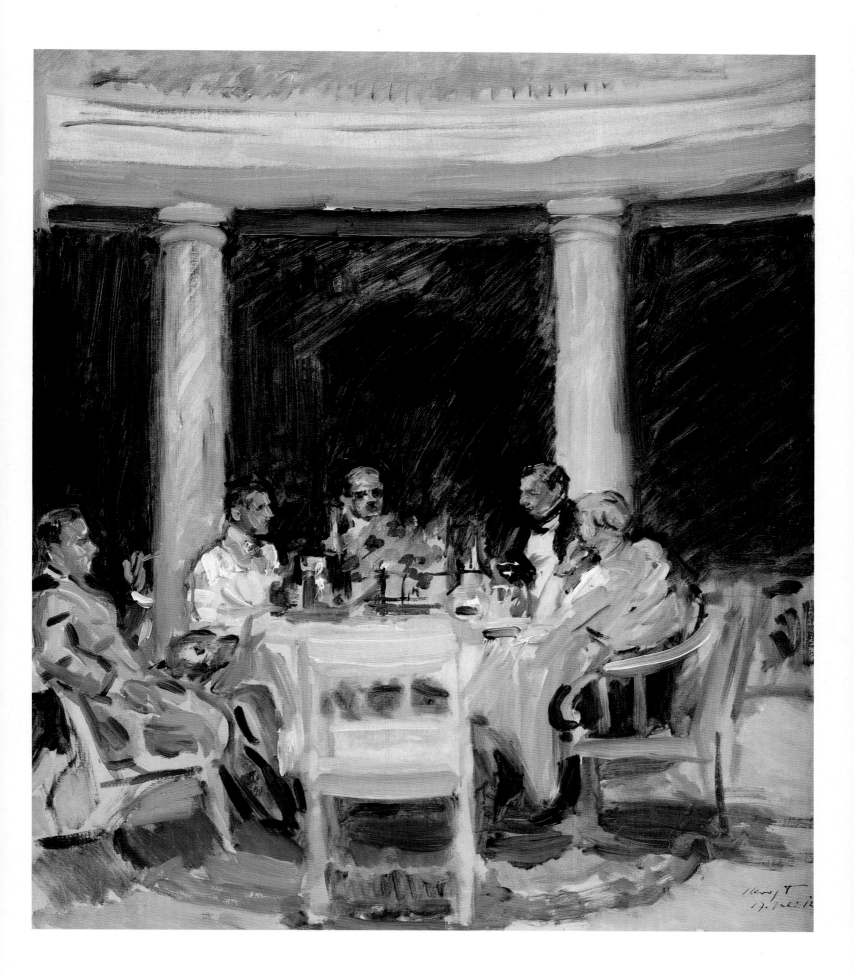

Paul-César-François Helleu (French, 1859-1927)

Portrait of a Pensive Woman
Pencil and crayon on paper,
27 3/4 x 22 in.
(70.5 x 56 cm)

Helleu executed the designs for his black and red lithographs so quickly that he earned the nickname "Watteau at full speed."[65] While attending the École des Beaux-Arts, he painted plates adorned with images of beautiful women for the ceramicist Theodore Deck. In 1884 he was commissioned to paint a portrait of Alice Guerin, whom he later married. Helleu drew her often, sometimes with their children, and she remained the guiding spirit behind the images of fashionable sitters that made him famous.

Although the drawings in the Cantor Collection do not appear to be portraits of Alice, they demonstrate Helleu's skill at depicting stylish young women. He portrayed his affluent subjects in their rarified milieu—drawing rooms, art galleries, and gardens, and he excelled in the depiction of the furs, feathers, and luxurious fabrics in their ensembles. The drawing of the woman glancing at a bust is a variation of a design he made for several etchings around 1896-1900. Under the influence of James Tissot, he mastered drypoint etching in the 1890s, and by 1913 he had produced 2000 drypoints.[66]

Helleu's friend Count Robert de Montesquiou celebrated his female subjects in an article, "Le Femme par Helleu," which was included in the October 1899 issue of *Le Figaro Illustré* devoted exclusively to the artist. Montesquiou, Helleu, and their friend Boldini figured prominently in the beau monde immortalized by Marcel Proust in *À la Recherche du Temps Perdu*. Proust, whom Helleu met in 1885, is said to have partially modeled the character of the painter Elstir on him.[67] In 1922, the author asked Helleu to make a drypoint portrait of him on his deathbed. By that time, the gilded world they had inhabited was quickly fading.

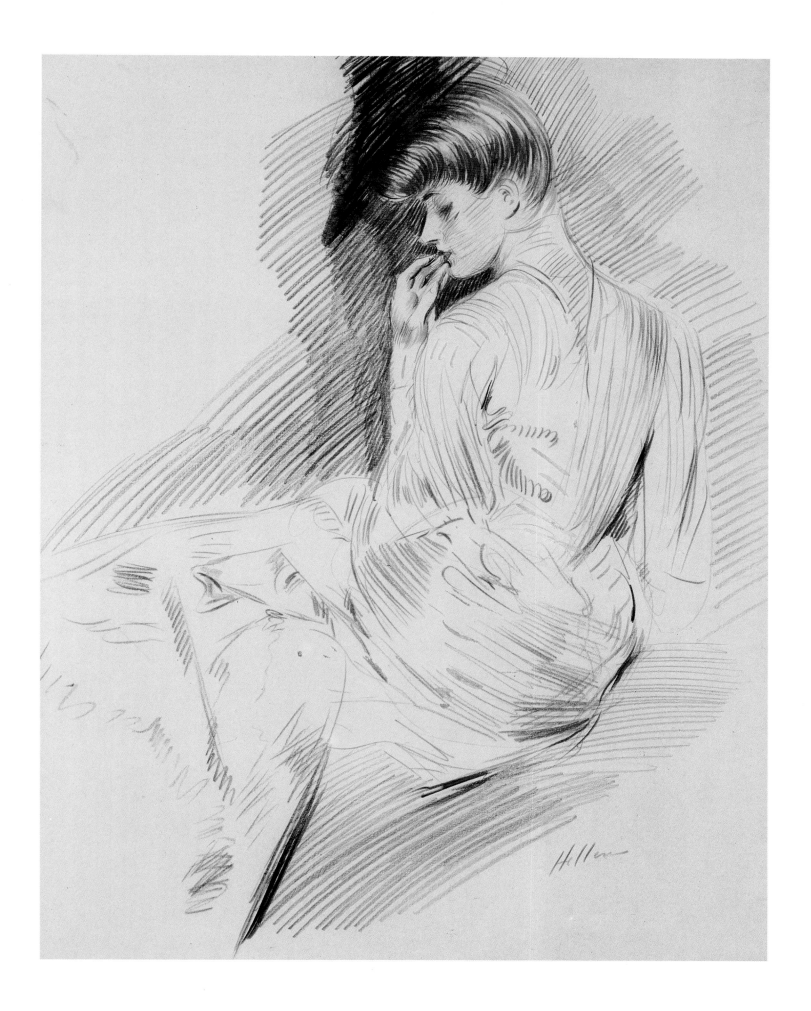

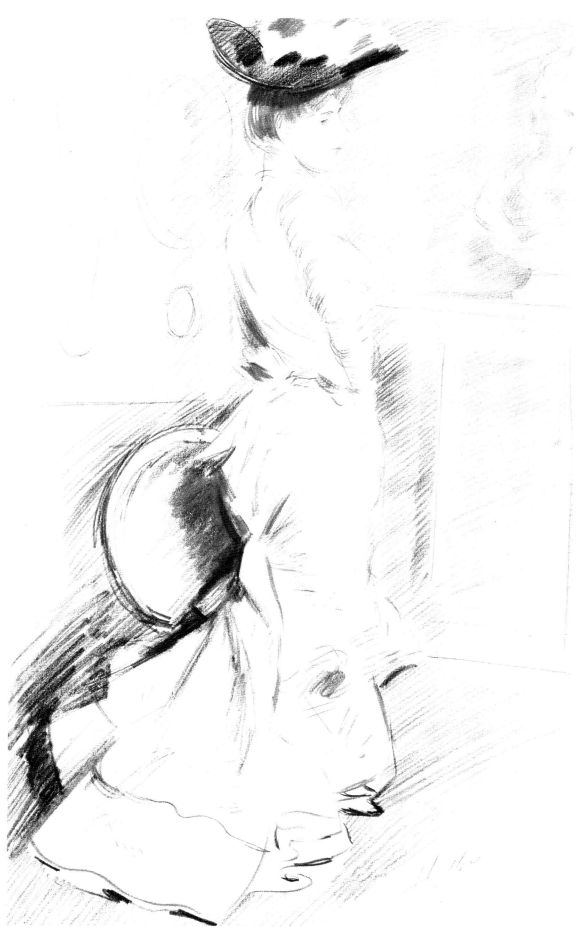

Woman Viewing a Bust
Pencil and crayon on paper,
26 x 16 in.
(66 x 40.7 cm)

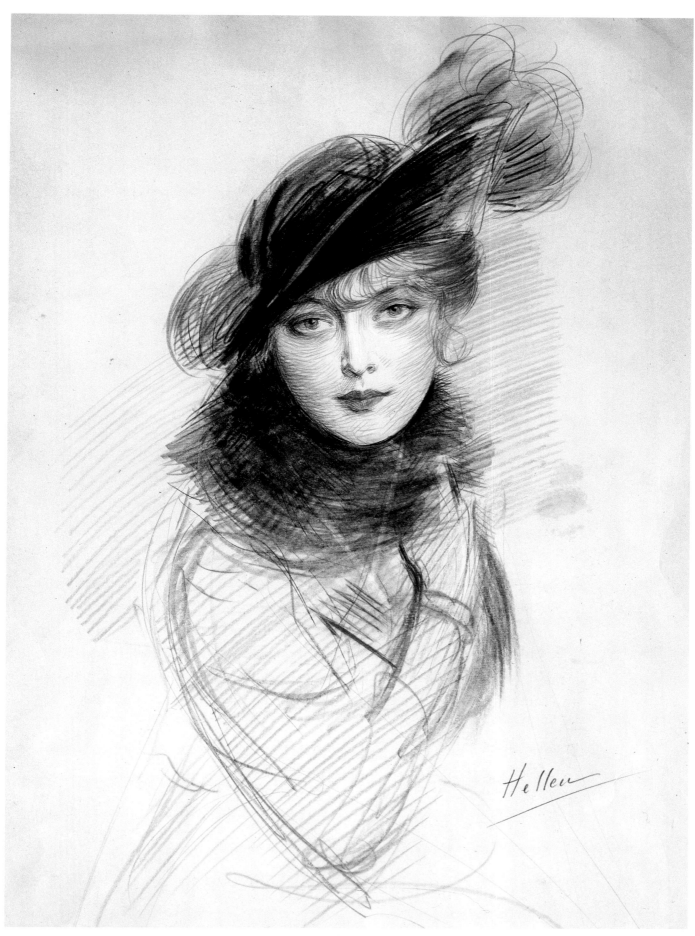

Portrait of a Young Woman
Chalk on buff paper,
26 1/2 x 18 1/2 in.
(67.3 x 47 cm)

Mikhail Larionov (Russian, 1881-1964)

Larionov was a prime mover in the development of the Russian avant-garde before World War I. Early on he embraced European modernist artistic currents. In 1904 he began to experiment with Impressionist and Neo-Impressionist techniques, which culminated in a few impressive works, notably *Fishes* (1906; formerly collection of the artist) and the *Gypsy at Tiraspol* (c. 1907; private collection, Paris).

The setting and the plunging perspective of *The Soldier's Cabaret* was directly inspired by van Gogh's *Night Café* (1888; Yale University Art Gallery, New Haven), which was shown at the first Golden Fleece (*Zolotoe Runo*) exhibition in Moscow in 1908.[68] Like van Gogh, Larionov presented a vertiginous view of a café interior and similarly depicted a glaring ceiling lamp and a table littered with bottles. The Russian painter, however, has portrayed a dancing couple at the center of the composition where van Gogh had placed a billiard table. Larionov's palette, dominated by hot yellows, reds, and pinks, is even more intense than that of *Night Café*. This bold, blazing color, along with the rough brushwork, reflects the impact of the Fauves, whose works he could have seen during his visit to Paris in 1906, or in the Moscow collection of Sergei Shchukin, one of Matisse's greatest patrons.

The *Soldier's Cabaret* bears the date of 1904, which is probably not accurate. Larionov dated some of his works years after they were executed, sometimes resulting in error.[69] In 1908 he performed his military duty, spending the winter in the Kremlin and the summer in a tent camp outside the city. Most of his soldier paintings are thus thought to date from 1908-10. At the Exhibition of International Art in Odessa in 1910-11, Larionov displayed a painting entitled *Soldiers in a Café*, which may be identical to *The Soldier's Cabaret*.[70] This appeared alongside still lifes, landscapes, and paintings of bathers, which largely comprised his oeuvre prior to that time.

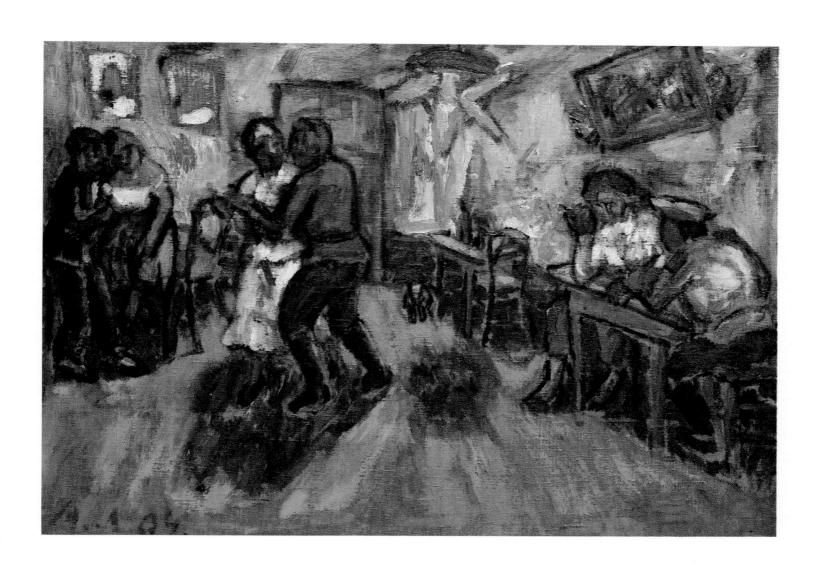

Oskar Kokoschka (Austrian, 1886-1980)

At the age of twenty-three Oskar Kokoschka established his reputation with several psychologically penetrating portraits. During the 1920s he lived comfortably and traveled throughout Europe with economic support from Paul Cassirer's Berlin gallery. Kokoschka was particularly attracted to the Italian countryside and began to paint landscapes there. From 1913 to 1951 he made at least twenty lyrical views of Italy.[71]

Kokoschka painted only a few portraits during his trips to Italy. This painting of an Italian peasant woman was probably executed in the summer of 1933, when the artist stayed at Rapallo, near Genoa, as the guest of Bob Gesinus Visser, the Dutch Consul.[72] During his visit there from May 10 to late August, Kokoschka created four landscapes and two portraits each of Visser and his wife. In a letter to Albert Ehrenstein dated June 1933, he wrote: "I paint here in the mornings a portrait of a heavy Italian woman for a little local man to pay for the...hotel pension."[73] It is likely that the portrait he mentioned is the painting in the Cantor Collection because no other picture corresponding to that description is known.

Kokoschka characteristically did not flatter or sentimentalize his subject. Her mood is mysterious and difficult to determine. She appears to be a placid, earthy creature lost in thought while engaged in sewing or another domestic task that cannot be identified with certainty due to the artist's sketchy brushwork. Her tanned complexion is flecked with red to harmonize with the rose-colored wall behind her. The strong warm hues of the background are countered by the woman's blue blouse and the suggestions of green foliage on either side.

This was a difficult period for Kokoschka. The Cassirer Gallery cancelled his contract in 1931. Consequently he was often plagued by financial problems and was forced to seek out commissions actively, possibly including this painting. Kokoschka was disappointed that Visser, his host in Italy, did not offer to pay for his train fare to Vienna, even though he had given him several paintings.[74] The following year the Nazis came to power in Germany. Branding him a "degenerate artist," they removed 417 of his paintings from German public institutions. Kokoschka was forced to flee to England, where he remained throughout the war.

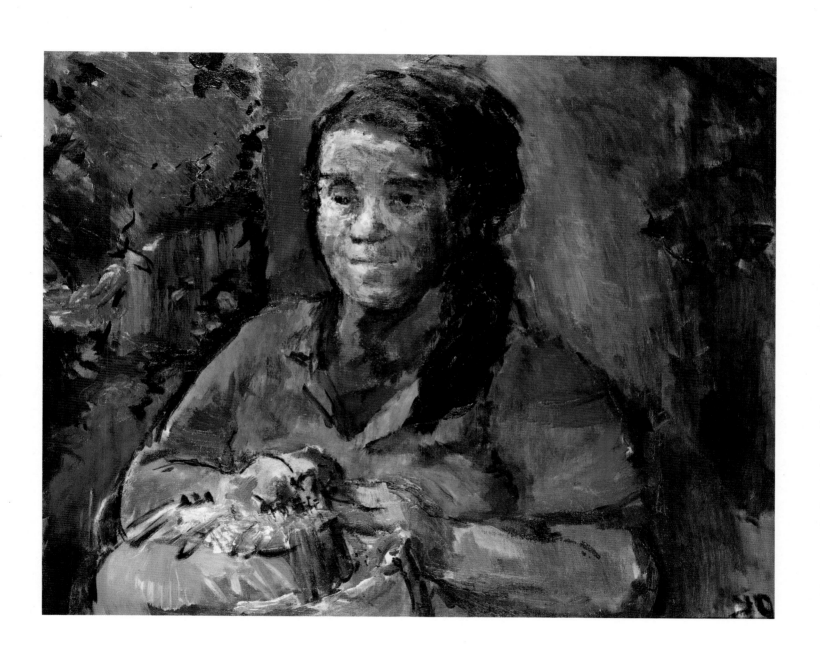

Paul Signac (French, 1863-1935)

Garden at Saint-Tropez, 1909
Oil on canvas, 25 3/4 x 31 3/4 in.
(65.5 x 80.5 cm)

Signac's father owned a successful saddler's shop in Paris, which enabled the artist to live comfortably throughout his life. His earliest paintings show his admiration for the works of Monet and Guillaumin. In the spring of 1884 he met Georges Seurat, and following his example, Signac rejected the Impressionists's intuitive approach and sought to devise a systematic method based on pseudoscientific color theories. Extroverted and energetic, Signac became the leader and most vocal advocate of the Neo-Impressionist style. His justification for the Divisionist technique was expounded in his study *D'Eugène Delacroix au Néo-Impressionisme* (1899). He used divided strokes in several views of the Parisian suburb of Clichy executed during the spring of 1886.

Signac was a passionate sailor and owned several yachts throughout his lifetime. Beginning with his trip to Port-en-Bessin in 1882, he spent each summer painting and sailing along the Seine or the seashore. His marine paintings of the late 1880s and early 1890s are among his finest works.[75] Severely depressed after Seurat's death, Signac sailed to Saint-Tropez in 1892, where he lived for the rest of his life. The rich vegetation and picturesque harbor of this Mediterranean port became his primary source of inspiration. In 1897 he purchased La Hune, a villa near the beach of Les Graniers, just below the town citadel. The painting in the Cantor Collection represents his beloved garden there. Two pen studies for the composition are known.[76] The painting clearly shows the transformation of Signac's style at the turn of the century: his brushstrokes became more pronounced and blocklike, and his palette brightened in response to the intense southern light. Here the dense foliage is set ablaze with vivid, sun-drenched color. These tendencies reveal an exotic, romantic sensibility far removed from Seurat's austerity.

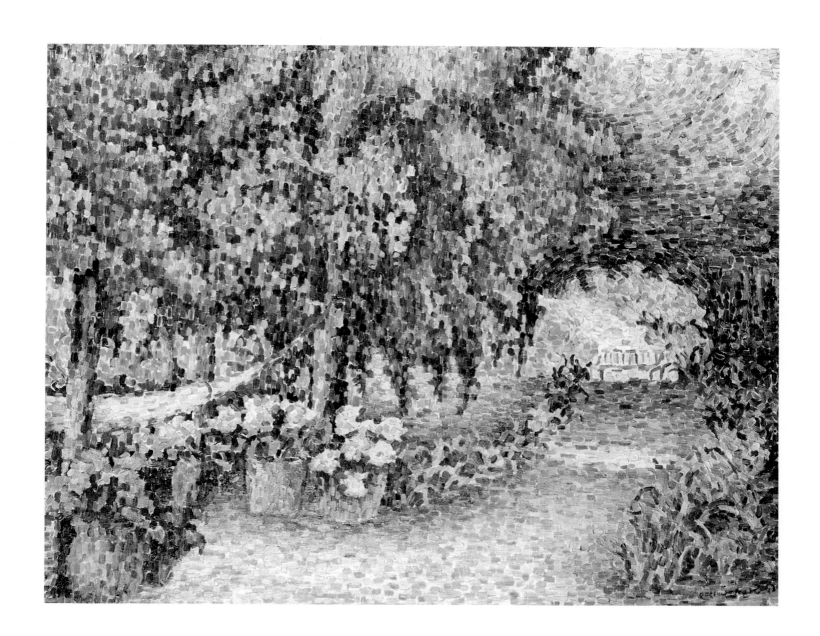

Additional Works in the Cantor Collection

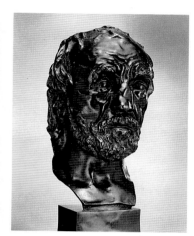

Mask of the Man with the
Broken Nose, 1864
Bronze, 18 1/4 x 7 3/8 x 6 1/2 in.
(46.4 x 18.7 x 16.5 cm)

Rodin: *Mask of the Man with the Broken Nose*

Rodin's first masterpiece, *The Man with the Broken Nose*, marked his liberation from the sculptural tradition of his contemporaries. In contrast to his earliest works, such as the bust of his father (1860; Musée Rodin, Paris) and the *Bust of Father Eymard* (1863; Musée Rodin, Paris), the surfaces are broken, with vigorous modeling and rich texture. From this time on, Rodin's bronzes retain the imprint of his fingers; the clay is pushed and gouged for both descriptive and expressive purposes. Rodin's highly personal portrait of a common man, enhanced by its accidental, fragmentary form, heralded his independence from academic canons. It established the direction of his later works, and led to achievements that placed him among the founders of modern sculpture.

The mask was produced by accident. Rodin began a bust of Bébé, a neighborhood handyman, in late 1862 or early 1863.[1] The clay bust froze in the young sculptor's unheated studio, and the back of the head cracked and broke off. The work was subsequently reproduced in a several sizes and variations. The bronze mask in the Cantor Collection was a gift from the Musée Rodin in Paris, cast from a plaster version presented by Mr. Cantor to the museum. This version, truncated just below the sternum, is thought to conform closely to the sculptor's original conception.[2]

Around 1887 Rodin told the American sculptor Truman H. Bartlett how his model's battered features had inspired him: "He had a fine head; belonged to a fine race—in form—no matter if he was brutalized. It was made as a piece of sculpture, solely, and without reference to the character of the model...I called it 'The Broken Nose,' because the nose of the model was broken. That mask determined all my future work. It was the first good piece of modeling I ever did."[3]

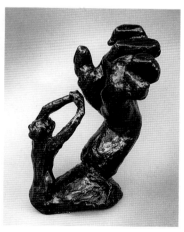

Large Clenched Left Hand with
Figure, c. 1890
Bronze, 17 1/2 x 10 1/2 x 13 1/2 in.
(44.5 x 26.7 x 34.3 cm)

Rodin: *Large Clenched Hand*

Albert Elsen suggested that the *Clenched Hand*, sometimes called the *Mighty Hand*, may have originated as a study for *The Burghers of Calais*, but that it was discarded when it could not be integrated with the final figures.[4] By far the most agonized of Rodin's hand studies, its boldly modeled swellings and depressions heighten the effect of suffering. Medical analysis of the hand suggests that the model suffered some sort of physical afflication.[5] Rodin later paired the left hand with the torso of the *Centauress*. The two elements appear to be engaged in a distressed, enigmatic dialogue.

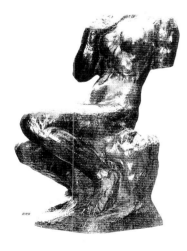

Rodin: Fallen Caryatid Carrying a Stone

In *The Gates of Hell* Rodin tucked the *Fallen Caryatid* behind drapery and a scroll because he did not consider the figure alone weighty enough to anchor the upper left corner.[6] The figure may not have been added to *The Gates* until 1899-1900. Truman H. Bartlett described the freestanding *Caryatid Carrying a Stone* as "a supple little creature, not more than eighteen inches high," adding that it "is regarded by the sculptor and his friends as one of his very best compositions . . . many copies of it have been made . . . in both marble and bronze."[7] This figure corresponds directly to the caryatids described in Dante's *Purgatorio* (cantos ten and eleven), who carry enormous stones in order to expiate their sins.

Fallen Caryatid Carrying a Stone.
(small version), c. 1881
Bronze, 17 3/8 x 12 x 12 in.
(44.2 x 30.5 x 30.5 cm)

Cybele

Cybele, formerly entitled *Study of a Seated Woman*, was first exhibited in its smaller, original size in 1897. The model for the monumental version, probably enlarged by Henri Lebossé in 1904, received mixed reviews when it was shown at the Salon of 1905.[8] Some critics condemned the broad, generalized modeling, as well as the partial form, which they considered incomplete or mutilated. For other observers, The *Seated Woman's* simple pose and calm demeanor suggested a "magnificent ruin" and evoked comparisons to the Parthenon pediment figures, the *Victory of Samothrace* and the *Venus de Milo.*[9] The strong classicizing orientation was underscored in 1914 when it was renamed *Cybele* after the ancient Greek earth goddess.

Rodin: Danaïd

Rodin created the *Danaïd* for *The Gates of Hell* but never incoporated the sensual figure into the composition. According to myth, King Danaüs of Argos ordered his fifty daughters to murder their husbands on their wedding night. In punishment they were condemned forever to draw water with perforated vases in Hades. Rodin depicted a Danaïd exhausted and saddened by her endless, futile task.

A cast of the five-inch-high preliminary study (1884-85) is in the collection of the Cummer Gallery of Art, Jacksonville, Florida.[10] The Cantor Collection features a rare cast by the Gruet Foundry which may have been produced in the early 1890s.[11] The well-known marble versions in the Musée d'Orsay, Paris, and the Princeton University Art Museum are admired for the contrast between the luminous, smoothly polished figure and the rougher rocky base.

Cybele, 1904-5
Bronze, 65 x 34 x 56 in.
(165.1 x 86.4 x 42.2 cm)

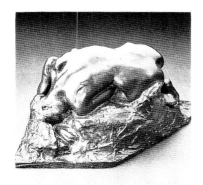

Danaid, c. 1884-85
Bronze, 8 1/2 x 15 3/8 x 10 1/4 in.
(21.6 x 39 x 26 cm)

Rodin: Despair

Victor Frisch, one of Rodin's studio assistants, observed that the sculptor kept "over twelve figures embodying the various human expressions of despair."[12] Certainly the subject occupied Rodin from 1880, when he began to work on *The Gates of Hell*. The figure now known as *Despair* can be seen in in the upper left door of *The Gates*, and therefore could have been made independently in the early to mid-1880s. Elsen noted that the basement at Meudon contains several versions of the torso alone.[13] Rodin reproduced the full figure in various sizes and materials, and he had *Despair* photographed from several angles by Druet, Bulloz, Haweis and Coles, and Bodmer.[14]

A 28-inch-high plaster version (now in the Bethnal Green Museum, London), without the rocky self-base, was bequeathed by Sir Charles Phillips to the Victoria and Albert Museum in 1924 . A bronze figure placed on a rough-hewn marble base (13-1/2 inches high) is in the collection of the Musée Rodin, Paris. Mr. Cantor presented a 37-inch-high limestone version of *Despair* to Stanford University in 1974.

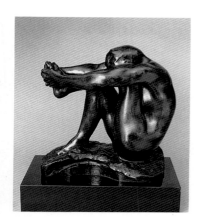

Despair, 1880s
Bronze, 9 1/2 x 8 x 6 1/4 in.
(24.2 x 20.3 x 16.5 cm)

Rodin: Embracing Couple

This couple, extracted and reduced in size from the lower right pilaster of *The Gates of Hell*, closely corresponds to embracing figures in a drawing (c. 1880) in the Musée Rodin, which is inscribed "Françoise Paolo/Virgile et Dante."[15] The drawing also carries the notation "l'amour profond comme les tombeaux, Baudelaire," a line Rodin paraphrased from the poem "La Mort des amants."[16] Rarely are the sculptor's dual sources of inspiration for *The Gates* —Dante and Baudelaire—so clearly defined. In the drawing one cannot determine the sex of either figure, but in the relief they are distinctly male and female. They are probably not intended to portray Paolo and Francesca, who appear elsewhere in the *The Gates of Hell*; they depict instead other anonymous, tormented lovers who populate the portals.

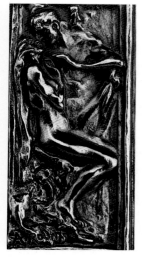

Embracing Couple, 1898
Bronze, 4 3/8 x 2 1/8 x 1/2 in.
(11 x 5.5 x 1.3 cm)

The Three Faunesses

As in *The Three Shades*, Rodin combined three casts of the same sculpture, the so-called *Little Breton Woman*, to form this dynamic ensemble. The individual figure appears three times in *The Gates of Hell*; below the tympanum at the left, at the far right of the cornice, and in the center of the right door. We do not known when Rodin created the group, which was included in his major retrospective exhibition in 1900 under the title *The Three Faunesses*.[17] It is sometimes entitled The *Three Nymphs* or *The Three Graces*. These titles are ironic, or at least inappropriate to the unidealized character of the figures. The catalog from the 1900 exhibition describes them as "savage."[18] Balanced somewhat precariously on their toes, they raise their arms and throw back their heads as if engaged in a primitive dance, and the multiplication of the figure enhances the ritualistic feeling of the piece.

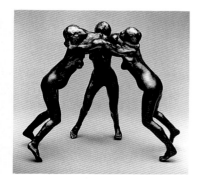

The Three Faunesses, 1882
Bronze, 9 1/4 x 11 1/2 x 6 1/2 in.
(23.5 x 29.2 x 16.5 cm)

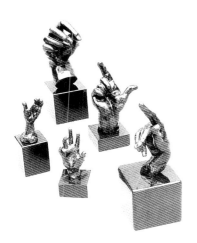

Hand Studies

Rodin: Hand Studies

Rodin considered the placement of the hands in his sculpture of utmost importance. In a 1909 interview he declared: "I have always had an intense passion for the expression of the human hands."[19] This preoccupation led him to create numerous small studies of isolated hands, some of which were later cast in bronze or enlarged. He once remarked that he had "modeled 12,000 hands and smashed up to 10,000."[20] It is not known exactly how many he actually made, but Leo Steinberg observed about 150 in the Musée Rodin.[21] They remained unmounted so the artist could easily examine them from every angle. The sculptor regarded them with great affection; a visitor to his studio in 1901 recalled that he would "pick them up tenderly one by one and them turn them about and lay them back."[22]

Rodin's hand studies, however, are not academic exercises of anatomy in movement. Rarely do they depict conventional gestures. They number among the most emotionally charged fragments he ever created, and elicited elaborate praise from his contemporaries. In an article on Rodin's hand studies in *La Plume* (1900), the Symbolist poet Gustave Kahn called him "the sculptor of hands, of furious, clenched, angered, damned hands."[23] Rilke observed: "Hands which leap up, irritated and spiteful; hands whose five bristling fingers seem to bellow like the five throats of a hell-hound. Hands that walk, sleeping hands, and hands that awaken. Criminal hands, cursed with heredity, and those …that have laid themselves down in a corner like sick animals…But hands are already a rather complicated organism, a delta into which much life has flowed from distant origins to bathe in the great stream of action."[24]

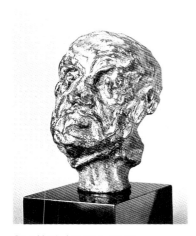

Small Head of the Man with the
Broken Nose, 1882
Bronze, 5 x 3 x 4 in.
(12.7 x 7.6 x 10.2 cm)

Rodin: Small Head of the Man with the Broken Nose

Throughout his life Rodin retained a fondness for *The Man with the Broken Nose*, which he regarded as one of his finest sculptures. He once remarked, "I have never succeeded in making a figure as good as `The Broken Nose.'"[25] The image haunted him, emerging unexpectedly in his work from time to time. Nearly twenty years after its initial creation Rodin revised the head while he worked on *The Gates of Hell*. He incorporated it in the lintel over *The Thinker*, and in the tympanum to the right of that figure. Bébé's likeness can no longer be discerned; his formerly distinctive features disintegrate into a mass of expressive lumps and hollows, and the extreme distortions of the face suggest suffering and tragedy.[26]

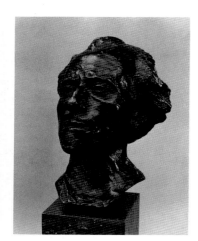

Gustav Mahler, 1909
Bronze, 13 x 13 1/2 x 12 in.
(33 x 34.3 x 30.5 cm)

Rodin: Gustav Mahler

Rodin received the commission for a bust of Gustav Mahler (1860-1911) in April 1909 from the Austrian painter Carl Moll, the composer's father-in-law. He met Mahler for the first time at a dinner with mutual friends on April 23, 1909, at the Café de Paris and was deeply moved by the meeting: "I find his features remarkable. There is a suggestion of the Eastern origin, but something even more remote, of a race now lost to us—the Egyptians in the days of Rameses."[27]

Mahler posed for Rodin at least four times in April of that year and again in October.[28] The sculptor strove to achieve not merely a physical likeness but to capture his subject's inner spirit as well. In order to establish the form of the face from every angle, Rodin always started with life studies, but his technique unintentionally offended Mahler. According to Rodin: "I told him, perhaps too brusquely, to get down on his knees. I wanted to see his head from above, to gauge its volume and contour, and the musician thought it was to humiliate him."[29] Rodin created two versions of the bust: one a straightforward, descriptive portrait; the other, as seen in the Cantor bronze, characterized by bold, exaggerated modeling.

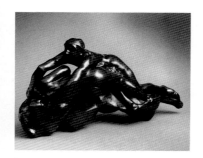

Paolo and Francesca, 1889
Bronze, 12 1/8 x 22 1/4 x 14 3/4 in.
(30.8 x 56.5 x 37.5 cm)

Rodin: Paolo and Francesca

As late as January 1886 the group known as *The Kiss* represented the ill-fated lovers Paolo Malatesta and Francesca da Rimini on *The Gates of Hell*.[30] It has not been determined how long after that Rodin replaced the figures with the portrayal of the couple drifting through hell. For Rodin, the fate of the tragic couple exemplified the theme of *The Gates*, that man is incapable of fulfilling his desires. As in the case of so many other frustrated inhabitants of Rodin's hell, the figures touch but remain isolated from one another. The group's animated, curved composition is echoed in the overall design of *The Gates*. As Robert Goldwater has observed, it is this surging, restless energy that "charges the figures with an agony of hopeless struggle" and ultimately unifies the colossal doors.[31]

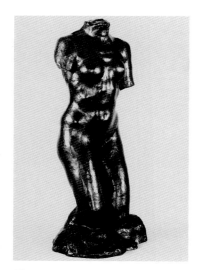

The Prayer, 1909
Bronze, 49 1/2 x 21 5/8 x 19 5/8 in.
(127 x 55 x 49.8 cm)

Rodin: The Prayer

Late in his life Rodin concentrated on the partial figure, which he considered to be his greatest artistic legacy. "I am an inventor," he declared, "I deliver the results of my researches in *morceaux* that are the study of planes and modeling. I am reproached for not personally showing all the applications that result from them. Let those who follow me occupy themselves with this task. I must content myself with having led the intelligence of the artists of my time into the environment of Michelangelo and the Antique."[32]

Rodin exhibited a 50-inch-high plaster version of *Prayer*, identical to the Cantor bronze, at the Salon of 1910. Two small plaster versions of the composition, one lacking the right leg, are preserved in the Musée Rodin, Paris.

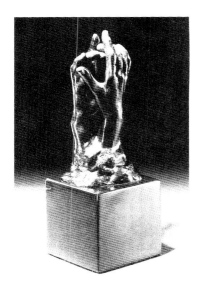

Study for the Secret, c. 1910
Bronze, 4 3/4 x 2 3/8 x 2 1/2 in.
(12 x 6 x 6.4 cm)

Rodin: Study for the Secret

This pair of hands is a product of Rodin's experimentation. In the enlarged *Secret* (33 1/2 inches high) the two identical right hands hold a scroll or tablet. According to Grappe, *The Secret* was exhibited in London in 1910 under the title *Hands Holding the Sacred Tablets.*[55] It has been proposed that the sculpture derived from Rodin's interest in Northern Renaissance emblems.[54] The alternate religious title suggests what is perhaps an unintended connection with Rodin's better-known paired hands, *The Cathedral* (1908).

Rodin: The Sorrow, from The Gates of Hell

The Sorrow is a truncated adaptation of a female figure from the upper right corner of *The Gates of Hell.* The figure is more emotionally restrained than most of the other demonstrative inhabitants in *The Gates.* Within the larger composition it is largely overshadowed by better-known figures and groups. The independent fragment endows the conception with greater poignancy.

Grappe dated the plaster model in the Musée Rodin to about 1892.[55] This bronze was produced in honor of Mr. Cantor's commission of a new cast of *The Gates of Hell*, which was made at the Coubertin Foundry from 1977 to 1981 for the exhibition *Rodin Rediscovered* at the National Gallery of Art, Washington, D.C. The prodigious enterprise resulted in the fifth and finest cast of the Gates. This cast, the only version produced through the lost-wax method as Rodin had stipulated, now resides at Stanford University.

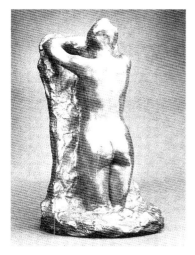

The Sorrow, from The Gates of Hell, 1889
Bronze, 11 1/2 x 6 1/2 x 6 3/4 in.
(29.2 x 16.5 x 17.2 cm)

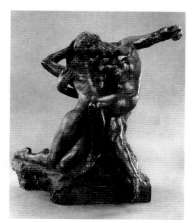

Eternal Spring, 1884
Bronze, 25 1/2 x 28 1/2 x 15 1/2 in.
(64.8 x 72.4 x 39.4 cm)

Rodin: Eternal Spring

The theme of embracing lovers preoccupied Rodin while he worked on *The Gates of Hell* and resulted in the creation of groups of amorous couples, notably *The Kiss, Eternal Idol,* and *Eternal Spring.* In 1891 he explained to the Dutch critic Willem Byvanck that he had intended to portray "Love in the various phases and poses in which it appears in our imagination. Or, rather I want to say passion, because above all the work must be alive."[36] As the imagery of *The Gates* evolved the tone became more tragic, and he chose instead to depict despairing lovers.[37] *Eternal Spring,* first entitled *Zephyr and the Earth,* was exhibited at the Salon of 1897 as *Cupid and Psyche.* The clay model of the group appears in front of an early version of *The Gates* in a photograph by Bodmer (c. 1881).[38]

The completed work brought Rodin tremendous fame and proved to be one of his greatest commercial successes. The first bronze edition was cast by Griffoul et Lorge from 1887 to1894, and Leblanc-Barbedienne produced about 141 casts in various sizes during Rodin's lifetime.[39] In the highly popular marble versions of the piece, the man's left arm is supported by a craggy, flower-covered rock, and the base of the sculpture is extended beneath the right leg. The man's back shows traces of wings, identifying him as Cupid. This design, considered to be a later variation, was selected for casting by Leblanc-Barbedienne. The setting adds a sentimental quality to the work that detracts from the power of the original composition as seen in the Cantor bronze.

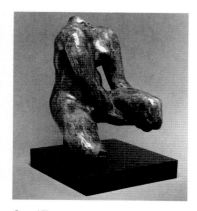

Seated Torso, c. 1890
Bronze, 14 3/8 x 9 1/2 x 11 in.
(36.5 x 24.2 x 28 cm)

Rodin: Seated Torso

In his 1908 biography of Rodin, Otto Grautoff identifies this partial figure as a study for *Iris, Messenger of the Gods.*[40] Certainly the informal pose relates it to other figures depicted holding their legs or feet that Rodin is thought to have made about 1890 in preparation for the Victor Hugo monument. The fleshy model for the *Torso* corresponds to a physical type Rodin sometimes portrayed in the 1890s.[41]

A small plaster version, 5 1/4 inches high, is in the Spreckels Collection at the California Palace of the Legion of Honor, San Francisco.[42] The Maryhill Museum of Art, Washington, D.C., possesses an eleven-inch plaster of the composition.[43]

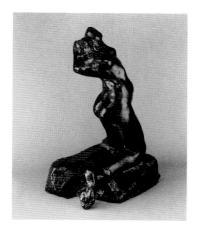

Kneeling, Twisting Nude Torso, n.d.
Bronze, 23 3/4 x 12 5/8 x 13 3/4 in.
(60.3 x 32 x 35 cm)

Rodin: Kneeling, Twisting Nude Torso

Rodin considered the silhouettes of his partial figures to be as important as the contours of his full figures. Even a fractured joint usually suggested direction and movement that were integral to the overall design of a piece.[44] He was particularly drawn to twisted, arabesque forms, which appear in *Meditation without Arms* and this torso, among other works. He termed this exaggerated torsion *désinvolture,* a phrase sometimes given as the title of this sculpture.[45] The figure looks almost as though Rodin had activated the serene kneeling torso *Prayer* to perform a gyrating motion. The date of the torso is not known; however, like *Meditation without Arms* and *Prayer,* it may have developed from studies for *The Gates of Hell.*

Catalog of Works

Auguste Rodin

Hand of God, 1897
Bronze, 6 x 3 1/2 x 3 in.
(15.2 x 9 x 7.7 cm)
Signature: "A. Rodin"
Inscription: "Alexis Rudier Fondeur Paris"

Hand of God, 1897
Plaster, 28 3/4 x 26 3/4 x 38 in.
(73 x 68 x 96.5 cm)
Signature: "A. Rodin"
Inscription: "La Main de Dieu offerte par le
Musée Rodin à B. Gerald CANTOR"
Exhibitions: *Rodin Rediscovered,* National Gallery
of Art, Washington, D.C. (June 28, 1981-May 2,
1982); *Rodin: The B. Gerald Cantor Collection,*
Metropolitan Museum of Art, New York
(April 19-June 15, 1986)

The Thinker, 1880
Bronze, 28 x 20 1/4 x 23 in.
(71 x 51.5 x 58.5 cm)
Signature: "A. Rodin"
Inscription: "2, Alexis Rudier Fondeur.Paris"
Exhibition: *Auguste Rodin from the B. Gerald Cantor
Collection and the B.G. Cantor Art Foundation,*
William Rockhill Nelson Gallery, Kansas City,
Missouri (October 7-November 14, 1971)

The Creator, c. 1900
Bronze, 16 x 14 1/4 x 2 1/2 in.
(40.6 x 36.2 x 6.4 cm)
Signature: "A. Rodin"
Inscription: "No. 3/8, © By Musée Rodin 1983"
Stamped with Coubertin Foundry cachet
Exhibition: *Rodin: The B. Gerald Cantor Collection,*
Metropolitan Museum of Art, New York
(April 19-June 15, 1986)

Adam, 1880
Bronze, 75 1/2 x 29 1/2 x 29 1/2 in.
(191.8 x 75 x 75 cm)
Signature: "RODIN"
Inscription: "No. 7/8, © By Musée Rodin 1984"
Stamped with Coubertin Foundry cachet

Eve, c. 1887
Marble, 30 1/4 x 11 1/2 x 13 in.
(76.8 x 29.2 x 33 cm)
Signature: "A. Rodin"

Eve, 1881
Bronze, 68 x 23 3/4 x 30 in.
(172.7 x 60.4 x 76.2 cm)
Signature: "A. Rodin"
Inscription: "Georges Rudier Fondeur Paris,
© Musée Rodin 1950"
Cast no. 8/12

The Three Shades, 1880 (enlarged c. 1898)
Bronze, 75 1/2 x 75 1/2 x 42 in.
(191.8 x 191.8 x 106.7 cm)
Signature: "A. Rodin."
Inscription: "No 3/8, © By Musée Rodin 1983"

**She Who Was Once the Helmet-Maker's
Beautiful Wife,** c. 1880-83
Bronze, 20 x 12 x 10 in.
(50.8 x 30.5 x 25.4 cm.)
Signature: "A. Rodin"
Inscription: "L. Perzinka/Fondeur"

Women Damned, c. 1885-86
Bronze, 8 x 10 3/4 x 5 in.
(20.3 x 27.3 x 12.7 cm)
Signature: "A. Rodin"
Inscription: "© by Musée Rodin, Paris 1973,
DON DU Musée Rodin à M. BERNIE CANTOR"

Cupid and Psyche, 1886
Bronze, 9 x 28 1/4 x 18 1/2 in.
(22.8 x 71.8 x 47 cm)
Signature: "A. Rodin"
No foundry mark
Exhibitions: *International Exhibition of Art,* Venice
(April 22-October 31, 1901); *Auguste Rodin from the
B. Gerald Cantor Collection and B.G. Cantor Art
Foundation,* William Rockhill Nelson Gallery of
Art, Kansas City, Missouri
(October 7-November 14, 1971)

The Kiss, c. 1880-84
Bronze, 34 x 17 x 22 in.
(86.4 x 43.2 x 55.9 cm)
Signature: "A. Rodin"
Inscription: "© by Musée Rodin 1958, Georges
Rudier Fondeur Paris 1958"
Cast no. 6/12
Exhibitions: *Auguste Rodin from the B. Gerald Cantor
Collection and the B.G. Cantor Art Foundation,* William
Rockhill Nelson Gallery of Art, Kansas City,
Missouri (October 7-November 14, 1971);
Metamorphoses in Nineteenth-Century Sculpture,
Fogg Art Museum, Harvard University,
Cambridge, Massachusetts
(November 19, 1975-January 7, 1976)

Eternal Idol, 1889
Bronze, 29 x 23 x 16 in.
(73.7 x 58.5 x 40.7 cm)
Signature: "A. Rodin"
Inscription: "Georges Rudier. Fondeur. Paris.
© by Musée Rodin 1970"
Cast no. 6/12

Auguste Rodin

Meditation, 1896-97
Bronze, 61 1/2 x 29 x 26 in.
(156 x 73.7 x 66 cm)
Signature: "A. Rodin"
Inscription: "No. 8, FONDERIE COUBERTIN,
© by Musée Rodin 1979"
Stamped with Coubertin Foundry cachet
Cast no. 8/12
Exhibitions: *Auguste Rodin*, C. W. Post Art
Gallery, Long Island University, Greenvale, New
York (April 27-May 11, 1980); *Sculpture for the
Blind*, Grey Art Gallery, New York University
(July-August, 1980); *Rodin Rediscovered*, National
Gallery of Art, Washington, D.C.
(June 28, 1981-May 2, 1982)

Meditation without Arms, 1896-97
Bronze, 57 1/2 x 28 x 22 1/8 in.
(146 x 71 x 56 cm)
Signature: "A. Rodin"
Inscription: "No. 6/8, © By Musée Rodin 1983"
Coubertin Foundry cachet
Exhibition: Rodin: *The B. Gerald Cantor Collection*,
Metropolitan Museum of Art, New York
(April 19-June 15, 1986)

Toilette of Venus and Andromeda
Bronze, 20 x 14 1/2 x 23 1/2 in.
(50.8 x 36.8 x 59.7 cm)
Signature: "A. Rodin"
Inscription: "No. 1/8, © by Musée Rodin,
Godard 1987"

Toilette of Venus, c. 1886
Bronze, 18 x 9 1/2 x 8 1/2 in.
(45.7 x 24.2 x 21.6 cm)
Signature: "A. Rodin"
Inscription: "© by Musée Rodin. 1967, Georges.
Rudier. Fondeur. Paris"
Cast no. 4/12
Exhibitions: *Homage to Rodin: Collection of B. Gerald
Cantor*, Los Angeles County Museum of Art
(November 14, 1967-January 7, 1968), and tour;
Rodin, Bon Marché, Seattle, Washington
(April 9-April 25, 1969)

The Walking Man, 1900
Bronze, 33 x 20 1/4 x 20 in.
(84 x 51.5 x 50.8 cm)
Signature: "A.R."
Inscription: "Alexis Rudier Fondeur Paris"
Exhibition: *The Passion of Rodin: Sculpture from the B.
Gerald Cantor Collection*, Dixon Gallery and
Gardens, Memphis, Tennessee
(February 9-April 3, 1988), and tour

Torso of the Walking Man, 1877
Bronze, 20 1/2 x 10 3/4 x 8 in.
(52 x 27.3 x 20.3 cm)
Signature: "A. Rodin"
Inscription: "No. 2, © By Musée Rodin 1979"
Stamped with Coubertin Foundry cachet

The Monumental Torso of the Falling Man, 1882
Bronze, 40 1/2 x 27 1/2 x 18 1/2 in.
(103 x 69.9 x 47 cm)
Signature: "A. Rodin"
Inscription: "No. 4, Georges Rudier Fordeur."

Iris, Messenger of the Gods, c. 1890-91
Bronze, 38 x 32 1/2 x 15 1/2 in.
(96.5 x 82.5 x 39.4 cm)
Signature: "A. Rodin" Inscription: "Georges
Rudier Fondeur. Paris, © by Musée Rodin 1969"
Exhibition: *Rodin: The B. Gerald Cantor Collection*,
Metropolitan Museum of Art, New York
(April 19-June 15, 1986)

Dance Movement A, c. 1910-11
Bronze, 25 3/4 x 10 7/8 x 5 1/4 in.
(65.5 x 27.5 x 13.3 cm)
Signature: "A. Rodin"
Inscription: "Alexis Rudier Fondeur, PARIS"
Exhibitions: *Auguste Rodin*, Flint Institute of Arts,
Flint, Michigan (January 13-March 16, 1980);
Rodin Rediscovered, National Gallery of Art,
Washington, D.C. (June 28, 1981-May 2, 1982);
*The Passion of Rodin: Sculpture from the B. Gerald Cantor
Collection*, Dixon Gallery and Gardens, Memphis,
Tennessee (February 6-April 3, 1988) and tour

Dance Movement B, c. 1910-11
Bronze, 12 1/2 x 5 1/8 x 4 1/2 in.
(31.8 x 13 x 11.5 cm)
Signature: "A. Rodin"
Inscription: "No. 7, © By Musée Rodin 1956"
Cast by Georges Rudier
Exhibitions: *Rodin Drawings True and False*,
Solomon R. Guggenheim Museum, New York
(March 9-May 14, 1972); *Rodin Rediscovered*,
National Gallery of Art, Washington, D.C. (June
28, 1981-May 2, 1982); *Rodin: The B. Gerald Cantor
Collection*, Metropolitan Museum of Art, New York
(April 19-June 15, 1986)

Auguste Rodin

Dance Movement D, c. 1910-11
Bronze, 12 3/4 x 41/4 x 3 5/8 in.
(32.5 x 10.8 x 9.2 cm)
Signature: "A. Rodin"
Inscription: "ALEXIS RUDIER Fondeur. PARIS"
Exhibition: *Rodin: The B. Gerald Cantor Collection,*
Metropolitan Museum of Art, New York
(April 19-June 15, 1986)

Dance Movement F, 1911
Bronze, 11 x 10 1/2 x 5 1/2 in.
(28 x 26.7 x 14 cm)
Signature: "A. Rodin"
Inscription: "No. 10"
Exhibition: *Rodin: The B. Gerald Cantor Collection,*
Metropolitan Museum of Art, New York
(April 19-June 15, 1986)

Dance Movement H, c. 1910
Bronze, 11 x 5 1/4 x 5 1/2 in.
(28 x 13.3 x 14 cm)
Signature: "A. Rodin"
Inscription: "Georges Rudier Fondeur Paris"
Cast no. 9/12
Exhibition: *Rodin: The B. Gerald Cantor Collection,*
Metropolitan Museum of Art, New York
(April 19-June 15, 1986)

Pas-de-Deux B, c. 1910-11
Bronze, 13 x 7 1/8 x 5 in.
(33 x 18.5 x 12.7 cm)
Signature: "A. Rodin"
Inscription: "No. 8, G. Rudier Fondeur Paris,
© By Musée Rodin. 1965"
Exhibition: *The Passion of Rodin: Sculpture from the B.
Gerald Cantor Collection,* Dixon Gallery and
Gardens, Memphis, Tennessee
(February 9- April 3, 1988), and tour

La France, 1904-06
Bronze, 23 3/4 x 21 1/2 x 12 in.
(60.5 x 54.5 x 30.5 cm)
Signature: "A. Rodin"
No foundry mark

Nijinsky, 1912
Plaster, 7 1/2 x 3 3/4 x 3 1/2 in.
(19 x 9.5 x 9 cm)
No inscriptions

Head of Hanako, 1908-11
Bronze, 12 x 9 1/2 x 9 1/2 in.
(30.5 x 24.2 x 24.2 cm)
Signature: "A. Rodin"
Inscription: "Georges Rudier Fondeur Paris,
© by Musée Rodin 1962"

**Monumental Head of St. John the Baptist,
c. 1879**
Bronze, 21 1/2 x 20 3/4 x 15 1/4 in.
(54.5 x 52.7 x 38.7 cm)
Signature: "A. Rodin"
Inscription: "No. 4/8, © By Musée Rodin 1986,
E. GODARD Fondr"
Exhibition: *The Passion of Rodin: Sculpture from the B.
Gerald Cantor Collection,* Dixon Gallery and
Gardens, Memphis, Tennessee
(February 9- April 3, 1988), and tour

Monumental Bust of Victor Hugo, 1897
Bronze, 29 1/4 x 23 1/2 x 21 1/4 in.
(74.3 x 59.7 x 54 cm)
Signature: "A. Rodin"
Inscription: "No. 7, © by Musée Rodin 1981"
Stamped with Coubertin Foundry cachet

Eustache de Saint-Pierre (grand model), 1885
Bronze, 85 x 30 x 48 in.
(216 x 76.2 x 122 cm)
Signature: "A. Rodin"
Inscription: "No. III/IV, © by Musée Rodin 1980"
Stamped with Coubertin Foundry cachet

Jean de Fiennes (grand model), 1885-86
Bronze, 82 x 48 x 38 in.
(208.6 x 122 x 96.5 cm)
Signature: "A. Rodin"
Inscription: "No. 2, © by Musée Rodin 1987"
Stamped with Coubertin Foundry cachet

Pierre de Wiessant (grand model), 1885-86
Bronze, 81 x 40 x 48 in.
(206 x 101.6 x 122 cm)
Signature: "A. Rodin"
Inscription: "No. 7/8, © By Musée Rodin 1983"
Stamped with Coubertin Foundry cachet

Monumental Head of Jean d'Aire, c. 1900
Bronze, 26 3/4 x 19 7/8 x 22 1/2 in.
(68 x 50.5 x 57.2 cm)
Signature: "A. Rodin"
Inscription: "No. 5, © by Musée Rodin [no date],
Georges Rudier Fondeur Paris"

**Monumental Head of Pierre de Wiessant,
c. 1900**
Bronze, 28 1/2 x 19 3/4 x 21 in.
(72.5 x 50.2 x 53.4 cm)
Signature: "A. Rodin"
Inscription: "No. 10, © by Musée Rodin 1980"

Balzac in a Robe, 1897
Bronze, 44 x 19 x 17 in.
(112 x 48.3 x 43.2 cm)
Signature: "A. Rodin"
Inscription: "No. 1/8, © by Musée Rodin 1983,
E. GODARD Fondr"

Auguste Rodin

Naked Balzac with Folded Arms, 1892-93
Bronze, 50 1/4 x 27 3/4 x 22 3/4 in.
(127 x 70.5 x 57.8 cm)
Signature: "A. Rodin"
Inscription: "No. 10, E. Godard Fondeur."

Head of Balzac, 1892-93
Bronze, 10 x 10 1/4 x 9 7/8 in.
(25.4 x 26 x 25.1 cm)
Signature: "A. Rodin"
Inscription: "No. 4/8, © by Musée Rodin 1985,
E. Godard Fondeur"

Hand of Rodin with a Torso, 1917
Bronze, 6 1/8 x 8 3/4 x 4 1/8 in.
(15.5 x 22.2 x 10.5 cm)
Signature: "A. Rodin"
Inscription: ".Georges Rudier. Fondeur. Paris,
© by Musée Rodin 1968"

Emile-Antoine Bourdelle (1861-1929)

Herakles the Archer, 1909
Bronze, 21 1/2 x 23 1/2 x 11 in.
(54.5 x 59.7 x 28 cm)
Inscription: "Susse Fondeur Paris No. 7,
© By Bourdelle"
Stamped with Bourdelle's cachet
Exhibitions: *Antoine Bourdelle*, National Gallery of
Canada, Ottawa (1961); *Bourdelle*, Slatkin Gallery,
New York (December 1969)

Camille Claudel (1864-1943)

The Waltz, 1891
Bronze, 18 x 14 x 7 in.
(45.8 x 35.5 x 17.8 cm)
Signature: "C. Claudel"
Inscription: "Eug. Blot Paris 8"

Jules Dalou (1838-1902)

Torso of Abundance
Bronze, 21 x 9 x 7 3/4 in.
(53.4 x 22.9 x 19.7 cm)
Signature: "J. DALOU"
Inscription: "cire perdue, Susse Fondeur edition"
Stamped with Susse Frères Foundry cachet

Georg Kolbe (1877-1947)

Seated Girl, 1907
Bronze, 17 1/4 x 12 x 11 in.
(45 x 30.5 x 28 cm)
Signature: "GK"
Inscription: "NOACK - BERLIN"
Exhibition: *Georg Kolbe: Sculpture from the Collection
of B. Gerald Cantor; Drawings from the Georg Kolbe
Museum, Berlin*, Herbert F. Johnson Museum of Art,
Cornell University, Ithaca, New York
(November 21-December 22, 1972), and tour

Assumption, 1921
Bronze, 77 x 15 1/2 x 19 1/2"
(195.5 x 40.3 x 49.5 cm)
Signature: "GK"
Inscription: "H. NOACK - BERLIN"
Exhibition: *Georg Kolbe: Sculpture from the Collection
of B. Gerald Cantor; Drawings from the Georg Kolbe
Museum, Berlin*, Herbert F. Johnson Museum of Art,
Cornell University, Ithaca, New York
(November 21-December 22, 1972), and tour

Lament, 1921
Bronze, 15 1/2 x 21 1/2 x 10 in.
(39.4 x 54.6 x 25.4 cm)
Signature: "GK"
Inscription: "H. NOACK - BERLIN"
Exhibition: *Georg Kolbe: Sculpture from the Collection
of B. Gerald Cantor; Drawings from the Georg Kolbe
Museum, Berlin*, Herbert F. Johnson Museum of Art,
Cornell University, Ithaca, New York
(November 21-December 22, 1972), and tour

Large Kneeling Woman, 1924
Bronze, 44 1/2 x 16 3/4 x 23 3/4 in.
(113 x 42.5 x 60.3 cm)
Signature: "GK"
Inscription: "H. NOACK - BERLIN"
Exhibition: *Georg Kolbe: Sculpture from the Collection
of B. Gerald Cantor; Drawings from the Georg Kolbe
Museum, Berlin*, Herbert F. Johnson Museum of Art,
Cornell University, Ithaca, New York
(November 21-December 22, 1972), and tour

Seated Girl, 1926
Bronze, 11 1/4 x 10 1/4 x 7 1/4 in.
(28.5 x 26 x 18.4 cm)
Signature: "GK"
Inscription: "H. NOACK - BERLIN"
Exhibition: *Georg Kolbe: Sculpture from the Collection
of B. Gerald Cantor; Drawings from the Georg Kolbe
Museum, Berlin*, Herbert F. Johnson Museum of Art,
Cornell University, Ithaca, New York
(November 21-December 22, 1972), and tour

Georg Kolbe (1877-1947)

Large Seated Woman, 1929
Bronze, 38 3/4 x 24 1/2 x 24 in.
(98.5 x 62.3 x 61 cm)
Signature: "GK"
Inscription: "H. Noack - Berlin"
Exhibition: *Georg Kolbe: Sculpture from the Collection of B. Gerald Cantor; Drawings from the Georg Kolbe Museum, Berlin,* Herbert F. Johnson Museum of Art, Cornell University, Ithaca, New York (November 21-December 22, 1972), and tour

Falling Woman, 1938
Bronze, 15 1/4 x 18 x 11 7/8 in.
(38.8 x 45.7 x 29.8 cm)
Signature: "GK"
Inscription: "H. Noack - Berlin"
Exhibition: *Georg Kolbe: Sculpture from the Collection of B. Gerald Cantor; Drawings from the Georg Kolbe Museum, Berlin,* Herbert F. Johnson Museum of Art, Cornell University, Ithaca, New York (November 21-December 22, 1972), and tour

Gaston Lachaise (1882-1935)

Classic Torso, 1928
Polished bronze, 11 x 7 x 3 in.
(28 x 17.8 x 7.6 cm.)
Inscription: "6/8 LACHAISE ESTATE"

Wilhelm Lehmbruck (1881-1919)

Seated Girl, 1913-14
Bronze, 11 1/2 x 18 1/2 x 8 1/4 in.
(29.2 x 47 x 21 cm)
Signature: "W. Lehmbruck"
Inscription: "H. Noack Berlin-Friedenau"

Giacomo Manzù (1908-1991)

Seated Cardinal, 1972
Bronze, 20 x 11 x 9"
(50.8 x 28 x 23 cm)
Signature: "MANZU"
Inscription: "MEF"

Alfred Sisley (1839-1899)

The Chestnut Tree at Saint-Mammès, 1880
Oil on canvas, 19 5/8 x 25 7/8 in.
(50 x 65.8 cm)
Signed and dated, lower left: "Sisley . 80"
Provenance: Paul Durand-Ruel, Paris; Robert Eisner, New York; Durand-Ruel Gallery, New York
Exhibitions: *Alfred Sisley,* Durand-Ruel Gallery, New York (October 1939); New York World's Fair Exhibition (1940); *140th Anniversary Exhibition,* Durand-Ruel Gallery, New York (1943); *Sisley,* Wildenstein Gallery, New York (1966)

Roger de la Fresnaye (1885-1925)

Eve, c. 1909-10
Oil on canvas, 50 x 37 1/2 in.
(127 x 95.3 cm)
Provenance: Henri Kapferer, Paris; Wildenstein, New York; Pedro Vallenilla Echeverria, Caracas
Exhibitions: Société des Artistes Indépendants, Paris (1910); Les Maîtres de l'Art Indépendant, 1895-1937, Petit Palais, Paris (June - October 1937); *Les Chefs-d'oeuvre des collections privées françaises, retrouvé en Allemagne,* Musée de l'Orangerie, Paris (June-August 1946); Roger de la Fresnaye, Musée National de l'Art Moderne, Paris (July - October 1950); *Roger de la Fresnaye,* M. Knoedler and Co., New York (February 1951); *Figures nues d'école française,* Galerie Charpentier, Paris (1953); *Las Colecciones Privadas en Venezuela: Coleccion Pedro Vallenilla Echeverria,* Museo de Bellas Artes, Caracas (1961)

Maurice de Vlaminck (1876-1955)

The Poet Fritz Vanderpyl, 1918
Oil on canvas, 25 5/8 x 21 1/2 in.
(65 x 54.5 cm)
Signed, lower left: "Vlaminck"
Provenance: Fritz Vanderpyl, Paris
Exhibitions: *Exposition Rétrospective de 70 Tableaux par Vlaminck*, Bernheim-Jeune, Paris (January 23-February 3, 1933); Vlaminck, Palais des Beaux-Arts, Brussels (1933); Selections fom the B. Gerald Cantor Collection, Des Moines Art Center (December 9, 197-January 10, 1971), and tour

Snowy Landscape, ca. 1924
Oil on canvas, 32 x 39 in.
(81.3 x 99 cm)
Signed, lower right: "Vlaminck"
Provenance: Paul Petrides Gallery, Paris

Hotel du Laboureur, Rueil-la-Gadelière, c. 1925
Oil on canvas, 35 1/2 x 45 3/4 in.
(90.2 x 116.3 cm)
Signed, lower right: "Vlaminck"
Provenance: André Weil, Paris; Edward G. Robinson, New York; Anthony Reinach, New York
Exhibitions: *Gladys Lloyd Robinson Collection*, Washington Museum of Fine Arts, Hagerstown, Maryland (1956-1957); *Inaugural Exhibition*, Oklahoma Art Center, Oklahoma City (1958-59)

Robert Delaunay (1885-1941)

Portrait of Jean Metzinger, 1906
Oil on paper, 20 3/8 x 17 in.
(51.8 x 43.2 cm)
Provenance: Galerie Bellier, Paris; Mrs. Algur H. Meadows, Dallas
Exhibitions: *Dallas Collects: Impressionist and Early Modern Masters*, Dallas Museum of Fine Arts (January-February 1978)

Emil Nolde (1867-1956)

Sunflower Garden, 1937
Oil on canvas, 26 3/4 x 35 in.
(68 x 89 cm)
Signed, lower right: "Emil Nolde"
Signed and inscribed on stretcher: "Emil Nolde, Sonnenblumengarten"
Provenance: Hedwig Berg; Hans Heinrich Berg; private collection, London; Serge Sabarsky Gallery, New York
Exhibition: *Expressionists*, Serge Sabarsky Gallery, New York (1984)

Three Figures, c. 1930
Watercolor on Japan paper, 13 x 17 1/4 in.
(33 x 43.8 cm)
Signed, lower right: "Nolde"
Provenance: David Peter Bloom

Landscape with Red House, c. 1920
Watercolor, 13 x 18 in.
(33 x 45.7 cm)
Signed, lower right: "Nolde"

Max Beckmann (1884-1950)

Femina Bar, 1936
Oil on canvas, 23 3/4 x 54 3/4 in.
(60.3 x 139 cm)
Signed and dated, lower left: "Beckmann 36"
Provenance: Curt Valentin, New York;
Buchholz Gallery, New York; Morton D. May,
St. Louis; Marlborough Fine Art, London;
Saul P. Steinberg, New York
Exhibitions: *Max Beckmann*, Kunsthalle, Bern
(February-March 1938); *German Expressionists and
Max Beckmann from the Collection of Mr. and Mrs.
Morton D. May*, Arts Club, Chicago (November-
December 1951); *Max Beckmann Retrospective
Exhibition*, City Art Museum, St. Louis (June-July
1956); *German Expressionist Paintings from the Collection
of Mr and Mrs. Morton D. May*, Denver Art Museum
(May 1960); *German Expressionist Paintings from the
Collection of Morton D. May*, Portland Art Museum,
Portland, Oregon (September-October 1967);
*Deutsche Expressionisten aus der Sammlung Morton D.
May*, Kunsthalle, Bielefeld (September-October
1968); *The Morton D. May Collection of Twentieth-
Century German Masters*, Marlborough-Gerson
Gallery, New York (January -February 1970);
Max Beckmann Retrospective Exhibition, Marlborough
Fine Art, London (October-November 1974)

Kees van Dongen (1877-1968)

Masked Ball at the Opéra, 1905
Oil on canvas, 18 1/2 x 25 5/8 in.
(47 x 65 cm)
Signed, lower center: "van Dongen"
Provenance: Galerie Daniel Malinque, Paris;
Galerie Charpentier, Paris

Portrait of Jules Berry, 1937
Oil on canvas, 88 5/8 x 51 5/8 in.
(227 x 131 cm)
Signed, lower right: "van Dongen"
Provenance: Galerie Charpentier, Paris
Exhibitions: Van Dongen Cinquante ans de
peintre, Galerie Charpentier, Paris (1942);
Van Dongen, Galerie Charpentier, Paris (1949)

Gustave Caillebotte (1848-1894)

Nude Reclining on a Divan, 1873
Pastel , 35 x 43 3/4 in.
(89 x 111 cm)
Signed and dated, lower right: "G. Caillebotte 1873"
Provenance: Wildenstein, Paris; Dr. E. Lionel Pavlo
Exhibition: *Monet to Matisse: French Art in Southern
California*, Los Angeles County Museum of Art
(June 9-August 11, 1991)

Armand Guillaumin (1841-1927)

Dr. Martinez in the Painter's Studio, 1878
Oil on canvas, 35 1/8 x 29 1/4 in.
(89 x 74.3 cm)
Signed and dated, lower right: "Guillaumin 78"
Provenance: J. M. Canneel, Brussels; Hugo Perls,
New York; Margit Chanin, New York; Mr. and
Mrs. Lester Avnet, Great Neck, New York;
Mr.and Mrs. Paul Mellon
Exhibitions: *French Paintings from the Collections of
Mr. and Mrs. Paul Mellon and Mrs. Mellon Bruce*,
National Gallery of Art in Washington, D.C.
(March-May 1966); *Monet to Matisse: French Art in
Southern California Collections*, Los Angeles County
Museum of Art (June 9-August 11, 1991)

Jean-Louis Forain

Woman Dressing, c. 1890
Oil on canvas, 32 x 26 in.
(81.3 x 66 cm)
Signed, lower left: "Forain"
Provenance: Pierre May, Paris
Exhibition: *Forain, oeuvres de 1875 à 1895*, Galerie
Philippe Reichenbach, Paris (June 16-30, 1965)

Eugène Carrière (1849-1906)

The New Wrist-Watch, c. 1892
Oil on canvas, 12 1/2 x 15 7/8 in.
(31.8 x 40.3 cm)
Signed, lower left: "Eugène Carrière"
Provenance: M. Choublier, the artist's grandson

Leaving the Theater, c. 1895-1900
Oil on canvas, 10 x 26 in.
(25.5 x 66 cm)
Signed, lower right: "Eugène Carrière"
Provenance: Ivan Loiseau, the artist's son-in-law

Théophile-Alexandre Steinlen (1859-1923)

The Lovers, c. 1895-1901
Pastel, 10 1/4 x 17 1/2 in.
(26 x 44.5 cm)
Signed, lower right: "Steinlen"
Provenance: Oscar Ghez, Geneva
Exhibition: *Théophile-Alexandre Steinlen*,
University Art Gallery, Rutgers University,
New Brunswick, New Jersey (1981)

Louis Valtat (1869-1952)

The Steamboat, c. 1895
Oil on canvas, 20 3/4 x 25 1/4 in.
(52.7 x 64.2 cm)
Signed with initials, lower right: "LV"
Exhibition: *Selections from the B. Gerald Cantor
Collection*, Des Moines Art Center
(December 9, 1970-January 10, 1971), and tour

La Toilette, c. 1893
Oil on canvas, 51 x 39 1/4 in.
(129.5 x 99.8 cm)
Signed, lower left: "L. Valtat"
Provenance: Ambroise Vollard, Paris; Modern
Art Foundation, Geneva
Exhibitions: *Rétrospective Valtat*, Salon d'Automne,
Grand Palais, Paris (1952); *Louis Valtat Rétrospective
Centenaire (1869-1969)*, Petit Palais, Geneva
(June 26-September 21, 1969)

Lovis Corinth (1858-1925)

Portrait of Elly, 1898
Oil on canvas, 74 1/2 x 45 1/2 in.
(189.2 x 115.5 cm)
Signed twice, lower right:
"Lovis Corinth Lovis Corinth"
Inscribed, center right: "Elly"
Exhibitions: Berlin Secession, 1913

Giovanni Boldini (1842-1931)

Portrait of Mrs. Edward Parker Deacon, 1906
Pastel on paper laid on canvas, 50 3/4 x 37 1/2 in.
(127 x 95.3 cm)
Signed, lower right: "Boldini"
Provenance: Gladys Deacon,
duchess of Marlborough

Louis Hayet (1864-1940)

The Concert, c. 1886-89
Encaustic on paper laid down on board, 7 x 10
(17.8 x 25.5 cm)
Provenance: Jean Sutter, Paris
Exhibitions: *Louis Hayet*, 19 rue Lamartine,
Paris (November 1903); *Les Premiers Indépendants*,
Grand Palais, Paris (1965); *Neo-Impressionism*,
Solomon R. Guggenheim Museum, New York
(February-April 1968); *Louis Hayet, oeuvres néo-
impressionistes de 1881 à 1895*, Musee Tavet, Pontoise
(April 13-August 4, 1991)

At the Café, 1888
Gouache on prepared linen, 8 1/4 x 6 3/4 in.
(21 x 17 cm)
Signed, lower right: "L. Hayet"
Provenance: Jean Sutter, Paris
Exhibition: *Louis Hayet, oeuvres néo-impressionistes de
1881 à 1895*, Musée Tavet, Pontoise
(April 13-August 4, 1991)

At the Theater, c. 1888
Watercolor and gouache on paper, 6 1/2 x 9 3/4 in.
(16.5 x 24.8 cm)
Provenance: Jean Sutter, Paris
Exhibition: *Louis Hayet, oeuvres néo-impressionistes de
1881 à 1895*, Musée Tavet, Pontoise
(April 13-August 4, 1991)

Boulevard in the Evening, Paris, 1884
Ink drawing, 9 x 12 in.
(22.9 x 30.5 cm)
Provenance: Jean Sutter, Paris
Exhibition: *Louis Hayet, oeuvres néo-impressionistes de
1881 à 1895*, Musée Tavet, Pontoise
(April 13-August 4, 1991)

Harold Knight (1874-1961)

A Village Wedding, 1908
Oil on canvas, 63 1/2 x 75 1/4 in.
(161.3 x 191 cm)
Signed, lower right: "Harold Knight"
Provenance: Garnet Wolseley, Jane Alexander
Exhibitions: Royal Academy of Arts, 1908;
Painting in Newlyn, Newlyn Orion Galleries,
Penzance, England (February 1985)

Richard Emil Miller (1875-1943)

Afternoon Tea
Oil on canvas, 34 x 36 in.
(86.4 x 91.5 cm)
Signed, lower right: "Miller"
Provenance: Hirschl and Alder Galleries,
New York

L'Aperitif, c. 1905
Oil on canvas, 38 1/4 x 50 1/4 in.
(97.2 x 127.5 cm)
Signed twice, upper right: "Miller / Miller"

Sewing by Lamplight, 1904
Oil on canvas, 24 x 24 in.
(61 x 61 cm)
Signed, lower right: "Miller"
Provenance: Berry Hill Galleries, New York;
David Peter Bloom, New York
Exhibition: *American Paintings IV*, Berry Hill
Galleries, New York (1986)

Julius Leblanc Stewart (1855-1919)

Five O'Clock Tea, 1883-84
Oil on canvas, 66 x 91 in.
(167.5 x 231.3 cm)
Signed and dated, lower right:
"JL Stewart Paris, 1883-4"
Provenance: Kugler's Restaurant, Philadelphia
Exhibition: Paris Salon (1884)

Lucien Simon

Studio Party, 1904
Oil on canvas, 90 x 180 in.
(229 x 458 cm)
Signed, lower left: "Simon"
Provenance: Museum of Art, Carnegie Institute,
Pittsburgh
Exhibitions: Paris Salon (1905); International
Exhibition, Carnegie Institute, Pittsburgh
(1905, 1913); International Exhibition of Art,
Venice (1912)

Max Slevogt (1868-1932)

Supper on the Terrace, 1912
Oil on canvas, 27 1/2 x 23 1/2 in.
(69.8 x 57.2 cm)
Signed and dated, lower right: "Slevogt 17. Juli 12"
Provenance: Dr. Johannes Guthmann,
Neu-Cladow
Exhibitions: Berlin Secession (1918); *Max Slevogt:
Gemalde Handzeichnungen Graphik,* Niedersachsisches
Landesmuseum, Hannover
(May 15-August 10, 1952)

Paul-César-François Helleu

Portrait of a Pensive Woman
Pencil and crayon on paper, 27 3/4 x 22 in.
(70.5 x 56 cm)
Signed, lower right: "Helleu"
Provenance: Pauline K. Cave

Portrait of a Young Woman
Chalk on buff paper, 26 1/2 x 18 1/2 in.
(67.3 x 47 cm)
Signed, lower right: "Helleu"

Woman Viewing a Bust
Pencil and crayon on paper, 26 x 16 in.
(66 x 40.7 cm)
Provenance: Edouard Sagot, Pauline K. Cave
Exhibitions: *William Merritt Chase and the Company
of Friends,* Parrish Art Museum, Southampton,
New York (1979)

Mikhail Larionov (1881-1964)

The Soldier's Cabaret, c. 1908-09
Oil on canvas, 26 3/4 x 38 1/2 in.
(68 x 97.8 cm)
Inscribed, lower left: "M . . 1 . 04"
Exhibitions: *Michel Larionov,* Galerie de l'Institut,
Paris (May 25-June 13, 1956); *Larionov and
Goncharova,* Arts Council of Great Britain (1961);
Larionov Goncharova, Galerie Beyeler, Basel (July-
September 1961); *Selections from the B. Gerald Cantor
Collection,* Des Moines Art Center
(December 9, 1970-January 10, 1971), and tour

Auguste Rodin

Mask of the Man with the Broken Nose, 1864
Bronze, 18 1/4 x 7 3/8 x 6 1/2 in.
(46.4 x 18.7 x 16.5 cm)
Inscriptions: "DON A MR CANTOR, © by
Musée Rodin [no date]"
Stamped with Coubertin Foundry cachet
Exhibitions: *Auguste Rodin,* Flint Institute of Arts,
Flint, Michigan (January 13-March 16, 1980); *The
Passion of Rodin: Sculpture from the B. Gerald Cantor
Collection,* Dixon Gallery and Gardens, Memphis,
Tennessee (February 9-April 3, 1988), and tour

Large Clenched Left Hand with Figure, c. 1890
Bronze, 17 1/2 x 10 1/2 x 13 1/2 in.
(44.5 x 26.7 x 34.3 cm)
Signature: "A. Rodin"
Inscription: "E. Godard Fondeur., © by Musée
Rodin [no date]"
Cast no. 1
Exhibition: *Rodin: Sculpture and Drawings,*
Hayward Gallery, London
(January 24-April 5, 1970)

Fallen Caryatid Carrying a Stone c. 1881
Bronze, 17 3/8 x 12 x 12 in.
(44.2 x 30.5 x 30.5 cm)
Signature: "A. Rodin"
Inscription: "Alexis.RUDIER. .Fondeur.Paris."

Cybele, 1904-05
Bronze, 65 x 34 x 56 in.
(165.1 x 86.4 x 42.2 cm)
Signature: "A. Rodin"
Inscriptions: "No. 3/8, © by Musée Rodin 1982"
Stamped with Coubertin Foundry cachet

Auguste Rodin

Danaïd, c. 1884-85
Bronze, 8 1/2 x 15 3/8 x 10 1/4 in.
(21.6 x 39 x 26 cm)
Signature: "A. Rodin"
Inscriptions: "Gruet Fondeur Paris"
Exhibitions: *Auguste Rodin*, Flint Institute of Arts,
Flint, Michigan (January 13-March 16, 1980),
and tour; *Rodin, The B. Gerald Cantor Collection*,
Metropolitan Museum of Art, New York
(April 1-June 15, 1986)

Despair, 1880s
Bronze, 9 1/2 x 8 x 6 1/4 in.
(24.2 x 20.3 x 16.5 cm)
Signature: "A. Rodin"
Inscription: "Georges Rudier Fondeur Paris"

Embracing Couple, 1898
Bronze, 4 3/8 x 2 1/8 x 1/2 in.
(11 x 5.5 x 1.3 cm)
Signature: "A. Rodin"
Inscription: ".Georges Rudier .Fondeur. Paris.,
© by Musée Rodin 1967"
Cast no.9/12

The Three Faunesses, 1882
Bronze, 9 1/4 x 11 1/2 x 6 1/2 in.
(23.5 x 29.2 x 16.5 cm)
Signature: "A. Rodin"
Inscription: "© by Musée Rodin 1980"
Stamped with Coubertin Foundry cachet
Exhibitions: *Rodin Rediscovered*, National
Gallery of Art, Washington, D.C.
(June 28, 1981-May 2, 1982)

Small Head of the Man with the Broken Nose, 1882
Bronze, 5 x 3 x 4 in.
(12.7 x 7.6 x 10.2 cm)
Signature: "A. Rodin"
Inscription: "Georges Rudier Fondeur Paris,
© By Musée Rodin, 1960"

Gustav Mahler, 1909
Bronze, 13 x 13 1/2 x 12 in.
(33 x 34.3 x 30.5 cm)
Signature: "A. Rodin"
Inscription: "Alexis Rudier Fondeur Paris"

Paolo and Francesca, 1889
Bronze, 12 1/8 x 22 1/4 x 14 3/4 in.
(30.8 x 56.5 x 37.5 cm)
Signature: "A. Rodin"
Inscription: "No. 5, Georges Rudier
Fondeur Paris"

The Prayer, 1909
Bronze, 49 1/2 x 21 5/8 x 19 5/8 in.
(127 x 55 x 49.8 cm)
Signature: "A. Rodin"
Inscription: "No. 8, © by Musée Rodin 1977"

Study for the Secret, c. 1910
Bronze, 4 3/4 x 2 3/8 x 2 1/2 in.
(12 x 6 x 6.4 cm)
Signature: "A. Rodin"
Inscription: "ALEXIS RUDIER Fondeur.PARIS"

The Sorrow, from The Gates of Hell, 1889
Bronze, 11 1/2 x 6 1/2 x 6 3/4 in.
(29.2 x 16.5 x 17.2 cm)
Signature: "A. Rodin"
Inscription: "© Musée Rodin, 1983 No 1/8,
La Porte de l'Enfer 1977-1981 don de
B. Gerald Cantor"
Stamped with Coubertin Foundry cachet

Eternal Spring, 1884
Bronze, 25 1/2 x 28 1/2 x 15 1/2 in.
(64.8 x 72.4 x 39.4 cm)
Signature: "A. Rodin"
No foundry mark

Seated Torso, c. 1890
Bronze, 14 3/8 x 9 1/2 x 11 in.
(36.5 x 24.2 x 28 cm)
Signature: "A. Rodin"
Inscription: "No. 8, Georges Rudier Fondeur
Paris, © By MUSÉE RODIN 1957"

Kneeling, Twisting Nude Torso
Bronze, 23 3/4 x 12 5/8 x 13 3/4 in.
(60.3 x 32 x 35 cm)
Signature: "A. Rodin"
Inscription: "No. 7/8, © by MUSÉE RODIN. 1984"

Oskar Kokoschka (1886-1980)

Italian Peasant Woman, 1933
Oil on canvas, 25 1/2 x 31 1/2 in.
(64.7 x 80 cm)
Signed with initials, lower left: "OK"
Provenance: Leicester Gallery, London; Galleria
Annunciata, Milan; E. and S. Silberman Galleries,
New York
Exhibitions: *Selections from the B. Gerald Cantor
Collection,* Des Moines Art Center (December 9,
1970-January 10, 1971), and tour

Paul Signac (1863-1935)

Garden at Saint-Tropez, 1909
Oil on canvas, 25 3/4 x 31 3/4 in.
(65.5 x 80.5 cm)
Signed and dated, lower left: "P. Signac 1909"
Provenance: New Gallery, New York; Larry
Aldrich, New York; Henry Ford II, Detroit
Exhibitions: *Paul Signac,* Fine Arts Association,
New York (November 5-24, 1951); *The Aldrich
Collection,* American Federation of the Arts
(October 1960-April 1962)

Highlights of B. Gerald Cantor Donations—Sculpture, 1961-91

Works by Rodin

**Naked Balzac with Folded Arms
(large version), 1893**
Bronze, 50 1/4 x 20 1/2 x 24 3/4 in.
Georges Rudier Foundry, cast no. 4/12
Gift to Los Angeles County Museum of Art,
11/67

The Martyr, 1885
Bronze, 4 1/2 x 24 x 17 in.
Georges Rudier Foundry, cast no. 5/12
Gift to Indianapolis Museum of Art
(formerly Herron Museum of Art), 3/68

The Age of Bronze, 1876-77
Bronze, 39 x 15 1/2 x 13 in.
Georges Rudier Foundry, cast no. 10/12
Gift to The Brooklyn Museum, 5/68

Crouching Woman, 1882
Bronze, 37 5/8 x 27 3/8 x 25 1/4 in.
Georges Rudier Foundry, cast no. 5/12
Gift to Museum of Fine Arts, Houston, 11/68

Study of Nude for Eustache de St Pierre, 1887
Bronze, 38 1/2 x 12 1/2 x 15 in.
Georges Rudier Foundry, cast no. 4/12
Gift to California Palace of the Legion of
Honor, 12/68

Mask of the Man with the Broken Nose, 1864
Plaster, 18 1/4 x 7 3/8 x 6 1/2 in.
Gift to Musée Rodin, Paris, 1968

La France, 1904
Bronze, 19 5/8 x 18 x 12 1/2 in.
Georges Rudier Foundry, cast no. 6
Gift to Tel Aviv Museum, 1/69

Head of Pope Benedict XV, 1915
Bronze, 10 x 7 x 9-1/2 in.
Georges Rudier Foundry, cast no. 7/12
Gift to Istituto per le Opere de Religione,
Vatican City, 4/71

The Shade (G.M.), 1880
Bronze, 75 1/2 x 44 1/8 x 19 3/4 in.
Susse Foundry, cast no. 6/12
Gift to Los Angeles Country Museum of Art, 2/74

Eve, 1881
Bronze, 69 x 23 3/4 x 30 1/4 in.
Susse Foundry, cast no. 9/12
Gift to Los Angeles County Museum of Art, 2/74

Iris, Messenger of the Gods, c. 1890
Bronze, 37 1/2 x 34 1/4 x 15 3/4 in.
Georges Rudier Foundry, cast no. 9/12
Gift to Los Angeles County Museum of Art, 2/74

Monumental Torso of a Man, c. 1882
Bronze, 41-1/2 x 23-1/2 x 15-3/4 in.
Georges Rudier Foundry, cast no. 2/12
Gift to Los Angeles County Museum of Art, 2/74

**She Who was the Helmet Maker's Beautiful
Wife, 1885**
Bronze, 19 3/4 x 12 1/8 x 9 in.
No foundry mark
Gift to Stanford University, 2/74

Despair, 1914
Limestone, 37 x 13 1/2 x 31 in.
Gift to Stanford University, 2/74

Bellona, 1879
Bronze, 32 x 18 1/2 x 17 3/4 in.
A. Gruet Foundry
Gift to Stanford University, 2/74

Prodigal Son (G.M.), c. 1888
Bronze, 55 x 42 1/2 x 28 in.
Georges Rudier Foundry, cast no. 8/12
Gift to Los Angeles County Museum of Art, 2/74

Orpheus, 1892
Bronze, 59 x 32 1/2 x 50 in.
Susse Foundry, cast no. 4/12
Gift to Los Angeles County Museum of Art, 2/74

The Kiss, 1886
Bronze, 34 x 17 x 22 in.
George Rudier Foundry, cast no. 9/12
Gift to Stanford University, 2/74

Bust of Young Balzac, 1891
Bronze, 17 x 16 x 9 1/4 in.
Georges Rudier Foundry, cast no. 2/12
Gift to The Museum of Modern Art, New York, 2/74

Balzac in Frockcoat, c. 1891-92
Bronze, 23 7/8 x 8 1/2 x 10 3/8 in.
Susse Foundry, cast no. 3/12
Gift to Museum of Modern Art, New York, 2/74

Naked Figure Study for Balzac "C", 1893
Bronze, 30 x 12 1/2 x 15 in.
Georges Rudier Foundry, cast no. 6/12
Gift toThe Museum of Modern Art, New York, 2/74

**Headless Naked Figure for Balzac "F"
(Athlete), c. 1896-97**
Bronze, 39 x 15 1/8 x 12 1/8 in.
Georges Rudier Foundry, cast no. 2/12
Gift to The Museum of Modern Art, New York, 2/74

Penultimate Head Study, Balzac, 1897
Bronze, 7 1/2 x 8 x 6 1/2 in.
No foundry mark
Gift to The Museum of Modern Art, New York, 2/74

Works by Rodin

Eternal Spring, 1884
Bronze, 26 x 28 1/2 x 16 in.
Georges Rudier Foundry, cast no. 6/12
Gift to High Museum of Art, Atlanta, 11/77

Monumental Bust of Victor Hugo, 1897
Bronze, 28 x 23 x 23 in.
No foundry mark
Gift to Solomon R. Guggenheim Museum,
New York, 2/78

Walking Man (large version), 1877
Bronze, 87 7/8 x 29 1/2 x 53 1/8 in.
Georges Rudier Foundry, cast no. 12/12
Gift to Stanford University, 12/82

Jean d'Aire (large version), c. 1889
Bronze, 85 x 35 1/2 x 39 in.
Susse Foundry, cast no. 6/12
Gift to Los Angeles County Museum of Art,
12/82

The Prayer, 1909
Bronze, 49 1/2 x 21 5/8 x 19 5/8 in.
Georges Rudier Foundry, cast no. 4/12
Gift to College of the Holy Cross, 12/82

Adam
Bronze, 75 1/2 x 29 1/2 x 29 1/2 in.
Georges Rudier Foundry, cast no. 11/12
Gift to Stanford University, 2/85

Cybele, c. 1904-5
Bronze, 63 x 31 x 46 in.
Coubertin Foundry, cast no. 1/8
Gift to The Brooklyn Museum, 3/85

Fallen Caryatid Carrying an Urn
(large version), c. 1881
Bronze, 45 1/4 x 36 3/4 x 31 1/8 in.
Coubertin Foundry, cast no. 3/8
Gift to The Metropolitan Museum of Art
New York, 3/85

Fallen Caryatid Carrying a Stone
(large version), c. 1881
Bronze, 51 1/8 x 37 1/2 x 37 1/2 in.
Coubertin Foundry, cast no. 1/8
Gift to The Metropolitan Museum of Art,
New York, 3/85

Eustache de St. Pierre
(large version), c. 1885-86
Bronze, 85 x 30 x 48 in.
Coubertin Foundry, cast no. 1/12
Gift to College of the Holy Cross, 5/85

Monument to Balzac, 1897
Bronze, 117 x 47 1/2 x 47 1/4 in.
Susse Foundry, cast no. 9/12
Gift to Los Angeles County Museum of Art,
12/85

Pierre de Wiessant, Nude (large version), 1885-86
Bronze, 76 x 50 x 32 in.
Coubertin Foundry, cast no. I/IV
Gift to The Brooklyn Museum, 9/86

Andrieu d'Andres (large version), 1885-86
Bronze, 79 x 33 x 51 in.
Coubertin Foundry, cast no. 3/8
Gift to The Brooklyn Museum, 6/87

The Gates of Hell, 1880-1900
Bronze, 250 3/4 x 158 x 33 3/8 in.
Coubertin Foundry, cast no. 5/12
Gift to Stanford University, 12/87

Monument to the Burghers of Calais, 1884-95
Bronze, 82 1/2 x 94 x 75 in.
Coubertin Foundry, cast no. I/II
Gift to The Metropolitan Museum of Art,
New York, 7/90

Crying Lion, 1881
Terra-cotta, 11 1/8 x 13 1/8 x 6 1/8 inches
Gift to Maryhill Museum of Art,
Goldendale, Wa., 12/90

Emile-Antoine Bourdelle

Torso of Herakles, 1909
Bronze, 38 x 28 1/2 x 19 in.
Godard Foundry, cast no. 1
Gift to University of Southern California, 11/69

Sir Jacob Epstein

Dr. Chaim Weizmann, 1933
Bronze, 18 1/2 x 24 x 11 1/2 inches
Gift to Hebrew University of Jerusalem, 11/71

Pierre Auguste Renoir

L'Eau: La Petite Laveuse Accroupi, 1916
Bronze, 10 1/2 x 9 x 4 3/4 in.
Valsuani Foundry, cast no. 2A
Gift to The Israel Museum, 10/72

Le Feu: Le Petite Forgeron Accroupi, 1916
Bronze, 11 x 9 1/2 x 5 3/4 in.
Valsuani Foundry, cast no. 1G
Gift to The Israel Museum, 10/72

Georg Kolbe

The Night, 1930
Bronze, 84 x 25 x 26 in.
H. Noack Foundry, cast no. 1/3
Gift to Los Angeles County Museum of Art,
12/82

Camille Claudel

L'Imploration, 1894-1905
Bronze, 11 x 6 3/4 x 12 1/2 in.
Eugene Blot Foundry, cast no. 52
Gift to The Metropolitan Museum of Art,
New York, 6/90

Highlights of B. Gerald Cantor Donations—Paintings, 1961-91

Ernst Ludwig Kirchner

Two Women in Street Dress, 1911
Oil on canvas, 59 x 47 in.
Gift to Los Angeles County Museum of Art, 7/61

Trees in Autumn, c. 1907-8
Oil on panel, 27 1/2 x 19 3/4 in.
Gift to Norton Simon Museum (formerly the
Pasadena Art Museum), 12/66

Ferdinand Hodler

The Disillusioned One, 1892
Oil on canvas, 21 3/4 x 17 1/2 in.
Gift to Los Angeles County Museum of Art, 8/78

Alfred Sisley

The Station at Sèvres, c. 1879
Oil on canvas, 18 1/4 x 22 in.
Gift to Los Angeles County Museum of Art, 1/87

Highlights of the Iris and B. Gerald Cantor Foundation Donations, 1983-91

Works by Rodin

Monumental Head of Balzac, c. 1897-98
Bronze, 19 1/2 x 19 1/2 x 15 3/4 in.
Georges Rudier Foundry, cast no. 8/12
Gift to Massachusetts Institute of Technology,
1/83

Flying Figure (large version), 1890
Bronze, 17 3/4 x 31 x 10 3/4 in.
Georges Rudier Foundry, cast no. 7/12
Gift to University of Judaism, 2/84

Female Torso (V. & A.)
Bronze, 24 7/8 x 15 x 7 7/8 in.
Coubertin Foundry, cast no. 2/12
Gift to The Israel Museum, 2/84

Saint John the Baptist Preaching, c. 1878-83
Bronze, 19 1/4 x 11 x 9 1/8 in.
Thiébaut FrèresFoundry
Gift to Des Moines Art Center, 2/84

Age of Bronze, c. 1875-76
Plaster, 26 x 8 1/2 x 7 in.
Gift to Stanford University, 11/84

Meditation (large version), 1886
Bronze, 61 1/2 x 29 x 26 in.
Coubertin Foundry, cast no. 7/12
Gift to Stanford University, 12/84

Bust of Jean d'Aire, before 1887
Plaster, 19 x 231/2 x 16 in.
Gift to National Gallery of Art, Washington,
D.C., 12/84

Head of Balzac "H", 1892-93
Bronze, 12 x 12 x 9-1/2 in.
Georges Rudier Foundry, cast no. 8/12
Gift to Beverly Hills Public Library, 1/85

Study for Eustache de St. Pierre, Nude, 1885
Bronze, 27 x 10 1/2 x 12 1/4 in.
Georges Rudier Foundry, cast no. 4/12
Gift to Gonzaga University, Spokane, 5/85

Reclining Female Nude
Bronze, 20 x 7 x 11 in.
Coubertin Foundry, cast no. 2/12
Gift to Jacksonville Art Museum, 11/85

Falling Man, c. 1882
Bronze, 23 1/8 x 15 3/4 x 12-1/8 in.
Godard Foundry, cast no. 1/1
Gift to The Metropolitan Museum of Art, 5/86

Paolo and Francesca, 1887
Bronze, 12 1/8 x 22 1/4 x 14 3/4 in.
Georges Rudier Foundry, cast no. 4/12
Gift to The Brooklyn Museum, 5/86

**Fallen Caryatid Carrying an Urn
(large version), 1883**
Bronze, 15 3/4 x 10 x 10 in.
Georges Rudier Foundry, cast no. 4/12
Gift to Dallas Museum of Art, 8/87

Young Girl with Flowers in Her Hair, 1865-70
Bronze, 19 x 14 x 10 3/4 in.
Coubertin Foundry, cast no. 6/12
Gift to The Dixon Gallery and Gardens,
Memphis, Tennessee 10/87

Danaïde, 1885
Bronze, 12 3/4 x 28 3/4 x 22 1/2 in.
Godard Foundry, cast no. 10/12
Gift to Lakeview Museum of Arts & Sciences,
Peoria, Illinois, 12/87

Pierre de Wiessant, (large version), 1885-86
Bronze, 81 x 40 x 48 in.
Coubertin Foundry, cast no. III/IV
Gift to The Israel Museum, 1/88

The Thinker (large version), 1902
Bronze, 78 3/4 x 51 1/3 x 55 1/8 in.
Georges Rudier Foundry, cast no. 10/12
Gift to Stanford University, 6/88

Portrait of Lady Sackville-West, 1913
Plaster, 18 x 18 3/4 x 14 3/4 in.
Gift to National Gallery of Art, Washington,
D.C., 9/88

Bastien-Lepage, 1887
Bronze, 71 x 36 1/2 x 33 1/2 in.
Coubertin Foundry, cast no. 2/8
Gift to Los Angeles County Museum of Art, 5/90

Highlights of Foundation Donations—Sculpture, 1983-91

Ernst Barlach

Der Buchleser
Bronze, 17-3/4 x 9 x 13 in.
H. Noack Foundry
Gift to Solomon R. Guggenheim Museum,
New York, 1/83

Sir Jacob Epstein

Head of Bernard Shaw, 1934
Bronze, 18 1/2 x 9 1/4 x 11 in.
No foundry mark
Gift to Brandeis University, 4/84

Albert Carrière-Belleuse

Bust of a Woman, 1867
Marble, 19 5/8 x 10 x 10 in.
Gift to Columbus Gallery of Fine Art,
Columbus, Ohio, 11/84

Georg Kolbe

Portrait of Max Lieberman, 1929
Bronze, 11 3/4 x 6 3/4 x 8 in.
Noack Foundry
Gift to Santa Barbara Museum of Art, 5/85

Jules Dalou

Head of a Young Boy, c. 1870
Marble, 18 3/4 x 9 5/8 x 8 7/8 in.
Gift to National Gallery of Art,
Washington, D.C., 12/90

Notes

Sculpture

1. Judith Cladel, *Rodin: The Man and His Art*, trans. S. K. Star (New York, 1917), p. 222.

2. Edouard Rod, "L'Atelier de M. Rodin," *Gazette des beaux-arts* 19 (May 1898): 427.

3. Clare Vincent, "Rodin at the Metropolitan Museum of Art," *Bulletin of the Metropolitan Museum of Art*, Spring 1981, p. 30.

4. Marcel Adam, "Saturday Night," cited in Albert E. Elsen, *Rodin's "Thinker" and the Dilemmas of Modern Public Sculpture* (New Haven and London: Yale University Press, 1985), p. 5.

5. Albert E. Elsen, *"The Gates of Hell" by Auguste Rodin* (Stanford, Calif.: Stanford University Press, 1985), p. 71.

6. Elsen, p. 71, fig. 60.

7. Manuscripts in the Musée Rodin, Paris. The Henley correspondence of 1882 is cited in Catherine Lampert, *Rodin: Sculpture and Drawings* (London: Hayward Gallery, 1986), p. 205, no. 74. The 1884 letter to Rodin from C. A. Ionides is cited in Elsen, *The Thinker*, p. 55.

8. Jacques de Caso and Patricia B. Sanders, *Rodin's Sculpture: A Critical Study of the Spreckels Collection* (San Francisco: Fine Arts Museums, 1977), p. 137, no. 14.

9. Elsen, *Gates of Hell*, p. 221.

10. Albert Alhadeff, "Rodin: A Self-Portrait in *The Gates of Hell*," *Art Bulletin* 48 (1966): 393-95.

11. Elsen, p. 221.

12. Elsen, *ibid.*, revised his former interpretation to that of a godlike artist. J. A. Schmoll considered the relief to be Rodin's signature for *The Gates*. See his *Rodin Studien: Persönlichkeit-Werk-Wirkung-Bibliographie* (Munich, 1983), pp. 225-28.

13. Camille Mauclair, *Auguste Rodin: The Man, His Ideas, His Works* (London, 1905), p. 67.

14. Paul Gsell, *Rodin on Art and Artists* (New York, 1957), p. 82.

15. Judith Cladel, *Rodin: Sa vie glorieuse, sa vie inconnue* (Paris: Bernard Grasset, 1950), pp. 135-36.

16. Gsell, *Rodin on Art*, p. 209.

17. Elsen, p. 74.

18. Ruth Butler Mirolli, "The Early Work of Rodin and Its Background," Ph.D. diss., New York University, 1966, p. 211.

19. De Caso and Sanders, *Rodin's Sculpture*, p. 144.

20. Daniel Rosenfeld, in *Rodin Rediscovered*, ed. Albert E. Elsen (Washington, D.C.: National Gallery of Art, 1981): 89.

21. Georges Grappe, *Catalogue du Musée Rodin. I. Hôtel Biron*, 5th ed. (Paris: Musée Rodin, 1944), no. 66.

22. Elsen, *Gates of Hell*, p. 83.

23. John L. Tancock, *The Sculpture of Auguste Rodin: The Collection of the Rodin Museum, Philadelphia* (Philadelphia: Philadelphia Museum of Art, 1976), p. 129; de Caso and Sanders, pp. 139-41.

24. Gsell, *Rodin on Art*, p. 63.

25. Monique Laurent in *Rodin Rediscovered*, p. 288.

26. Elsen, p. 112.

27. Tancock, p. 257; de Caso and Sanders, p. 111.

28. Grappe, no. 144.

29. See Tancock for illustrations of the sculptures, pp. 260-61.

30. *Catalogue of the International Exhibition of Art*, Venice, 1901, p. 47, no. 19.

31. Elsen, p. 48, fig. 43; see also the detail of the group, fig. 46.

32. *La Revue*, November 1, 1907, cited in de Caso and Sanders, p. 151.

33. Albert E. Elsen, *In Rodin's Studio* (Ithaca, N.Y.: Cornell University Press, 1980, p. 181.

34. *Ibid.*

35. Rainer Maria Rilke, *Rodin*, trans. Robert Firmage (Salt Lake City, Utah, 1979), p. 38.

36. Grappe, no. 241.

37. Cited by Elsen, p. 169.

38. Rosalyn Frankel Jamison in *Rodin Rediscovered*, p. 108.

39. Tancock, p. 193.

40. Grappe, no. 109.

41. Grappe, no. 159.

42. Most modern scholars concur that Rodin made the figure in 1900. For discussion of the history and dating, see de Caso and Sanders, pp. 79-80.

43. Albert E. Elsen, *The Partial Figure in Modern Sculpture from Rodin to 1969* (Baltimore: Baltimore Museum of Art, 1970), p. 18.

44. Leo Steinberg, "Rodin," in *Other Criteria* (London, 1972), p. 349.

45. Elsen, *In Rodin's Studio*, p. 167.

46. *La Jeune France*, July 1886, see Lampert, p. 205.

47. Judith Cladel, "An Interview with Maillol," in *Rodin in Perspective*, ed. Ruth Butler (Englewood Cliffs, N.J.: Prentice Hall, 1980), p. 149.

48. Lampert, p. 121.

49. Steinberg, p. 325.

50. Lampert, p. 221; Elsen, no. 95.

51. Robert Descharnes and Jean-François Chabrun, *Auguste Rodin* (Lausanne: Edita Lausanne, 1967), p. 246.

52. Albert E. Elsen, *Rodin* (New York, 1963), p. 151.

53. Malvina Hoffman, *Yesterday is Tomorrow* (New York, 1965), p. 118.

54. Elsen, *Rodin Rediscovered*, p. 143.

55. It has been proposed that the figure represents another dancer. See the exhibition catalog *Rodin*, Fondation Pierre Gianadda, Martigny, 1984, p. 140. Richard Buckle also questioned the identity of the figure; see his *Nijinsky* (Harmondsworth, 1975), p. 367.

56. Mario Amaya, "Rodin's Dancers," *Dance and Dancers*, March 1963, p. 26.

57. Tancock, p. 604, fig. 110-12.

58. Lampert, p. 230.

59. Letter from René Chéruy, Tate Gallery Archives, August 18, 1957, cited in de Caso and Sanders, p. 289.

60. Grappe, nos. 337 and 338; Tancock, p. 601, accepted Grappe's date.

61. The traditional date of their first meeting, 1908, was revised by Monique Laurent in the exhibition catalog *Rodin et l'Extrême Orient* (Paris: Musée Rodin, 1979), p. 24.

62. Frederic V. Grunfeld, *Rodin: A Biography* (New York, 1987), p. 521.

63. For information on the plaster version in the Musée Rodin, Paris, see Grappe, no. 372, and Laurent, no. 23.

64. Cited by Ruth Butler in *Rodin Rediscovered*, p. 82.

65. Henri Dujardin-Beaumetz, "Rodin's Reflections on Art," in *Auguste Rodin: Readings on His Life and Work*, ed. Albert E. Elsen (Englewood Cliffs, N.J.: Prentice Hall, 1965), pp. 165-66.

66. Volume 6 (1883), 176.

67. Vincent, p. 27, no. 28.

68. Henri Dujardin-Beaumetz, *Entretiens avec Rodin* (Paris, 1913), p. 108.

69. T. H. Bartlett, "Auguste Rodin, Sculptor," *Readings*, p. 56.

70. For information on the history of the monument, see Jane Mayo Roos, "Rodin's *Monument to Victor Hugo*: Art and Politics in the Third Republic," *Art Bulletin* 68 (1986): 632-56.

71. Some of the sketches are illustrated in Victoria Thorson, *Rodin Graphics* (San Francisco, 1975), pp. 46-56.

72. Gsell, p. 148.

73. The history of the commission is discussed in Mary Jo McNamara and Albert E. Elsen, *Rodin's "Burghers of Calais"* (Los Angeles, 1977).

74. Rodin departed from Froissart's *Chronicles*, which stated that the men stripped themselves to their shirts and breeches.

75. Edmond de Goncourt, *Journal: Mémoires de la vie littéraire* (Paris, 1959), vol. 3, p. 563.

76. De Caso and Sanders, p. 209.

77. Elsen, 1963, pp. 74, 78.

78. For detailed information on the monument, see Albert E. Elsen, Stephen C. McGough, and Steven H. Wander, *Rodin and Balzac* (Beverly Hills, Calif.: 1973), and Jacques de Caso, "Balzac and Rodin in Rhode Island," *Bulletin of the Rhode Island School of Design*, May 1966, pp. 1-22.

79. *Le Matin*, July 13, 1908, cited by de Caso and Sanders, p. 236, no. 17.

80. De Caso and Sanders, p. 232.

81. Cited by Elsen, *Rodin and Balzac*, p. 55.

82. Cladel, 1950, p. 129.

83. Judith Cladel, *Auguste Rodin: Pris sur la vie* (Paris, 1903), p. 402.

84. Elsen, *Partial Figure in Modern Sculpture*, p. 28.

85. For details, see Marina Lambraki-Plaka, *Bourdelle et la Grèce* (Athens, 1985), pp. 65-66.

86. Pierre Descargues, *Bourdelle* (Paris, 1954), p. 38.

87. Their relationship is documented in Reine-Marie Paris, *Camille, The Life of Camille Claudel* (New York, 1984), *L'interdite Camille Claudel 1864-1943* (Paris, 1983), and *Camille Claudel,* (Paris: Musée Rodin, 1984).

88. Reine-Marie Paris, p. 21.

89. Musée Rodin, pp. 49-52.

90. It was illustrated in *L'Art décoratif,* July 1913, and is reproduced in the Musée Rodin catalog, p. 109.

91. See Musée Rodin, p. 50.

92. Reine-Marie Paris, pp. 231, 238. Alexis Rudier also cast *The Waltz,* and the Valsuani Foundry made an enlargement about 36 in. high.

93. For information on the commission, see John M. Hunisak in *The Romantics to Rodin,* (Los Angeles: Los Angeles County Museum of Art, 1980), p. 185.

94. *Ibid.*

95. Maurice Dreyfous, *Dalou sa vie et son oeuvre* (Paris, 1903), pp. 126-27; see also his article "Dalou inconnu," *L'art et les artistes* 2 (October 1905): 72.

96. Anne Pingeot and Laure de Margerie, *Musée d'Orsay Catalogue sommaire illustré des sculptures* (Paris: Musée d'Orsay, 1986), p. 114.

97. For details on Kolbe's life and works see *German Painting and Sculpture* (New York: Museum of Modern Art, 1931), p. 41, and Ursel Berger, *Georg Kolbe: Leben und Werk* (Berlin, 1990).

98. *Gaston Lachaise,* (New York: M. Knoedler and Co., 1947).

99. Elsen, *The Partial Figure,* p. 49.

100. Gerald Nordland, *Gaston Lachaise: The Man and His Work* (New York, 1974), p. 140.

101. Albert E. Elsen, *Origins of Modern Sculpture: Pioneers and Premises* (New York, 1974), p. 29.

102. See Dietrich Schubert, *Die Kunst Lehmbrucks* (Worms: 1981), p. 165; Reinhold Heller, *The Art of Wilhelm Lehmbruck* (Washington, D.C., 1972), no. 71.

103. Siegfried Salzmann, letter to Vera Green, July 17, 1973.

104. Mario Miniaci, *Giacomo Manzù* (New York: World House Galleries, 1960), p. 1.

105. Giacomo Manzù (Florence: Accademia delle Arti del Disegno, 1979).

106. John Rewald, *Giacomo Manzù* (London: 1966), p. 60.

107. *Giacomo Manzù* (New York: Wildenstein, 1989), p. 4.

Paintings

1. Anita Brookner, "Sisley at Durand-Ruel," *Burlington Magazine* 99 (July 1957): 248.

2. Sisley to Monet, August 31, 1881, cited in François Daulte, *Loan Exhibition Sisley* (New York: Wildenstein, 1966), p. 60.

3. François Daulte, *Alfred Sisley: Catalogue raisonné de l'oeuvre peint* (Lausanne, 1959), no. 371.

4. *Roger de la Fresnaye* (Paris: Musée National d'Art Moderne, 1950), p. 15; Germain Seligman, *Roger de la Fresnaye* (Greenwich, Ct., 1969), p. 16.

5. *Femme assise,* illustrated in *Collection André Lefevre* (Paris: Palais Galliera, 1964), no. 8.

6. Beginning with Nicolas Poussin and Claude Lorrain, French painters aspired to depict the pastoral ideal described by Hesiod, Ovid, and Virgil. See *Places of Delight: The Pastoral Landscape* (Washington, D.C.: Phillips Collection, 1988).

7. Judi Freeman, "Surveying the Terrain: The Fauves and the Landscape," *Fauve Landscape,* (Los Angeles: Los Angeles County Museum of Art, 1990), pp. 24-29.

8. Seligman, no. 30.

9. Maurice de Vlaminck, *Dangerous Corner* (London, 1961), p. 12.

10. Maurice de Vlaminck, *Paysages et Personages* (Paris, 1953), p. 42.

11. Cited in *Vlaminck: Il pittore e la critica* (Centre Saint-Benin, 1988), p. 254.

12. Klaus Perls, *Vlaminck* (New York, 1941), p. 70.

13. Sherry A. Buckberrough, *Robert Delaunay: The Discovery of Simultaneity* (Ann Arbor, Mich., 1982), pp. 10-11.

14. The portrait in Houston measures 21 5/6 x 17 in. (54.9 x 43.2 cm). I am grateful to Alison de Lima Greene, Associate Curator of Twentieth-Century Art at the museum, for information regarding the painting.

15. *Modern Portraits: The Self and Others* (New York: Wildenstein, 1976), p. 38.

16. Buckberrough, p. 10.

17. Emil Nolde, *Jahre der Kampfe* (Berlin, 1934), p. 49, translated by William S. Bradley in *Emil Nolde and German Expressionism* (Ann Arbor, Mich., 1981), p. 57.

18. Martin Urban, *Emil Nolde Werkverzeichnis der Gemälde, Band 2, 1915-1951* (Munich, 1990), no. 1172.

19. Robert Rosenblum, *Modern Painting and the Northern Romantic Tradition* (New York, 1975), p. 136.

20. *Ibid.*, Bradley, p. 98.

21. Erhard and Barbara Göpel, *Max Beckmann Katalog der Gemälde* (Bern, 1976), I, no. 445.

22. Göpel, p. 293.

23. Dated c. 1912, 19 3/4 x 28 3/4 in. (50 x 73 cm). Around 1900-1903 he executed a painting related to these, *The Revellers* (Pierre Levy Collection, Troyes), which depicts a group of men and women in evening dress ascending a staircase. See *Van Dongen: Le Peintre, 1877-1968*, (Paris: Musée National d'Art Moderne, 1990), no. 5.

24. Olivier Barrot, "Jules Berry," *Antologie du Cinema* (Paris, 1973), pp. 409-56.

25. Marie Berhaut, *Caillebotte sa vie et son oeuvre* (Paris, 1978), no. 7.

26. Kirk Varnedoe, *Gustave Caillebotte* (New York and London, 1987), p. 45.

27. *Paintings by Jean-Baptiste-Armand Guillaumin* (New York: Hirschl and Adler, 1971), n.p.

28. Cited by John Rewald in "Cézanne and Guillaumin," *Études d'art française offertes à Charles Sterling*, ed. Albert Chatelet and Nicole Reynaud (Paris, 1975), p. 343.

29. Rewald, p. 344.

30. G. Serret and D. Fabiani, *Armand Guillaumin 1841-1927: Catalogue raisonné de l'oeuvre peint* (Paris, 1971), nos. 48, 49.

31. For information on Forain's early works see Jean-François Bory, *Forain* (Paris, 1979), and Lillian Browse, *Forain the Painter* (London, 1978).

32. Browse, fig. 22.

33. Jean Puget, *La Vie Extraordinaire de Forain* (Paris, 1957), p. 124; trans. by Browse, p. 12.

34. John L. Tancock, *The Sculpture of Auguste Rodin: The Collection of the Rodin Museum, Philadelphia* (Philadelphia: Philadelphia Museum of Art, 1976), p. 338.

35. Robert Goldwater, *Symbolism* (New York, 1979), p. 161.

36. Correspondence, June 12, 1991. I am grateful to Dr. Bantens for his analysis of the painting.

37. Correspondence, January 30, 1991.

38. Robert James Bantens, *Eugène Carrière: The Symbol of Creation* (New York, 1990), pp. 78-79.

39. Phillip Dennis Cate and Susan Gill, *Théophile-Alexandre Steinlen* (Salt Lake City, Utah, 1982), p. 17.

40. A chalk drawing of the design, in the Petit Palais Gent, is illustrated in Peter Ditmar, *Théophile-Alexandre Steinlen* (Zurich, 1984), no. 58.

41. Another variation of the design, entitled *Lovers on a Bench*, is dated April 1902. See E. de Crauzat, *L'Oeuvre Gravé et Lithographié de Steinlen* (1913; reprinted San Francisco, 1983), no. 71.

42. Illustrated in Raymond Cogniat, *Louis Valtat* (Neuchâtel, 1963), no. 11.

43. Robert Herbert, *Neo-Impressionism* (New York, 1968), no. 166.

44. Charlotte Berend-Corinth, *Die Gemälde von Lovis Corinth* (Munich, 1958), no. 159.

45. These are illustrated in Berend-Corinth, p. 73, and in Felix Zdenek, *Lovis Corinth 1858-1925* (Cologne, 1985), p. 198.

46. Carlo L. Ragghianti and Ettore Camesasca, *L'opera completa di Boldini* (Milan, 1970), no. 424.

47. Details of her life in Europe are documented in Hugo Vickers, *Gladys, Duchess of Marlborough* (New York, 1979).

48. John Rewald, *Post-Impressionism* (New York, 1962), p. 112.

49. Jean Sutter, *Les Néo-Impressionnistes* (Neuchâtel, 1970), p. 109.

50. Herbert, p. 62.

51. For information on the Knights and the Newlyn art colony see Caroline Fox, *Painting in Newlyn* (Penzance, England: Newlyn Orion Gallery, 1985).

52. Herbert Grimsdritch, "Mr. Harold Knight: A Quiet Painter," *Creative Art* 3 (July 1928): 14-21.

53. Oswaldo Roque Rodriguez, *Directions in American Painting, 1875-1925,* (Pittsburgh: Museum of Art, Carnegie Institute, 1982) p. 52.

54. The painting was illustrated with the title *At the Café de Nuit* in *L'Art et les artistes* 17 (1913): 79, and in *Emporium* 39 (1914): 176, where it is called *In the Café.*

55. *The Art Amateur* 11 (June 1884): 6.

56. Michael Quick, *American Expatriate Painters of the Late Nineteenth Century* (Dayton, Ohio: Dayton Art Institute, 1977), p. 135.

57. D. Dodge Thompson, "Julius L. Stewart, a 'Parisian from Philadelphia,'" *Antiques,* November 1986, p. 1046.

58. Anna Seaton-Schmidt, "Lucien Simon," *Art and Progress* 5 (November 1913): 9.

59. For information on this group see Jacques Dupont, "La bande noire," *L'Amour de l'ar,* 14 (March 1933): 60-64, and *R. X. Prinet, 1861-1946* (Paris: Musée Bourdelle, 1986), pp. 14-16.

60. "Exhibition of Watercolors by Lucien Simon," *Carnegie Magazine,* February 1934, p. 274.

61. Maurice Hamel, "Les Salons de 1905," *Les Arts,* May 1905, pp. 24, 29; Eugene Monard, "Les Salons de 1905," *Gazette des beaux-arts* 33 (May 1905): 346-357.

62. Seaton-Schmidt, p. 4.

63. Hans Jürgen Imiela, ed., *Max Slevogt an Johannes Guthmann Briefe von 1912-1932* (St. Ingebert-Saar, 1960), p. 8.

64. Guthmann's account is given in Hans Jürgen Imiela, *Max Slevogt* (Karlsruhe, 1968), p. 395, no. 20.

65. *From Realism to Symbolism: Whistler and His World* (Philadelphia: Philadelphia Museum of Art, 1971), p. 82.

66. Victor Arwas, *Belle Epoque Posters and Graphics* (New York, 1978), p. 25.

67. P. Howard-Johnston, "Bonjour M. Elstir," *Gazette des beaux-arts* 69 (1967): 247-50; J. Monnin-Hornung, *Proust et la peintre* (Geneva, 1951), pp. 95-100.

68. Anthony Parton, "Mikhail Fedorovich Larionov 1881-1964," Ph.D. diss., University of Newcastle-upon-Tyne, 1985, p. 32.

69. Larionov seldom dated paintings at the time they were made, and in 1948 he began to predate many of his older works.

70. Valentine Marcadé, *Le Renouveau de l'Art Pictural Russe, 1863-1914* (Lausanne, 1971), p. 311, no. 266.

71. Hans Wingler, *Introduction to Kokoschka* (London, 1963), p. 30.

72. Hans Wingler, in correspondence with Vera Green, September 16, 1970, dated the painting to this period, and stated that it was either painted at Rapallo or during one of the artist's excursions from the city.

73. *Oskar Kokoschka Briefe II, 1919-1934,* ed. Olda Kokoschka and Heinz Spielmann (Dusseldorf, 1985), p. 265.

74. Oskar Kokoschka, *My Life,* trans. David Britt (London, 1974), p. 144.

75. Robert L. Herbert, *Neo-Impressionism* (New York, 1968), p. 129.

76. A drawing nearly identical to the painting is illustrated in Françoise Cachin, *Paul Signac* (Greenwich, Ct., 1971), p. 89, fig. 76. Another related drawing is reproduced in Georges Besson, *Signac Dessins* (Paris, 1950), pl. 5.

Additional Works

1. T. H. Bartlett, "Auguste Rodin, Sculptor," in *Auguste Rodin: Readings on His Life and Work,* ed. Albert E. Elsen (Englewood Cliffs, N.J.: Prentice Hall, 1965), pp. 20-21.

2. Patricia Sanders, in *Metamorphoses in Nineteenth-Century Sculpture,* ed. Jeanne L. Wasserman (Cambridge, Mass.: Fogg Art Museum, Harvard University, 1975), p. 154.

3. Elsen, ed., *Readings,* pp. 20-21.

4. Albert E. Elsen, *In Rodin's Studio* (Ithaca, N.Y.: Cornell University Press, 1980), p. 173.

5. *Rodin, les mains, les chirurgiens,* (Paris: Musée Rodin, 1983), p. 62, no. 36.

6. Albert E. Elsen, *"The Gates of Hell" by Auguste Rodin* (Stanford, Ca.: Stanford University Press, 1985), p. 211.

7. Elsen, ed., *Readings,* p. 79.

8. Albert E. Elsen in *Rodin Rediscovered* (Washington, D.C.: National Gallery of Art, 1981), p. 258.

9. Lynne Ambrosini and Michelle Facos, *Rodin: The Cantor Gift to the Brooklyn Museum* (Brooklyn: Brooklyn Museum, 1987), p. 149.

10. John L. Tancock, *The Sculpture of Auguste Rodin: The Collection of the Rodin Museum, Philadelphia* (Philadelphia: Philadelphia Museum of Art, 1976), p. 254.

11. Monique Laurent in *Rodin Rediscovered*, p. 286.

12. Victor Frisch and Joseph T. Shipley, *Auguste Rodin* (New York, 1939), p. 426.

13. Elsen, *In Rodin's Studio*, p. 178.

14. Elsen, nos. 93-94; Kirk Varnedoe in *Rodin Rediscovered*, pp. 210-12.

15. Elsen, *Gates of Hell*, p. 16, fig. 11.

16. Catherine Lampert, *Rodin: Sculpture and Drawings* (London: Hayward Gallery, 1986), p. 211.

17. Jacques de Caso and Patricia B. Sanders, *Rodin's Sculpture A Critical Study of the Spreckels Collection* (San Francisco: Fine Arts Museums, 1977), p. 174.

18. *Ibid.*

19. *New York Sun*, September 12, 1909, p. 2.

20. Anita Leslie, *Rodin, Immortal Peasant* (New York, 1937), p. 219.

21. Leo Steinberg, "Rodin," *Other Criteria* (New York, 1972), p. 339.

22. *Ibid.*

23. Gustave Kahn, "Les Mains chez Rodin," *Rodin et son oeuvre, La Plume*, 1900, p. 28.

24. Rainer Maria Rilke, *Rodin*, trans. Robert Firmage (Salt Lake City, Utah, 1979), p. 37.

25. *Readings*, pp. 20-21.

26. De Caso and Sanders, p. 257.

27. Tancock, p. 552.

28. Marion Jean Hare, "The Portraiture of Auguste Rodin," Ph.D. diss., Stanford University, 1984, vol. 2, p. 573.

29. *Gustav Mahler, une homme, une oeuvre, une époque*, (Paris: Musée d'Art Moderne, 1985), pp. 146-47.

30. Félicien Champsaur described the group in *Le Figaro*, supp., January 16, 1886.

31. Robert Goldwater, *Symbolism* (New York, 1979), p. 170.

32. Judith Cladel, *Auguste Rodin, l'homme et l'oeuvre* (Brussels, 1908), pp. 97-98.

33. Georges Grappe, *Catalogue du Musée Rodin. I. Hôtel Biron* (Paris: Musée Rodin, 1944), no. 415.

34. Sommerville Story, *Rodin* (London, 1939), p. 17.

35. Grappe, no. 223.

36. W.G.C. Byvanck, *Un Hollandais à Paris en 1891* (Paris, 1892), pp. 9-10.

37. Elsen, *In Rodin's Studio*, p. 171.

38. Elsen, pl. 48.

39. Lampert, p. 206.

40. Otto Grautoff, *Auguste Rodin* (Bielefeld, 1908), p. 81.

41. Tancock, p. 288; *The Romantics to Rodin* (Los Angeles: Los Angeles County Museum of Art, 1980), p. 343, no. 204.

42. De Caso and Sanders, pp. 320-21.

43. *Rodin: The Maryhill Collection*, (Malibu, Calif.: J. Paul Getty Museum, 1975), p. 34.

44. Albert E. Elsen, in *Rodin Rediscovered*, pp. 141-42.

45. *Ibid.*, Lampert, pp. 21-22.

Sources Consulted

Ambrosini, Lynne, and Michelle Facos. *Rodin: The Cantor Gift to the Brooklyn Museum.* New York: Brooklyn Museum, 1987.

Butler, Ruth, ed. *Rodin in Perspective.* Englewood Cliffs, N.J.:Prentice-Hall,1980.

Cladel, Judith. *Rodin: Sa vie glorieuse, sa vie inconnue.* Paris: Bernard Grasset, 1950.

Caso, Jacques de, and Patricia B. Sanders. *Rodin's Sculpture: A Critical Study of the Spreckels Collection.* San Francisco: Fine Arts Museums of San Francisco, 1977.

Descharnes, Robert, and Jean-François Chabrun. *Auguste Rodin.* Lausanne: Edita Lausanne, 1967.

Elsen, Albert E. *The Partial Figure in Modern Sculpture From Rodin to 1969.* Baltimore: Baltimore Museum of Art, 1970.

— *In Rodin's Studio.* Ithaca, N.Y.: Cornell University Press, 1980.

— *"The Gates of Hell" by Auguste Rodin.* Stanford, Calif.: Stanford University Press, 1985.

Elsen, Albert E., ed. *Auguste Rodin: Readings on His Life and Work.* Englewood Cliffs, N.J.: Prentice-Hall, 1965.

— *Rodin Rediscovered.* Washington, D.C.: National Gallery of Art, 1981.

Grappe, Georges. *Catalogue du Musée Rodin: I. Hôtel Biron.* 5th ed. Paris: Musée Rodin, 1944.

Lampert, Catherine. *Rodin Sculpture and Drawings.* London: Hayward Gallery, 1987.

Miller, Joan Vita, and Gary Marotta. *Rodin: The B. Gerald Cantor Collection.* New York: Metropolitan Museum of Art, 1986.

Tancock, John L. *The Sculpture of Auguste Rodin: The Collection of the Rodin Museum, Philadelphia.* Philadelphia: Philadelphia Museum of Art, 1976.